Oil Paintings in Public Ownership in Kent

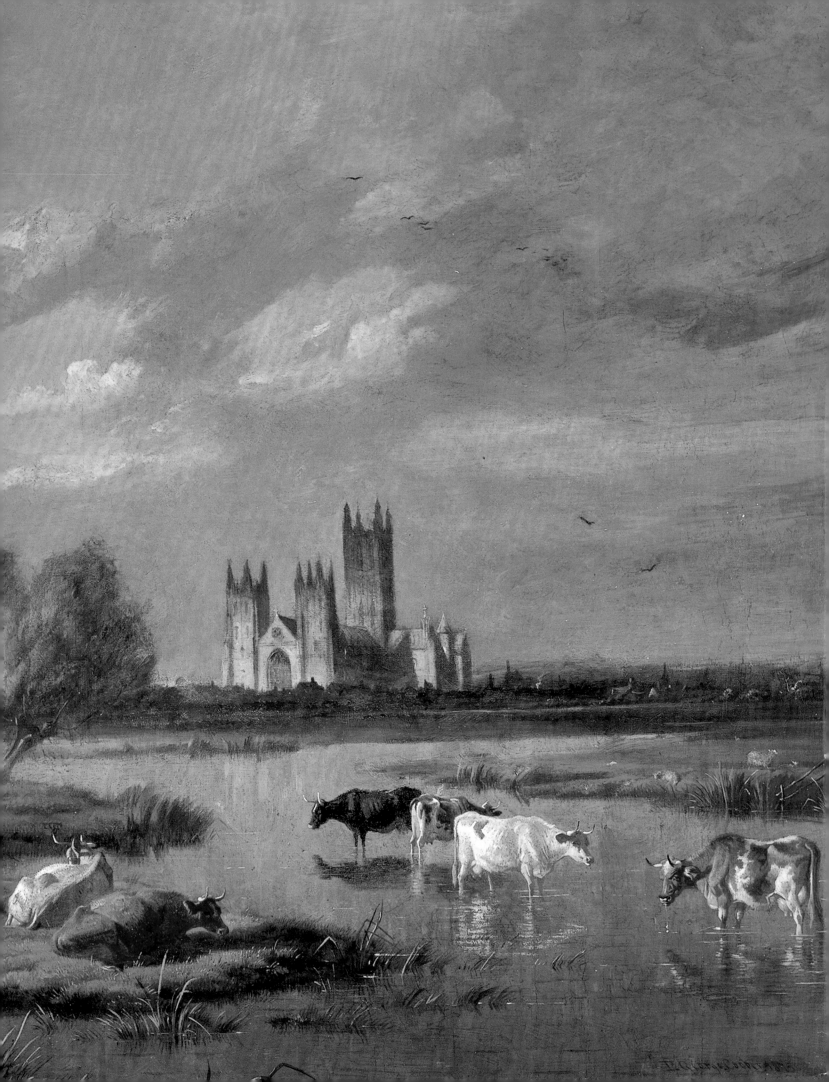

Oil Paintings in Public Ownership in Kent

The Public Catalogue Foundation

First published in 2004 by the Public Catalogue Foundation, 17 Buckingham Gate, London SW1E 6LB

ISBN 1–904931–02–2 (hardback)
ISBN 1–904931–03–0 (paperback)

Kent photography: www.ajphotographics.com

Designed by Jeffery Design, London

Distributed by the Public Catalogue Foundation, 17 Buckingham Gate, London SW1E 6LB
Telephone 020 7932 8460

Printed and bound in the UK by Butler & Tanner Ltd, Frome, Somerset

Cover image:

Parris, Edmund Thomas 1793–1873
The Canterbury Pilgrims (detail) 1836
Canterbury City Council Museums and Galleries
(see p. 22)

Image opposite title page:

Cooper, Thomas George 1836–1901
Canterbury Meadows (detail) 1875
Canterbury City Council Museums and Galleries
(see p. 7)

Back cover images (from top to bottom):

Dahl, Michael I 1656/1659–1743
Sir Cloudesley Shovell, MP
Guildhall Museum, Rochester (see p. 199)

Hunter, Ian b.1939
Gutter Apples
Canterbury City Council Museums and Galleries
Collections (see p. 16)

Coward, Noël 1899–1973
White Cliffs
Dover Collections (see p. 60)

Contents

vii Foreword
viii The Public Catalogue Foundation
ix Financial Supporters
x Acknowledgements
xi Catalogue Scope and Organisation
xii Key to Painting Information

THE PAINTINGS

Broadstairs
1 Dickens House Museum

Canterbury
1 Canterbury City Council Museums and Galleries:
3 *Herne Bay Museum and Gallery*
5 *Royal Museum and Art Gallery and other Canterbury collections*
35 *Whitstable Museum and Gallery*
39 Corridor Arts, Marlowe Theatre

Chatham
40 Historic Dockyard, Chatham
44 Kent Police Museum

Cranbrook
45 Cranbrook Museum
45 Cranbrook Parish Council

Dartford
46 Dartford Borough Council Civic Centre
46 Dartford Borough Museum
47 Dartford Library

Deal
52 Deal Town Council

Dover
53 Dover Collections

Faversham
91 Faversham Town Council, Mayor's Parlour and Guildhall

Folkestone
80 Folkestone Charter Trustees
82 Folkestone Museum

Gillingham
92 Medway NHS Trust, Gillingham
94 Royal Engineers Museum, Gillingham

Gravesend

98 Gravesham Borough Council

Hythe

104 Hythe Council Offices, Local History Room and Town Hall

Maidstone

106 Kent County Council, Arts and Museums
112 Kent Fire and Rescue Service Museum
113 Kent Police
113 Maidstone County Hall
122 Maidstone Museum & Bentlif Art Gallery
179 Museum of Kent Life

Margate

179 Margate Library
180 Margate Old Town Local History Museum

Queenborough

187 The Guildhall, Queenborough

Ramsgate

188 Ramsgate Maritime Museum
189 Ramsgate Museum

Rochester

197 Fairway Library, Rochester
197 Guildhall Museum, Rochester

Sandwich

210 Sandwich Guildhall Museum

Sittingbourne

217 Court Hall Museum
218 Swale Borough Council

Tenterden

219 Tenterden Museum Collection
220 Tenterden Town Council

Tunbridge Wells

223 Tunbridge Wells Museum and Art Gallery

Walmer

235 English Heritage, Walmer Castle

238 Paintings Without Reproductions
240 Further Information
254 Collection Addresses
256 Index

Foreword

From the very earliest days of the Public Catalogue Foundation's tentative existence, we received material and financial support for its work and for the cataloguing of the Kent collection from Kent County Council. Without this support, both at officer and member level, it is likely that neither the Foundation nor this catalogue would have come to life. Roger de Haan, then chairman of Saga Group Ltd, soon matched this support and to both of them the Foundation is enormously grateful. As it is to others, including the Boorman family and the Kent Messenger Group, Elaine Craven, Val Fleming, Chloe Teacher, Mary Villiers and others too numerous to mention. To all of them we recognize a great debt.

We know – we were warned – that Kent would be difficult, and it has been. Some 1,850 images at over 40 sites tested our embryonic system: found it wanting and showed us how to correct it. It has taught us, too, how difficult it can be for all collections, but especially for the small ones, to work with us in this venture – and to all the curators involved, I must express my sincere thanks.

We aim to include every publicly owned oil painting in the county. We will inevitably miss some. Sadly, some we know are missing. Following a fire at Ramsgate Library on Friday 13 August, many paintings in that collection were destroyed or damaged beyond repair. Happily, we had already photographed and recorded them, and we have included them in this catalogue – an event that on its own seems to me to vindicate the Foundation's purpose. Under the circumstances, that another collection in Ramsgate (uniquely) declined to have its two portraits recorded in this catalogue for reasons of security, defies logic.

While in general, County Councils and Local Authorities have welcomed the Foundation and its work and helped where they can within their limited resources, the fact remains that the resources available even to maintain our National Collection are limited and in general reducing. So it is hugely exciting that during our cataloguing of Kent, Canterbury City Council and the curator of the Canterbury Museums and Galleries, have found the political will and the financial resources to enhance their collection with the purchase of a magnificent Van Dyck for the city; and that Kent County Council, together with Margate, are jointly constructing an astonishing and innovative gallery in the sea off the pier at Margate, Turner Contemporary, to bring the finest of British Art of all periods to this county. Well done Kent!

Fred Hohler, Chairman

The Public Catalogue Foundation

The United Kingdom holds in its galleries and civic buildings arguably the greatest publicly owned collection of oil paintings in the world. However, an alarming four in five of these paintings are not on view. Whilst many galleries make strenuous efforts to display their collections, too many paintings across the country are held in storage, usually because there are insufficient funds and space to show them. Furthermore, very few galleries have created a complete photographic record of their paintings, let alone a comprehensive illustrated catalogue of their collections. In short, what is publicly owned is not publicly accessible.

The Public Catalogue Foundation, a registered charity, has three aims. First, it intends to create a complete record of the nation's collection of oil, tempera and acrylic paintings in public ownership. Second, it intends to make this accessible to the public through a series of affordable catalogues and, after a suitable delay, through a free Internet website. Finally, it aims to raise funds through the sale of catalogues in gallery shops for the conservation and restoration of oil paintings in these collections.

The initial focus of the project is on collections outside London. Highlighting the richness and diversity of collections outside the capital should bring major benefits to regional collections around the country, including a revenue stream for conservation and restoration, the digitisation of their collections and publicity for the collections through the published county catalogues. These substantial benefits to galleries around the country come at no financial cost to the collections themselves.

The project should be of enormous benefit and inspiration to students of art and to members of the general public with an interest in art. It will also provide a major source of material for scholarly research into art history.

Financial Supporters

The Public Catalogue Foundation would like to express its profound appreciation to the following organisations and individuals who have made the publication of this catalogue possible.

Donations of £5000 or more

Canterbury City Council
Department for Culture, Media and
 Sport
Hazlitt, Gooden & Fox Ltd
Kent County Council
Kent Messenger Group
Saga Group Ltd
Chloe Teacher

Donations of £1000 or more

Elaine Craven, Earl Street
 Employment Consultants Ltd
Cripps Portfolio
Elizabeth & Val Fleming
The Gulland Family
Maidstone Borough Council
H. R. Pratt Boorman Family
 Foundation
The Bernard Sunley Charitable
 Foundation
The John Swire 1989 Charitable Trust

Other Donations

Brachers Solicitors
Elizabeth Cairns
Mr and Mrs Charles Dawes
Robert M. De Fougerolles
Dominion Business Supplies Ltd
Nick & Rosie Evelegh
Mr & Mrs Simon Russell Flint
Peter & Sue Gardiner-Hill
Frank Gibson OBE
David M. Holman
The Honourable Charles James
Mrs M. Julius
Lord Kingsdown
Mr & Mrs David Lough
John Lumley
Mr & Mrs Philip Merricks
Richard Oldfield
The Royal Bank of Scotland
Mr & Mrs Jeremy Scott
Stone Court Hotel
James Swartz
Individual Members of Tunbridge
 Wells University of the Third Age
Charles Villiers
Stuart Wheeler

National Supporters

Hiscox Plc
The Mercers' Company
Provident Financial

National Sponsor

Christie's

Acknowledgements

The Public Catalogue Foundation would like to thank the individual artists and copyright holders for their permission to reproduce for free the paintings in this catalogue. Exhaustive efforts have been made to locate the copyright owners of all the images included within this catalogue and to meet their requirements. Copyright credit lines for copyrights owners who have been traced, are listed in the Further Information section.

The Public Catalogue Foundation would like to express its great appreciation to the following organisations for their great assistance in the preparation of this catalogue:

Bridgeman Art Library
Flowers East
Marlborough Fine Art
National Association of Decorative and Fine Art Societies (NADFAS)
National Gallery, London
National Portrait Gallery, London
Royal Academy of Arts, London
Tate

The participating collections included in the catalogue would like to express their thanks to the following organisations which have so generously enabled them to acquire paintings featured in this catalogue:

Bentlif Trust
Brenchley Trust
Friends of the Canterbury Museums
Heritage Lottery Fund (HLF)
MLA/V&A Purchase Grant Fund
National Art Collections Fund (the Art Fund)
National Heritage Memorial Fund (NHMF)

Catalogue Scope and Organisation

Medium and Support

The principal focus of this series is oil paintings. However, tempera, acrylic and mixed media, where oil is the predominant constituent, are also included. Paintings on all forms of support (e.g. canvas, panel etc) are included as long as the support is portable. The principal exclusions are miniatures, hatchments or other purely heraldic paintings and wall paintings *in situ*.

Public Ownership

Public ownership has been taken to mean any paintings that are directly owned by the public purse, made accessible to the public by means of public subsidy or generally perceived to be in public ownership. The term 'public' refers to both central government and local government. Paintings held by national museums, local authority museums, English Heritage and independent museums, where there is at least some form of public subsidy, are included. Paintings held in civic buildings such as local government offices, town halls, guildhalls, public libraries, universities, hospitals, crematoria, fire stations and police stations are also included. Paintings held in central government buildings as part of the Government Art Collection and MoD collections are not included in the county-by-county series but should be included later in the series on a national basis.

Geographical Boundaries of Catalogues

The geographical boundary of each county is the 'ceremonial county' boundary. This county definition includes all unitary authorities. Counties that have a particularly large number of paintings are divided between two or more catalogues on a geographical basis.

Criteria for Inclusion

As long as paintings meet the requirements above, all paintings are included irrespective of their condition and perceived quality. However, painting reproductions can only be included with the agreement of the participating collections and, where appropriate, the relevant copyright owner. It is rare that a collection forbids the inclusion of its paintings. Where this is the case and it is possible to obtain a list of paintings, this list is given in the Paintings Without Reproductions section. Where copyright consent is refused, the paintings are also listed in the Paintings Without Reproductions section. All paintings in collections' stacks and stores are included, as well as those on display. Paintings which have been lent to other institutions, whether for short-term exhibition or long-term loan, are listed under the owner collection. In addition, paintings on long-term loan are also included under the borrowing institution when they are likely to remain there for at least another five years from the date of publication of this catalogue. Information relating to owners and borrowers is listed in the Further Information section.

Layout

Collections are grouped together under their home town. These locations are listed in alphabetical order. In some cases collections that are spread over a number of locations are included under a single owner collection. A number of collections, principally the larger ones, are preceded by curatorial forewords. Within each collection paintings are listed in order of artist surname. Where there is more than one painting by the same artist, the paintings are listed in order of collection accession number (inventory number). Where the artist is unknown and the school is given instead, paintings are listed in order of date first and then in order of collection accession number.

The few paintings that are not accompanied by photographs are listed in the Paintings Without Reproductions section.

There is additional reference material in the Further Information section at the back of the catalogue. This gives the full names of artists, titles and media if it has not been possible to include these in full in the main section. It also provides acquisition credit lines and information about loans in and out, as well as copyright and photographic credits for each painting. Finally, there is an index of artists' surnames.

Key to Painting Information

Almost all paintings are reproduced in the catalogue. Where this is not the case they are listed in the Paintings Without Reproductions section. Where paintings are missing or have been stolen, the best possible photograph on record has been reproduced. In some cases this may be black and white. Paintings that have been stolen are highlighted with a red border. Some paintings are shown with conservation tissue attached to parts of the painting surface.

Adam, **Patrick William** 1854–1929
Interior, Rutland Lodge: Vista through Open Doors 1920
oil on canvas 67.3 × 45.7
LEEAG.PA.1925.0671.LACF 🐝

Artist name This is shown as surname first. Where the artist is listed on the Getty Union List of Artist Names (ULAN), ULAN's preferred presentation of the name is always given. In a number of cases the name may not be a firm attribution and this is made clear. Where the artist name is not known, a school may be given instead. Where the school is not known, the painter name is listed as *unknown artist*. If the artist name is too long for the space, as much of the name is given as possible followed by (…). This indicates the full name is given at the rear of the catalogue in the Further Information section.

Painting title A painting followed by *(?)* indicates that the title is in doubt. Where the alternative title to the painting is considered to be better known than the original, the alternative title is given in parentheses. Where the collection has not given a painting a title, the publisher does so instead and marks this with an asterisk. If the title is too long for the space, as much of the title is given as possible followed by *(…)* and the full title is given in the Further Information section.

Medium and support Where the precise material used in the support is known, this is given.

Artist dates Where known, the years of birth and death of the artist are given. In some cases one or both dates may not be known with certainty, and this is marked. No date indicates that even an approximate date is not known. Where only the period in which the artist was active is known, these dates are given and preceded with the word *active*.

Execution date In some cases the precise year of execution may not be known for certain. Instead an approximate date will be given or no date at all.

Dimensions All measurements refer to the unframed painting and are given in cm with up to one decimal point. In all cases the height is shown before the width. Where the painting has been measured in its frame, the dimensions are estimates and are marked with (E). If the painting is circular, the single dimension is the diameter. If the painting is oval, the dimensions are height and width.

Collection inventory number In the case of paintings owned by museums, this number will always be the accession number. In all other cases it will be a unique inventory number of the owner institution. (P) indicates that a painting is a private loan. Details can be found in the Further Information section. The 🐝 symbol indicates that the reproduction is based on a Bridgeman Art Library transparency (go to www.bridgeman.co.uk) or that the Bridgeman administers the copyright for that artist.

Facing page: Halhed, Harriet, *The Little Girl at the Door* (detail), 1910, Canterbury City Council Museums and Galleries (p. 14)

THE PAINTINGS

Dickens House Museum

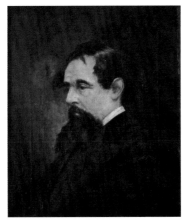

unknown artist
Charles Dickens (Aged Late 40s, Early 50s)
1860s?
oil on canvas 29.2 × 24.1
PCF_KT_DM_001

Canterbury City Council Museums and Galleries

Canterbury City Council's picture collection is relatively compact in size but nonetheless contains a number of choice works, notably the recent acquisition of a portrait by Van Dyck. These works are displayed in its main city art museum, the Royal Museum and Art Gallery, and in the branches: the Museum of Canterbury, Herne Bay Museum and Gallery, and Whitstable Museum and Gallery. Some civic pictures also hang in the Lord Mayor's Parlour at Tower House and in the Guildhall in Canterbury.

The city has built up the collection through gift and bequest, in some cases by public subscription and commission, and more recently by purchase, with the help of national and local grant-aid – the plural funding which is now the essential life-blood of cultural renewal and development. The collection has a long history, for the Museums and Galleries service traces its origins back to 1825 when the Museum of the Philosophical and Literary Institution was opened in Canterbury's Guildhall Street. Portraits of the founders, and subsequently also portraits from the Canterbury Catch Club, were among its collections and survive as cherished links with those earnest times.

One of the earliest picture acquisitions for that museum – by public subscription – was Thomas Sidney Cooper's *View of Canterbury from Tonford, with Cattle*, painted in 1835. This remains among the highlights of the nationally important Cooper collection on display in the Royal Museum and Art Gallery. This museum is an integral part of the late Victorian Beaney Institute, built thanks to the bequest of Canterbury-born Dr J. G. Beaney, to replace the 1825 museum and its library.

Dr Beaney's bequest also contained his picture collection, and the opening of his new building attracted other gifts and bequests, notably the G. F. de Zoete collection of English and continental paintings – partly gifted by him in 1905 and partly bequeathed in 1932. Funding from the Slater family allowed the building of an extension to the Beaney Institute in 1934, including, for the first time, an art gallery to display the picture collection.

Collecting in the years up to the 1970s reflected interests in local topography and portraiture, adding value to the collective memory of people and places

which is a continuing role of the service. There were also gifts of pictures by
Thomas Sidney Cooper, and transfer of a number of mayoral portraits which
had been displaced in the 1950s, on the demolition of the medieval guildhall.
Of some note for the early history of provincial painting is the commission
paid by the city in 1689 for a 'chimney piece' by Canterbury Alderman Henry
Gibbs. The resulting *Judgement of Solomon*, after Rubens, was no doubt
considered appropriate for a guildhall which was also the city courthouse. This
picture is now in the art gallery, while another work by him is in the Tate in
London.

The wider availability of grant-aid, and the formation from the mid-1970s
of a Friends of the Museum group with Lord Clark of Saltwood as its first
patron, helped change the direction of collecting, widening the range and
reflecting the extended Canterbury local government area created in 1974 with
the inclusion of the towns of Herne Bay and Whitstable.

The gallery displays do justice to Thomas Sidney Cooper, who was born in
Canterbury in 1803 and died there in 1902. Distinguished artists with local
links are one of the main collecting themes, and among them are John Ward,
Carel Weight, Fred Cuming, Roger de Grey, Thomas Monnington, Walter
Sickert and Gary Hume. Artists who visited the city and its monuments, or who
were commissioned to portray local people or themes, are also represented.
They include: James Ward (with his view of Reculver Towers); Thomas
Hudson; John Opie (with the monumental *Murder of Thomas Becket*); Ben
Marshall (with his huntsman); Cornelis Janssens van Ceulen (from the mid-
17th century, whose magnificent portraits are a special highlight); Lucien
Pissarro, J. B. Manson, Laura Knight and John Piper (from the 20th century).
The paintings by Gary Hume and John Piper are not oils, so they are not
featured in this catalogue. Documenting changes to the interior of the
cathedral is a further continuing theme, while 'Canterbury Faces' is a newer one
and seeks in various media to document people who have a particular
connection with the city – from Chaucer to Orlando Bloom of current times.

Inevitably, a number of works are in the reserve collection, not on
continuous display; but there – as in the case of family and other portraits –
they have nonetheless an important and legitimate archive function. Not
everything in the collection can ever be shown at the same time for lack of
space, or for lack of a suitable display context. And inevitably, over the passage
of time a number of works will need the help of a conservator and will be in
reserve until this work can be funded. Separate space for reserve collections is
therefore an important adjunct to any gallery. In such contexts innovative
projects like this catalogue, and related digitisation projects, are especially
welcome as ways of documenting, of widening access and sharing information,
and of providing also an element of income towards conservation work.

Challenges for the city council remain, and as part of its developing cultural
leadership for the sub-region, it is planning with partners ways to extend its city
art museum so to provide more space for collections, for exhibitions, for
educational services based on both, and for encouraging creativity. The
challenges are also to resource care for the existing collections, to research them
and make them more widely accessible, and to fund relevant new acquisitions.
While the real thing is the stuff of museums and galleries, there are practical
limitations – such as space – on collecting; but if this problem can be allied
with developments in IT, it might focus attention on innovative ways of
'acquisition' by documentation, and so widen the net to capture more of the

contemporary interests and concerns of the area's artistic community. In all this we need also take heed of what is wanted by service users – who now include the city's burgeoning student population, as well as visitors from most parts of the world. Canterbury's art collections have a vibrant, new and challenging future.

Ken Reedie, Curator of Museums & Galleries, Canterbury City Council

Canterbury City Council Museums and Galleries: Herne Bay Museum and Gallery

Cook, Janet
Fossil Fishes c. 2000
acrylic on board 76.0 × 51.5
CANHB:2003.11

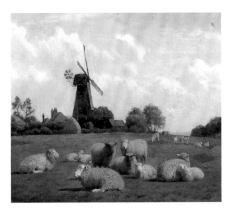

Cooper, William Sidney 1854–1927
Herne Mill, Kent 1914
oil on canvas 32.0 × 37.5
CANCM:1988.22

Cooper, William Sidney 1854–1927
Cattle on a Bridge, Kent 1897
oil on canvas 26 × 36
CANCM:1997.39.1

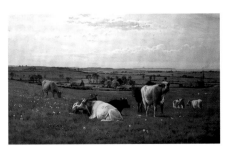

Cooper, William Sidney 1854–1927
Herne Bay, Kent 1892
oil on canvas 57 × 92
CANCM:1997.175

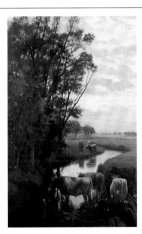

Cooper, William Sidney 1854–1927
Evening at Sturry, Kent c.1890
oil on canvas 91 × 60
H1670

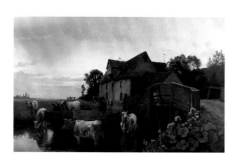

Cooper, William Sidney 1854–1927
Cattle Watering on the River Stour 1893
oil on canvas 113 × 170
H1671

Cox, D. C.
Eddington Post Office and Forge, Herne Bay as in 1887 c.1920
oil on wood panel 23 × 36
H1044

Cox, D. C.
Toll Gate, Canterbury Road, Herne Bay as in 1860 c.1920
oil on board 30 × 40
H1045

Cox, D. C.
School Lane, Herne Bay c.1920
oil on wood panel 21 × 31
H1056

Cox, D. C.
School Lane, Herne as in 1862 c.1920
oil on canvas 26 × 36
H1057

Goodwin, Albert 1845–1932
Reculver, Kent 1904
oil on wood panel 31 × 54
CANCM:1997.30

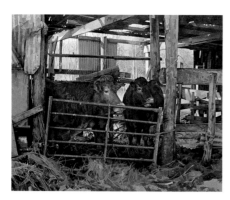

Grey-Jones, Michael b.1950
Cows in a Farm Barn Near Herne Bay 1992
acrylic on board 37 × 43
CANCM:1993.23

T. E. 19th C
Boats and Barges, Reculver in Distance
oil on wood panel 18 × 28
H1661

Thoresby, Valerie
Towards Reculver c.2000
mixed media on board 33 × 33
CANHB:2001.94

unknown artist
John Banks, First Postmaster of Herne Bay
c.1850
oil on canvas 54 × 44
H1392

unknown artist 19th C
Moonlight Scene off Reculver as in 1779
oil on canvas 70 × 90
H1083

Westmacott, Stewart b.c.1824
View of Reculver 1851
oil on canvas 43 × 61
CANHB:2003.10

Canterbury City Council Museums and Galleries: Royal Museum and Art Gallery and other Canterbury collections

Atkinson, John Gunson active 1849–1885
Moel Siabod from the Llugwy, North Wales with Welsh Cattle
oil on canvas 30.5 × 50.8
CANCM:3077

Atkinson, John Gunson active 1849–1885
Old Moel Siabod from Near Dolwyddelan, North Wales
oil on canvas 30.6 × 51.0
CANCM:3079

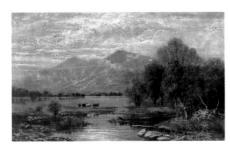

Atkinson, John Gunson active 1849–1885
Skiddaw, Derwentwater
oil on canvas 31 × 51
CANCM:3082

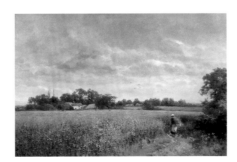

Bates, David active 1868–1893
A Bean Field at Pickersleigh, Near Malvern
1890
oil on canvas 51.0 × 76.5
CANCM:11058

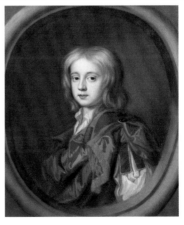

Beale, Mary 1633–1699
Sir Basil Dixwell 1681
oil on canvas 74.0 × 61.5
CANCM:2004.237

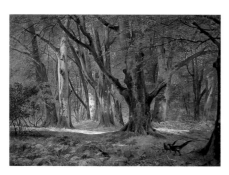

Beavis, Richard 1824–1896
In the Shade of the Beeches, Buckhurst Park
1840–1896
oil on canvas 43.8 × 61.2
CANCM:10889

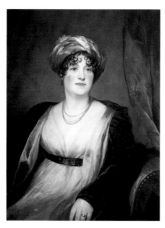

Beechey, William (studio of) 1793–1839
Mrs Crole
oil on canvas 92 × 71
CANCM:2003.380

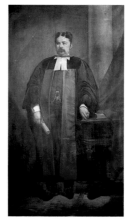

Bionda, P.
Dr J. G. Beaney 1886
oil on canvas 225 × 135
PCF_KT_CAN_047_029

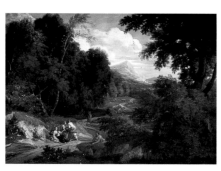

Bloemen, Jan Frans van 1662–1749
A Classical Landscape with Figures 1690–1749
oil on canvas 62.2 × 85.5
CANCM:4042

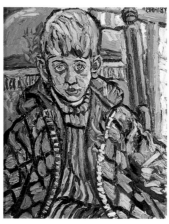

Bratby, John 1928–1992
The Artist's Ten-Year-Old Son
oil on canvas 53 × 43
CANCM:1998.48

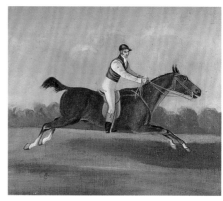

British (English) School
William Hutchinson of Canterbury on 'Staring Tom' riding from Canterbury to London Bridge in 2 hours 25 minutes and 51 seconds (...) 1819
oil on canvas 30.8 × 38.0
CANCM:10837

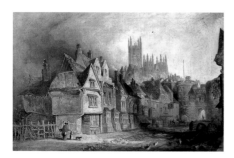

British (English) School
West Gate from St Dunstan's, Canterbury
c.1900
oil on canvas 53 × 77
CANCM:9939

Brown, Alfred J.
Downland Pasture 1889
oil on canvas 76.5 × 120.5
CANCM:11030

Bruton, W.
River Scene with Bridge
oil on canvas 30.5 × 61.2
CANCM:3080

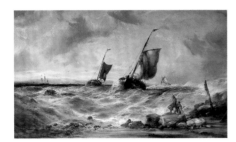

Burrell, James active 1859–1876
Fishing Boats on a Choppy Sea 1876
oil on canvas 76 × 127
CANCM:3051

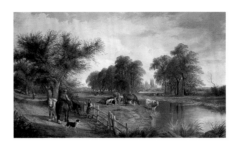

Clarke, S.
Canterbury Cathedral from the Stour Meadows
1888
oil on canvas 76.5 × 128.0
CANCM:9940

Cleeve, E.
An Officer in Tropical Uniform 1900
oil on canvas 67.0 × 47.5
CANCM:11384

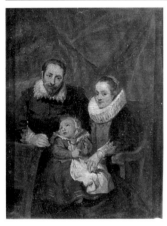

Collins, William 1788–1847
The Snyders Family (after Anthony van Dyck)
oil on board 27.1 × 21.9
CANCM:4038

Constable, John (style of) 1776–1837
Watermill at Flatford 1801–1850
oil on panel 20.0 × 25.8
CANCM:8337

Constable, John (style of) 1776–1837
Landscape with Man Fishing 1801–1850
oil on canvas 22.7 × 34.3
CANCM:8342

Cooper, Thomas George 1836–1901
Canterbury Meadows 1875
oil on canvas 71.0 × 91.4
CANCM:3050

Cooper, Thomas Sidney 1803–1902
A Border Collie 1838
oil on canvas 27.4 × 40.0
CANCM:1992.99

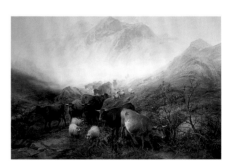

Cooper, Thomas Sidney 1803–1902
Through the Glen in a Mist 1897
oil on canvas 51.0 × 76.2
CANCM:1995.22

Cooper, Thomas Sidney 1803–1902
The Stolen Horse 1839
oil on canvas 51.4 × 72.0
CANCM:1996.7

Cooper, Thomas Sidney 1803–1902
A Young Bull 1844
oil on panel 15.9 × 21.1
CANCM:1996.87

Cooper, Thomas Sidney 1803–1902
A Study of Cattle and Sheep on a Cliff Top
1867
oil on millboard 21.9 × 45.8
CANCM:1999.237

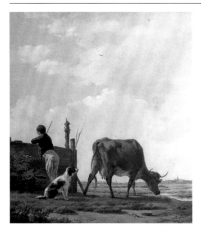

Cooper, Thomas Sidney 1803–1902
A Peasant Boy with a Cow and a Dog 1827
oil on canvas 36.8 × 33.0
CANCM:2003.393

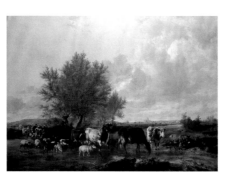

Cooper, Thomas Sidney 1803–1902
View of Canterbury from Tonford, with Cattle
1835
oil on canvas 132.1 × 182.9
CANCM:4043

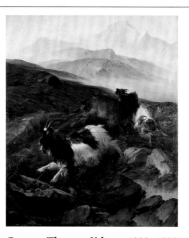

Cooper, Thomas Sidney 1803–1902
*Catching Wild Goats on Moel Siabod, North
Wales* 1862
oil on canvas 157.7 × 131.9
CANCM:4044

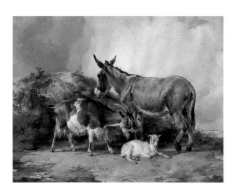

Cooper, Thomas Sidney 1803–1902
Donkey, Goat and Kid 1838
oil on panel 34.9 × 45.7
CANCM:8348

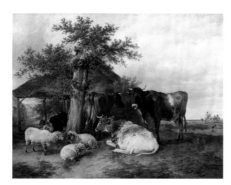

Cooper, Thomas Sidney 1803–1902
The Home Farm 1844
oil on canvas 109.2 × 146.1
CANCM:8365

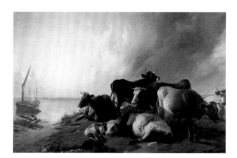

Cooper, Thomas Sidney 1803–1902
On the Thames, Pushing off for Tilbury Fort
1884
oil on canvas 224.2 × 330.8
CANCM:10609

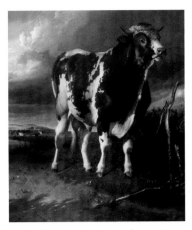

Cooper, Thomas Sidney 1803–1902
Separated, but not Divorced (The Bull)
1874–1882
oil on canvas 261.8 × 228.6
CANCM:10610

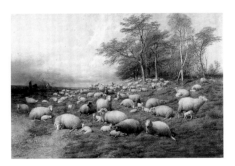

Cooper, Thomas Sidney 1803–1902
Spring: in the Springtime of the Year 1901
oil on canvas 101.6 × 152.4
CANCM:10611

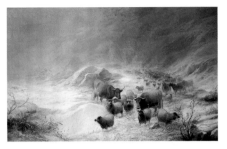

Cooper, Thomas Sidney 1803–1902
*Winter: through the Fells, Cumberland; the
Drove in a Snowdrift* 1901
oil on canvas 92 × 148
CANCM:10612

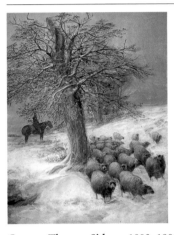

Cooper, Thomas Sidney 1803–1902
Sheep in the Snow 1902
oil on canvas 91.8 × 71.1
CANCM:10613

Cooper, Thomas Sidney 1803–1902
Self Portrait c.1832
oil on canvas 91.5 × 71.2
CANCM:11022

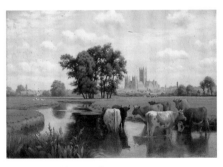

Cooper, William Sidney 1854–1927
Canterbury Cathedral from the Stour Meadows
oil on canvas 33.5 × 48.5
CANCM:10122

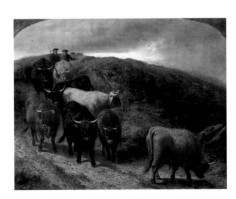

Corbould, Aster Richard Chilton 1811–1882
Highland Cattle on the Hills 1868
oil on canvas 51.2 × 63.9
CANCM:11061

Cotman, John Sell 1782–1842
Woodland Scene with Stream, Man and Dog
oil on canvas 44.5 × 35.7
CANCM:8336

Cox, E. Albert 1876–1955
Ancient and Modern 1901–1946
oil on canvas 57.1 × 60.6
CANCM:10816

Cox, E. Albert 1876–1955
Venice 1901–1946
oil on board 45.4 × 50.5
CANCM:10817

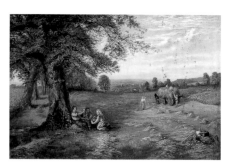

Creswick, Thomas (attributed to)
1811–1869
Hayfield
oil on canvas 51.5 × 76.3
CANCM:11358

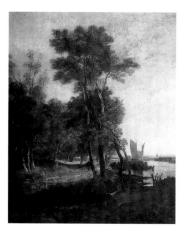

Crome, John 1768–1821
Woodland with River and Barges with Sails
oil on canvas 76.0 × 63.5
CANCM:8333

Cuming, Frederick b.1930
Rye Harbour 1970–1990
oil on hardboard 51 × 51
CANCM:1997.139.2

Cuming, Frederick b.1930
Verandah Evening 1972
oil on hardboard 123 × 123
PCF_KT_CAN_L 27_001

Curtois, Mary Henrietta Dering 1854–1929
Figure in a Street 1870–1910
oil on canvas board 25.5 × 35.0
CANCM:11397

Davies, Gordon b.1926
*Rebuilding and Repairs in St George's,
Canterbury, including the construction of the
David Greig shop* c.1954
oil on canvas 40.5 × 61.0
CANCM:1999.290.1

Dawson, Alfred active 1860–1894
Canterbury from Kingsmead 1881
oil on panel 20.4 × 25.4
CANCM:10217

de Grey, Roger 1918–1995
Orchard c.1970
oil on canvas 71.0 × 91.5
CANCM:1996.117

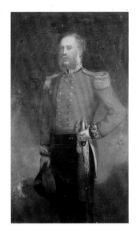

Desanges, Louis William 1822–c.1887
*Thomas Gilbert Peckham, Deputy Lieutenant,
JP* 1874
oil on canvas 168 × 98
CANCM:2003.382

Desanges, Louis William 1822–c.1887
Virginia Peckham c.1870
oil on canvas 168 × 98
CANCM:2003.383

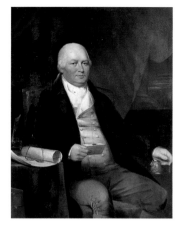

Dinsdale, T. early 19th C
William Baldock of Petham, Near Canterbury
oil on canvas 125.0 × 100.5
TH5

Dodd, Charles Tattershall I (attributed to)
1815–1878
Deane, Near Canterbury (after L. L. Razé)
1840
oil on canvas 55.2 × 76.0
CANCM:10395

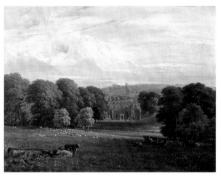

Dodd, Charles Tattershall I (attributed to)
1815–1878
Broome Park, Canterbury (after L. L. Razé)
1820–1880
oil on canvas 55 × 76
CANCM:10400

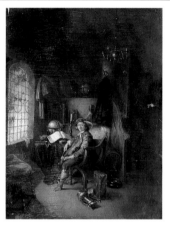

Dou, Gerrit (after) 1613–1675
The Viola Player
oil on panel 32.1 × 25.2
CANCM:8331

Doxford, James 1899–1978
Self Portrait 1920–1950
oil on canvas laid on hardboard 58.2 × 43.2
CANCM:1996.26

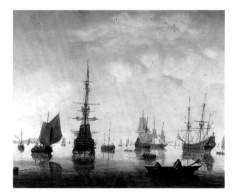

Dubbels, Hendrik Jacobsz. (attributed to)
1620/1621–1676
Seascape
oil on panel 37.4 × 47.2
CANCM:4041

Dudley, Colin b.1923
*Freedom Ceremony at Canterbury Guildhall for
the Prince of Wales* 1979
oil on canvas 151.0 × 228.5
G2

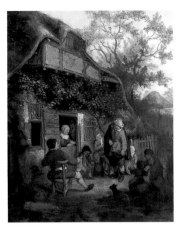

Dusart, Cornelis 1660–1704
The Hurdy-gurdy Player
oil on panel 33.3 × 28.4
CANCM:4037

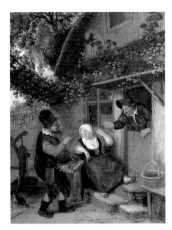

Dusart, Cornelis 1660–1704
The Pedlar 1692
oil on copper panel 18.8 × 14.4
CANCM:8345

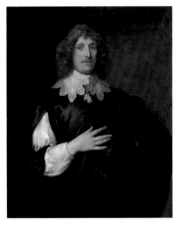

Dyck, Anthony van 1599–1641
Sir Basil Dixwell c.1638
oil on canvas 108 × 87
CANCM:2004.72

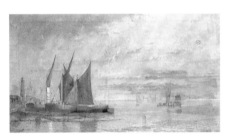

Fletcher, E.
Seascape with Fishing Boats 1879
oil on canvas 61 × 107
CANCM:3048

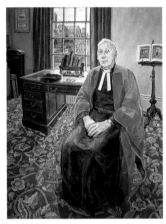

Foreman, Margaret b.1951
Canon Ingram Hill MA, DD, FSA 1984
oil on canvas 120 × 91
CANCM:10368

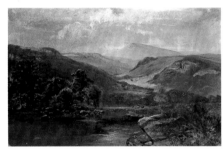

Foster, Walter H. active 1861–1888
The Lledr Valley from Near the Conway Falls
oil on canvas 66.0 × 101.9
CANCM:3055

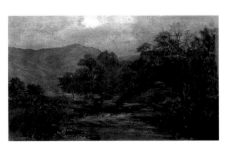

Foster, Walter H. active 1861–1888
At Beddgelert, North Wales
oil on canvas 46.0 × 76.5
CANCM:3073

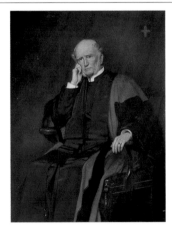

Fox, Ernest R. active 1886–1919
Dr Henry Wace, Dean of Canterbury,
(1903–1924) c.1919
oil on canvas 142 × 112
CANCM:2003.591

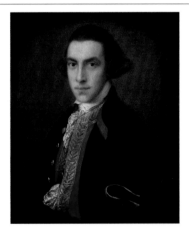

Gainsborough, Thomas 1727–1788
Portrait of a Gentleman mid-1760s
oil on canvas 75.8 × 62.4
CANCM:4024

Gerrard, Kaff 1894–1970
Still Life with Pumpkin and Green Jug
oil on canvas 51 × 77
CANCM:1991.68.1

Gerrard, Kaff 1894–1970
Poppy in a Glass Jar
oil on canvas 46.0 × 35.8
CANCM:1991.68.2

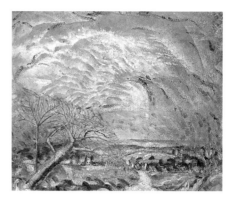

Gerrard, Kaff 1894–1970
In the Twilight, in the Evening
oil on canvas 51.3 × 61.8
CANCM:1991.68.3

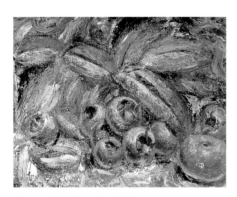

Gerrard, Kaff 1894–1970
Still Life with Fruit and Mushrooms
oil on canvas 35.8 × 46.0
CANCM:1991.68.4

Gibbs, Henry 1630/1631–1713
The Judgement of Solomon (after Peter Paul Rubens) 1689
oil on canvas 157.5 × 137.0
CANCM:11942

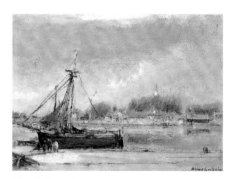

Goodwin, Albert 1845–1932
Bosham, Sussex 1928
oil, bodycolour & ink on card 18.0 × 24.6
CANCM:10790

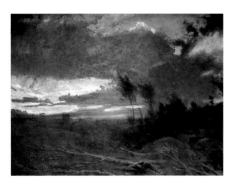

Goodwin, Albert 1845–1932
Nightfall 1870–1930
oil on canvas 107.5 × 142.4
CANCM:11040

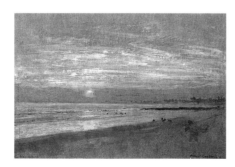

Goodwin, Albert 1845–1932
The Shrimper 1880–1932
oil on board 25.6 × 37.1
CANCM:11065

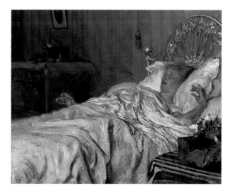

Gregory, Edward John 1850–1909
The Awakening 1870–1909
oil on canvas 41.2 × 51.5
CANCM:11013

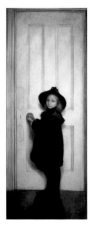

Halhed, Harriet 1850–1933
The Little Girl at the Door 1910
oil on canvas 215 × 87
CANCM:8334

Hallady, A. E.
Canterbury Blitz 1st June 1942 c.1970
oil on board 50.5 × 61.0
CANCM:11368

Hardy, Paul active 1890–1903
The Canterbury Pilgrims c.1903
oil on canvas 96.4 × 194.8
CANCM:1989.29

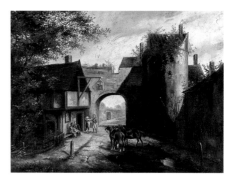

Harrison
Unknown Mayor of Canterbury
oil on canvas 92.0 × 71.5
CANCM:11360

Hawksley, Arthur 1842–1915
The Old Gangway, Broadstairs 1883
oil on canvas 71.8 × 92.0
CANCM:11353

Hayman, H. W.
Old Ridingate, Canterbury as in 1770 1884
oil on canvas 31.0 × 40.5
CANCM:2003.579

Herrick, William Salter active 1852–1888
Annie Clara Dudley
oil on canvas 127 × 87
PCF_KT_CAN_047_010

Hewson, Stephen 1775–1807
*William Goulden (1749–1816), holding a
Leyden jar with a friction machine for
generating electricity (...)* 1805
oil on canvas 76.5 × 64.0
CANCM:3058

Hewson, Stephen 1775–1807
*Thomas Ridout (1761–1843), Land Surveyor
and a Founder of the Canterbury Philosophical
and Literary Institution*
oil on canvas 76.5 × 64.0
CANCM:10809

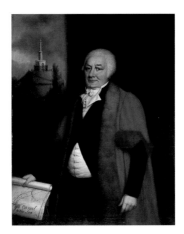

Hewson, Stephen 1775–1807
Alderman James Simmons, (1741–1807) 1806
oil on canvas 124.8 × 98.8
CANCM:10894

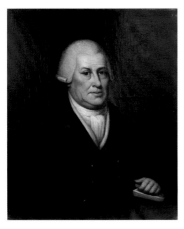

Hewson, Stephen 1775–1807
John Calloway, Silk Weaver and a Founder of
the Canterbury Philosophical and Literary
Institution
oil on canvas 75.6 × 63.6
CANCM:11105

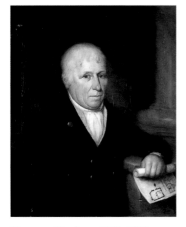

Hewson, Stephen 1775–1807
Mr Cooper Holding an Architectural Plan,
Member of the Canterbury Philosophical and
Literary Institution c.1803
oil on canvas 76.5 × 63.5
CANCM:11383

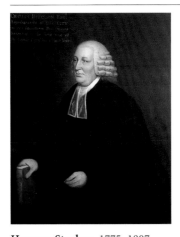

Hewson, Stephen 1775–1807
Charles Robinson (1732–1807), MP for
Canterbury 1807
oil on canvas 125.0 × 100.5
TH3

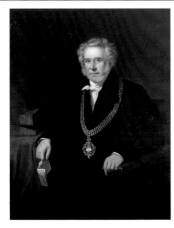

Hodges, Sidney 1829–1900
Henry Cooper, Mayor of Canterbury 1856
oil on canvas 128.0 × 102.2
CANCM:11363

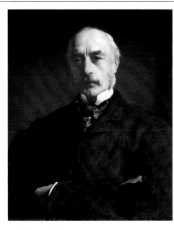

Holl, Frank 1845–1888
William Oxenden Hammond 1883
oil on canvas 71.0 × 59.7
CANCM:10386

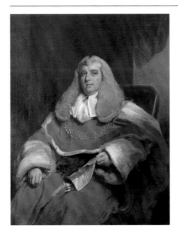

Hollins, John 1798–1855
Charles Abbott, Lord Chief Justice 1st Baron
Tenterden 1850
oil on canvas 141.5 × 111.0
TH1

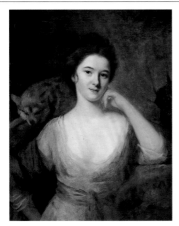

Hone, Nathaniel I 1718–1784
Kitty Fisher 1750–1784
oil on canvas 75.8 × 62.4
CANCM:4031

Honthorst, Gerrit van (after) 1590–1656
Cavalier Carousing
oil on panel 71 × 63
CANCM:Loan 1941.1 (P)

Howard, Bill d.c.1975
Tudor Tea Rooms, High Street, Canterbury
1968
oil on board 58.7 × 43.3
CANCM:1996.28

Hudson, Thomas 1701–1779
Margaret, Wife of Sir Henry Oxenden 1756
oil on canvas 127 × 101
CANCM:1998.65

Hunter, Ian b.1939
Gutter Apples
oil on board 92.0 × 100.4
CANCM:10017

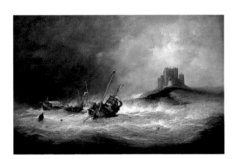

Isabey, Eugène (attributed to) 1803–1886
Fishing Boats in Rough Weather off St Michael's Mount
oil on canvas 72.5 × 112.0
CANCM:3045

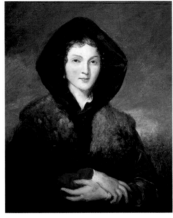

Jackson, John 1778–1831
Portrait of a Lady
oil on canvas 76.3 × 63.5
CANCM:4029

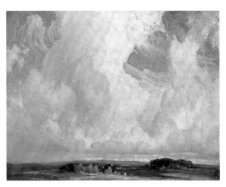

James, Walter John 1869–1932
The Big Cloud - Near Canterbury 1921
oil on canvas 36 × 46
CANCM:10863

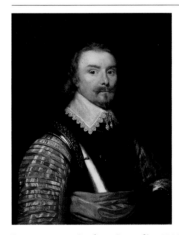

Janssens van Ceulen, Cornelis 1593–1661
Colonel Robert Hammond
oil on canvas 75.8 × 63.0
CANCM:1989.74

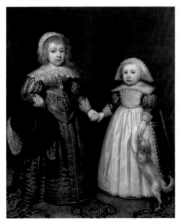

Janssens van Ceulen, Cornelis 1593–1661
Two Children with a Dog 1633
oil on canvas 118.6 × 98.0
CANCM:2001.411

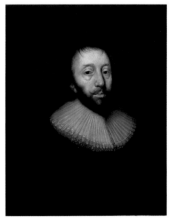

Janssens van Ceulen, Cornelis (after)
1593–1661
Dudley Digges
oil on canvas 70.5 × 56.0
CANCM:10384

Jenkins, George Henry 1843–1914
Mountain Landscape with Stream and Highland Cattle
oil on canvas 76.3 × 127.6
CANCM:11355

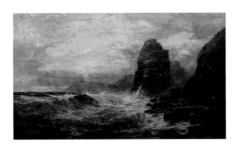

Jenkins, George Henry 1843–1914
Seascape with Fisherman and Rocky Shore
oil on canvas 76.5 × 127.5
CANCM:11356

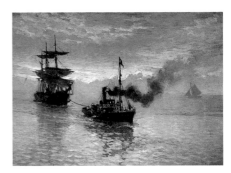

Jobert, Paul 1863–after 1924
Tug Towing a Three-Master
oil on canvas 46.5 × 61.0
CANCM:2003.605

Jordaens, Jacob (after) 1593–1678
A Musical Party 19th C
oil on canvas 103.5 × 157.0
CANCM:11364

Judkin, Reverend Thomas James 1788–1871
Windmill on St Martin's Hill, Canterbury
1850–1868
oil on canvas 81.5 × 126.5
CANCM:5612

Knight, John Prescott 1803–1881
Thomas Sidney Cooper, RA 1850
oil on canvas 76.2 × 63.5
CANCM:8362

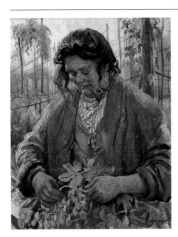

Knight, Laura 1877–1970
Hop-picking Granny Knowles - an Old Hand
1940
oil on canvas 64 × 51
CANCM:10329.1

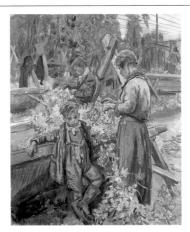

Knight, Laura 1877–1970
Hop-picking No.1 c.1946
oil on canvas 76.3 × 63.6
CANCM:10329.2

Kooyhaylen or Koningshusen, J.
Portrait of a Gentleman 1701
oil on canvas 48.7 × 42.3
CANCM:11068

L. A. R 19th C
Burgate, Canterbury
oil on canvas 27.5 × 35.2
CANCM:8405

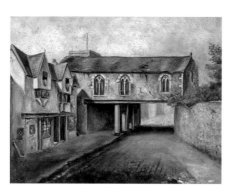

L. A. R. 19th C
Northgate, Canterbury
oil on canvas 27.3 × 34.9
CANCM:8406

La Thangue, Henry Herbert 1859–1929
Farm Near Horsey, Norfolk 1885
oil on board 25.9 × 39.3
CANCM:8404

Lee, P.
On the Moira Station, Australia 1890
oil on millboard 31 × 47
CANCM:3044

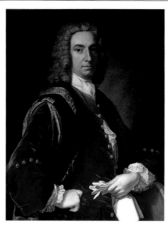

Loo, Jean-Baptiste van 1684–1745
Sir Thomas Hales, MP, (1694–1762)
c.1710–1745
oil on canvas 91.4 × 71.6
CANCM:10465

MacTavish, Euphemia L. C.
'Nothing to do with me' 1955
oil on card 51.4 × 48.3
CANCM:1995.16

Manson, James Bolivar 1879–1945
Summer Fields, Rye 1913
oil on canvas 54.0 × 66.5
CANCM:1997.58

Maratti, Carlo (style of) 1625–1713
St Cecilia (from Canterbury Catch Club)
oil on canvas 153.5 × 121.0
CANCM:10885

Marshall, Benjamin 1767–1835
Thomas Hilton and His Hound 'Glory' 1822
oil on canvas 91.0 × 70.9
CANCM:10344

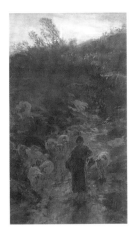

McLachlan, Thomas Hope 1845–1897
Shepherd Girl with Sheep in Moonlight 1884
oil on canvas 44.5 × 28.5
CANCM:11396

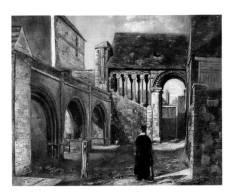

Meadows, (Canon)
Norman Stairs, Canterbury c.1830
oil on canvas 51 × 61
CANCM:2003. 578

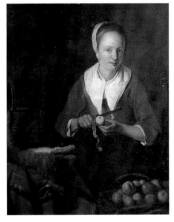

Metsu, Gabriel (after) 1629–1667
Woman Peeling Apples
oil on canvas 28.5 × 26.0
CANCM:4040

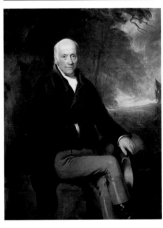

Middleton, James Godsell active 1826–1872
Sir Henry Oxenden, (b.1756)
oil on canvas 120.7 × 100.2
CANCM:11418

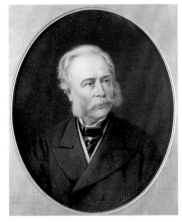

Miles, Arthur active 1851–1885
*A Posthumous Portrait of John Brent,
Canterbury Antiquarian* 1885
oil on canvas 36.0 × 30.5
CANCM:1998.173.3

Mitchell 19th C
River Scene
oil on canvas 30.5 × 61.0
CANCM:3076

Money-Coutts, Godfrey Burdett 1905–1979
Teasels 1950–1970
oil on canvas 68.8 × 84.0
CANCM:1995.101.2

Monnington, Walter Thomas 1902–1976
*The Artist's Home at Groombridge Looking at
Kaff Gerrard's Garden* c.1950
oil on canvas 102.0 × 76.5
CANCM:1998.157

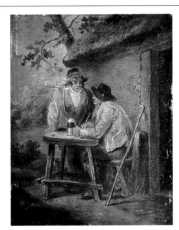

Morland, George 1763–1804
Outside the Alehouse Door 1791
oil on panel 22.3 × 18.0
CANCM:8344

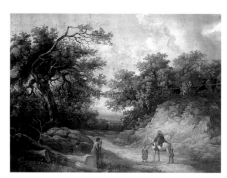

Morland, George (after) 1763–1804
A Road through a Woodland (A Man on a White Horse Giving Alms to a Child)
1780–1810
oil on panel 52.4 × 68.4
CANCM:8396

Müller, William James 1812–1845
Woodland Scene 1835
oil on panel 24.4 × 19.2
CANCM:4027

Müller, William James (attributed to)
1812–1845
On the River Avon
oil on canvas 35.5 × 53.0
CANCM:11060

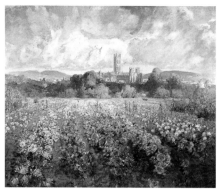

Murray, David 1849–1933
'It Was the Time of Roses' 1914
oil on canvas 140.8 × 168.0
CANCM:11055

Nasmyth, Patrick (after) 1787–1831
Landscape with Labourer and Dog 1827
oil on panel 42.0 × 53.4
CANCM:8357

Neame, Austin 1789–1862
A Bay Hunter in a Landscape 1838
oil on canvas 44.8 × 56.2
CANCM:1996.27

Neer, Aert van der 1603–1677
A River Moonlit Scene with Cattle 1620–1677
oil on canvas 27.1 × 34.9
CANCM:4039

Ogden, Joseph d.1925
Still Life with Tankard and Bananas 1894
oil on canvas 52.4 × 64.5
CANCM:10900

Opie, John 1761–1807
Murder of Thomas Becket in Canterbury Cathedral
oil on canvas 221.0 × 171.5
CANCM:10069

Facing page: Raphael (after), *Portrait of a Young Man* (detail), Canterbury City Council Museums and Galleries (p. 23)

Orley, Bernaert van c.1492–1541
*The Virgin and Child Resting in an Imaginary
Landscape*
oil on panel 34.5 × 25.5
CANCM:4032

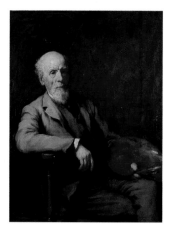

Ouless, Walter William 1848–1933
Thomas Sidney Cooper, RA 1889
oil on canvas 112.8 × 86.7
CANCM:8363

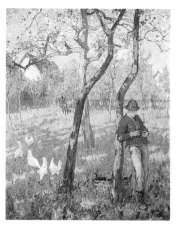

Palmer, Alfred 1877–1951
Boy in the Orchard
oil on canvas 100 × 82
CANCM:10064

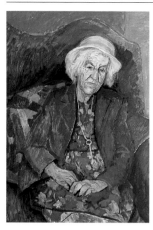

Palmer, James
Daisy Law of Canterbury (1895–1984) 1965
oil on hardboard 73.2 × 52.9
CANCM:1993.80

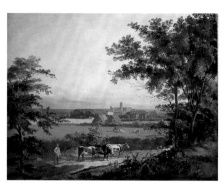

Pardon, James c.1794–1862
Canterbury from St Stephen's 1819
oil on canvas 69 × 90
CANCM:10461

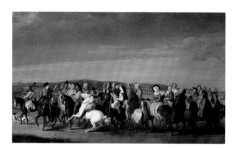

Parris, Edmund Thomas 1793–1873
The Canterbury Pilgrims 1836
oil on canvas 106.0 × 172.4
CANCM:1990.48

Pemell, James active 1836–1856
*Stephen Rumbold Lushington (1776–1868), MP
for Canterbury, (1812–1830 & 1835–1837)*
1856
oil on canvas 127.5 × 102.5
CANCM:2177

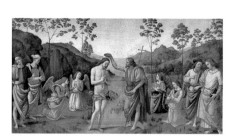

Perugino (after) c.1450–1523
The Baptism of Christ
oil on panel 36.0 × 60.5
CANCM:4030

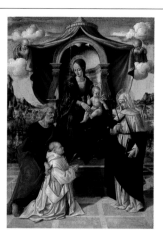

Pirri, Antonio active 1509–1520
*The Madonna and Child Enthroned with St
Peter and a Carthusian Prior, and St Catherine
of Siena* c.1520
oil on panel 51 × 37
CANCM:4035

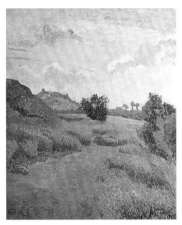

Pissarro, Lucien 1863–1944
Rye from Cadborough Hill - Grey Afternoon
1913
oil on canvas 54.2 × 43.8
CANCM:2003.445

Pyne, James Baker (attributed to)
1800–1870
A River Landscape with Figure and a Bridge
oil on canvas 20.3 × 30.8
CANCM:10899

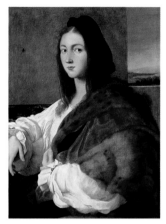

Raphael (after) 1483–1520
Portrait of a Young Man (copy of a self portrait believed to be by Raphael)
oil on canvas 77.4 × 60.1
CANCM:4034

Read, Catherine (attributed to) 1723–1778
Little Girl with a Bonnet
oil on canvas 50 × 45
CANCM:11025

Richards, F.
A Pair of Roach 1888
oil on canvas 31 × 41
CANCM:8413.1

Richards, F.
A Roach 1898
oil on canvas 30.4 × 40.5
CANCM:8413.2

Richards, F.
A Catch with Ruffe, Gudgeon and Dace 1884
oil on canvas 25.5 × 35.9
CANCM:8413.3

Richards, F.
A Catch of Perch and Bream c.1878–1898
oil on canvas 33.5 × 46.3
CANMC:8413.4

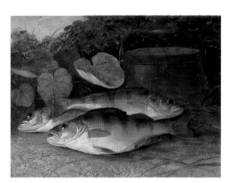

Richards, F.
A Catch of Perch 1878
oil on canvas 31 × 40
CANCM:8413.5

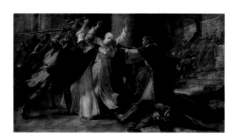

Richmond, George 1809–1896
The Murder of Becket 1855
oil on canvas 39.8 × 71.5
CANCM:1994.75

Rosenburg, Gertrude Mary d.1912
Fishing Smacks off the Cornish Coast 1900
oil on canvas 33.3 × 46.5
CANCM:10984

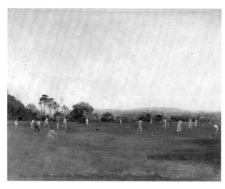

Schaefer, Henry Thomas active 1873–1915
Cricket Match at Heathfield Park, Sussex 1903
oil on canvas 24.5 × 31.2
CANCM:10869

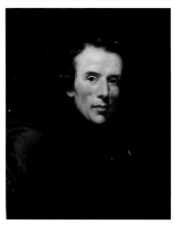

Scott, Walter 1771–1832
Thomas Sidney Cooper
oil on canvas 61.0 × 50.8
CANCM:11023

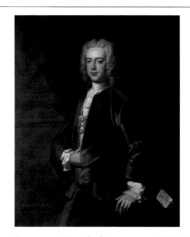

Seemann, Enoch the younger 1694–1744
Sir George Oxenden, 5th Baronet
oil on canvas 128.3 × 102.9
CANCM:1988.52.1

Sevier, Joseph b.1961
Town, Gown, Mitre and Drum - Marking the Millennium
oil on canvas 91.4 × 106.7
TH8

Sickert, Walter Richard 1860–1942
Romeo and Juliet Near Reculver, Kent 1937
oil on canvas 51.5 × 71.5
CANCM:1998.118

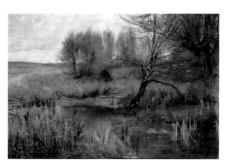

Snell, James Herbert 1861–1935
Marshy Landscape with Trees 1890–1910
oil on canvas 71.5 × 107.5
CANCM:11394

Snell, James Herbert 1861–1935
Figure on a Bridge, with River and Buildings
1893?
oil on canvas 76.0 × 106.5
CANCM:11395

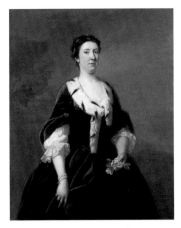

Soldi, Andrea (attributed to) c.1703–1771
Lady Oxenden, Daughter of Edmund Dunch
Esq. Married to Sir George Oxenden, 5th Bt
oil on canvas 120.7 × 100.3
CANCM:1988.52.2

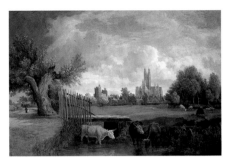

Stannard, Alfred 1806–1889
Canterbury from the Stour Meadows 1828
oil on canvas 45.5 × 65.5
CANCM:10259

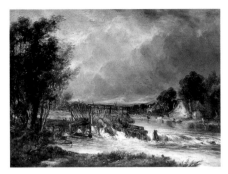

Stark, James 1794–1859
Eel Traps 1800–1859
oil on panel 26.4 × 33.8
CANCM:4018

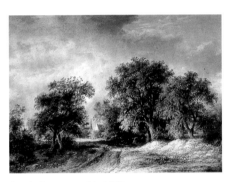

Stark, James 1794–1859
Landscape with a Church c.1800–1815
oil on panel 31.5 × 42.4
CANCM:4022

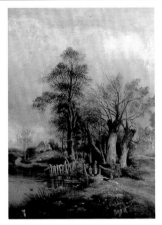

Stark, James 1794–1859
View of Uxbridge 1801–1859
oil on canvas laid on panel 49.4 × 36.8
CANCM:8335

Stokes, Adrian Scott 1854–1935
By the Walls of the Hougue, France 1881
oil on canvas 25 × 38
CANCM:10898

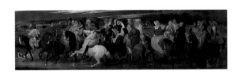

Stothard, Thomas 1755–1834
The Canterbury Pilgrims 1817
oil on panel 27 × 94
CANCM:9936.1

Stothard, Thomas 1755–1834
The Pardoner's Tale
oil on panel 27.1 × 21.2
CANCM:10291.1

Stothard, Thomas 1755–1834
Martyrdom of St Thomas Becket
oil on panel 26.4 × 21.4
CANCM:1988.51

Swain, Ned d.1902
Fordwich Bridge from the River 1883
oil on canvas 90.5 × 56.0
CANCM:10458

Swiney, Captain Stephen
The Vale of Rest - At Eventime There Shall Be Light (copy of John Everett Millais)
oil on canvas 50.8 × 76.5
CANCM:3054

Syer, John 1815–1885
A Rocky River Landscape 1879
oil on canvas 51.0 × 76.5
CANCM:11059

Tayler, Albert Chevallier 1862–1925
John Howard Esq. JP, DL of Sibton and Chartham, MP for Northeast Kent, (1902–1908) 1913
oil on canvas 112.0 × 83.6
CANCM:5208

Temple, Robert Scott active 1874–1905
Lingering Summer: Ightham Woods, Kent
oil on canvas 138 × 183
CANCM:11056

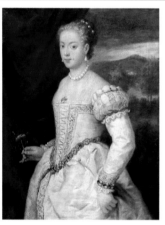

Titian (after) c.1488–1576
Lady in White Satin Holding a Rose
oil on canvas 54 × 40
CANCM:4036

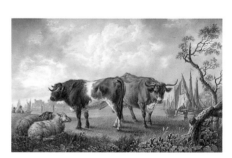

Towne, Charles 1763–1840
Cattle on a River Bank 1818
oil on canvas 15.5 × 25.0
CANCM:4026

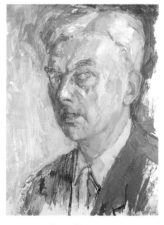

Townsend, William 1909–1973
Self Portrait 1930–1970
oil on canvas 46.0 × 35.5
CANCM:10180.1

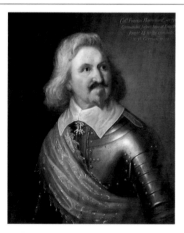

unknown artist
Colonel Francis Hammond c.1605–1630
oil on canvas 76.0 × 63.2
CANCM:1992.112

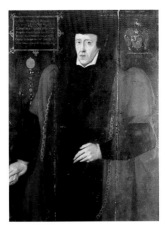

unknown artist
Sir Thomas White, Benefactor (d.1566)
1608–1609
oil on panel 113.4 × 84.0
CANCM:10888

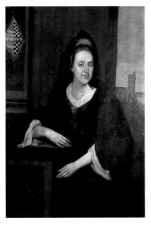

unknown artist
Mrs Elizabeth Lovejoy (1627–1694)
1650–1750
oil on canvas 136.5 × 94.5
CANCM:11129

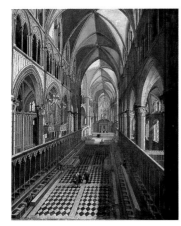

unknown artist
Interior of Canterbury Cathedral - The Quire
c.1663
oil on canvas 77.0 × 64.5
CANCM:1998.61

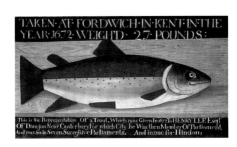

unknown artist
The Fordwich Trout 1672–1700
oil on canvas 74.5 × 113.0
CANCM:11039

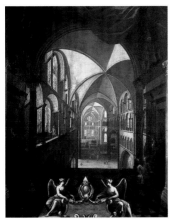

unknown artist 17th C
Interior of Canterbury Cathedral
oil on canvas 126.5 × 102.5
CANCM:1996.73

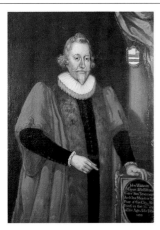

unknown artist 17th C
John Watson, Mayor (d.1633) Aged 75
oil on canvas 118 × 85
CANCM:2003.593

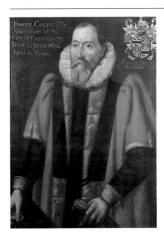

unknown artist 17th C
Joseph Colfe, Mayor (d.1620)
oil on canvas 91.5 × 66.0
CANCM:2003.596

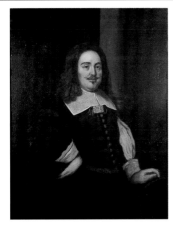

unknown artist 17th C
Henry Johnson, Benefactor
oil on canvas 112.5 × 89.0
CANCM:2003.597

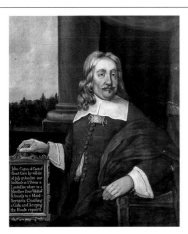

unknown artist 17th C
John Cogan, Benefactor
oil on canvas 106 × 91
TH4

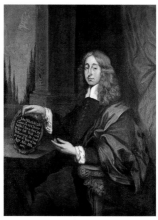

unknown artist late 17th C
John Whitfield, (1636–1691)
oil on canvas 142.0 × 108.5
CANCM:10895

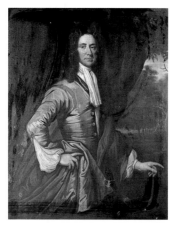

unknown artist late 17th C?
Portrait of a Gentleman
oil on canvas 125.5 × 102.0
CANCM: 2003.592

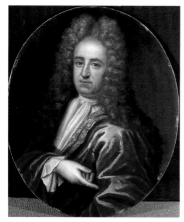

unknown artist
John Warly - Surgeon of Canterbury
1700–1780
oil on canvas 75.5 × 63.4
CANCM:8379.1

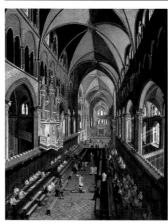

unknown artist
Interior of Canterbury Cathedral c.1710
oil on canvas 125 × 102
CANCM:1991.101

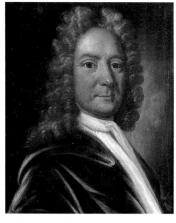

unknown artist
Portrait of a Man with a White Cravat and Indigo Jacket (Head and Shoulders)
1720–1790?
oil on canvas 35.5 × 30.5
CANCM:11388

unknown artist
Herbert Randolph (d.1752), Recorder of Canterbury, Buried in the Cathedral
1730–1752
oil on canvas 127.6 × 102.0
CANCM:11354

unknown artist
Portrait of a Man Holding a Wine Glass
1730–1760
oil on canvas 45.0 × 38.3
CANCM:11385

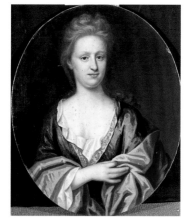

unknown artist
Mary, Wife of Surgeon John Warly, and Daughter of Alderman Lee of Canterbury
1740–1799
oil on canvas 76.5 × 64.0
CANCM:8397.2

unknown artist
Wooded Landscape and Distant Village
c.1750–1850
oil on canvas 91.5 × 118.5
CANCM:4033

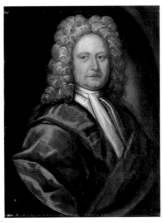

unknown artist
Mr Frend of Canterbury 1767
oil on canvas 73.0 × 55.7
CANCM:10182

unknown artist
Portrait of a Man with White Cravat and Holding a Box in his Left Hand, Mr William Paine, Canterbury Apothecary 1780–1830
oil on canvas 77 × 63
CANCM:11382

unknown artist
Mr Delmar, Member of the Canterbury Catch Club 1790–1830
oil on canvas 92.0 × 71.5
CANCM:11361

unknown artist
Alderman Cyprian Rondeau Bunce, Archivist and Mayor c.1790 76.5 × 64.0
CANCM:2003.379

unknown artist
Richard Harris Barham as a Boy with Dog Lion c.1795
oil on canvas 125.8 × 105.4
CANCM:10893

unknown artist 18th C
Handel, Holding the Score of the Messiah - from Canterbury Catch Club
oil on canvas 97.0 × 74.5
CANCM:11379

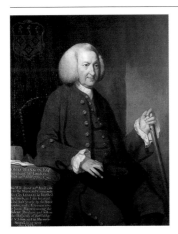

unknown artist 18th C
Thomas Hanson (1691–1770), Benefactor
oil on canvas 125.0 × 100.5
TH2

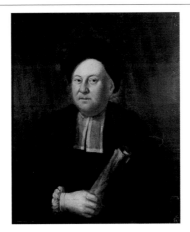

unknown artist 18th C?
Rev. William Gostling, Historian of Canterbury
oil on board 75.5 × 63.0
CANCM:3060

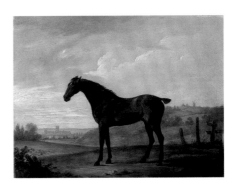

unknown artist
The Cob, Owned by Osborn Snoulten of Canterbury 1800–1850
oil on panel 30.0 × 39.5
CANCM:8346

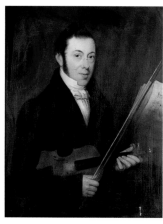

unknown artist
Mr Goodban of Canterbury Catch Club with Violin and Music 1801–1850
oil on canvas 91.6 × 71.0
CANCM:11375

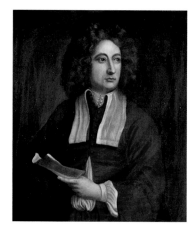

unknown artist
Arcangelo Corelli - from Canterbury Catch Club 1801–1850
oil on canvas 91 × 78
CANCM:11381

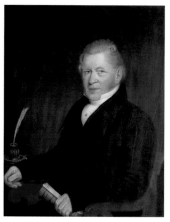

unknown artist
Mr Baskerville of Canterbury Catch Club, Holding a Scroll and a Quill Pen in an Ink Stand 1801–1855
oil on canvas 91 × 71
CANCM:11378

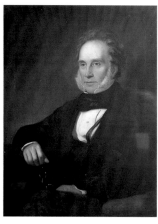

unknown artist
William Mount JP, DL (1789–1871) of Howfield, Chartham 1802–1871
oil on canvas 91.5 × 71.2
CANCM:1994.44.1

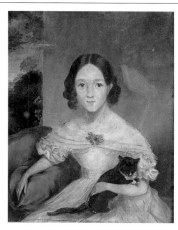

unknown artist
Miss Polly Barham, Daughter of Richard Harris Barham of Canterbury 1803–1855
oil on canvas 35.0 × 30.5
CANCM:11386

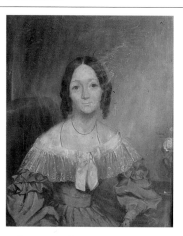

unknown artist
Dame Frances Caroline Bond, Daughter of Richard Harris Barham 1803–1855
oil on canvas 35.0 × 30.5
CANCM:11387

unknown artist
William Warman (1806–1875), Latin Master at The King's School
oil on canvas 75.0 × 57.5
CANCM:4928

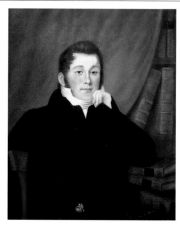

unknown artist
Rev. Richard Harris Barham (1788–1845) (Author of Ingoldsby Legends) 1820
oil on canvas 86.8 × 71.5
CANCM:8364

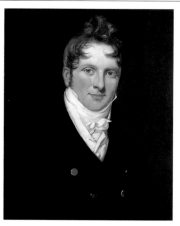

unknown artist
Richard Halford (1754–1823), Alderman and Chamberlain c.1822
oil on canvas 61.3 × 51.0
CANCM:10892

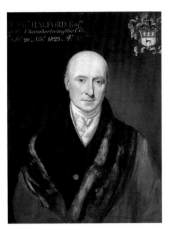

unknown artist
Richard Halford Esq. 33 Years Chamberlain to this City Died 26 November 1823 Aged 69
c.1823
oil on canvas 76.5 × 58.5
CANCM:11106

unknown artist
Richard Frend, Mayor of Canterbury (1803 & 1833) c.1833
oil on canvas 76.2 × 63.6
CANCM:10183

unknown artist
Lake Scene with Mountains 1850–1899
oil on canvas 30.5 × 61.0
CANCM:3081

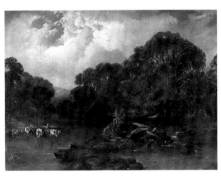

unknown artist
Landscape with Stream and Groups of Cattle
1850–1899
oil on canvas 42.5 × 58.5
CANCM:8361

unknown artist
Mr Saffrey with a Viola (Committee Member of the Canterbury Catch Club) 1850–1899
oil on canvas 89 × 71
CANCM:10829

unknown artist
Sunset Lake Scene with Mountains and Cows Watering c.1850–1899
oil on canvas 30.5 × 61.0
CANCM:3074

unknown artist
North Lane, Canterbury 1850–1900
oil on panel 21.0 × 29.5
CANCM:2003.577

unknown artist
Alderman W. H. Linom, Mayor of Canterbury, (1871 & 1876) c.1876
oil on canvas 48 × 38
CANCM:2003.384

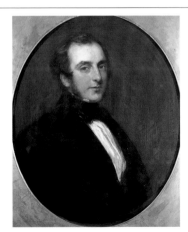

unknown artist 19th C
Dr Chalk
oil on canvas 77 × 64
CANCM:1994.44.2

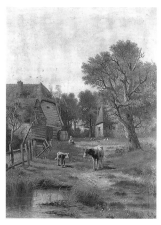

unknown artist 19th C
Farmyard with Cattle, Calf and Child
oil on canvas 101.8 × 76.0
CANCM:3046

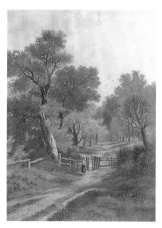

unknown artist 19th C
Forest Scene with Figures and Sheep
oil on canvas 101.8 × 76.0
CANCM:3047

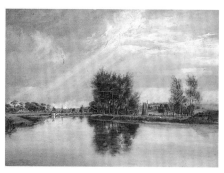

unknown artist 19th C
The Norfolk Broads with Storm Brewing
oil on panel 21 × 29
CANCM:4023

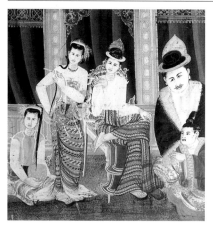

unknown artist 19th C
King Thibor, His Wife and Attendants in a Palace in Mandalay
oil on cloth 74 × 74
CANCM:4863

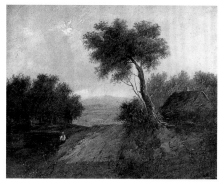

unknown artist 19th C
Landscape with Tree, House and Figure of a Man
oil on canvas 20.1 × 25.2
CANCM:8343

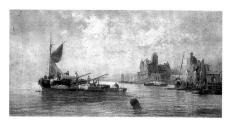

unknown artist 19th C
Fishing Boats with a Continental Town to the Right - Labelled Granville
oil on canvas 30.5 × 61.0
CANCM:11359

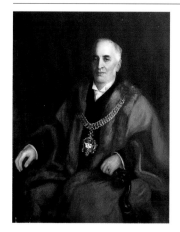

unknown artist 19th C
Alderman Collard, Mayor of Canterbury
oil on canvas 117.0 × 91.5
CANCM:11362

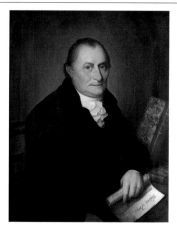

unknown artist 19th C
Mr Burgess (First Violin of Canterbury Catch Club) Holding a Roll of Music
oil on canvas 89.3 × 70.0
CANCM:11380

unknown artist 19th C
Fisherman with Net on a Boat in a Lake, Trees to the Right
oil on canvas 30.5 × 40.0
CANCM:11398

unknown artist 20th C
*Alderman W. S. Bean, Mayor of Canterbury
1956–1958*
oil on canvas 77.5 × 63.0
TH9

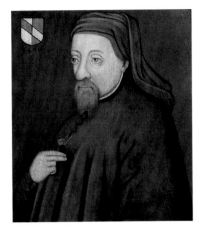

unknown artist
Geoffrey Chaucer
oil on panel 30.2 × 25.5
CANCM:1991.66

unknown artist
Landscape with Pool
oil on canvas 76 × 51
CANCM:2003.576

unknown artist
Leonard Cotton, Mayor
oil on canvas 115 × 81
CANCM:2003.594

unknown artist
Sir John Boys, (d. 1612) Aged 77
oil on canvas 103.5 × 78.0
CANCM:2003.595

unknown artist
Seascape with Fishing Boats (Y51 on Sail)
oil on canvas 61 × 107
CANCM:3052

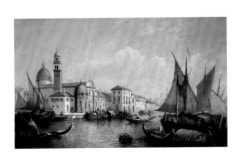

unknown artist
San Giorgio Maggiore, Venice
oil on canvas 76.5 × 127.6
CANCM:3053

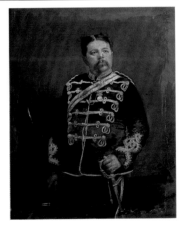

unknown artist
Dr J. G. Beaney in Military Uniform
oil on canvas 61 × 51
CANCM:3075

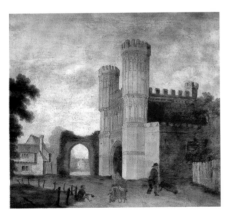

unknown artist
St Augustine's Great Gateway, Canterbury
oil on panel 31.0 × 36.2
CANCM:4900

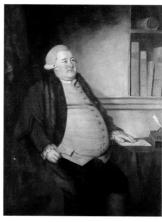

unknown artist
Alderman Barham (1788–1845)
oil on canvas 140 × 111
TH6

Vickers, Alfred 1786–1868
Farmhouse and Figure in a Wooded Landscape
oil on canvas 20.5 × 30.5
CANCM:3083

Ward, James 1769–1859
Reculver Church, Isle of Thanet 1818
oil on canvas 56.1 × 82.8
CANCM:10362

Ward, John Stanton b.1917
Self Portrait Seated at an Easel 1947
oil on canvas 30.2 × 35.5
CANCM:1994.28.14

Ward, John Stanton b.1917
Geraldine Caufield 1974
oil on canvas 92 × 71
CANCM:10157

Ward, John Stanton b.1917
The East Kent School 1985–1987
oil on canvas 101.6 × 127.0
CANCM:10469

Ward, John Stanton b.1917
Councillor Tom Steele, First Lord Mayor of Canterbury 1988/1989
oil on canvas 61.5 × 51.0
TH7

Weenix, Jan Baptist (after) 1621–1660/1661
The Tinker and His Dog
oil on panel 47.1 × 58.2
CANCM:8359

Weight, Carel Victor Morlais 1908–1997
Edwin La Dell's Cottage 1959
oil on canvas 46.0 × 61.5
CANCM:1995.104

Wicks, Sara
Angel over Canterbury 2001
mixed media on paper 28.5 × 41.0
CANCM:2002.328

Wilkie, David (after) 1785–1841
A Study for the Jews Harp
oil on panel 20.5 × 15.6
CANCM:4025

Williams, George Augustus 1814–1901
Wooded Landscape with Figures, Church in the Distance 1871–1879
oil on canvas 57.5 × 91.2
CANCM:10983

Woodward, Thomas (after) 1801–1852
The Market Pony
oil on canvas 30.5 × 35.8
CANCM:8332

Canterbury City Council Museums and Galleries: Whitstable Museum and Gallery

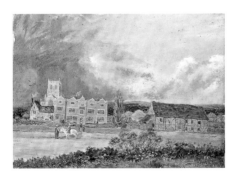

Archer, C.
The Abbey House and Refectory, Malvern 1837
oil on canvas 25 × 36
CANWH:2003.53

Cassell, H.
Tankerton Pier, Whitstable 1916
oil on board 36 × 49
CANWH:2003.38

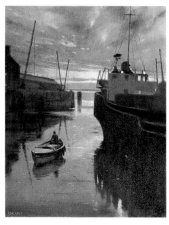

Cheadle, David
Whitstable Harbour
oil on board 52 × 40
CANWH:1995.12

Davies, Peter b.1970
Upturned Boat, Whitstable 1998
oil on canvas 29 × 36
CANWH:2003.37

De Simone, Alfredo (style of) 1898–1950
'Sparkling Foam 60232' with Vesuvius
oil on board 42 × 62
CANWH:1985.16.3

Dunlop, Ronald Ossory 1894–1973
Whitstable Beach c.1935
oil on canvas 63 × 77
CANWH:2003.40

Fannen, John active 1887–1901
'Raymond'
oil on canvas 50 × 75
CANWH:2002.85

Fannen, John active 1887–1901
'Guide'
oil on canvas 49 × 75
CANWH:2003.42

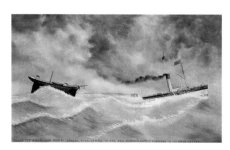

Fannen, John active 1887–1901
'Rapid'
oil on canvas 50 × 83
CANWH:2003.44

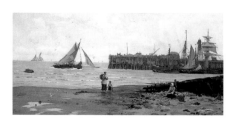

Fraser, John 1858–1927
Low Tide, Whitstable Harbour 1885
oil on canvas 55 × 102
CANWH:1989.2

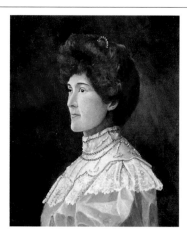

Goodsall, R. H.
Lady with a Lace Collar 1950
oil on canvas 60 × 50
CANWH:2003.27

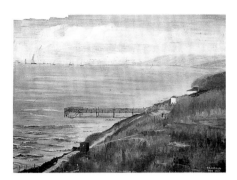

Harold, S. R.
Tankerton Pier, Whitstable
oil on paper 36 × 49
CANWH:1994.17.10

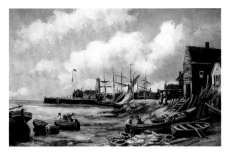

Koekkoek, Hermanus the younger
1836–1909
Landing the Catch, Whitstable
oil on canvas 58 × 91
CANWH:1991.21

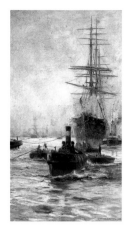

Lacy, Charles John de c.1860–1936
Shipping in the Pool of London 1892
oil on canvas 103 × 59
CANWH:2003.39

Lynn, John active 1826–1838
Smeaton's Eddystone Lighthouse
oil on canvas 46 × 61
CANWH:2003.49

Niemann, Edmund John 1813–1876
Unloading Barges at the Horse Bridge,
Whitstable 1866
oil on canvas 60 × 50
CANWH:1987.50

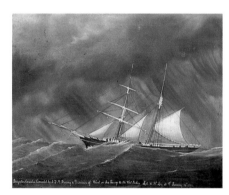

Roberto, Luigi active 1870–1890
'Cassandra' 45554 Foul Weather c.1876
oil on canvas 50 × 62
CANWH:2003.45

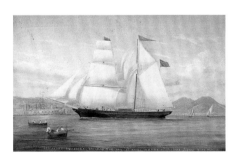

Roberto, Luigi (attributed to) active
1870–1890
'Cassandra' 45554 Fair Weather
oil on canvas 42 × 65
CANWH:1985.16.2

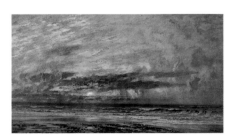

Severn, Arthur 1842–1931
Sunset
oil on canvas 80 × 147
CANWH:2003.46

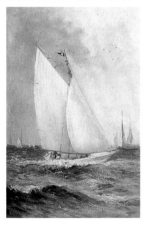

Sherrin, Daniel 1869–1940
Sailing Boat
oil on board 29 × 20
CANWH:1994.18.1

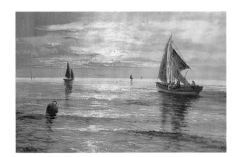

Sherrin, Daniel 1869–1940
Sailing Boats
oil on canvas 50 × 75
CANWH:1995.16

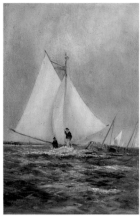

Sherrin, Daniel 1869–1940
Sailing Boat
oil on board 29 × 20
CANWH:1999.29

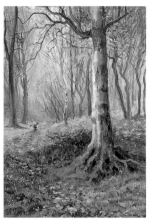

Sherrin, Daniel 1869–1940
Woodland
oil on board 29 × 20
CANWH:2003.36

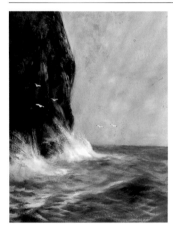

Sherrin, Daniel 1869–1940
Cliff and Birds
oil on canvas 58 × 44
CANWH:2003.43

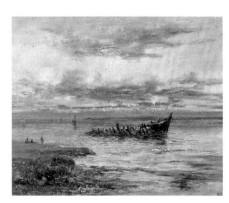

Sherrin, Daniel 1869–1940
The Wreck at Sunset, Seasalter
oil on board 27.0 × 35.5
CANWH:2003.50.2

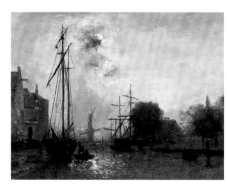

unknown artist 19th C
Dutch Canal Scene
oil on board 32 × 41
CANWH:1995.18

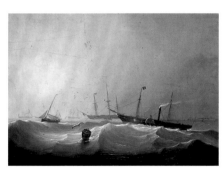

unknown artist 19th C
Paddle Steamer in a Storm
oil on canvas 55 × 78
CANWH:2003.31

unknown artist 19th C
Man with High Collar and Cravat
oil on canvas 20 × 18
CANWH:2003.33

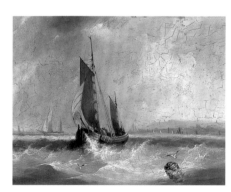

unknown artist 19th C
Ships off a Coast
oil on board 24.5 × 33.0
CANWH:2003.50.1

unknown artist 19th C
Landscape with Cottage at Forest Edge
oil on canvas 71 × 100
CANWH:2003.52

unknown artist
Two Brewers Inn
oil on board 27 × 37
CANWH:1989.52

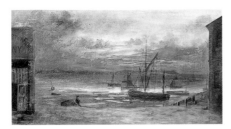

unknown artist
Sunset with Boats at Horsebridge, Whitstable
oil on canvas 37 × 68
CANWH:2003.32

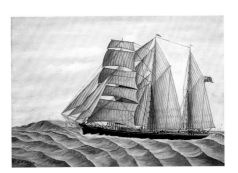

Walker, G. H.
'Resolute' 1887
oil on board 48 × 69
CANWH:1993.42.1

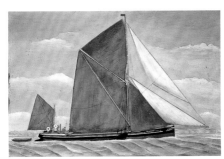

Walker, G. H.
'Duluth'
oil on board 56 × 83
CANWH:1993.42.2

W. H. G.
Fred Goldfinch, Museum Founder 1951
oil on canvas 51 × 36
CANWH:2003.41

Corridor Arts, Marlowe Theatre

Hill, Austin b.1933
The Old Marlowe Theatre 1985
oil on canvas 53.3 × 43.2
PCF_KT_MTC_001_021

Historic Dockyard, Chatham

The Dockyard Trust and Historical Society's fine art collections hold, either on loan or as part of their collections, a number of important examples of British marine art. The paintings span the last 200 years of both the Dockyard's and the Royal Navy's history. The earliest painting shows a view of the Dockyard in the late 18th century, during its heyday as a shipbuilding centre, whilst the two latest show '*HMS Endurance*' returning to the Dockyard after the Falklands Crisis in 1982 and a scene showing tall ships in the River Medway in 1985, following the closure of the Royal Dockyard in March 1984.

One of the most significant paintings is Elias Martin's *A View of Chatham Dockyard*, c.1774. The painting depicts the Dockyard before the reconstruction of the Ropery and the Anchor Wharf Stores, and is one of the finest paintings of the Dockyard executed during the 18th century. Elias Martin was a Swedish artist who had studied in France before travelling to England, where he spent the years 1768–1780.

The Kent connection within the collection is particularly strong. Twelve paintings are on loan from the widow of Mr Arthur Joyce, a Lyminge-based artist who painted maritime scenes during the late 20th century. His works include the two 1980s paintings mentioned above and other paintings of Royal Naval vessels visiting the county, including '*HMS Lynx*' *at Dover, 26th September 1973* and '*HMS Illustrious*' in 1983 (both visiting the port of Dover), and *Fleet Tenders at Work in the River Medway* in 1981.

The work of the famous maritime artist Montague J. Dawson is represented in the collections by a painting on loan from the shipping company Furness Withy & Company Ltd. Dawson himself had served in the RNVR during the First World War. *The Convoy Got Through* depicts '*HMS Jervis Bay*' engaging the German surface raider '*Admiral Scheer*' whilst escorting convoy '*HX84*' across the Atlantic Ocean in November 1940. The '*Jervis Bay*', heavily outgunned and outranged, sank in 20 minutes, with the loss of 198 lives, 84 from the Chatham Manning Division. The Acting Captain of the Jervis Bay, Captain E. S. Fogarty Fegen, RN, was posthumously awarded the Victoria Cross. The convoy scattered successfully and 31 of the 38 ships which had left Halifax, Nova Scotia, reached Britain safely.

Donald Maxwell was the naval artist of *The Graphic* for 20 years. During World War I he was an official naval artist to the Admiralty. He lived at Borstal, near Rochester, for many years, and the River Medway and surrounding naval activities are depicted in many of his paintings. Two works of art held in these collections represent his work. The first is a painting which hung for many years in the Wardroom at HMS Pembroke, the Royal Naval Barracks at Chatham. The painting, entitled *The Recall - Zeebrugge, April 23 1918*, depicts the events of the St George's Day raid of 1918, when the Chatham-built cruiser, '*HMS Vindictive*', was used as an assault ship to attack the harbour mole. The battered '*Vindictive*' is shown alongside the mole, with '*HMS Daffodil*' and motor launches making smoke. '*HMS Vindictive*' had been fitted out at Chatham for this raid. The second painting, *A Giant Refreshed*, shows the cruiser '*HMS Roxburgh*' sailing down the River Medway following a long refit in Chatham Dockyard in 1911–1912.

Alison Marsh, Curator

Facing page: Nickalls, Beatrix, *On Guard at the Nore* (detail), Historic Dockyard, Chatham (p. 44)

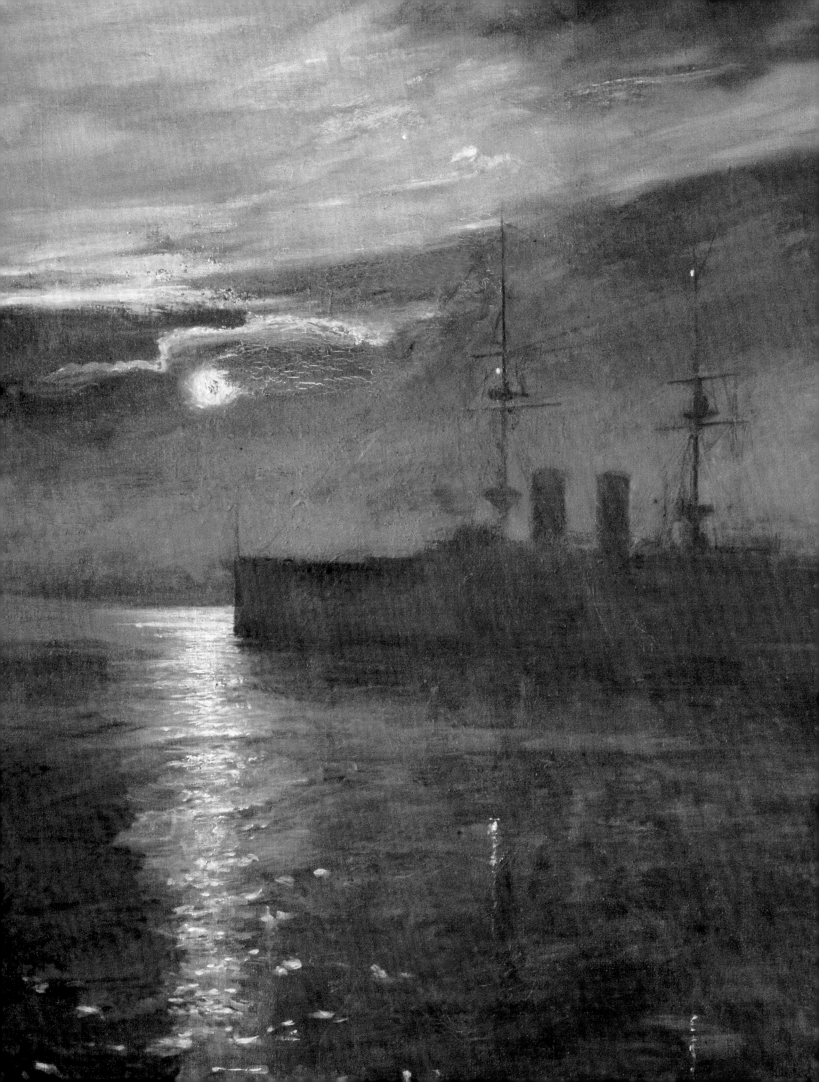

Beadle, James Prinsep 1863–1947
Admiral Sir Edward Eden Bradford
oil on canvas 59.4 × 49.6
1991.0013 ART 50

British (English) School 19th C
Sloop/Frigate Moored off Anchor Wharf
oil on canvas 45 × 61
1996.0029 ART 83

Dawson, Montague J. c.1894–1973
The Convoy Got Through
oil on canvas 89 × 182
2001.0030 ART 164 (P)

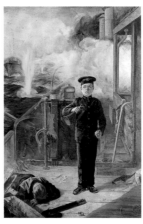

Hyde, Frank 1849–1937
Bugler Timmins RM - The Boy Hero
oil on canvas 150.0 × 105.4
PCF_KT_HDC_03_010

Jarvis, P. V. active 1930–1935
Alfie Merryweather
oil on canvas 165.0 × 48.5
PCF_KT_HDC_03_023

Joyce, Arthur 1923–1997
'HMS Lynx' at Dover, 26 September 1973 1973
oil on canvas 39.5 × 75.0
2000.0004.01 ART 144 (P)

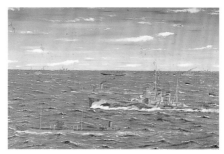

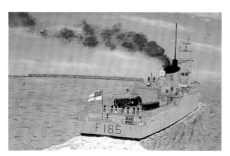

Joyce, Arthur 1923–1997
*'HMS Endurance' Returning to Chatham
Dockyard, 20 August 1982* 1982
oil on canvas 39.5 × 79.0
2000.0004.02 ART 145 (P)

Joyce, Arthur 1923–1997
*'HMS Prince of Wales' Going through the
Convoy*
oil on canvas 49.5 × 75.0
2000.0004.03 ART 146 (P)

Joyce, Arthur 1923–1997
'HMS Avenger' 1979
oil on canvas 49.5 × 75.2
2000.0004.04 ART 147 (P)

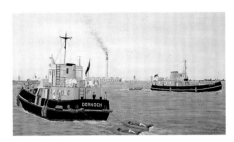

Joyce, Arthur 1923–1997
Fleet Tenders at Work in the River Medway
1981
oil on canvas 29.7 × 50.5
2000.0004.05 ART 148 (P)

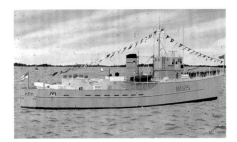

Joyce, Arthur 1923–1997
'HMS Cuxton' 1977 1977
oil on canvas 29.7 × 49.5
2000.0004.06 ART 149 (P)

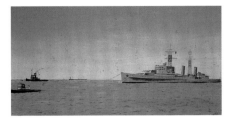

Joyce, Arthur 1923–1997
'HMS Belfast' 1971
oil on canvas 39 × 75
2000.0004.07 ART 150 (P)

Joyce, Arthur 1923–1997
Tall Ships Race, River Medway, 24 July 1985
1985
oil on canvas 39.5 × 75.0
2000.0004.08 ART 151 (P)

Joyce, Arthur 1923–1997
'HMS Ark Royal' 1977
oil on canvas 49.5 × 75.0
2000.0004.09 ART 152 (P)

Joyce, Arthur 1923–1997
'HMS Illustrious' 1983
oil on canvas 49.5 × 75.0
2000.0004.10 ART 153 (P)

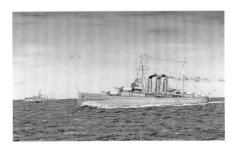

Joyce, Arthur 1923–1997
'HMS Kent'
oil on canvas 29.7 × 49.5
2000.0004.11 ART 154 (P)

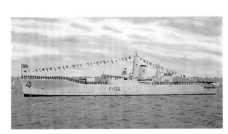

Joyce, Arthur 1923–1997
'HMS Brighton' 1977
oil on canvas 39.0 × 74.5
2000.0004.12 ART 155 (P)

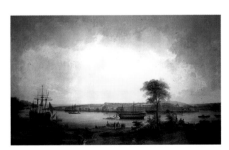

Martin, Elias 1739–1818
A View of Chatham Dockyard c.1774
oil on canvas 147.3 × 240.0
1993.0003 ART 59

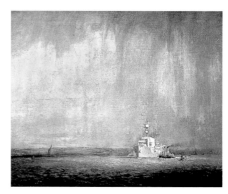

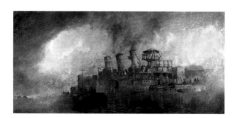

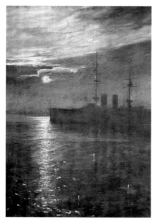

Maxwell, Donald 1877–1936
A Giant Refreshed 1912
oil on canvas 86.4 × 106.7
2001.0015 ART 163

Maxwell, Donald 1877–1936
The Recall - Zeebrugge, April 23 1918 1918
oil on canvas 144 × 291
PCF_KT_HDC_03_006

Nickalls, Beatrix
On Guard at the Nore
oil on canvas 110.0 × 79.8
1988.0043 ART 32

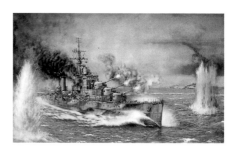

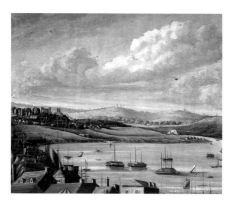

Tonkin, Paul b.1951
'HMS Cleopatra' at the Battle of Sirte, 23 March 1942
oil on canvas 51 × 91
2003.0019.01 ART 174

Turner
Chatham Reach c.1815
oil on canvas 62.2 × 77.5
1988.0050 ART 34

unknown artist
William Drake, Foreman, Chatham Dockyard
oil on canvas 21 × 22
1987.0018 ART 11

Kent Police Museum

Fowler, Norman 1903–2001
Kent '9 Pints of the Law' c.1970
oil on hardboard 122 × 234
94/031

Cranbrook Museum

Burrell, Joseph Francis b.1770
Rev. W. Huntington before 1813
oil on canvas 127.0 × 102.9
3394 (P)

Chapman (jnr), W. J. b.1808
Old Buck Wraight (Aged 90) 1828
oil on board 33.3 × 28.8
1332

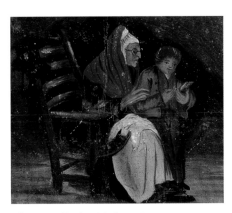

Chapman (jnr), W. J. b.1808
Mrs Farmer (Dame Schoolmistress)
oil on board 17.0 × 21.1
1893 (P)

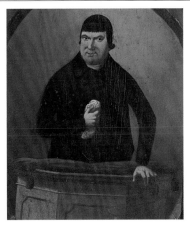

unknown artist
Rev. W. Huntington before 1813
oil on board 25.0 × 23.3
3393 (P)

unknown artist
Rev. I. Beeman before 1850
oil on canvas 76.2 × 63.2
2341

Cranbrook Parish Council

Johnson, G.
Mrs Mary Buss - Professional Fortune Teller
c.1850
oil on wood 78.2 × 61.0
Cranbrook 84

Dartford Borough Council and Dartford Library

The paintings are in Dartford Borough Council Civic Centre, Dartford Borough Museum (both owned by Dartford Borough Council) and Dartford Library (managed by Kent County Council). The first public art collection in Dartford was established in 1908 and is now held in the library and, to a lesser extent, in the museum. Local scenes from the town of Dartford and the wider rural area are depicted, from the late 19th century to the 1970s. The majority are by local artists, including two members of the Youens family: Clement, who worked as a professional artist, and Ernest, a prominent local photographer and the first curator of the museum. Later additions include works painted by members of the Dartford Art Group. The two paintings displayed at the town's Civic Centre depict Everard Hesketh, a local engineer and philanthropist, and Alfred Penney, Dartford's first mayor.

Chris Baker, Manager of Dartford Borough Museum

Dartford Borough Council Civic Centre

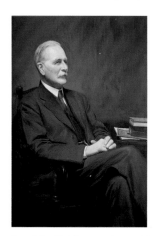

Lee, May Bridges active c.1905–1967
Everard Hesketh 1928
oil on canvas 125.8 × 87.6
PCF_KT_DBC_01_017

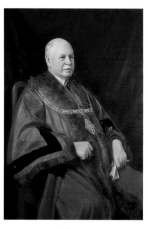

Lee, May Bridges active c.1905–1967
Alderman Alfred J. Penney 1934
oil on canvas 128.3 × 88.9
PCF_KT_DBC_01_026

Dartford Borough Museum

Pearce, Sylvia
Nos 13 & 15 Miskin Road, Dartford 1970
oil on hardboard 22.9 × 30.5
1980-20

Pearce, Sylvia
Nos 17 & 19 Miskin Road, Dartford 1970
oil on hardboard 22.9 × 30.5
1980-20a

Pearce, Sylvia
Athol Lodge and Alpine Lodge, Dartford 1970
oil on hardboard 22.9 × 30.5
1980-20b

Pearce, Sylvia
No. 25 Miskin Road, Dartford 1970
oil on hardboard 22.9 × 30.5
1980-20c

Pearce, Sylvia
The Prince of Orange, 19 Heath Lane, Dartford
1960s
oil on plywood 29.2 × 27.9
1992-7

Dartford Library

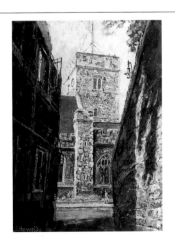

Bugg, E. J.
Overy Street, Dartford 1969
oil 48.2 × 61.0
269

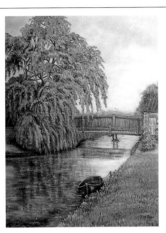

Coker, Olive
River Darent, Horton Kirby 1972
oil 55.9 × 45.8
282

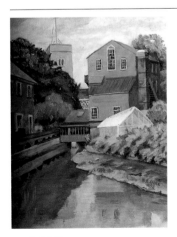

Cork, M. E.
Colyer's Mill 1958
oil 43.1 × 36.8
130

Howells, Gerald S.
Dartford Parish Church 1958
oil 40.6 × 30.5
34

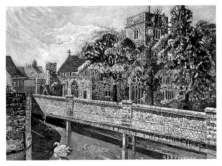

Howells, Gerald S.
Dartford Parish Church 1948
oil 25.4 × 34.3
60

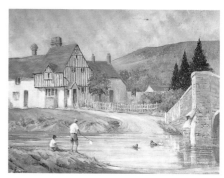

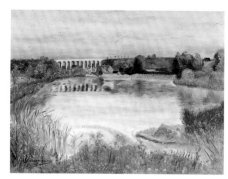

Jowett, F.
Eynsford 1956
oil 30.5 × 39.3
86

Lee, May Bridges active c.1905–1967
Everard Hesketh 1928
oil 76.1 × 61.0
248

Passingham, E. S.
Horton Kirby 1955
oil 30.5 × 39.4
220

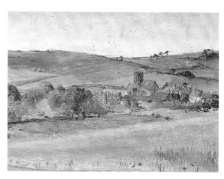
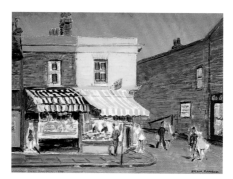
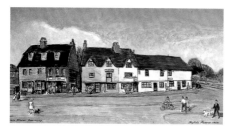

Pearce, Sylvia
Horton Kirby 1957
oil 14.0 × 19.1
158

Pearce, Sylvia
Lowfield Street, Dartford 1970
oil 29.2 × 40.6
254

Pearce, Sylvia
Overy Street, Dartford 1969
oil 29.2 × 57.2
268

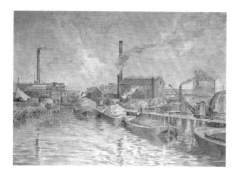

Pearce, Sylvia
Dover-London Coach c.1860 1970
oil 43.2 × 58.4
277

Pearce, Sylvia
Dartford Market 1971
oil 45.8 × 58.9
289

Rousham, Edwin
Dartford Creek 1950
oil 40.6 × 55.9
82

Rousham, Edwin
Darenth Mill 1951
oil 40.6 × 26.7
143

unknown artist 19th C
Dartford Heath
oil 33.0 × 48.3
20

unknown artist 19th C
Richard Trevithick
oil 58.4 × 48.3
176

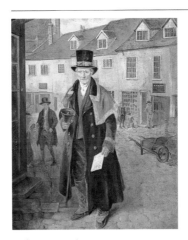

unknown artist
Thomas Batt, the Beadle c.1830
oil 41.9 × 35.6
202

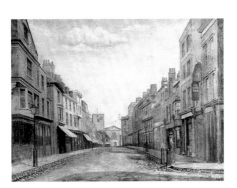

unknown artist
High Street, Dartford 1860
oil 44.4 × 59.6
165

unknown artist
The Windmill, the Brent c.1870
oil 39.4 × 53.3
211

unknown artist
The Priory, Dartford c.1900
oil 25.4 × 39.3
126

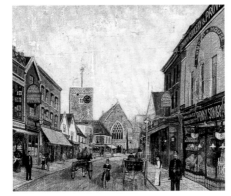

unknown artist
High Street, Dartford c.1900
oil 29.2 × 35.6
164

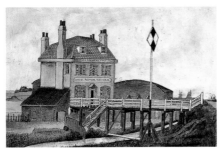

unknown artist
Long Reach Tavern, Dartford Marshes
1914–1918
oil 20.4 × 30.5
246

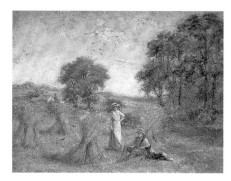

unknown artist
Cornfield, Cotton Lane Farm, Stone c.1920
oil 30.5 × 38.1
299

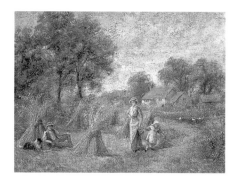

unknown artist
Cornfield and Farmhouse, Cotton Lane, Stone
c.1920
oil 30.5 × 38.1
300

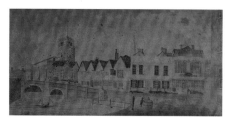

Warcup, Samuel
Overy Liberty, Dartford 1808
oil 27.9 × 55.8
206

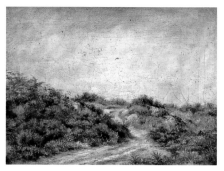

Youens, Clement T. 1852–1919
Gravel Path, Dartford Heath c.1890
oil 22.9 × 31.8
10

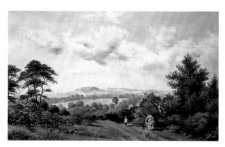

Youens, Clement T. 1852–1919
Dartford Heath c.1892
oil 40.6 × 68.5
16

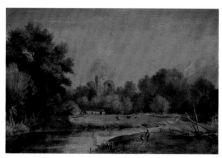

Youens, Clement T. 1852–1919
Central Park, Dartford 1898
oil 38.1 × 58.4
24

Youens, Clement T. 1852–1919
Lowfield Street, Dartford 1884
oil 6.3 × 8.9
84

Youens, Clement T. 1852–1919
High Street, Dartford 1893
oil 63.5 × 88.9
167

Youens, Clement T. 1852–1919
Stanham Farm, Dartford c.1900
oil 25.4 × 35.6
200

Youens, Clement T. 1852–1919
Chancespring Wood, Dartford Heath 1893
oil 39.4 × 30.5
232

Youens, Clement T. 1852–1919
John Treadwell 'Old Nattie' 1884
oil 55.9 × 40.6
235

Youens, Clement T. 1852–1919
Stoneham Farm, Dartford c.1900
oil 22.9 × 35.5
272

Youens, Clement T. 1852–1919
Priory Building c.1900
oil 21.6 × 35.5
273

Youens, Clement T. 1852–1919
Priory, Infirmary Building c.1900
oil 25.4 × 35.6
274

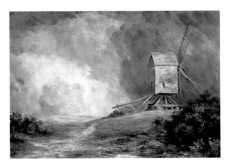

Youens, Clement T. 1852–1919
The Windmill, the Brent
oil 40.7 × 55.9
301

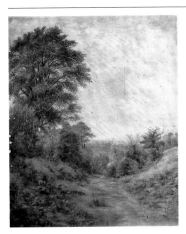

Youens, Clement T. 1852–1919
Dartford Heath
oil on canvas 76.1 × 63.5
302

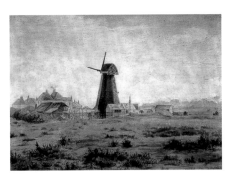

Youens, Ernest Christopher 1856–1933
The Windmill, the Brent c.1885
oil 43.1 × 52.0
245

Deal Town Council

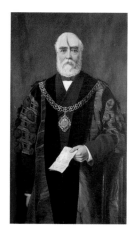

Appleton, Thomas Gooch 1854–1924
Alderman J. R. Lush 1878–1895
oil on canvas 124 × 75
Death 0.442

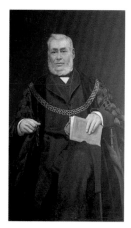

Appleton, Thomas Gooch 1854–1924
Alderman A. F. Bird, Mayor 1871–1880
oil on canvas 124 × 75
Death 0.443

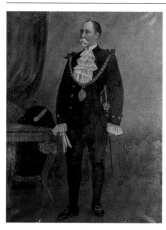

Appleton, Thomas Gooch 1854–1924
Alderman W. H. Hayward, Mayor 1895–1900
oil on canvas 142 × 110
Death 0.459

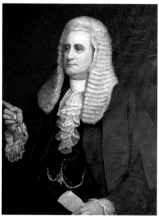

Brooks, F. G.
J. F. Torr, Recorder 1900–1910
oil on canvas 89.0 × 68.5
Death 0.449

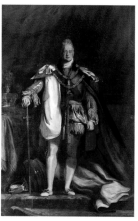

Grant, Francis 1803–1878
William IV
oil on canvas 260 × 165
Death 0.457

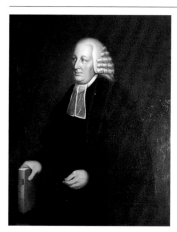

Henson, S. active late 18th C
Chas Robinson 1800
oil on canvas 125 × 95
Death 0.451

Highmore, Joseph 1692–1780
Elizabeth Carter
oil on canvas 124 × 100
Death 0.448

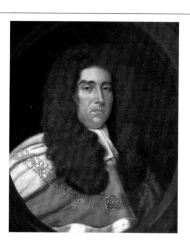

Hudson, Thomas 1701–1779
Lord Chief Justice Ward, Mayor
oil on canvas 73 × 61
Death 0.447

Ramsey, Dennis
Winston Churchill, Lord Warden of the Cinque Ports 1967
oil on canvas 128 × 98
Death 0.458

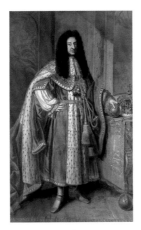

Wissing, Willem c.1656–1687
William III
oil on canvas 240 × 145
Death 0.453

Dover Collections

The ancient Corporation of Dover dates back to Saxon times, and the borough archives largely survive from the 13th century onwards. The Corporation began its art collection in 1598, as the council minutes record the purchase of a portrait of Queen Elizabeth for five shillings, and also the purchase of a frame carved with dragons to display it in.

The museum was founded by Edward Pett Thompson, the mayor, in February 1836. Originally run by the Dover Philosophical Institute in the old guildhall, the museum was formally adopted by the town council in 1848, which built a new museum and market building that year in the market square.

Between 1849 and 1942, the museum attracted many donations, particularly of natural history specimens, from famous naturalists such as Lord Rothschild, who gave the museum stuffed antelopes, a walrus, a giraffe, a zebra and much more. The collection of art continued to grow, with portraits of kings and local politicians and businessmen being commissioned or purchased.

In 1942, the museum was badly damaged by German shelling, and much of the collection was destroyed. What did survive was put into various stores and caves, where it was left in damp conditions for the next four years. It is estimated that only thirty percent of the original collection survived.

In 1948, a temporary museum opened in the undercroft of the town hall. The collections remained there until 1991, when the museum moved back to its earlier home in the market square, into a new building behind the original 1848 facade.

As well as the original portrait of Elizabeth mentioned above, the collection's more interesting pictures include: *Duke of Wellington, Lord Warden of the Cinque Ports*, by John Lilley; *Michael Russell, Agent Victualler of Dover*, by George Romney; and a Dover seascape, *Off Dover*, by James Wilson Carmichael. Many paintings are displayed in the public areas and offices of the town's civic buildings, such as the 13th century Maison Dieu, converted to a town hall in 1835 and refurbished in the 1860s by the great architect-designer William Burges; the Dover Town Council offices in the adjoining 17th century Maison Dieu House; and the modern Dover District Council offices on the

outskirts of town. These pictures are mostly of mayors and other corporation officers, but also include *The Children of Hughes Minet* (members of a Dover banking family) by Joseph Highmore, and *Army Waggoners beneath Dover Castle* by William Burgess.

The museum also holds the Victoriana Museum collection, bequeathed to the museum in 1990 by William Williamson of Deal. This collection includes works by Dame Laura Knight, Lady Alma-Tadema, Henri Fantin-Latour, J. F. Herring, Henry Bernard Chalon, David Cox, E. W. Cooke and Benjamin Robert Haydon.

Mark Frost, Assistant Curator

Alma-Tadema, Laura Theresa Epps
1852–1909
Measuring Heights
oil on canvas 56.6 × 42.8
Deavm 2003.1

Amos, George Thomas 1827–1914
Sheep in a Stable
oil on canvas 69.8 × 90.0
Oil/FS/53

Amos, George Thomas 1827–1914
Sheep and Horses in a Wind
oil on canvas 70.0 × 89.8
Oil/T/7

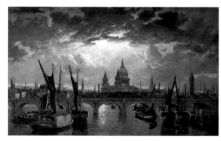

Anderson, William 1757–1837
London Bridge and St Paul's by Moonlight
oil on canvas 61 × 102 (E)
Deavm 1998.8

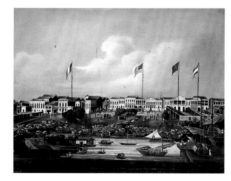

Anglo-Chinese School
Foreign Legations in Peking
oil on canvas 45.0 × 59.3
Dovrm 0.634

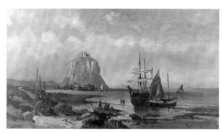

Arison, Mark
Mont St Michel
oil on canvas 44.5 × 80.5
Deavm 1

Bailey, Colin C.
Buckland Paper Mill, Dover, in the 1600s
oil on canvas 39.3 × 54.3
Dovrm 2004.48

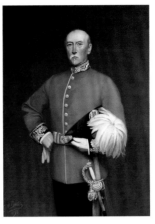

Baldry, George W.
Soldier in Dress Uniform 1893
oil on canvas 125.7 × 90.0
Dovrm 1987.78

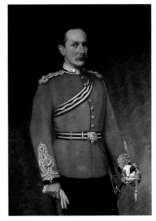

Baldry, George W.
Soldier in Mess Uniform 1895
oil on canvas 154 × 118 (E)
Dovrm 1987.79

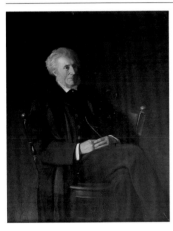

Baldry, George W.
Dr E. F. Astley MD, Mayor of Dover 1895
oil on canvas 144 × 114
Dovrm 0.11004 DTH

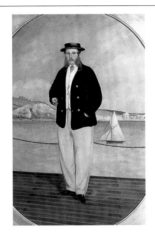

Baldry, George W.
H. P. Mackenzie, Dover Builder c.1865
oil on canvas 60 × 46
Oil/L/7

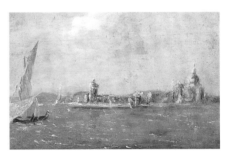

Barker, Thomas 1769–1847
View of Venice
oil on panel 24 × 34
Deavm 25

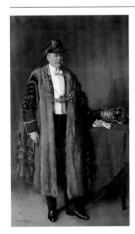

Birley, Oswald Hornby Joseph 1880–1952
Sir William Crundall 1936
oil on canvas 249.3 × 150.0
Dovrm. 0.11009 DTH

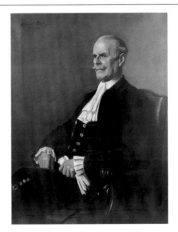

Birley, Oswald Hornby Joseph 1880–1952
Alfred Charles Leney JP 1934
oil on canvas 120 × 94
KT_DOV_021_018

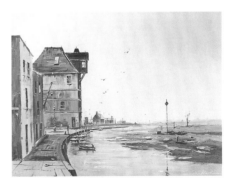

Blackman, John
The River Stour at Sandwich
oil on canvas 44 × 59
DDC1/DIR

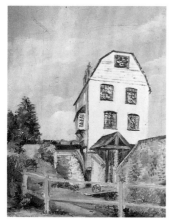

Blommaert, G.
Temple Ewell Mill
oil on board 45.5 × 35.5
Dovrm 1985.235

Booth, Raymond C. b.1929
Jay in a Winter Woodland
oil on card 59.0 × 29.3
Deavm 23

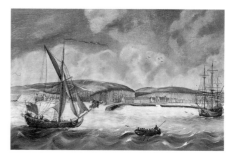

British (English) School
Excise Cutter off Dover c.1750
oil on canvas 49.5 × 74.7
Oil/L/6

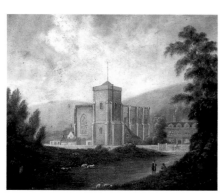

British (English) School
Maison Dieu, Dover 1800
oil on canvas 49.5 × 60.0
Dovrm 0.8703

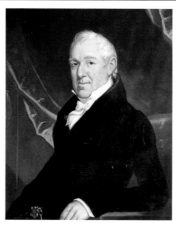

British (English) School
George Stringer of Archers Court c.1810
oil on canvas 74.7 × 62.0
Dovrm 1987.89

British (English) School
Charles Lamb, Mayor 1853 1853
oil on canvas 73.5 × 60.8
Dovrm 0.11010 DTH

British (English) School 19th C
Mrs Williamson's Great Grandmother
oil on canvas 74.5 × 61.5
Deavm 1998.12

British (English) School 19th C
Fishing Boat by Moonlight
oil on canvas 19.5 × 24.5 (E)
Deavm 7

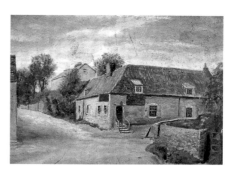

British (English) School 19th C
George and Dragon Inn, Temple Ewell
oil on canvas 22.0 × 29.5
Dovrm 0.1213

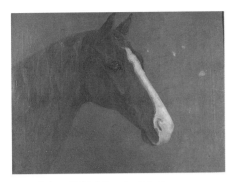

British (English) School 19th C
Study of a Horse's Head
oil on canvas 62.5 × 83.8
Dovrm 0.8711

British (English) School 19th C
Lieutenant Sclater
oil on canvas 36.2 × 29.1
Oil/FS/5

British (English) School 19th C
Dock Hand Mummery
oil on paper? 50.8 × 41.0 (E)
Oil/FS/19

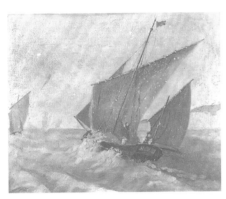

British (English) School late 19th C?
Fishing Vessels off the Coast
oil on canvas 27.5 × 34.0
Dovrm 0.6004

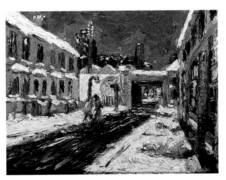

British (English) School 20th C
Wintry Street Scene
oil on canvas 39.7 × 50.2
Dovrm 0.1210

British (English) School
John Lewis Minet
oil on canvas 90.0 × 69.5
1967/246.13b

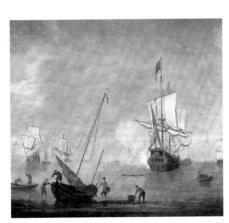

British (English) School
Fishing Boats and Man of War
oil on panel 35.3 × 40.7
Deavm 10

Broad, William Henry (attributed to)
1853–1939
Mayor George Raggett 1906
oil on canvas 101.0 × 75.2
Oil/FS/54

Brooks, Henry Jamyn 1865–1925
Earl Granville, Lord Warden of the Cinque Ports
1891
oil on canvas 240 × 147
Dovrm 0.11000

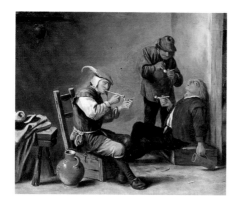

Brouwer, Adriaen 1605/1606–1638
The Topers (Boors Smoking in an Interior)
oil on panel 36.5 × 44.5
Deavm 40

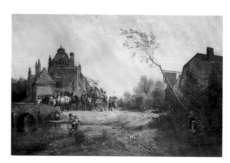

Burgess, William 1805–1861
Buckland Bridge 1839 1839
oil on canvas 59.7 × 89.5
Dovrm 2003.67

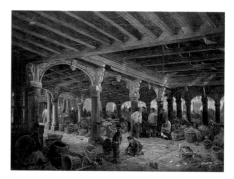

Burgess, William 1805–1861
The Old Market House 1858
oil on canvas 44.5 × 59.5
Dovrm 0.11029 DTH

Burgess, William 1805–1861
Army Wagoners beneath Dover Castle
oil on canvas 69 × 90
DTC

Burgess, William 1805–1861
Toll Gate, Crabble Hill c.1836
oil on canvas 43.7 × 59.5
Oil/L/1

Burgess, William 1805–1861
Christchurch from the Folkestone Road
oil on paper 50 × 71
WAT/FS/60

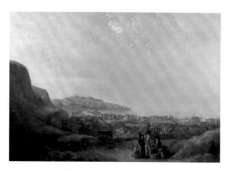

Burgess, William (attributed to) 1805–1861
Dover from the Western Heights
oil on canvas 73.7 × 106.7

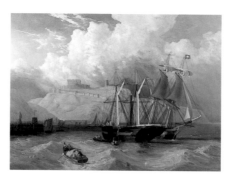

Carmichael, James Wilson 1800–1868
Off Dover
oil on canvas 114.3 × 162.6 (E)
Dovrm 0.11028 DTH

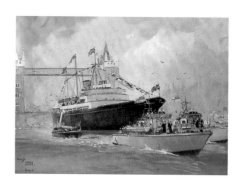

Carr, Leslie active 20th C
The Royal Yacht
oil on board 28.6 × 39.4
Deavm 38

Castan, Pierre Jean Edmond 1817–after 1865
Coming out of Church 1867
oil on panel 33.5 × 25.4
Dovrm 0.3424

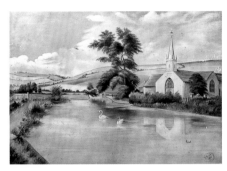

Castle, G.
Charlton Church 1866
oil on canvas 40.6 × 56.0
Dovrm 0.1239

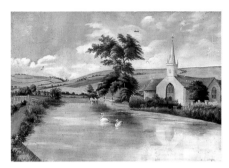

Castle, G.
Charlton Church 1866
oil on canvas 39.7 × 55.2
Dovrm 0.9021

Chalon, Henry Bernard 1770–1849
Two Chestnut Horses with Eager Spaniel 1825
oil on canvas 90.6 × 125.4
Deavm 1998.16

Clint, Alfred 1807–1883
Landing at East Cliff, Dover c.1840
oil on wood 47.3 × 60.0
Dovrm 0.6012

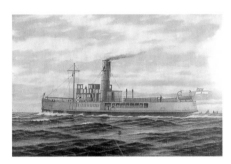

Cockerham, Charles active c.1900–1935
'HMS Daffodil' after Zeebrugge 1918
oil on canvas 39.4 × 61.0
Dovrm 1992.65

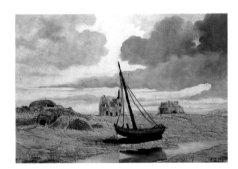

Coffyn, A.
Ruines, la Panne 1948
oil on canvas 50.8 × 70.8
Oil/L/10

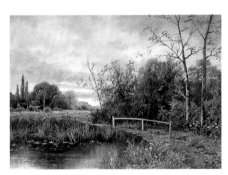

Cole, Ethel b.1892
Pastoral Landscape, Stream with Bridge
oil on board 34.3 × 46.4
Deavm 1998.2a

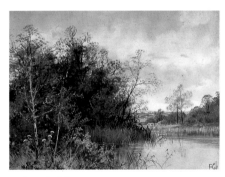

Cole, Ethel b.1892
Pastoral Landscape, Stream with Town in Distance
oil on board 33.5 × 46.5
Deavm 1998.2b

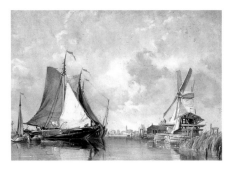

Cooke, Edward William 1811–1880
Dutch Saw Mill and Shipping on the Zuyder Zee 1850
oil on panel 27.3 × 37.6
Deavm 1998.6

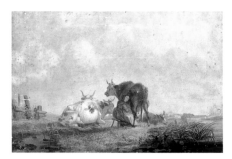

Cooper, Thomas Sidney (after) 1803–1902
Milking Time c.1850?
oil on canvas 45.8 × 53.3
Dovrm 0.8732

Copri, Adrienne
The Visit to Grandmamma
oil on canvas 44.5 × 83.2
Deavm 11

Coward, Noël 1899–1973
White Cliffs
oil on paper 76.2 × 72.4
Dovrm d02630

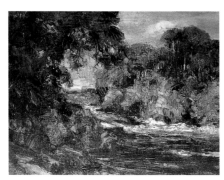

Cox, David the elder 1783–1859
Bettys-y-Coed
oil on canvas 49.3 × 59.5
Deavm 1998.10

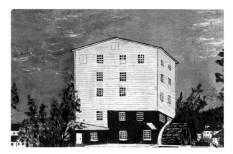

Curtis, C. E.
Crabble Mill 1812 1976
oil on wood 19.0 × 30.2
Dovrm 0.6015

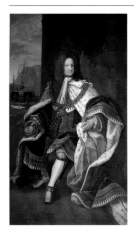

Dahl, Michael I 1656/1659–1743
George I
oil on canvas 227.5 × 133.5
Dovrm 0.11022 DTH

Davey, Doreen b.1968
Dover
oil on board 35.6 × 61.0
Dovrm 1994.77

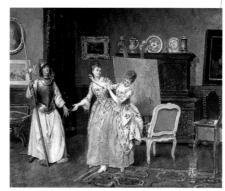

de Garay, Talla
The Charade
oil on panel 18.5 × 23.5
Deavm 42

Facing page: Fantin-Latour, Henri, *White Azaleas* (detail), Dover Collections (p. 63)

Dommard, E. M.
The Shepherd
oil on canvas 30.0 × 34.7
Deavm 37

Dubreuil, C.
Allied Fleet before Cherbourg 1855
oil on canvas 101.6 × 152.4 (E)
Dovrm 0.11039

Dutch School 19th C
Peasants (Pipes)
oil on panel 23.8 × 19.6
Deavm 12

Dutch School 19th C
Peasants
oil on panel 23.8 × 19.6
Deavm 13

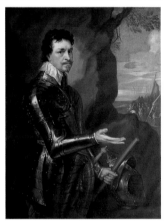

Dyck, Anthony van (after) 1599–1641
The Earl of Strafford in Armour
oil on canvas 131.5 × 101.5
Deavm 39

Eddy, W.
Queen Victoria Reviewing the Fleet
oil on canvas 59.7 × 89.7
Dovrm 0.1184

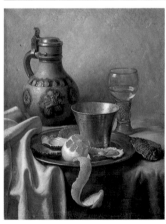

Eversen, Johannes Hendrik 1906–1995
Still Life of Tankard and Oysters 1955
oil on canvas 49.3 × 39.0
Deavm 46

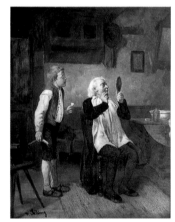

Failing, R.
The Young Barber
oil on panel 47.4 × 37.8
Deavm 21

Fallshaw, Daniel 1878–1971
Kearsney Abbey Gardens 1957
oil on canvas 43.7 × 58.7
Dovrm 2004.24

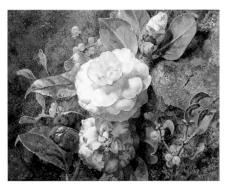

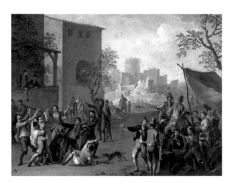

Fantin-Latour, Henri 1836–1904
White Azaleas
oil on canvas 24 × 19
Deavm 1998.3a

Fantin-Latour, Henri 1836–1904
Camelias
oil on canvas 19.6 × 24.5
Deavm 1998.3b

Ferg, Franz de Paula 1689–1740
Peasants Brawling in a Village Street
oil on panel 24.4 × 34.0
Deavm 29

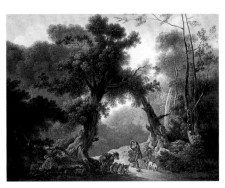

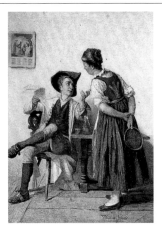

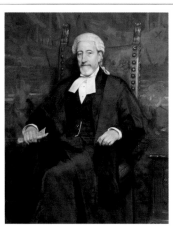

Gainsborough, Thomas (after) 1727–1788
Wooded Landscape
oil on canvas 45.0 × 55.2
Deavm 3

Gerard, Theodore 1829–1895
Interior with Serving Maid and Young Man
oil on canvas 40 × 30
Deavm 22/1

Glazebrook, Hugh de Twenebrokes
1870–1935
Sir Harry Bodkin Poland 1896
oil on canvas 128 × 103
Dovrm 0.11025 DTH

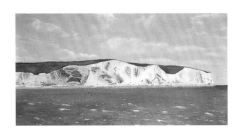

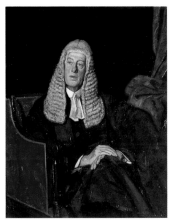

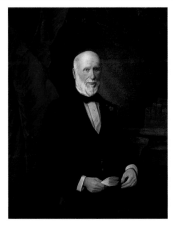

Goodwin, H. C.
White Cliffs
oil on canvas 49.0 × 84.6
Dovrm 2004.47

Greiffenhagen, Maurice 1862–1931
Sir A. H. Bodkin, Recorder 1920
oil on canvas 126 × 103
Dovrm 0.11008 DTH

Grossmann, Alexander J. 1833–1928
John Coram 1892
oil on canvas 147.3 × 120.7 (E)
Dovrm 1987.76

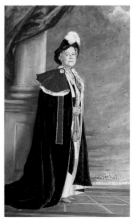

Hailstone, Bernard 1910–1987
HM Queen Elizabeth the Queen Mother, Lord Warden of the Cinque Ports 1979–1980
oil on canvas 264.2 × 177.8 (E)
Dovrm 0.11036 DTH

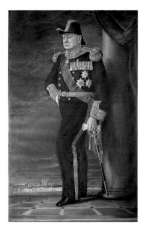

Hailstone, Bernard 1910–1987
Sir Winston Churchill, Lord Warden of the Cinque Ports 1955
oil on canvas 264.2 × 177.8 (E)
Dovrm 0.11037 DTH

Hals, Dirck 1591–1656
An Elegant Company
oil on panel 38.1 × 59.0
Deavm 31

Harle, Dennis F. 1920–2001
Young Magpie
oil on board 63.7 × 76.0
Deavm 2004.4

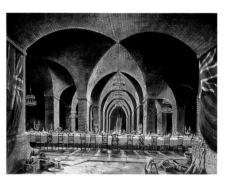

Harp, C. S.
The Waterworks High Reservoir 1854
oil on canvas 44.2 × 59.5
Dovrm 0.11027 DTH

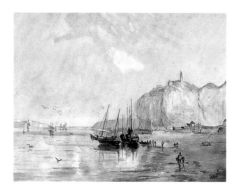

H. F. H.
The Beach at Dover
oil on canvas 21.2 × 27.6
Dovrm 0.1196

Harrod, J.
'The Cause is Altered Inn', Dover c.1900?
oil on canvas 33.1 × 42.4
Dovrm 0.8710

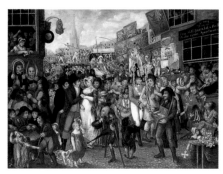

Haydon, Benjamin Robert 1786–1846
Bartholomew Fair
oil on canvas 71.5 × 96.0
Deavm 1998.15

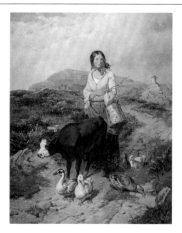

Henzell, Isaac 1815–1876
Country Maid Driving Calf and Ducks 1859?
oil on canvas 60 × 47
Deavm 49

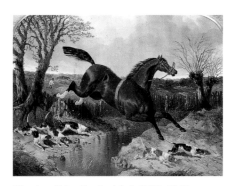

Herring, John Frederick I 1795–1865
Runaway Chestnut Horse with Beagles 1850
oil on canvas 36.5 × 49.0
Deavm 1998.9

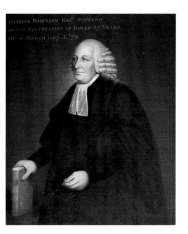

Hewson, S.
Dr Charles Robinson, Recorder
oil on canvas 127.0 × 76.2 (E)
Dovrm 0.11035 DTH

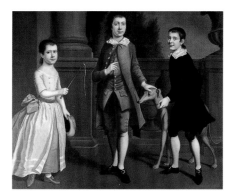

Highmore, Joseph 1692–1780
The Children of Hughes Minet
oil on canvas 130.8 × 161.3
1967/246.13a

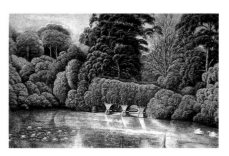

Hosking, H. L.
Russell Gardens, Kearsney
oil on canvas 33.4 × 52.8
Dovrm 1988.24

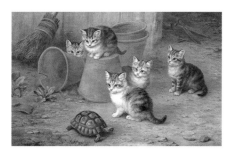

Hunt, Edgar 1876–1953
Dicing with Death 1945
oil on canvas 29.5 × 44.2
Deavm 27

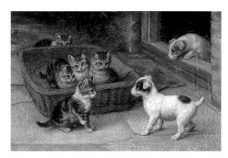

Hunt, Edgar 1876–1953
Meeting the Opposition 1945
oil on canvas 29.0 × 44.5
Deavm 28

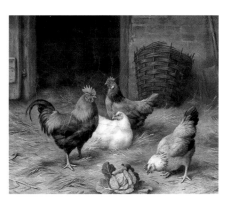

Hunt, Edgar 1876–1953
Cockerel and Three Hens 1925
oil on canvas 24.1 × 29.2
Deavm 33

Innis, D. active 20th C
Three Pot Plants c.1965
oil on board 48 × 48
Deavm 62

Italian School
View of Old Naples c.1820
oil on canvas 50.2 × 76.3
Dovrm 0.8719

Italian School
Icon: Madonna and Child
oil on panel 35.0 × 22.4
Deavm 57

Italian (Venetian) School 19th C
Trading on the Canal at Rialto Bridge
oil on panel 28 × 43 (E)
Deavm 5

Kennedy, Cecil 1905–1997
Still Life of Basket of Flowers
oil on canvas 49.3 × 59.4
Deavm 52

Kennedy, Philomena 1932–1999
From Chiesi, Tuscany 1966
oil on board 30.5 × 36.8
Dovrm 2002.110.264

Kennedy, Philomena 1932–1999
Kent Landscape 1965
oil on board 25.4 × 34.3
Dovrm 2002.110.265

Kennedy, Philomena 1932–1999
Near Meifod
oil on board 39.1 × 48.7
Dovrm 2004.50.1

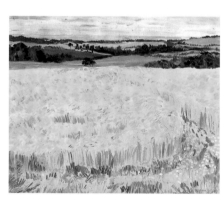

Kennedy, Philomena 1932–1999
Kent Landscape
oil on canvas 29.0 × 36.5
Dovrm 2004.50.2

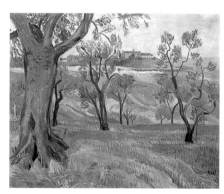

Kennedy, Philomena 1932–1999
Near Sierra 1970
oil on board 33.0 × 39.4
PK43

Kent, M. A.
Dover College 1966
oil on canvas 53.5 × 53.2
Dovrm 0.9984

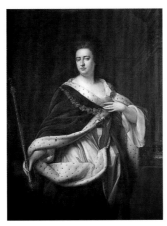

Kneller, Godfrey 1646–1723
Queen Anne before 1713
oil on canvas 147.3 × 114.3 (E)
Dovrm 0.11030 DTH

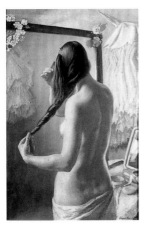

Knight, Laura 1877–1970
The Coil of Hair
oil on canvas 90 × 59
Deavm 48

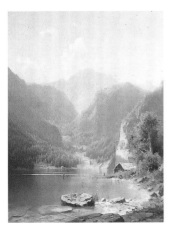

Krieghoff, Cornelius 1815–1872
Mountainous Lake Scene
oil on panel 49.8 × 39.7
Deavm 34

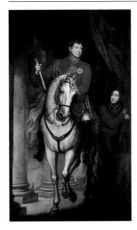

Lawrence, Thomas (attributed to)
1769–1830
George IV
oil on canvas 289 × 176
Dovrm 0.11001 DTH

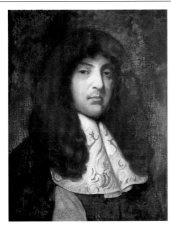

Lely, Peter (attributed to) 1618–1680
John, Duke of Lauderdale c.1660
oil on canvas 59.2 × 47.2
Oil/FS/30

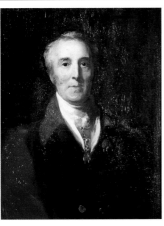

Lilley, John active 1832–1853
Duke of Wellington, Lord Warden of the Cinque Ports 1837
oil on canvas 75 × 62
Dovrm 0.3430

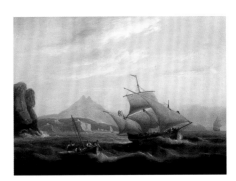

Luny, Thomas 1759–1837
Ischia, Bay of Naples 1826
oil on canvas 49.5 × 67.2
Deavm 1998.1

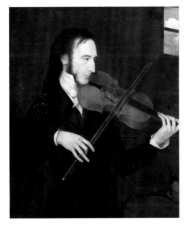

Maclise, Daniel 1806–1870
Nicolo Paganini 1831
oil on canvas 91.6 × 76.2
Dovrm 0.8745

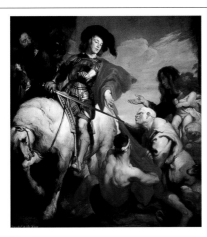

Martin
St Martin Dividing His Cloak (after Anthony van Dyck) before 1857
oil on canvas 172.7 × 182.9 (E)
Dovrm 0.11024 DTH

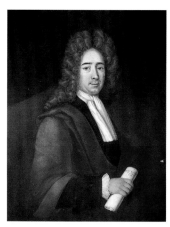

Mignard, Pierre I (school of) 1612–1695
Isaac Minet
oil on canvas 89.5 × 69.5
Oil/FS/38

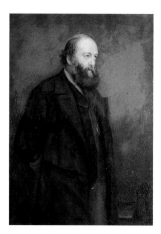

Millais, John Everett 1829–1896
Marquess of Salisbury, Lord Warden of the Cinque Ports
oil on canvas 129.8 × 94.5
Dovrm 0.11011 DTH

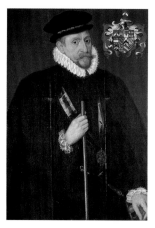

Mor, Antonis b.1512–1516–d.c.1576
William Brook, Lord Cobham, Lord Warden of the Cinque Ports
oil on panel 102.0 × 68.5
Dovrm 2003.68

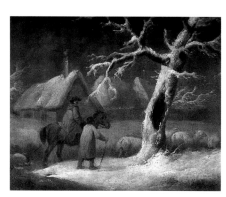

Morland, George 1763–1804
Shepherd in a Snowy Landscape
oil on panel 24.0 × 30.5
Deavm 8

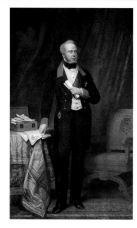

Morris, Ebenezer Butler active 1833–1863
Lord Palmerston, Lord Warden of the Cinque Ports 1863
oil on canvas 264.2 × 177.8 (E)
Dovrm 0.11006 DTH

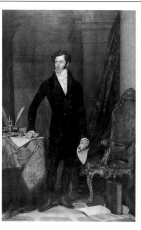

Morris, Ebenezer Butler active 1833–1863
Sir John Rae Reed, MP
oil on canvas 264.2 × 177.8 (E)
Dovrm 0.11034 DTH

P. N.
HMS Mail Steam Packet 'Vivid' c.1855
oil on glass 41.9 × 61.0
Oil/FS/26

P. N.
'HMS Arethusa' c.1855
oil on glass 47.3 × 60.0
Oil/FS/46

Nash, John Northcote 1893–1977
Bore Hill Gower
oil on canvas 54.6 × 75.0
Deavm 1998.14

Nelson, Arthur active 1766–1790
A View of the Town and Castle of Dover c.1767
oil on canvas 119.1 × 167.1
Dovrm 1988.19

Nicholls, Charles Wynne 1831–1903
Envious Glances 1866
oil on canvas 86.5 × 111.5
Dovrm 0.8832

Ogilvie, Frank Stanley b.c.1856
Sir E. Wollaston Knocker 1908
oil on canvas 153 × 112
Dovrm 0.11026 DTH

Olsson, Albert Julius 1864–1942
A Port Scene with Shipping
oil on canvas 81.3 × 172.7 (E)
Dovrm 0.11038

Ostade, Adriaen van 1610–1685
Peasants Dancing in a Barn
oil on panel 31.7 × 33.4
Deavm 43

Page, Patricia
Kentish Landscape
oil on canvas 12.0 × 24.1
Deavm 2004.3

Parish, James Harnett b.1832
Peace (after Edwin Henry Landseer) 1899
oil on canvas 89 × 132
Dovrm 1987.80

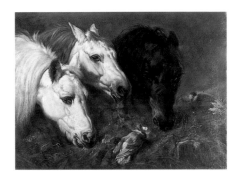

Parish, James Harnett b.1832
The Scanty Meal (after John Frederick Herring I) c.1900
oil on canvas 73.7 × 94.6 (E)
Oil/FS/44

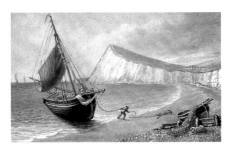

Parish, James Harnett b.1832
Old Dover about 1840
oil on board 20.5 × 33.3
Oil/L/4

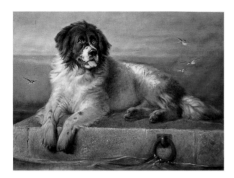

Parish, James Harnett b.1832
*'A Distinguished Member of the Humane
Society'* 1901
oil on canvas 54.2 × 74.8
Oil/T/3

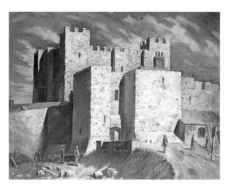

Parker, Mordaunt M.
Palace Gate and Castle Keep 1968
oil on board 40.0 × 49.2
Dovrm 0.3465

Parker, Mordaunt M.
Peverells Tower 1968
oil on board 49.5 × 39.3
Dovrm 0.3466

Parker, Mordaunt M.
Constable's Gate, Dover Castle 1968
oil on board 49.4 × 40.0
Dovrm 0.3475

Parker, Mordaunt M.
Inner Curtain Wall, Dover Castle 1968
oil on board 49.5 × 39.2
Dovrm 0.3476

Parker, Mordaunt M.
Castle Keep and Averanches Tower 1968
oil on board 39.5 × 49.8
Dovrm 0.8722

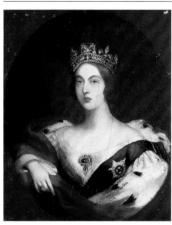

Parris, Edmund Thomas 1793–1873
Queen Victoria 1835–1840
oil on canvas 78.2 × 65.7
Dovrm 1987.100

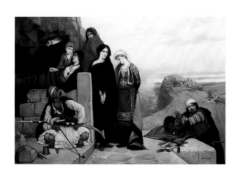

Peellaser, J.
Middle East White Slave Trade c.1860?
oil on canvas 93.9 × 138.5
Oil/FS/51

Piper, J. E.
Montmatre 1959
oil on canvas 48.7 × 38.3
Dovrm 0.6000

Proctor, E.
Highstead Farm, Leeds 1898
oil on canvas 40 × 55
Dovrm 0.8736

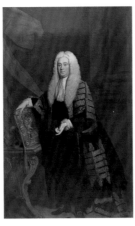

Ramsay, Allan 1713–1784
Lord Chancellor Hardwicke 1740
oil on canvas 237 × 147
Dovrm 0.11012 DTH

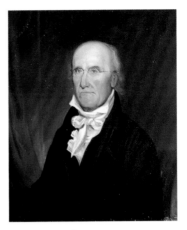

Reynolds, Joshua 1723–1792
Portrait of an Old Gent
oil on canvas 74.8 × 62.0
Oil/FS/37

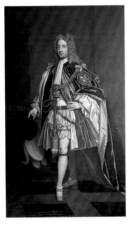

Richardson, William (attributed to)
Lionel Sackville, Duke of Dorset, Lord Warden of the Cinque Ports 1761
oil on canvas 238.8 × 147.3 (E)
Dovrm 0.11023 DTH

Robins, Thomas Sewell 1814–1880
Fishng Craft in a Choppy Sea 1853
oil on canvas 45 × 69
Deavm 1998.5

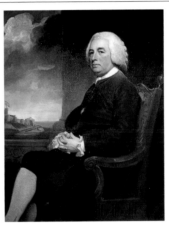

Romney, George 1734–1802
Michael Russell, Agent Victualler of Dover 1777–1781
oil on canvas 126 × 101
Dovrm 2000.91

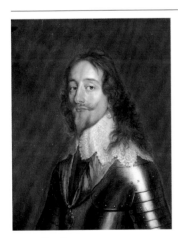

Russell, John
Charles I
oil on panel 38.4 × 30.5
Deavm 47 (pair)

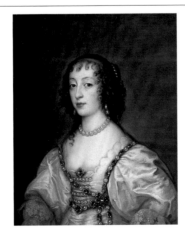

Russell, John
Queen Henrietta Maria
oil on panel 38 × 31
Deavm 47 (pair)

Russian School 19th C
Icon: Life of Christ
oil on panel 49.5 × 40.5 (E)
Deavm 30

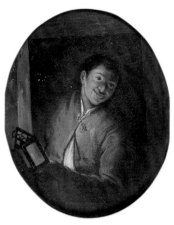

Schendel, Petrus van 1806–1870
The Lantern
oil on panel 20 (E)
Deavm 2004.1

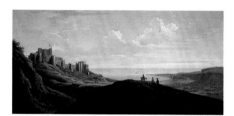

Scott, S.
Dover Castle from the Heights
oil on canvas 74 × 107
Dovrm 2004.43

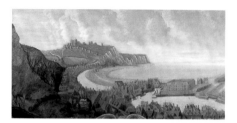

Scott, S.
Dover Castle from the Pier
oil on canvas
DTC

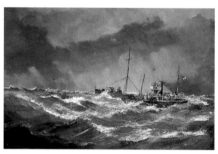

Sears, E. H.
Rescuing HMAT 'Blackburn Rovers'
oil on canvas 49.5 × 75.0
Dovrm 2003.70

Smart
Woolcomber Street about 1850 c.1850
oil on canvas 22.5 × 33.5
Dovrm 1992.29

Snagg, J.
Dover Castle and the Rice Mansion 1796
oil on metal 30.5 × 41.4
Dovrm 0.3444

Snagg, J.
Dover from the Castle Jetty 1801
oil on tin 30.5 × 41.3
Dovrm 0.6009

Snagg, J.
Dover Castle and the Rice Mansion c.1796
oil on canvas 44.8 × 67.1
Dovrm 0.8729

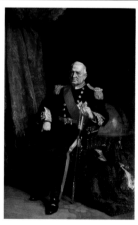

Speed, Harold 1872–1957
Earl Brassey, Lord Warden of the Cinque Ports
1912
oil on canvas 227.5 × 14.9
Dovrm 0.11003 DTH

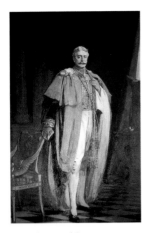

Speed, Harold 1872–1957
The Rt Hon. George Wyndham, MP 1914
oil on canvas 251 × 170
Dovrm 0.11005 DTH

Stanfield, Clarkson 1793–1867
Fishing Barges off the South Foreland
oil on canvas 33.5 × 51.0 (E)
Deavm 44

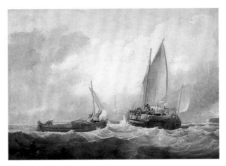

Stannard, Joseph 1797–1830
Fishing Boats in a Rough Sea
oil on panel 33.7 × 47.0
Deavm 1998.4

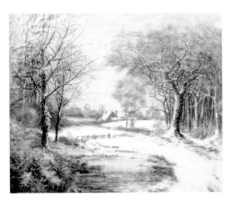

Stone, D. W.
A Winter Scene 1812
oil on canvas 63 × 75
Deavm 58

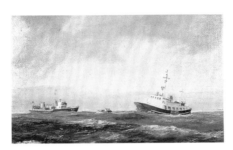

Tapley, M. E.
Pilots Transferring to Pilot Cutter
oil on board 30.5 × 50.8
CPP 19

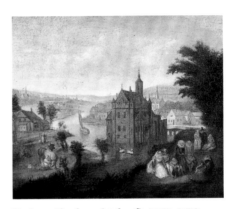

Teniers, Abraham (style of) 1629–1670
Landscape with Cottages
oil on panel 22.5 × 27.3
Deavm 58

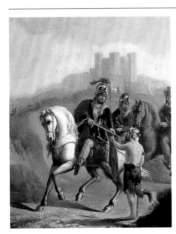

Terry, W. J.
St Martin Dividing His Cloak
oil on canvas 44.5 × 36.7
Oil/T/1

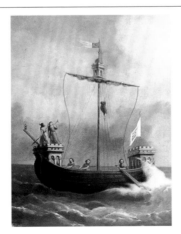

Terry, W. J.
Cinque Ports Ship at Sea
oil on canvas 44.6 × 36.2
Oil/T/8

Troubetzkoy, Paolo Prince 1866–1938
*Marquis of Dufferin and Ava, Lord Warden of
the Cinque Ports* 1892–1895
oil on canvas 225 × 114
Dovrm 0.11013 DTH

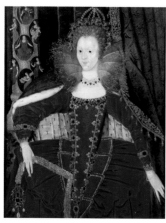

unknown artist
Queen Elizabeth I and the Cardinal and Theological Virtues 1596
oil on panel 111.8 × 88.9 (E)
Dovrm 0.11031

unknown artist 18th C
The Lower Road
oil on panel 36.2 × 39.3
Deavm 1998.7

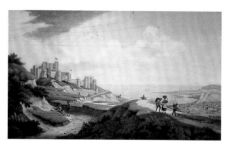

unknown artist
View of Dover from the Guston Road c.1840
oil on canvas 64.1 × 90.2 (E)
Oil/T/4

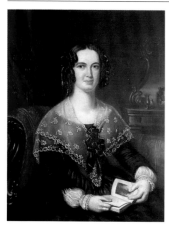

unknown artist
Miss Martha Winthrop, Principal Founder 1849
oil on canvas 59.5 × 46.5
Oil/T/5

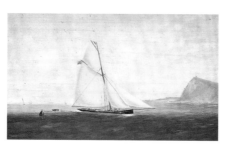

unknown artist
Dover Cutter off Shakespeare Cliff c.1850?
oil on canvas 28.3 × 45.5
Dovrm 0.9011

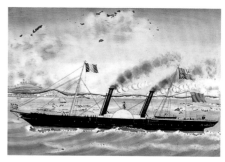

unknown artist
HMS Steam Packet 'Vivid' c.1855
oil on glass 29.2 × 39.1
Dovrm 1985.183

unknown artist
Clergyman c.1880s?
oil on canvas 110 × 85
Dovrm 1987.77

unknown artist
St Mary's Church, Dover before 1897?
oil on canvas 30.7 × 40.7
Dovrm 1984.1

unknown artist 19th C
Madonna della sedia (copy of Raphael)
oil on panel 71.5 (E)
Deavm 17

unknown artist
Mayor of Dover Receiving Royalty 1908
oil on canvas 120 × 95
Oil/T/6

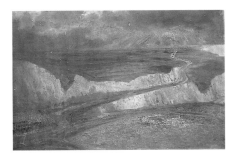

unknown artist
Proposed Dover-St Margaret's Road
oil on canvas 145.4 × 206.4 (E)
Dovrm 1987.81

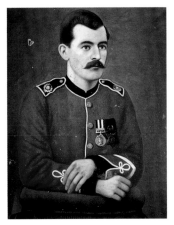

unknown artist
Sergeant-Major Quinlan, Royal Marines Light Infantry
oil on canvas 63.3 × 50.0
Dovrm 2004.44

unknown artist
Dover Harbour 1897
oil on canvas 30.5 × 45.5
Dovrm 2004.45

unknown artist
Sailing Boats off Dover
oil on canvas 76.8 × 127.2
Dovrm 2004.46

unknown artist
Maison Dieu, Dover and Tram
oil on wood 23.4 × 34.2
Dovrm 0.3473

unknown artist
View of Old Naples
oil on canvas 50.2 × 76.3
Dovrm 0.8720

unknown artist
Dover Castle from the Pier Heads
oil on canvas
DTC 1

unknown artist
Windmill in Cornfield
oil on canvas 71.8 × 55.8
Oil/FS/20

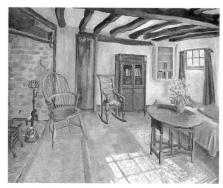

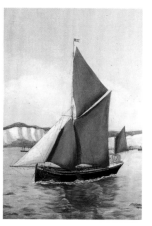

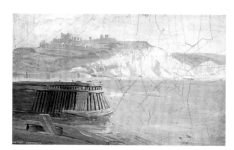

unknown artist
Living Room Scene
oil on board 61.0 × 76.3
Oil/FS/21

unknown artist
Sailing Boat off Dover
oil on canvas 87.0 × 63.8
Oil/FS/27

unknown artist
Old Dover about 1830
oil on panel 20.5 × 33.1
Oil/L/2

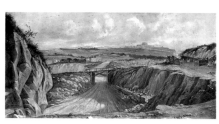

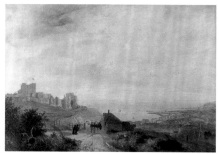

unknown artist
Castle from Alkham Valley (?)
oil on canvas 30.5 × 61.0
Oil/L/3

unknown artist
Dover from the Deal Road
oil 40.6 × 53.3 (E)
Oil/L/11

Veale, S. I.
Phyllis Williamson
oil on canvas 49.5 × 39.5
Deavm 15

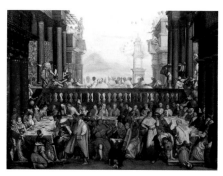

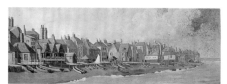

Veroucke, P. 1528–1588
The Marriage at Cana (after Paolo Veronese)
oil on panel 63.0 × 85.4
Deavm 2

Victoryns, Anthoni d.before 1656
The Foot Doctor
oil on panel 27.3 × 34.2
Deavm 32

Warren, K.
Deal Seafront
oil on board 86 × 211 (E)
Deavm 18

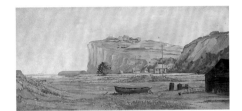

Warren, K.
Kingsdown, Kent
oil on panel 84 × 176 (E)
Deavm 60

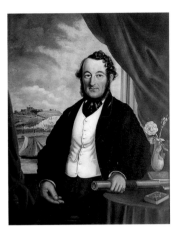

Waters, William Richard 1813–1880
William Marsh, Cinque Ports Pilot c.1875
oil on canvas 57.8 × 45.8
Dovrm 1985.182

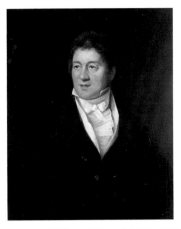

Waters, William Richard 1813–1880
Richard Arnold, Cinque Ports Pilot
oil on canvas 74.4 × 62.0
Dovrm 1999.5.1

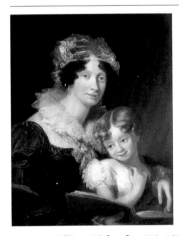

Waters, William Richard 1813–1880
Elizabeth Arnold, Wife of Richard Arnold
oil on canvas 74.4 × 62.0
Dovrm 1999.5.2

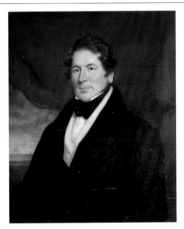

Waters, William Richard 1813–1880
James Sandford, Cinque Ports Pilot
oil on canvas 75.6 × 62.2
CPP 38

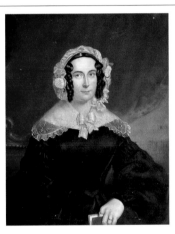

Waters, William Richard 1813–1880
Mary, Wife of James Sandford
oil on canvas 75 × 62
CPP 39

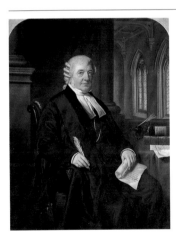

Waters, William Richard 1813–1880
Sir W. H. Bodkin 1861
oil on canvas 144 × 112
Dovrm 0.11002 DTH

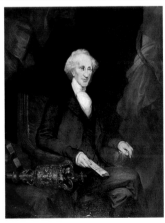

Waters, William Richard 1813–1880
James Poulter, Mayor c.1855
oil on canvas 143 × 112
Dovrm 0.11007 DTH

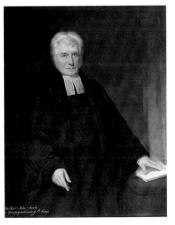

Waters, William Richard 1813–1880
Rev. J. Maule, Vicar of St Mary's 1842
oil on canvas 125 × 100
Dovrm 0.11014 DTH

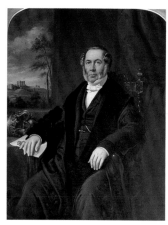

Waters, William Richard 1813–1880
John Birmingham, Mayor of Dover 1862
oil on canvas 140 × 110
Dovrm 0.11016 DTH

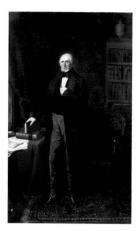

Waters, William Richard 1813–1880
Edward Royd Rice MP 1858
oil on canvas 270 × 182
Dovrm 0.11019 DTH

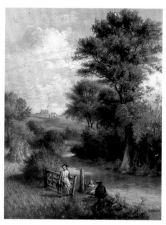

Waters, William Richard 1813–1880
Country Road, Dover c.1845
oil on canvas 44.5 × 34.5
Oil/L/5

Waters, William Richard 1813–1880
Country Lane Near Dover c.1845
oil on canvas 34.4 × 24.0
Oil/L/8

Waters, William Richard 1813–1880
Red Cow Inn at Night c.1845
oil on canvas 16.5 × 29.0
Oil/L/9

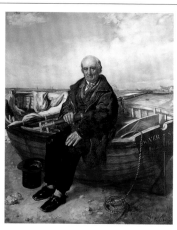

Waters, William Richard 1813–1880
William Waters, Cinque Ports Pilot 1852
oil on canvas 74.8 × 62.1
Oil/T/2

Whitcombe, George E.
Best of British 1974 1974
oil on board 78 × 106

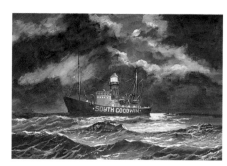

Whiting, Alf 1905–1972
S. Goodwin Lightship (WAT)
oil on canvas 30.5 × 43.2
Dovrm 1998.72

Whiting, Alf 1905–1972
150th Anniversary of the Lifeboat
oil on canvas paper 28 × 38
Dovrm 0.9033

Wilkinson, Norman 1878–1971
The Ostend Boat Leaving Dover 1957
oil on canvas 43.7 × 58.7
Dovrm 2000.103

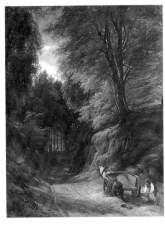

Willis, Henry Brittan 1810–1884
A Sunny Lane in Sussex
oil on board 42.6 × 34.0
Deavm 1998.13

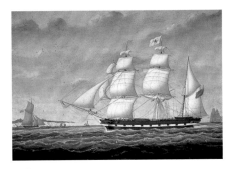

Wilson
Shipping off Dover c.1820?
oil on canvas 51.4 × 73.7
Dovrm 1987.90

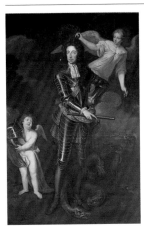

Wissing, Willem c.1656–1687
William of Orange
oil on canvas 264.2 × 177.8 (E)
Dovrm 0.11017 DTH

Wootton, Frank 1914–1998
The Convoy
oil on canvas 54.0 × 74.3
Dovrm 2003.69

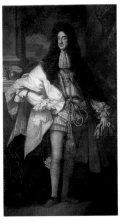

Wright, John Michael 1617–1694
Charles II
oil on canvas 231 × 134
Dovrm 0.11018 DTH

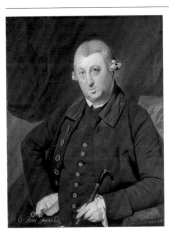

Zoffany, Johann 1733–1810
Peter Fector, Dover Banker 1810
oil on canvas 90.5 × 69.5
Dovrm 0.11020 DTH

Folkestone
Charter Trustees

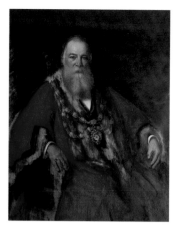

Baldry, George W.
Alderman John Banks 1893
oil on canvas 122 × 91
FCT 3

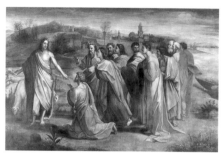

unknown artist 17th C?
Christ's Charge to Peter (Feed My Sheep) (after Raphael)
oil on canvas 137 × 206
FCT 5 (P)

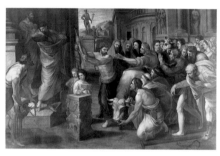

unknown artist 17th C?
Paul & Barnabas at Lystra (Sacrifice at Lystra) (after Raphael)
oil on canvas 137 × 206
FCT 8 (P)

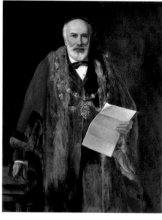

unknown artist
Alderman John Sherwood 1883
oil on canvas 125 × 99
FCT 6

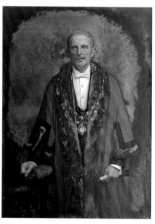

unknown artist
Sir Stephen Penfold 1898
oil on canvas 122 × 91
FCT 2

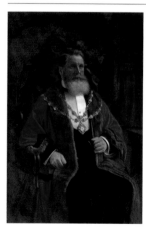

unknown artist
Alderman W. Salter 1899
oil on canvas 132 × 91
FCT 4

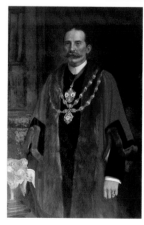

unknown artist
Councillor George Peden 1905
oil on canvas 135 × 91
FCT 7

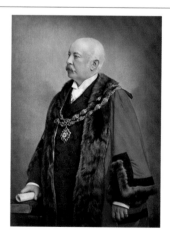

Weston, Lambert
Councillor Chas Carpenter 1900
oil on canvas 122 × 91
FCT 1

Facing page: unknown artist, *Queen Elizabeth I and the Cardinal and Theological Virtues* (detail), Dover Collections (p. 74)

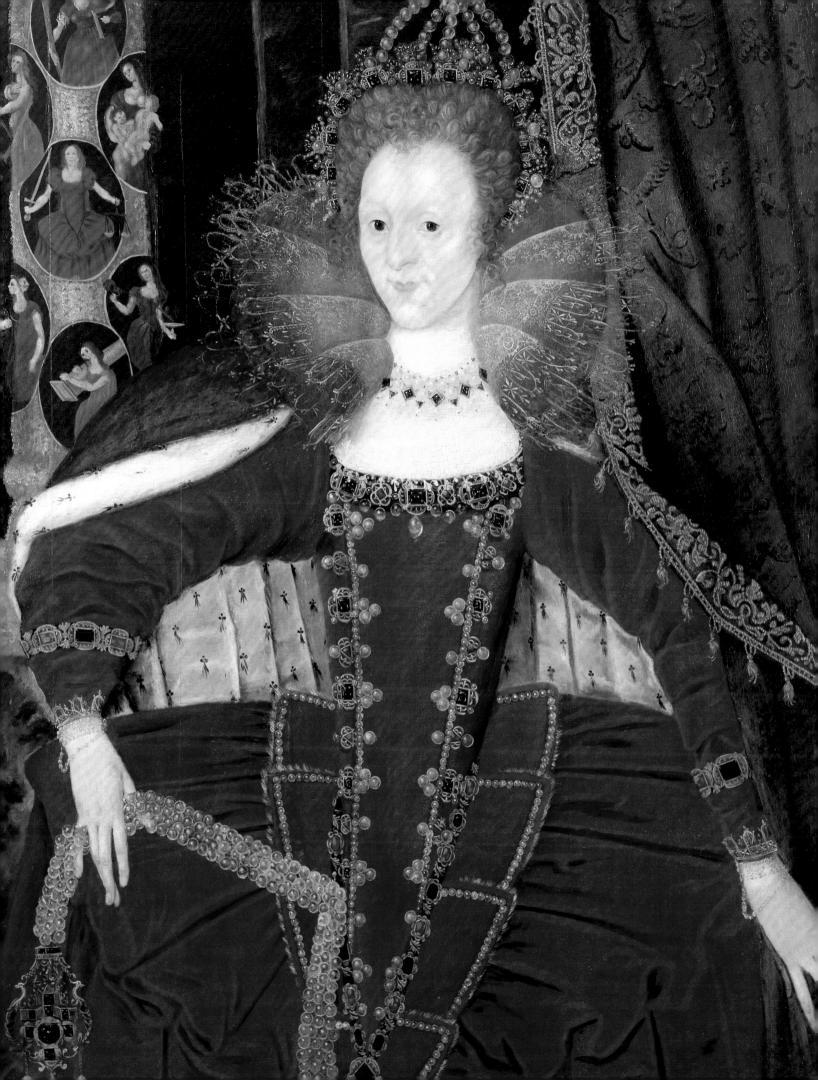

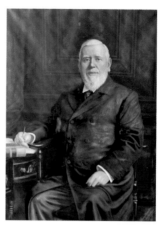

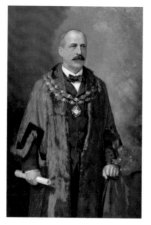

Weston, Lambert
H. B. Bradley 1906
oil on canvas 122 × 91
FCT 9

Weston, Lambert
Councillor Daniel Baker 1901
oil on canvas 137 × 91
FCT 10

Folkestone Museum

The museum was established by the Folkestone Natural History Society in 1868, and moved to a purpose-built museum and library building in Grace Hill in 1888, where it occupies rooms on the first floor. The art collection has been actively expanded since the 1920s, when the curator enlisted the help of Marion Harry Spielmann FSA, an art lecturer, novelist and classicist, to advise on making Folkestone a leading provincial arts centre. He arranged many exhibitions of the works of living artists, supplemented by paintings and drawings from his own collection.

Many paintings were donated before the World War II; the oils and watercolours being mostly of topographical scenes or by locally-based artists. An important collection of chalk, ink and pencil drawings, from the 15th to 19th centuries was donated by Mrs Amy Master in 1924.

Since it opened in 1910, the adjoining Sassoon Gallery has often been used for temporary exhibitions of donations and loans to the museum, as well as for touring exhibitions. Now some of the paintings are regularly displayed in the library and museum; the rest are held in store within the building. Copies are available in the Heritage Research Room, which holds a large collection of items on the history of Folkestone and the surrounding district.

The museum was run by Folkestone Borough Council until 1974, when the library and museum collections were passed to Kent County Council. The building now houses a craft gallery and café as well as the museum, library and gallery. It is a vibrant centre for the arts and is open seven days a week.

Janet Adamson, Heritage Officer

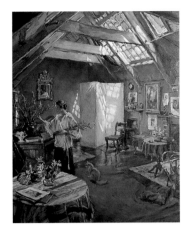

Akerbladh, Alexander 1886–1958
Lady Arranging Flowers
oil on canvas 60 × 50
F3687

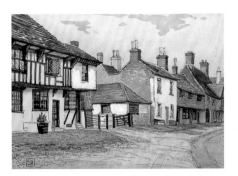

Argyle, R. V.
Elham 1930
oil on canvas 26.5 × 37.0
F3807

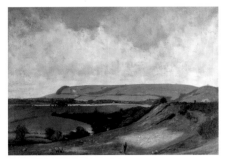

Beach, Ernest George 1865–c.1934
At the Foot of the Downs
oil on canvas 86 × 124
F3973

Brockman, Cornelia active 19th C
Old Houses, the Stade 1889
oil on canvas 49.5 × 75.0
F3894

Cackett, Leonard 1896–1963
Morning, Whitby Harbour
oil on canvas 50 × 60
F3962

Cox, E. Albert 1877–1955
Little Thatched Cottage 1943
oil on canvas 44 × 49
F3686

Cox, E. Albert 1877–1955
Doubtful Story
oil on canvas 40 × 41
F3689

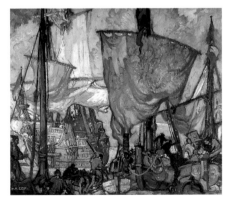

Cox, E. Albert 1877–1955
Departure of William
oil on canvas 49 × 60
F3703

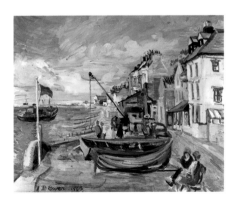

Ewer, Peggy
Seafront, Sandgate 1965
oil on canvas 45 × 55
F3916

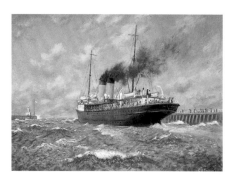

Farrar, C. Brooke
'Victoria' Leaving Boulogne 1957
oil on canvas 43 × 60
F3760

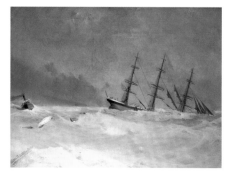

Foley, Victor Sebastian d.1962
Sinking of the 'Bienvenue' 1891
oil on canvas 90 × 121
F6158

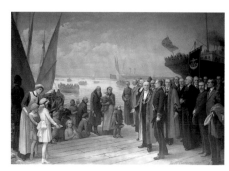

Franzoni, Fredo
Landing of the Belgian Refugees 1915
oil on canvas 212 × 284
F3978

Goodall, Frederick 1822–1904
Landscape Near Folkestone c.1900
oil on board 112 × 244
F6129

Grant, Francis 1803–1878
Lady Mary Watkin c.1870
oil on canvas 124 × 100
F3974

Grant, Francis 1803–1878
Sir Edward Watkin c.1870
oil on canvas 124 × 100
F3975

Harpers, D.
Lower Sandgate Road
oil on canvas 15 × 30
F3860

Haughton, Benjamin 1865–1924
Coombe in the Quantocks
oil on canvas 39 × 47
F3783

Henry, James Levin 1855–1929
Lengthening Shadows
oil on canvas 49.5 × 69.0
F3787

Kerr, Richard
Folkestone c.1790 c.1890
oil on canvas 155 × 250
F3977

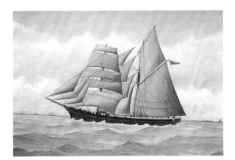

Laidman, G.
'Aneroid' 1898
oil on canvas 51.0 × 76.2
F3780

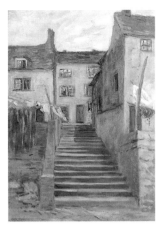

Lindon, Francis
Steps at Stade, Folkestone before 1914
oil on canvas 38.0 × 28.2
F3854

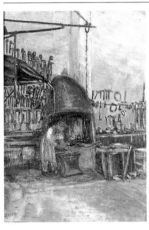

Lindon, Francis
Oil Forge, Fishing Town c.1914
oil on canvas 39.5 × 29.0
F3873

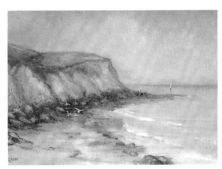

Lindon, Francis
Copt Point before 1914
oil on canvas 27 × 37
F3911

Maitland, Paul Fordyce 1863–1909
Folkestone Pier, Morning
oil on canvas 19.5 × 9.0
F3813

Major, John
Old Folkestone 1820
oil on canvas 29.0 × 44.3
F3886

Marlow, William 1740–1813
Old Folkestone
oil on canvas 40 × 58
F3752

Mears, George active 1866–1890
'Mary Beatrice' Leaving Boulogne
oil on canvas 45 × 75
F3755

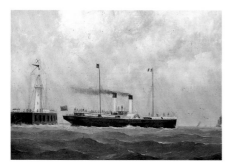

Mears, George active 1866–1890
'Mary Beatrice' Leaving Boulogne
oil on canvas 29.0 × 41.5
F3762

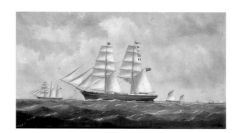

Mears, George active 1866–1890
'Woodside' 1883
oil on canvas 50.8 × 91.4
F3778

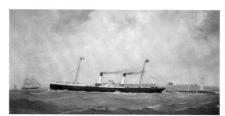

Mears, George active 1866–1890
'Albert Victor' Leaving Boulogne 1887
oil on canvas 60 × 110
F6130

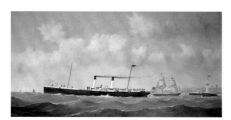

Mears, George active 1866–1890
'Louise Dagmar' Leaving Boulogne 1888
oil on canvas 60 × 122
F6131

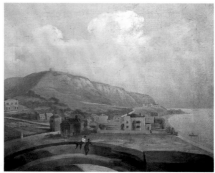

Mitchell 19th C
Sandgate 1846
oil on canvas 53.4 × 66.0
F3964

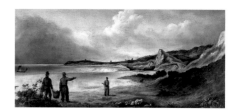

Mornewick I and II, Charles Augustus active
1832–1874
'Pelter' in the Warren c.1832
oil on canvas 42 × 93
F2845

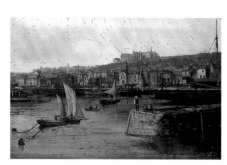

Morris, D.
Folkestone Harbour
oil on canvas 57 × 76
F6119

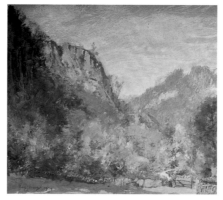

Murray, David 1849–1943
Golden Autumn - Bettws-y-coed
oil on canvas 37.0 × 44.5
F3754

Norman, M.
Warren Inn
oil on canvas 19 × 34
F3830

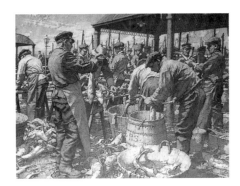

Padday, Charles 1890–1940
Dogfish Season
oil on canvas 90 × 118
F3972

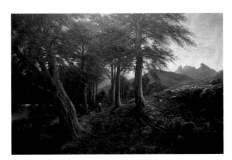

Paton, Waller Hugh 1828–1895
Cobbles at Sundown, Arrochar
oil on canvas 91 × 137
F6124

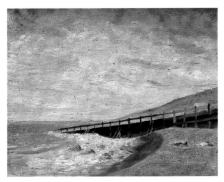

Pole-Stuart, Reginald d.1959
Beach Below Radnor Cliff c.1912
oil on canvas 24 × 32
F3833

Pragoe, C. b.1830
Jenny Pope's Alley c.1905
oil on canvas 24 × 17
F3835

Priestman, Bertram 1868–1951
Folkestone Boat Train 1932
oil on canvas 87 × 111
F6128

Ribera, Jusepe de (attributed to) 1591–1652
St Francis of Assisi
oil on canvas 104 × 83
F6125

Roberts, Edna Dorothy 1877–1970
Landing the Catch 1955
oil on canvas 47.0 × 46.5
F3712

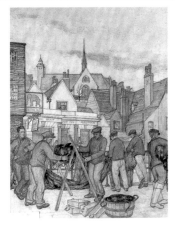

Roberts, Edna Dorothy 1877–1970
Folkestone Fishermen 1955
oil on canvas 41.8 × 31.5
F3739

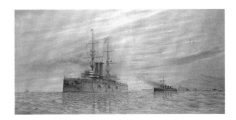

Sampson, John
'Dignity' and 'Impudence' 1901
oil on canvas 70 × 150
F6123

Schulman, David 1881–1966
Old Farm
oil on canvas 107 × 170
F6122

Stevens, Charles Hastings d.1936
Harbour Steps 1929
oil on canvas 35.0 × 25.5
F5873

Tayler, Albert Chevallier 1862–1925
Manor House Hall 1919
oil on canvas 61 × 51
F3784

Taylor, Terri
'British Lion' 1996
oil on canvas 19.0 × 23.5
F7188

Taylor, Terri
The Bayle 1998
oil on canvas 24.5 × 34.5
F7189

unknown artist
Sandgate - Looking West c.1822–1849
oil on canvas 18 × 24
F3811

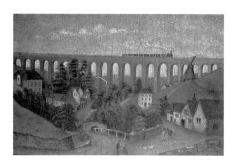

unknown artist
Folkestone Viaduct after 1844
oil on canvas 20 × 30
F3875

unknown artist
Mr Radford c.1870
oil on canvas 61 × 51
F7243

unknown artist
Mrs Radford c.1870
oil on canvas 51 × 40
F7244

unknown artist
Alderman Sherwood 1876
oil on canvas 75 × 63
F6132

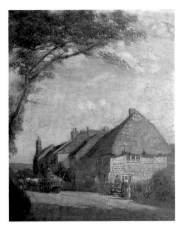

unknown artist
Sandy Lane, Foord 1877
oil on canvas 29 × 24
F3880

unknown artist
Saltwood Castle c.1920
oil on canvas 33 × 25
F3849

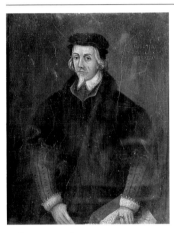

unknown artist
William Harvey
oil on canvas 22 × 18
F3832

unknown artist
Rakemere Pond
oil on canvas 21.8 × 39.0
F3838

unknown artist
Rakemere Pond
oil on canvas 32 × 39
F3844

unknown artist
John Clark Jnr
oil on canvas 60 × 49
F3855

unknown artist
Rakemere Pond
oil on canvas 20.7 × 30.0
F3869

unknown artist
Cheriton Rectory
oil on canvas 52 × 65
F3968

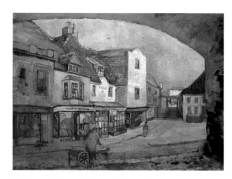

Videan, **John Allen** 1903–1989
Beach Street, Folkestone
oil on canvas 55 × 75
F3751

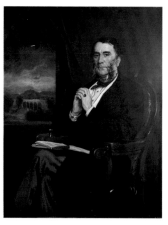

Ward, **Edwin Arthur** 1859–1933
Sir Alfred Mellor Watkin
oil on canvas 66 × 52
F3976

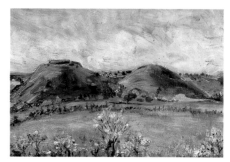

Watton, **M. H.**
Caesar's Camp before 1927
oil on canvas 17 × 26
F3815

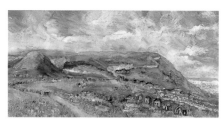

Watton, **M. H.**
Sugar Loaf and Dover Hill before 1927
oil on canvas 17.5 × 35.5
F3817

Wightwick, **William** 1831–1907
Saltwood Castle 1895
oil on canvas 24.0 × 33.5
F3864

Wightwick, **William** 1831–1907
Millfield Mill
oil on canvas 34 × 44
F3866

Williams, **R.**
Alkham Valley 1842
oil on canvas 13.0 × 22.2
F3810

Williamson, **James** active 1868–1889
Leas Shelter, Folkestone
oil on canvas 45.0 × 59.5
F3764

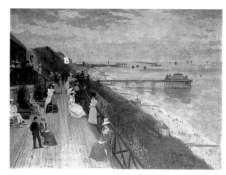

Williamson, **James** active 1868–1889
Leas Shelter, Folkestone
oil on canvas 46 × 59
F3859

Williamson, James active 1868–1889
Toll House, Lower Sandgate Road
oil on canvas 30 × 61
F3960

Wilson, John Snr
Old Star Inn, Newington 1750
oil on canvas 22.8 × 47.0
F3882

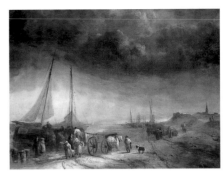

Wilson, John H. 1774–1855
After the Storm c.1800
oil on canvas 48.0 × 63.2
F3806

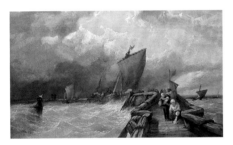

Wilson, John James II 1818–1875
Ships Returning to Harbour
oil on canvas 25 × 50
F3749

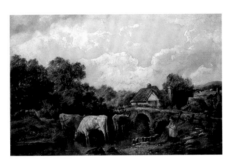

Wilson, John James II 1818–1875
Pastoral Scene, Redhill c.1870
oil on canvas 44 × 68
F3781

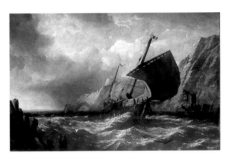

Wilson, John James II 1818–1875
View on Coast of Norway 1866
oil on canvas 44 × 67
F3785

Faversham Town Council, Mayor's Parlour and Guildhall

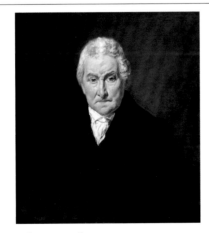

unknown artist
George Beckett c.1804
oil on canvas 67.0 × 58.5
PCF_KT_FTC_02_001

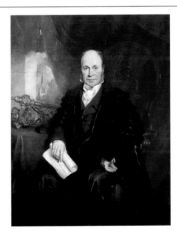

unknown artist
Henry Wreight Esq. c.1827
oil on canvas 142.5 × 111.5
PCF_KT_FTC_01_020

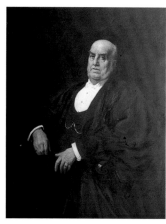

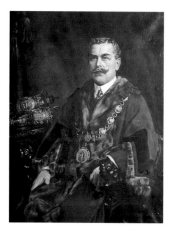

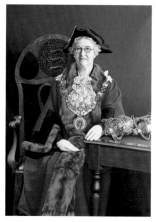

unknown artist
Alderman John Andrew Anderson JP c.1899
oil on canvas 127 × 102
PCF_KT_FTC_01_024

unknown artist
Sidney Robert Alexander Mayor, (1910–1919)
1911
oil on canvas 90.5 × 70.5
PCF_KT_FTC_01_009

unknown artist
Florence Emily Graham c.1956
oil on canvas 93.0 × 67.5
PCF_KT_FTC_01_014

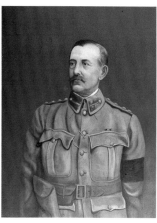

unknown artist
*Lord Harris the 4th of Belmont, Captain of the
England Amateur Cricket Team*
oil on canvas 112 × 86
PCF_KT_FTC_01_028

Medway NHS Trust, Gillingham

Crosse, Tony b.1944
Isis and Queen Nefertari 2001
oil on canvas 121.9 × 91.4
PCF_KT_MMH_01_021

Crosse, Tony b.1944
Best of Friends 2002
oil on canvas 121.9 × 121.9
PCF_KT_MMH_01_026

Crosse, Tony b.1944
Moonset 2001
oil on canvas 121.9 × 121.9
PCF_KT_MMH_01_032

Crosse, Tony b.1944
Feeder of the Fish 2002
oil on MDF 182.9 × 121.9
PCF_KT_MMH_01_035

Crosse, Tony b.1944
Space City 2000
acrylic on MDF 182.9 × 182.9
PCF_KT_MMH_02_005

Crosse, Tony b.1944
Feeder of the Birds 2002
oil on MDF 182.9 × 121.9
PCF_KT_MMH_03_003

Crosse, Tony b.1944
Siesta 2000
oil on canvas 121.9 × 91.4
PCF_KT_MMH_03_025

Crosse, Tony b.1944
Happy Giraffes 2000
acrylic on MDF 121.9 × 182.9
PCF_KT_MMH_03_031

Crosse, Tony b.1944
Two Colourful Kissing Fish 2000
acrylic on MDF 83.9 × 248.9
PCF_KT_MMH_03_036

Crosse, Tony b.1944
Love Nests 2001
oil on canvas 121.9 × 121.9
PCF_KT_MMH_04_027

Crosse, Tony b.1944
A House by the Sea 2001
oil on canvas 121.9 × 121.9
PCF_KT_MMH_04_031

Foster, Roger b.1936
Sharp's Green, Low Tide 1999
acrylic on canvas 91.4 × 121.9
PCF_KT_MMH_01_010

Foster, Roger b.1936
Sharp's Green, Estuary View 1999
acrylic on canvas 91.4 × 121.9
PCF_KT_MMH_01_016

Foster, Roger b.1936
Upper Upnor on the River Medway 2000
acrylic on canvas 86.4 × 121.9
PCF_KT_MMH_04_024

Fricker, Pat b.1948
Field of Sunflowers 1999
acrylic on canvas 76.2 × 91.4
PCF_KT_MMH_03_012

Fricker, Pat b.1948
The Pasture 1999
acrylic on canvas 76.2 × 91.4
PCF_KT_MMH_03_016

Fricker, Pat b.1948
The Path 1999
acrylic on canvas 76.2 × 91.4
PCF_KT_MMH_03_021

Royal Engineers Museum, Gillingham

The Royal Engineers Museum tells the story of the Corps of Royal Engineers, the Sappers. The Corps traces its history back to 1066 and the military engineers brought to England by William the Conqueror for his invasion of Saxon England, with Humphrey de Tilluel as the chief engineer.

The museum reflects this long and distinguished history. 26 galleries contain displays charting the history of military engineering, from the creation of the Ordnance Survey (the national mapping agency for Great Britain) in 1791 to the beginnings of flying, from designing the Royal Albert Hall to the dangerous ongoing task of bomb disposal. In peace and war, the Corps has been in all parts of the world and involved in all British Army activities.

The collection of the Royal Engineers Museum contains artwork of all types. These paintings and drawings have come to the museum through many different routes. Some were painted or drawn by Royal Engineers; some were acquired on campaign and brought back by members of the Corps; and others

were portraits executed by artists for specific officers or men. Overall the artwork brings to life the history of the Corps in pictures.

The museum is one of only 60 museums across the country singled out by the Department of Culture, Media and Sport for the excellence of its collection. It is the only museum in Kent to have received this coveted designated status.

Craig Bowen, Registrar

Baldry, George W.
Sergeant G. Howkett 1917
oil on board 52.2 × 26.5
9107.5.27

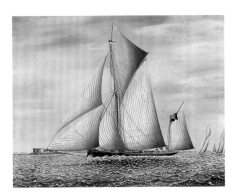

Bennett, H.
Buccaneer REYC
oil on board 53.0 × 65.9
6811.9

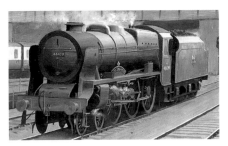

Davidson, G. H.
'The Royal Engineer' Locomotive
oil on paper 36.1 × 49.1
6207.1

Desanges, Louis William 1822–c.1887
Major General Sir H. C. Elphinstone
oil on canvas 106.6 × 91.5
4201.431.1 (P)

Desanges, Louis William 1822–c.1887
General Sir H. N. D. Prendergast
oil on canvas 88.9 × 114.3
4201.431.4 (P)

Guggisberg, F. G.
Brigadier General Sir F. G. Guggisberg
oil on canvas 69.6 × 54.3
8310.21.1

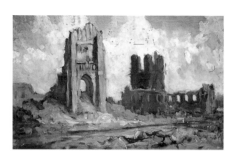

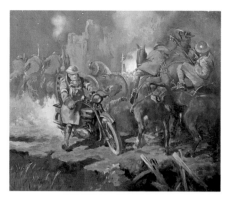

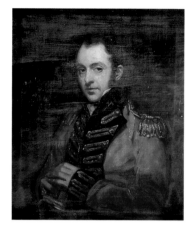

Holden, W. F. C.
Ypres Cathedral 1914–1915
oil on wood 60.9 × 88.9
5807.3

Hutching, R. F.
The Menin Gate 1957
oil on canvas 75.9 × 88.8
5811.4

Leighton, Charles Blair 1823–1855
General Sir C. W. Pasley
oil on canvas 93.0 × 81.5
4501.24

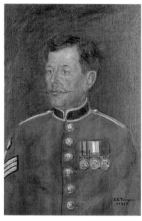

Tomkys, A.
'Gordon' Locomotive 1980
oil on canvas 56.0 × 81.4
8109.9

Turner, E.
CQMS A. Sergison
oil on canvas 68 × 53
9907.1

unknown artist
Gibraltar after 1783
oil on paper 54.1 × 66.9
5601.46.3

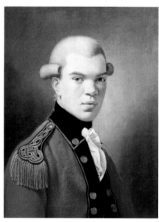

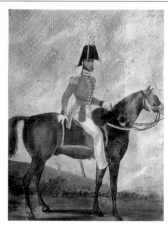

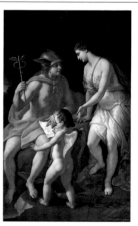

unknown artist
Captain J. Fiddes 1795
oil on canvas 68.5 × 55.5
9309.15

unknown artist
Unknown R. E. Officer 1840?
oil on wood 36 × 31
4101.19

unknown artist
Painting from King of Oudh's Palace before
1857
oil on canvas
5301.119.A

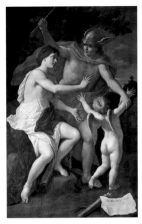

unknown artist
Painting from King of Oudh's Palace before
1857
oil on canvas
5301.119.B

unknown artist
HMS Troopship 'Nevasa' 1961
oil on canvas 55 × 69
9603.14

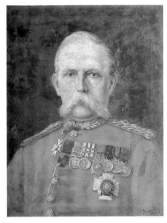

unknown artist
General Sir W. O. Lennox VC, KCB
oil on canvas 45.8 × 35.5
4101.27

unknown artist
2nd Corporal James Cray R. S. & M.
oil on canvas 43.7 × 33.2
5401.96.1

unknown artist
Major General P. Barry
oil on photograph 31.8 × 26.7
6611.3.2

unknown artist
Lieutenant D. C. Home, VC
oil on canvas 46.8 × 40.4
7206.7

unknown artist
Sir H. Elphinstone
oil on canvas 152.4 × 121.9
7705.9.3 (P)

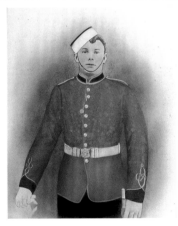

unknown artist
Sapper Wise
oil on card 30.5 × 25.4
7912.6

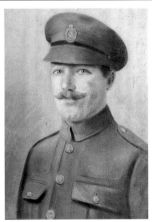

unknown artist
Sapper G. W. Whatford
oil on board 50.5 × 41.8
8703.3.1

unknown artist
Major General C. G. Gordon
oil on card 17.8 × 15.2
8905.13.1

Willass, C.
Major General C. G. Gordon 1943
oil on canvas 118 × 82
GGC355 (P)

Gravesham Borough Council

Over many centuries, oil paintings, including portraits, watercolours and sketches have come into council ownership, through donation and for other reasons, to record the deeds of prominent citizens and celebrate important occasions or events. This catalogue records all the oil paintings in the collections, which have rarely, if ever, been seen as a whole.

Although unique in every sense, the collection is not highly valuable in financial terms; it lacks works by the more famous portrait artists of the last century. However, what is amply evident is the style and format adopted to portray the eminent of the town in the Victorian period. The collection thus offers interesting material on social history. The painting of the schooner by W. Dunnage is undoubtedly the pick of the collection.

We are pleased to have this opportunity to make the Gravesham Collection available to a wider audience than was hitherto possible, and feel this publication will become an important resource for the art enthusiast, the genealogist and historian alike.

Alan Ridgers, Heritage Centre Manager

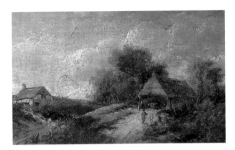

Barland, **Adams** active 1843–1916
Cottage Scene 1916
oil on canvas 39 × 51
LAH 02/04

Clark active 1899–1930
Henry Huggins 1930
oil on canvas 186 × 154
LAH 02/28

Clark active 1899–1930
John Russell 1899
oil on canvas 185 × 150
LAH 02/30

Clark active 1899–1930
Henry E. Davis 1911
oil on canvas 270 × 185
LAH 02/37

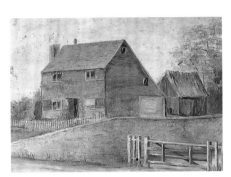

Cook or Cooke
House on Tubbs Hill, Sevenoaks
oil on canvas 33 × 43
LAH 02/02

Cowan, Ian
General Gordon 1985
oil on canvas 130 × 100
LAH 02/13

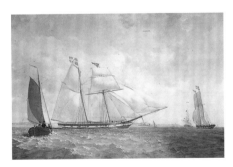

Dunnage, W. active 1843–1852
Topsail Schooner 'Commodore' 1843
oil on canvas 100 × 135
LAH 02/10

Gilbert, A.
Sevenoaks, Kent
oil on canvas 43 × 58
LAH 02/01

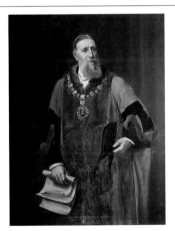

Haynes-Williams, John 1836–1908
George M. Arnold 1894
oil on canvas 175 × 145
LAH 02/36

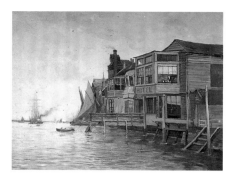

Holloway, Charles Edward 1838–1897
The Old Falcon
oil on canvas 91 × 114
LAH 02/21

Leeder, H.
Chiddingstone 1971
oil on canvas 38 × 46
LAH 02/05

Leeder, H.
Milton Church (Sittingbourne)
oil on canvas 35 × 42
LAH 02/35

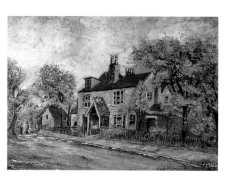

Leeder, H.
Fort House
oil on canvas 38 × 46
LAH 02/40

Lowcock, C. J.
Casper Paine 1896
oil on canvas 190 × 160
LAH 02/29

Mason, Arnold 1885–1963
Robert Palmer, VC 1948
oil on canvas 74 × 66
LAH 02/18

Mason, Arnold 1885–1963
Alderman W. E. Thomas 1942
oil on canvas 170 × 150
LAH 02/23

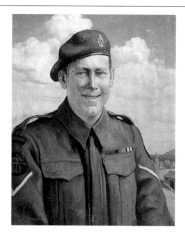

Miller, William Ongley b.1883
Eric Harden, VC 1946
oil on canvas 84 × 71
LAH 02/17

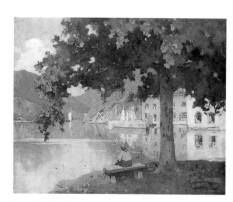

Petrie, Graham 1859–1940
Tree in front of Lake
oil on canvas 51 × 62
LAH 02/09

Facing page: Haydon, Benjamin Robert, *Bartholomew Fair* (detail), Dover Collections (p. 64)

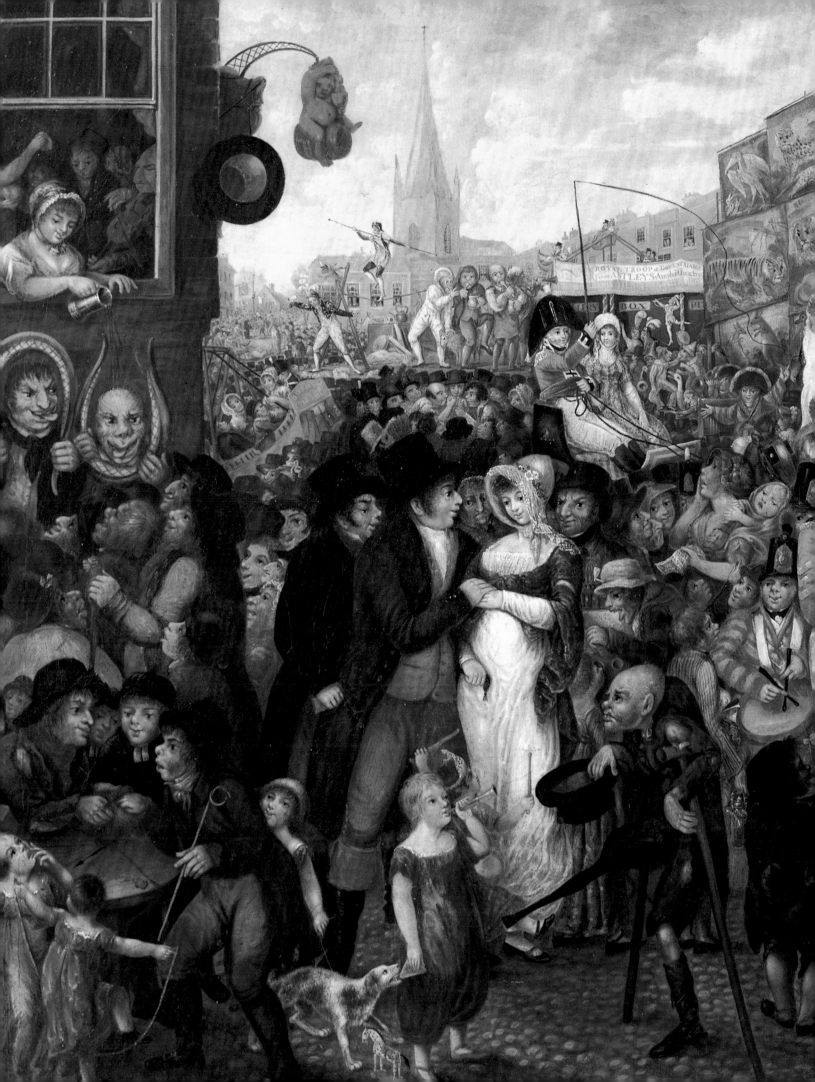

Snowman, Isaac b.1874
Unknown Mayor 1893
oil on canvas 180 × 160
LAH 02/24

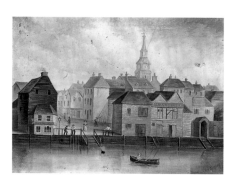

Thompson, A. H.
Waterfront Gravesend
oil on canvas 41 × 56
LAH 02/07

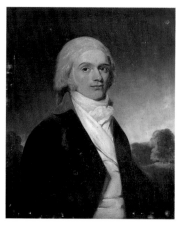

unknown artist 18th C
Gentleman in High White Collars
oil on canvas 76.2 × 50.8
LAH 02/39

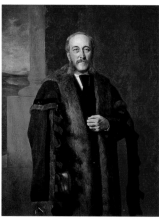

unknown artist
Thomas Troughton 1873
oil on canvas 180 × 155
LAH 02/35

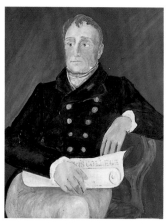

unknown artist 19th C
Huggens
oil on wood 77 × 61
LAH 02/08

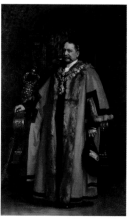

unknown artist
James Harmer 1909
oil on canvas 280 × 225
LAH 02/38

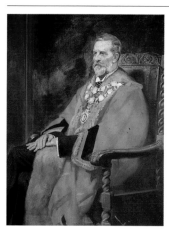

unknown artist
John Hanks Cooper 1925
oil on canvas 175 × 145
LAH 02/31

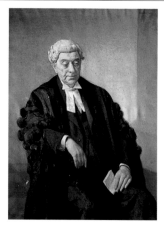

unknown artist
Henry Hopton Brown 1947
oil on canvas 150 × 116
LAH 02/25

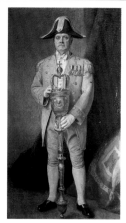

unknown artist
John Parkinson 1947
oil on canvas 210 × 124
LAH 02/26

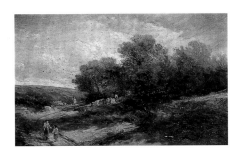

unknown artist
Landscape
oil on canvas 34 × 47
LAH 02/03

unknown artist
Portrait of a Gentleman
oil on wood 185 × 160
LAH 02/27

unknown artist
T. F. Wood
oil on canvas 135 × 115
LAH 02/32

Walters, Douglas
Robert Pocock 1993
oil on canvas 72 × 106
LAH 02/22

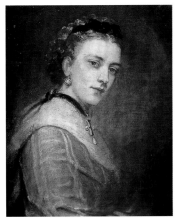

Weigall, Henry 1829–1925
Queen Alexandra
oil on canvas 186 × 75
LAH 02/34

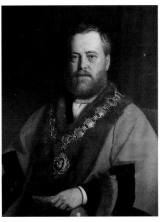

Williams, Edgar
George H. Edmunds 1884
oil on canvas 120 × 100
LAH 02/33

Winter, M.
Thames Barge, Bawley Bay 1998
oil on canvas 75 × 90
LAH 02/11

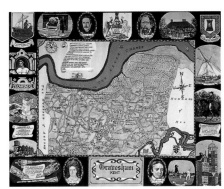

Winter, M.
Gravesham, Kent 1998
oil on canvas 75 × 90
LAH 02/12

Hythe Council Offices, Local History Room and Town Hall

The Hythe Local History Room was established in the neighbourhood of Oaklands, in 1933, in a house left to the town and Cinque Port of Hythe by Dr Randolph Davis. The collection, including material about archaeology and social history as well as paintings, illustrates the history of the town and the Small Arms School, in three rooms adjoining the public library. Much of the framed material is watercolour or local prints; most of the oils have been donated by local people, or are of local scenes. The portraits are mostly located in the town hall, and have belonged to the town for many years.

Janet Adamson, Honorary Curator

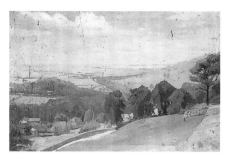

Alvaridale
Looking across Romney Marshes
oil on canvas 50 × 75
Y615

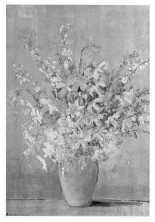

Baker-Clack, Arthur 1877–1955
Daffodils c.1920
oil on canvas 76.0 × 55.5
Y557

Baker-Clack, Arthur 1877–1955
Church Hill Steps, Hythe c.1930
oil on canvas 35 × 23
Y2026

Cardew, G. E.
Harry Sharp, Mayor, (1937–1938) 1967
oil on canvas 38.5 × 29.1
Y293

Hoogsteyns, Jan b.1935
The Table
oil on board 49 × 59
Y938

Lavery, John 1856–1941
The Right Hon. Mayor of London Sir Charles Cheers Wakefield
oil on canvas 125 × 100
PCF_KT_HYC_04_001

Lee, L. M.
Landscape 1892
oil on canvas 32 × 42
Y297

Playford
Hythe High Street 1905
oil on canvas 50 × 75
Y2013

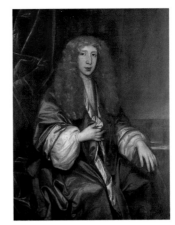

unknown artist 17th C
Painting of a Man
oil on canvas 132.5 × 109.0
PCF_KT_HYC_03_008

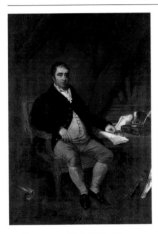

unknown artist 18th C
Charles James Fox
oil on canvas 236 × 160
PCF_KT_HYC_06_001

unknown artist 18th C
Bathsheba
oil on canvas 27.3 × 19.0
Y217

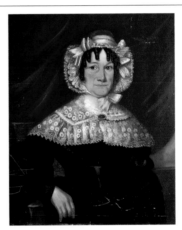

unknown artist 19th C
Portrait of a Woman
oil on canvas 76.0 × 63.5
Y939

unknown artist
Landscape c.1910
oil on canvas 76.0 × 45.9
Y554

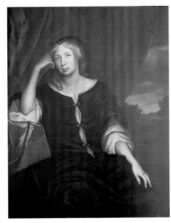

unknown artist
Painting of a Lady
oil on canvas 132.5 × 109.0
PCF_KT_HYC_03_014

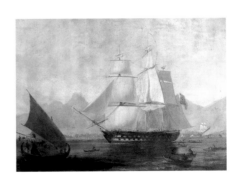

unknown artist
The East Kent Indiaman Going into Macao Roads
oil on canvas 74.5 × 105.0
PCF_KT_HYC_05_001

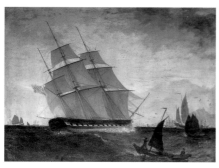

unknown artist
The East Kent Indiaman off Amere Point in the Strait of Sunda
oil on canvas 74.5 × 105.0
PCF_KT_HYC_07_001

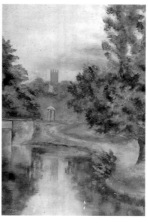

unknown artist
Hythe Church from the Green
oil on canvas 29.5 × 22.0
Y294

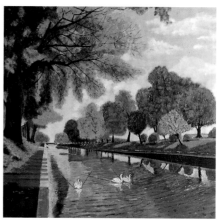

unknown artist
Hythe Canal
oil on canvas 30 × 30
Y991

Kent County Council, Arts and Museums

The collection of the Kent Visual Arts Loan Service is managed by the Arts and Museums service of Kent County Council. We have a diverse and extensive collection of artworks available for loan, with over 1,500 items to choose from. It has been acquired from purchases, commissions and gifts over the past 40 years.

The main aim of the scheme is to make the works available to schools, colleges and other establishments for educational purposes by aiding the development of knowledge through an understanding and appreciation of original works of artists, designers and crafts people. We also make original pictures available to organisations based in Kent, or which have a Kent connection, for display, decorative and exhibition purposes.

A number of paintings are included in the scheme, featuring a variety of media such as watercolour, oils, gouache and mixed media. The collection also features a range of drawings, photographs, lithographs and etchings.

The art ranges from topographical works based on the landscape and life of Kent to original prints and paintings by top contemporary artists on a variety of themes. Many of the artists live in Kent or have a strong Kentish connection and include Graham Clarke, Andy Goldsworthy, Martin Parr, John Ward, Stephen Farthing, Anthony Gross, John Piper, David Gentleman, Elizabeth Frink and Martin Leman. The artists mentioned above are not necessarily represented in this catalogue as only the oil paintings are presented below.

John Brazier, Head of Arts and Museums

Alexander, Christopher 1926–1982
Broadstairs
oil 35 × 42
AL573

Alexander, Jack
Little Sands, Folkestone Harbour
oil 71 × 110
AL446

Beamand, B.
Canal
oil on hardboard 81.5 × 58.5
AL400

Beamand, B.
The Black Line around England
oil on hardboard 30 × 209
AL401

Brown, W. T.
County Road Near Ashford
oil on board 35 × 45
AL195

Bull, W. B.
The High Street, Ashford
oil 42 × 50
AL368

Clegg, Richard b.1966
King and Queen 1988
oil on canvas 154 × 174
AL565

Corke, C.
The Shambles, Sevenoaks, 1883
oil on canvas 51 × 70
AL700

Coulson, J.
Singing while She Falls, 1987
oil on canvas 170 × 150
AL695

Farthing, Stephen b.1950
Ramsgate
oil on canvas 183 × 122
AL577

Foster
Woods Near Sevenoaks
oil on canvas 44 × 34
AL702

Hackney, Arthur b.1925
Winter Scene
oil 36 × 31
EF1105H

Harris, P. A.
Tonbridge Castle
oil 13 × 21
AL170

Helm, Stewart b.1960
Trees
oil 24 × 33
EF562H

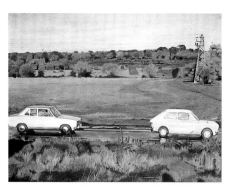

Hosking, John
Wet Road – Cars
acrylic 62.5 × 78.5
EF1481H

Hosking, John
Self Portrait (triptych)
acrylic 81.0 × 58.5
EF1530H.A

Hosking, John
Self Portrait (triptych)
acrylic 81.0 × 58.5
EF1530H.B

Hosking, John
Self Portrait (triptych)
acrylic 81.0 × 58.5
EF1530H.C

Illingworth, Nancy
Changing Weather, Warehorne
oil on hardboard 30 × 50
AL407

Illingworth, Nancy
The Weald from Linton
oil 20 × 25
AL409

Knight, J.
St Nicholas Church and Rectory
oil 55 × 70
AL737

Le Claire, M.
The Warren, Folkestone
oil on canvas 109 × 70
AL564

Lloyd, Vincent b.1960
Quarry with Apple
oil on canvas 61 × 70
AL485

Lord, Sarah b.1964
Steps
oil on plywood 26 × 27
AL579

Lord, Sarah b.1964
Golden Sands
oil on plywood 16 × 18
AL580

Lord, Sarah b.1964
Triangle
oil on hardboard 33.5 × 24.0
AL640

Lord, Sarah b.1964
Fishing Debris
oil on canvas
AL709

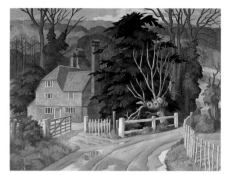

Mackley, George 1900–1983
title unknown
oil on canvas 51 × 66
AL16

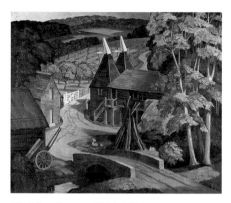

Mackley, George 1900–1983
Kentish Oast
oil on canvas 50 × 60
AL711

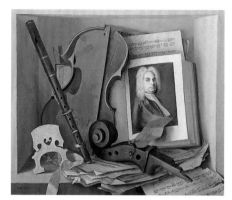

Norden, Gerald
Pieces of Music
acrylic 42 × 46
EF1441N

Osborne, K.
La voyageuse
oil on canvas 72 × 60
AL584

Parsons, Christine
Elephant Just Walked Through
oil on canvas 25 × 25
EF1125P

Parsons, Christine
White Cyclamen with Fruit and Bottle
oil on canvas 31 × 31
EF1126P

Peisley, T.
Abstract Woman
oil on canvas 152 × 121
AL713

Peisley, T.
Odious Norma
oil on canvas 58.5 × 157.5
AL736

Robinson, Beverley
Cottages
oil on canvas 41.5 × 55.5
AL2015

Robinson, Beverley
Orchard
oil on canvas 40.5 × 51.0
AL2016

Titchell, Tim
Interior
oil 80 × 54
EF1430T

Titchell, Tim
End of the Bed
acrylic 67.5 × 80.0
EF1476T

unknown artist 20th C
Still Life
oil on canvas 76 × 76
AL3

unknown artist
Coastal Landscape in Kent
oil on canvas 91.5 × 122.0
AL73

unknown artist
Tonbridge Castle
oil 20.5 × 31.0
AL166

unknown artist
The Pantiles, Tunbridge Wells
oil 42 × 31
AL182

Watt, Thomas 1920–1989
Mario's Blue Boat at Margate
oil on hardboard 18 × 26
AL462

Weight, Carel Victor Morlais 1908–1997
Battersea Park Tragedy
oil on canvas 198 × 260
EF1438W

Weight, Carel Victor Morlais 1908–1997
Old Lovers
acrylic 74 × 74
EF1443W

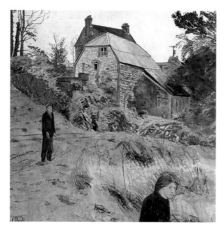

Weight, Carel Victor Morlais 1908–1997
Young Lovers
acrylic 72 × 72
EF1444W

Kent Fire and Rescue Service Museum

In February 2001, the Kent Fire and Rescue Service Museum acquired a portrait, painted in 1922, of John Cruttenden, a fireman in the Hastings Fire Brigade.

The painting had been passed to the curator for inclusion in the museum by Mr Bryan Cruttenden, the subject's grandson. It was, apparently, painted by an admirer. John Cruttenden's wife was not altogether happy about this and consequently never allowed it to be hung in their house. It was therefore consigned to the attic, and until now, has never been framed.

John Meakins, Museum Curator

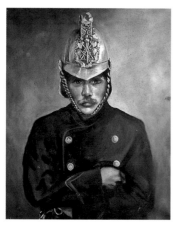

unknown artist
Fireman John Cruttenden of Hastings Fire Brigade (1875–1963) 1922
oil on canvas 80 × 65
1131/01

Kent Police

Palmer, **Alfred** 1877–1951
Constable R. J. Stone, Canterbury City Police
1911
oil on canvas 188.0 × 83.8
PCF_KT_CPS_001_016

Maidstone County Hall

The Knatchbull Collection

This historic collection of oil paintings, dating from the early 16th century to the mid-20th century, depicts various members of the Knatchbull family, who have resided at Mersham-Le-Hatch in Kent since 1486. The collection includes work by the renowned artists Angelica Kauffmann and Godfrey Kneller amongst others.

Originally housed at the family home in Mersham-Le-Hatch, in 1946 the collection was loaned to Kent County Council by Lord Brabourne and Countess Mountbatten of Burma, for display with the existing Kent County Council collection in the many grand halls and offices within the headquarters of the county council in Maidstone. The collection remains the property of the Brabourne Family.

The paintings are seen as a collection of national importance, not only because of the significance of the artists, but because they portray one family's social history over the past 500 years. They include information about the public and private lives of many of the men and women within the family who have had influence on local and national events over the years. The joint collection comprises some 85 paintings by more than 20 different artists.

Although painted by many different artists over a period of more than 500 years, these paintings have some common characteristics in technique and style, as well as in the composition and posing of the subjects. The collection shows how the family became connected, mainly by marriage, to other notable Kentish families, including the Astleys, Derings, Knights, Wyndhams and Harrises.

The collection has been produced by some of the key portrait painters of their time, and along with their subjects, they read as a *Who's Who* of high society in Kent over the past 500 years. Sir Norton Knatchbull Knight (1569–1636), was the eldest son of Richard Knatchbull and his second wife Susan Green. He was a noted scholar and antiquarian and founded the Free Grammar School in Ashford. He was knighted in 1604 and became Sheriff of Kent in 1608 and MP for Hythe in the following year.

Herbert Michael Rudolph Knatchbull, son of Sir Cecil Knatchbull and

Helene von Flesch-Brunningen, became the 14th Baronet and 5th Baron in 1933 on the death of his father. Well-known in his own right as a Member of Parliament for Ashford between 1931 and 1933, he gained the respect of the local people. He went on to become Governor of Bombay from 1933 to 1937, and Governor of Bengal in 1937, before his death in 1939. This portrait of him in his Star of India robes, painted by Sir Oswald Birley, is currently in the Knatchbull Collection. There is also a copy of it at Government House in Calcutta.

The painter Sir Oswald Birley (1880–1952) studied at Cambridge and later in Florence and Paris. He became the Vice-President of the Royal Portrait Society and was knighted in 1949. He was best known for his paintings of members of the royal family, including King George V and Queen Mary.

Paintings from the Knatchbull Collection are identified by a (P)

The Kent County Council Collection

Over the years, Kent County Council has amassed a collection of about 20 paintings by a variety of well-known and lesser-known artists. The images range in subject matter, but the majority are of previous chairmen and leaders of the council. There are works of high quality, notably the piece by Frank Dicksee depicting Joan Marion Neville, which adorns a wall in Sessions Hall. She was the wife of John Charles Pratt 4th Marquis Camden, Lord Lieutenant of Kent 1905–1943. Frank Dicksee (1853–1928) exhibited extensively throughout his life at the Royal Academy in London. He was best known for his genre paintings and portraiture, which included elegant society names such as the Duchess of Westminster and the Duchess of Buckingham. He was knighted in 1925.

Victoria Danville, Visual Arts Coordinator

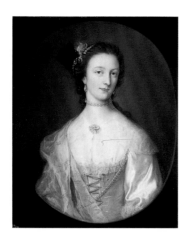

Bardwell, Thomas 1704–1767
Judith Long, Mrs Knatchbull, (d.1772)
oil on canvas 75 × 62
(P)

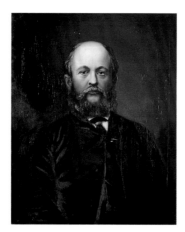

Bassano, Alessandro
Sir Hugessen Edward Knatchbull, 11th Bt,
(1838–1871)
oil on canvas 75 × 62
(P)

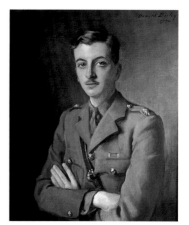

Birley, Oswald Hornby Joseph 1880–1952
Norton Knatchbull, 6th Lord Brabourne,
(1922–1943)
oil on canvas 74 × 61
(P)

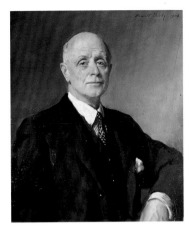

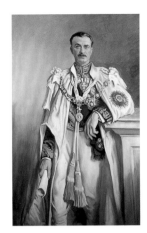

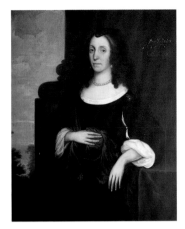

Birley, Oswald Hornby Joseph 1880–1952
Sir Edward Hardy
oil on canvas 104 × 86
PCF_KT_MCC_08_009

Birley, Oswald Hornby Joseph (and studio)
1880–1952
Herbert Michael Rudolf Knatchbull, 5th Baron Brabourne, (1895–1939)
oil on canvas 157 × 102
(P)

Bower, Edward (attributed to) d.1666/1667
Dorothy Westrow, Lady Knatchbull
oil on canvas 127 × 102
(P)

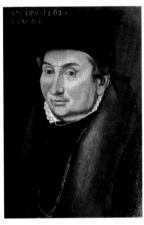

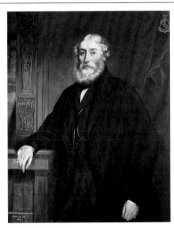

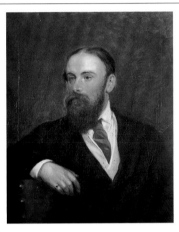

British (English) School
Gentleman of the Knatchbull Family 1562
oil on panel 47 × 32
(P)

Buckner, Richard active 1820–1877
Sir Norton Knatchbull, 10th Bt, (1808–1868)
oil on canvas 126 × 100
(P)

Buckner, Richard active 1820–1877
Sir Wyndham Knatchbull, 12th Bt,
(1844–1917)
oil on canvas 75 × 62
(P)

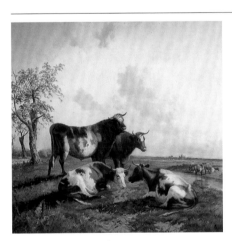

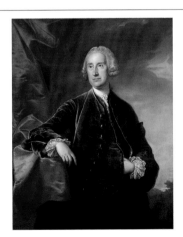

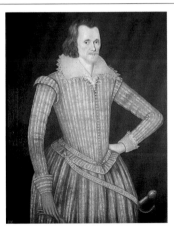

Cooper, Thomas Sidney 1803–1902
Cattle on the Banks of the River Stour
oil on canvas 135 × 135
PCF_KT_MCC_04_002

Cotes, Francis 1726–1770
Sir Edward Knatchbull, 7th Bt, (1704–1789)
oil on canvas 126 × 100
(P)

Critz, John de the elder (circle of)
1551/1552–1642
Richard Knatchbull, (1554–1590)
oil on canvas 105 × 83
(P)

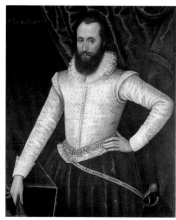

Critz, John de the elder (circle of)
1551/1552–1642
Sir Norton Knatchbull, (1569–1636)
oil on canvas 106 × 91
(P)

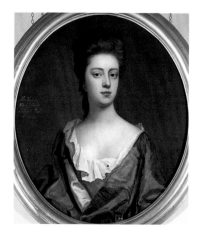

Dahl, Michael I 1656/1659–1743
Alice Wyndham, (1676–1723)
oil 84 × 76
(P)

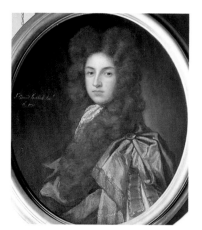

Dahl, Michael I 1656/1659–1743
Edward Knatchbull
oil 84 × 76
(P)

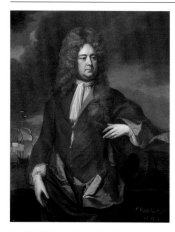

Dahl, Michael I 1656/1659–1743
*The Rt Hon. Sir George Rooke, (1650–1709),
Vice-Admiral of England*
oil on canvas 126 × 100
(P)

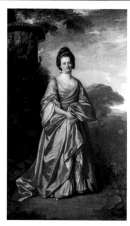

Dance-Holland, Nathaniel 1735–1811
Grace Legge, Lady Knatchbull, (d.1788)
oil on canvas 236 × 146
(P)

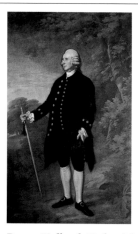

Dance-Holland, Nathaniel 1735–1811
Sir Edward Knatchbull, 7th Bt, (1704–1789)
oil on canvas 239 × 146
(P)

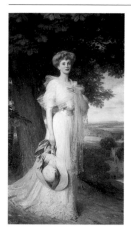

Dicksee, Frank 1853–1928
Joan Marion Neville c.1908
oil on canvas 300 × 183
KT_MCC_04_024a

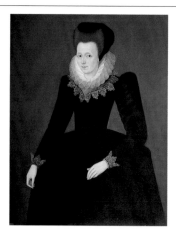

Geeraerts, Marcus the younger (circle of)
1561–1635
Susan Greene, Mrs Richard Knatchbull
oil on canvas 105 × 83
(P)

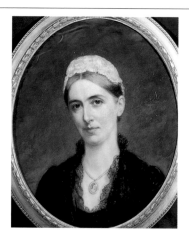

Graves, Henry Richard (circle of) 1818–1882
*Anna Maria Elizabeth Southwell, Lady
Brabourne, (d.1889)*
oil on canvas 157 × 53
(P)

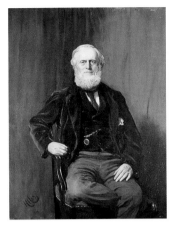

Herkomer, Hubert von 1849–1914
Rt Hon. Edward Hugessen-Knatchbull, 1st
Baron Brabourne, (1829–1893)
oil on canvas 141 × 110
(P)

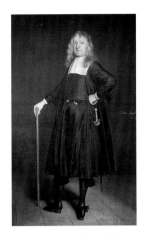

Hoogstraten, Samuel van 1627–1678
Sir Norton Knatchbull, 1st Bt, (1601–1684)
oil on canvas 203 × 127
(P)

Hoogstraten, Samuel van 1627–1678
Thomas Knatchbull
oil on canvas 127 × 104
(P)

Janssens van Ceulen, Cornelis 1593–1661
Mary Aldersey, Lady Knatchbull, (d.1674)
oil on canvas 77 × 62
(P)

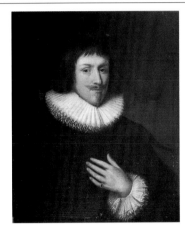

Janssens van Ceulen, Cornelis 1593–1661
Sir Norton Knatchbull, 1st Bt, (1601–1684)
oil on canvas 74 × 61
(P)

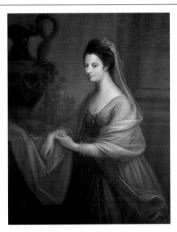

Kauffmann, Angelica 1741–1807
Sarah Sophia Banks (1744–1818)
oil on canvas 126 × 100
(P)

Kennedy, Charles Napier 1852–1898
Ivo Francis Walter
oil on canvas 94 × 83
PCF_KT_MCC_05_023

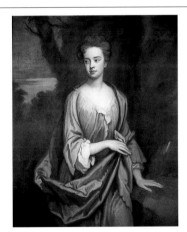

Kneller, Godfrey 1646–1723
Catherine Harris, Lady Knatchbull Wyndham,
(d.1741)
oil on canvas 124 × 100
(P)

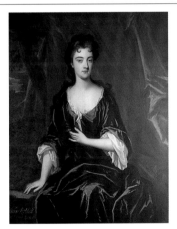

Kneller, Godfrey 1646–1723
Catherine Knatchbull, Lady Rooke
oil on canvas 126 × 101
(P)

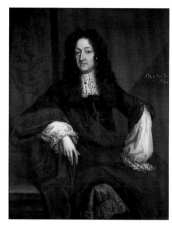

Kneller, Godfrey 1646–1723
Edward Dering, 2nd Bt, (1625–1685)
oil on canvas 127 × 102
(P)

Noakes, Michael b.1933
Mrs Patricia Nesham 1986–1987
oil on canvas 104 × 88
PCF_KT_MCC_08_004

Partridge, John 1790–1872
Mary Watts Russell, Lady Knatchbull
oil on canvas 89 × 69
(P)

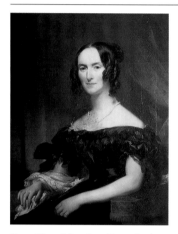

Partridge, John (attributed to) 1790–1872
*Fanny Cathering Knight, Lady Knatchbull,
(b.1793)*
oil on canvas 89 × 69
(P)

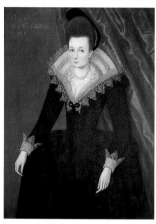

Peake, Robert I (circle of) c.1551–1619
Eleanor Astley (1575–1638)
oil on canvas 106 × 81
(P)

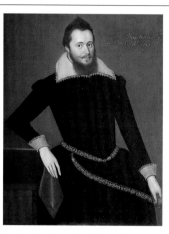

Peake, Robert I (circle of) c.1551–1619
Thomas Knatchbull
oil on canvas 105 × 82
(P)

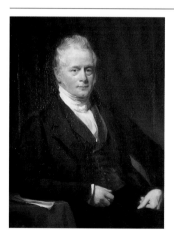

Phillips, Thomas 1770–1845
Sir Edward Knatchbull, 9th Bt, (1781–1849)
oil on canvas 89 × 69
(P)

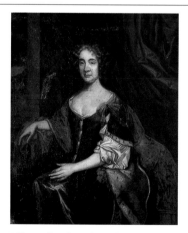

Riley, John (attributed to) 1646–1691
*Dorothea Honywood, Lady Knatchbull,
(d.1694)*
oil on canvas 127 × 102
(P)

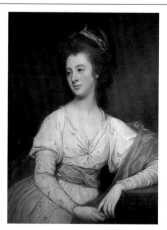

Romney, George 1734–1802
Mary Hugessen, Lady Knatchbull, (d.1784)
oil on canvas 90 × 70
(P)

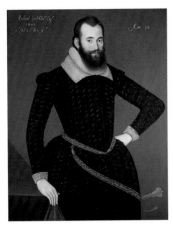

Somer, Paulus van I 1576–1621
Sir Norton Knatchbull (1569–1636)
oil 130 × 108
(P)

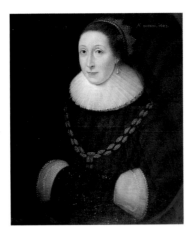

Somer, Paulus van I (circle of) 1576–1621
Susan Knatchbull, (b.1579)
oil on canvas 70 × 58
(P)

unknown artist 19th C
Unknown Lady
oil on canvas 151 × 123
PCF__MCC_05_031

unknown artist
Alderman E. W. Hussey c.1923
oil on canvas 108 × 89
PCF__MCC_03_032

unknown artist
Bridgit Astley (1570–1625)
oil 127 × 102
(P)

unknown artist
Charles, 3rd Earl of Romney 1870
oil on canvas 250 × 177
PCF__MCC_01_017

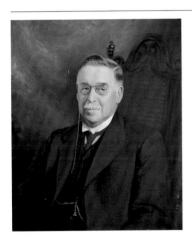

unknown artist
Frederick Walter Payne c.1935
oil on canvas 96 × 90
PCF__MCC_03_027

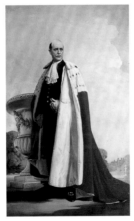

unknown artist
George, 4th Baron Harris 1889–1890
oil on canvas 440 × 170 (E)
PCF__MCC_02_018

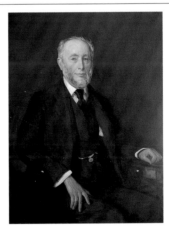

unknown artist
George Marsham 1911
oil on canvas 190 × 140
PCF__MCC_03_017

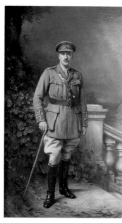

unknown artist
John Charles Pratt 1916
oil on canvas 300 × 177
PCF__MCC_06_004

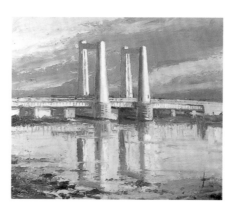

unknown artist
Kings Ferry Bridge c.1960
oil on canvas 75 × 65

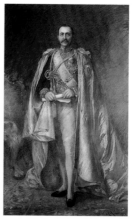

unknown artist
Lionel Edward, 3rd Baron Sackville 1930
oil on canvas 440 × 175 (E)
PCF__MCC_02_029

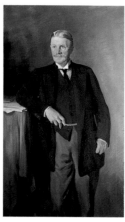

unknown artist
Lord Cornwallis (1864–1935)
oil on canvas 180 × 122 (E)
PCF__MCC_02_025

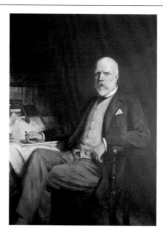

unknown artist
Rt Hon. J. G. Talbot 1910
oil on canvas 135 × 110
PCF__MCC_03_009

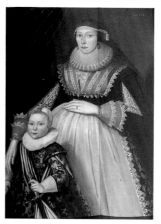

unknown artist
Sarah Isles and Her Eighth Son 1626
oil on canvas 127 × 99
PCF__MCC_10_19

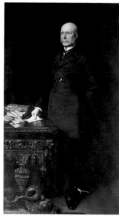

unknown artist
Sir John Farnaby Lennard 1889–1890
oil on canvas 297 × 208
PCF__MCC_03_021

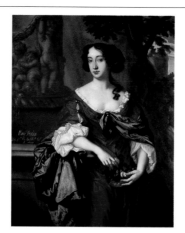

Wissing, Willem c.1656–1687
Mary Dering, Lady Knatchbull, (d.1724)
oil on canvas 126 × 100
(P)

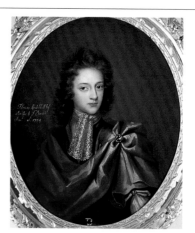

Wissing, Willem c.1656–1687
Thomas Knatchbull, (d.1702)
oil on canvas 74 × 61
(P)

Facing page: Dyck, Anthony van, *Sir Basil Dixwell* (detail), Canterbury City Council Museums and Galleries (p. 12)

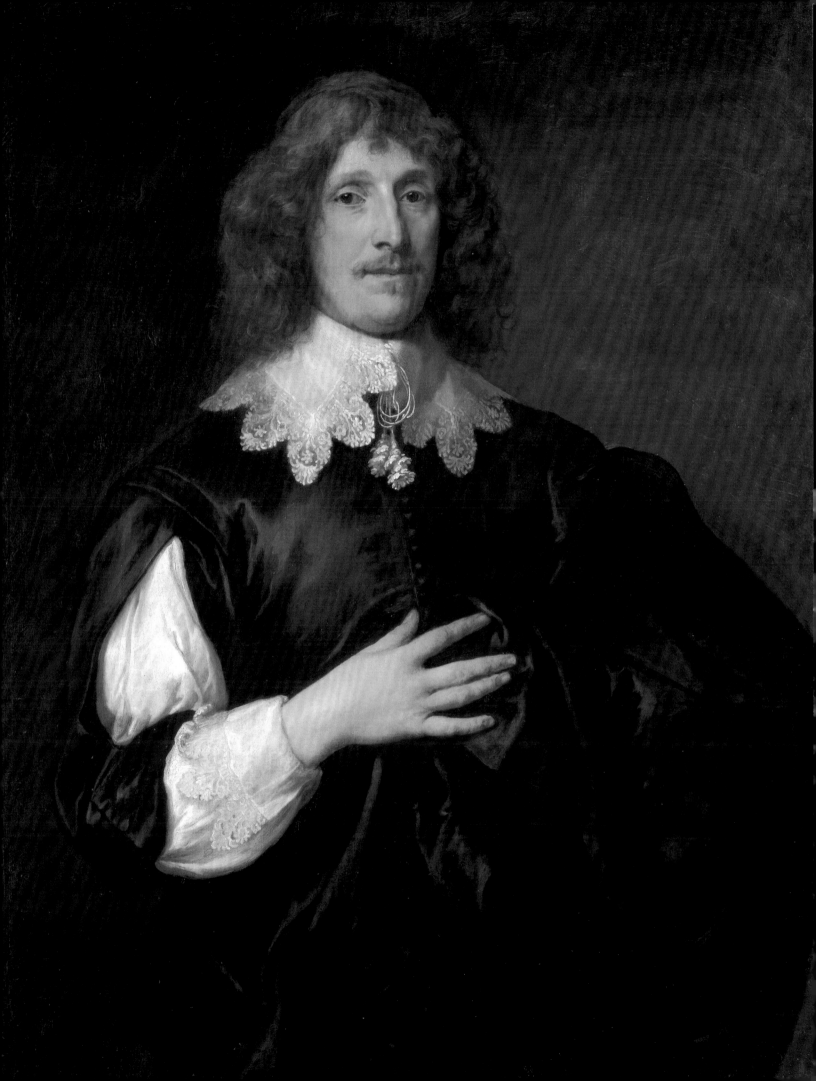

Wissing, Willem c.1656–1687
Sir Thomas Knatchbull, 3rd Bt, (d.1711)
oil on canvas 124 × 100
(P)

Wright, John Michael 1617–1694
Mary Knatchbull, (1610–1696)
oil on canvas 130 × 108
(P)

Wright, John Michael 1617–1694
Sir John Knatchbull, 2nd Bt, (1637–1698)
oil on canvas 127 × 102
(P)

Maidstone Museum & Bentlif Art Gallery

Maidstone Museum owes its existence to an eccentric bachelor, Thomas Charles (1777–1855), a kindly surgeon-turned-antiquary who owned the picturesque but run-down Chillington Manor (c.1651), in the town centre. Charles's bequest of his house and considerable art and archaeological collections to Maidstone coincided with the formation of the Public Libraries Act in 1855, an act which enabled the creation of civic museums from the rates. The first curator was his old friend Edward Pretty (1792–1865) a drawing master and antiquary then teaching in Northampton, who was born in Hollingbourne, Kent. The Charles Bequest included a number of foreign 'old masters', including the 17th century portrait *Elizabeth, Queen of Bohemia*, after Miereveld. Pretty added his own paintings, including *The Mocking of Christ*, attributed to Frans Francken II (1581–1642).

W. J. Lightfoot, the second curator, came from the British Museum. He acquired one of Maidstone's most important collections of art and ethnography from his close friend Julius Lucius Brenchley (1816–1873). This included two of the museum's key foreign paintings – a pair of *capricci* in the style of Giovanni Paolo Panini (c.1692–1765) of the Colosseum and the Basilica of Constantine. The Brenchley Trust, still active today in care and conservation of this wide-ranging collection, also acquired some good 'contemporary' Victorian oils including two 'Sinbads' by Albert Goodwin (1845–1932), the much sought-after lyrical landscapist who was born in Maidstone.

Maidstone Museum's heyday was from 1890 to 1900. In 1889, Samuel Bentlif (1819–1897), a high street footwear wholesaler and retailer, offered to build a two-storey art gallery wing onto Chillington House, a late-Victorian building next to Chillington Manor, in memory of his art collector brother George Amatt Bentlif (1806–1887). The Bentlif Art Gallery wing was opened in 1890 and comprised a library and three separate galleries for exhibitions, watercolours and oils in the late 19th century Renaissance taste. George's collection of over 200 paintings was bequeathed to the museum in 1897 and the Bentlif Trust was set up to care for and develop the collection under the

museum's curator, J. H. Allchin (d.1923), a botanical illustrator from Kew Gardens.

The Bentlif Collection contained significant foreign paintings such as two port scenes by Abraham Storck (1644–1708) and two landscapes by Jan Frans van Bloemen (1662–1749). It also included works by leading Victorian or local artists such as Albert Goodwin (1845–1932), Arthur Hughes (1832–1915), Thomas Sidney Cooper (1803–1902), Henry Bright (1814–1873) and Henry Mark Anthony (1817–1886). The Bentlif Trust today maintains an ongoing conservation and temporary exhibition programme in its galleries, and continues to acquire appropriate Victorian and contemporary local art under the curatorship of the Museum's Keeper of Fine and Applied Art.

During the 20th century, Maidstone Museum & Bentlif Art Gallery continued to acquire several oil paintings or mixed collections every year via gifts, bequests and purchases. In 1908 Sir George Donaldson gave James Dromgole Linton's *The Casket Scene from the Merchant of Venice*, and in 1909, W. C. Hazlitt, grandson of the famous Maidstone-born essayist William Hazlitt, donated 18 oils, many by William himself. In 1932 the Art Fund assisted with a River Medway scene by J. P. André (active 1823–1859), and 1944 saw the G. S. Elgood Bequest in the museum, which included an Italian 14th century *Madonna of Humility*. A year later, Sir Garrard Tyrwhitt-Drake, an entrepreneur and Maidstone's mayor, gave a large English Post-Impressionist wartime hop-picking scene by the London artist Cecilia Carpmael (currently on loan to the Museum of Kent Life).

During the 1950s and 1960s, the collections continued to expand, with mainly local works, often via the Contemporary Art Society to which the museum subscribed at the time. Small but intriguing works by artists such as Mervyn Peake (1911–1968), George Lambourn (1900–1977), Anna Katrina Zinkeisen (1901–1976), Elinor Bellingham-Smith (1906–1988) and Rodrigo Moynihan (1910–1991) helped to broaden the museum's 20th century collections, maintaining the 'accessible to the man in the street' feel that the Victorian philanthropists had always instinctively followed.

In the 1970s, Maidstone Museum & Bentlif Art Gallery gained the first of its professionally qualified, specialist keepers of fine art. Working mainly with the Bentlif Trust, using Maidstone Borough Council and outside grant-aid, a rolling programme of oil painting conservation was prioritised to bring the Victorian collections up to the standard where they could be displayed, used in temporary exhibitions or loaned to other galleries in Britain and abroad. Oil painting purchases now needed to be very relevant to the museum's excellent and high quality collections and to fit into professionally defined and appraised collecting policies. Paintings really worth pursuing often became out of price range on the expanding art market, and donations diminished as people became educated to the value of their family art collections. Over the last 30 years or so the museum has acquired just a few special oils, including *Auberge Belles Choses, St Cirq-Lapopie*, by Bernard Dunstan (b. 1920; painted in November 1985), *Hythe Beach (with Winding Gear)* by Frederick Cuming (b. 1930), and *At the Seaside: Pegwell Bay, Near Ramsgate, 1862* by Arthur Boyd Houghton (1836–1875).

Veronica Tonge, Keeper of Fine and Applied Art

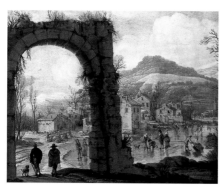

A. B. C. 17th C
Winter Scene with an Arch
oil on copper 19 × 24
00.1873.22

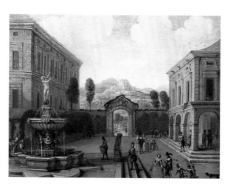

A. B. C. 17th C
Summer Townscape with a Fountain
oil on copper 19 × 24
00.1873.23

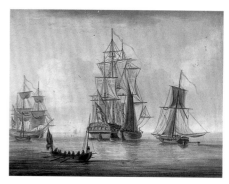

Anderson, William 1757–1837
Seascape with Shipping
oil on canvas 18 × 25
B75/26

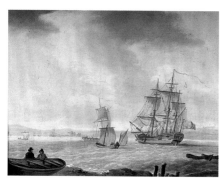

Anderson, William 1757–1837
Seascape with Shipping
oil on canvas 18 × 25
B75/47

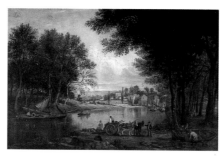

André, James Paul the younger active
1823–1859
View of Maidstone from Bearsted Ferry, 1829
1829
oil on canvas 53 × 75
20.1932

Anguissola, Sofonisba c.1532–1625
*The Granddaughter of the Duke and Duchess of
Parma* c.1580
oil on canvas 116 × 75
1.1959.100

Anthony, Henry Mark 1817–1886
A Funeral Procession Near Lake Killarney
oil on canvas 28 × 45
Bentlif 1

Anthony, Henry Mark 1817–1886
A Mill on the Hague
oil on canvas 59 × 75
Bentlif 2

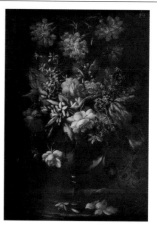

Arellano, Juan de (attributed to) 1614–1676
*Carnations, Roses and Other Flowers in a Thin-
stemmed Vase*
oil on canvas 58 × 46
Bentlif 40.1897.90

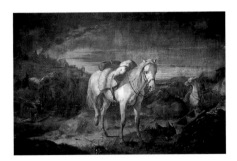

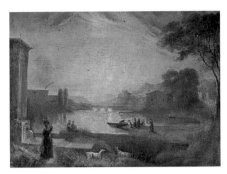

Banner, Delmar Harmond 1896–1983
Scafell from Hardiknott Fell 1946
oil on canvas 45 × 56
6.1947

Barker, Thomas Jones 1815–1882
Riderless War Horses After the Battle of Sedan
1873
oil on canvas 90 × 136
PCF_KT_MM_35_006

Barrett, George (attributed to) 1728–1784
River Scene with Buildings and Bridge
oil on panel 23 × 30
10.1944

Beadle, James Prinsep 1863–1947
The Battle of Neuve Chapelle, 1915
oil on canvas 112 × 175
PCF_KT_MM_02_015

Beale, Mary 1633–1699
Two Figures - Vertumnus and Pomona
oil on panel 46 × 35
28.39

Bellingham-Smith, Elinor 1906–1988
Burning Stubble
oil on panel 8 × 12 (each panel)
37.1974

Bensted, Joseph
Fowling in the Marshes
oil on canvas 29 × 56
PCF_KT_MM_01_006

Berry, John
Arthur H. Clark, Mayor of Maidstone 1968
oil on canvas 91 × 51
PCF_KT_MM_2/02_015

Birch, Samuel John Lamorna 1869–1955
The Stream in My Garden
oil on canvas 60 × 50
93.1959

Blinks, Thomas 1860–1912
Startled
oil on canvas 33 × 43
13.1940 ※

Bloemen, Jan Frans van (attributed to)
1662–1749
Landscape with a Fountain
oil on canvas 76 × 57
Bentlif 03.1897.14

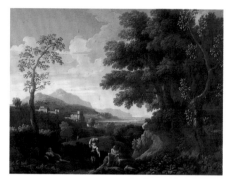

Bloemen, Jan Frans van (attributed to)
1662–1749
Classical Landscape with Figures
oil on canvas 74 × 99
Bentlif 04.1897.15 ※

Boddington, Henry John 1811–1865
Lake Scene with Men Fishing
oil on canvas 20 × 40
Bentlif 5

Bogdany, Jakob c.1660–1724
Still Life (Flowers and Fruit) c.1720
oil on canvas 88 × 137
Bentlif 7.1897.95

Bolitho, A.
Stretcher Bearers, Passchendaele, 1917
oil on canvas 61 × 46
MNERM 1966.425a

Bolitho, A.
Lone Casualty, Polygon Wood
oil on canvas 61 × 46
MNERM 1966.425b

Bolitho, A.
Ration Party, Gommecourt
oil on canvas 61 × 46
MNERM 1966.425c

Bouvier, Augustus Jules c.1825–1881
Italian Gossip at a Fountain 1881
oil on canvas 43 × 53
PCF_KT_MM_07_000

Breydel, Karel 1678–1733
Battle Scene: Cavalry Skirmish
oil on copper 10 × 14
17.1970.54.A

Breydel, Karel 1678–1733
Battle Scene: Cavalry Skirmish
oil on copper 10 × 14
17.1970.54.B

Breydel, Karel 1678–1733
Battle Scene: Cavalry Skirmish
oil on copper 10 × 14
17.1970.54.C

Breydel, Karel 1678–1733
Battle Scene: Cavalry Skirmish Aftermath
oil on copper 10 × 14
17.1970.54.D

Bright, Henry 1814–1873
Tintern Abbey 1867
oil on canvas 60 × 75
Bentlif 8

British (Norwich) School
Landscape with Cottage and Figures
oil on canvas 60 × 83
Bentlif 63

British (Norwich) School
Landscape with Church
oil on canvas 22 × 43
PCF_KT_MM_32_010

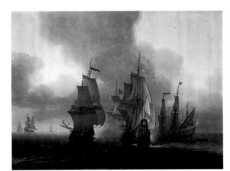

Brooking, Charles 1723–1759
Sea Fight
oil on canvas 53 × 71
PCF_KT_MM_20_020

Brothers, Alfred active 1882–1893
View of Maidstone from the South
oil on paper 36 × 54
1.1925

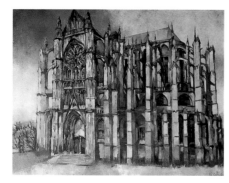

Broun, Phillip
Beauvais Cathedral 1962
oil on canvas 40 × 50
PCF_KT_MM_2/01_020

Brueghel, Jan the elder 1568–1625
Rest on the Flight into Egypt
oil on copper 22 × 38
Bentlif 09.1897.65 ✦

Brueghel, Jan the elder 1568–1625 &
Rottenhamer, Hans I 1564–1625
Rest on the Flight into Egypt
oil on panel 44 × 58
00.1855.66

Bryan, Edward 1804–1860
Mrs William Hazlitt, née Catherine Reynell
oil on canvas 78 × 63
PCF_KT_MM_05_022

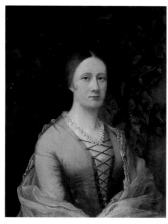

Bryan, Edward 1804–1860
Catherine Reynell 1858–1859
oil on canvas 94 × 72
PCF_KT_MM_05_033

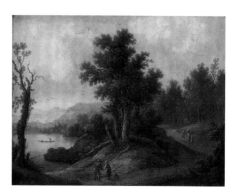

Burgess, C. W. B. (**attributed to**)
Mountain Scene
oil on canvas 37 × 49
Bentlif 77

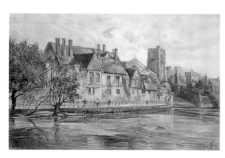

Burton, Frederic William 1816–1900
River Scene at Maidstone
oil on board 34 × 47
15.1962

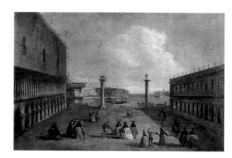

Canaletto (style of) 1697–1768
View of the Piazetta, Venice
oil on canvas 46 × 71
00.1873.37

Carpmael, Cecilia
Sir Garrard Tyrwhitt-Drake, Mayor of Maidstone c.1941
oil on canvas 148 × 109
PCF_KT_MM_2/01_030

Chalon, Alfred Edward 1780–1860
Woman Holding a Pendant
oil on canvas 35 × 25
B75/43

Charlton, John 1849–1917
The Challenge 1909
oil on canvas 119 × 209
PCF_KT_MM_02_008

Chatelain active 18th C
The Virgin and Infant Saviour (after Bartolomé Esteban Murillo)
oil on canvas 160 × 109
00.1881.109

Chatelain, Antoine (attributed to)
1794–1859
Portrait of a Young Woman Holding a Rose (Titian's Daughter?)
oil on canvas 102 × 88
00.1881.110

Chatelain, Antoine (attributed to)
1794–1859
Portrait of a Woman (after Titian)
oil on canvas 101 × 89
PCF_KT_MM_30_006

Chinnery, George (after) 1748–1847
Hunting Piece: Horsemen Attended by Four Hounds
oil on canvas 54 × 77
PCF_KT_MM_25_010

Chitty, Cyril
Benjamin Harrison
oil on canvas 78 × 65
PCF_KT_MM_35_027

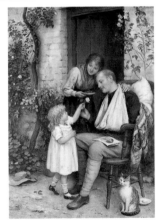

Clark, Joseph 1834–1926
Home from the War, 1901 1901
oil on canvas 67 × 49
Bentlif 10 🐝

Clarke, J. H.
Stephen Monckton (1824–1885) 1887
oil on canvas 136 × 112
PCF_KT_MM_08_032

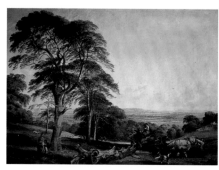

Cobbett, Edward John 1815–1899
*A Woodland Scene with a Wagon Drawn by
Two Horses* 1846
oil on canvas 84 × 114
6.1937

Codazzi, Viviano (style of) c.1604–1670
Classical Ruins with Peasants and Cattle
oil on panel 37 × 40
00.1855.1

Codazzi, Viviano (style of) c.1604–1670
Roman Capriccio
oil on canvas 110 × 137
Bentlif 44.1897.2

Codazzi, Viviano (style of) c.1604–1670
The Pantheon, Rome
oil on canvas 55 × 72
Bentlif 59.1897.3

Collier, John (attributed to) 1850–1934
The Connoisseur, Reginald Barrett, RWS
oil on canvas 100 × 125
7.195

Collin, Charles
View in the Farnese Palace Gardens
oil on canvas 80 × 68
PCF_KT_MM_27_036

Collins, James Edgell 1820–after 1875
Charles Ellis, 1865
oil on canvas 126 × 99
PCF_KT_MM_01_011

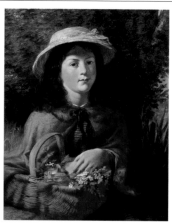

Collinson, Robert 1832–after 1890
Young Girl with a Basket of Flowers 1860
oil on canvas 75 × 60
PCF_KT_MM_99_001

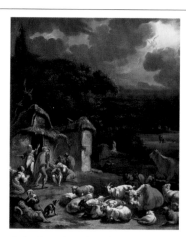

Colonia, Adam (attributed to) 1634–1685
The Annunciation to the Shepherds
oil on canvas 74 × 62
00.1873.79

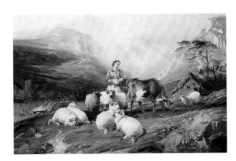

Cooper, Thomas George 1836–1901
Cows and Sheep on a Mountain Pasture 1868
oil on canvas 61 × 98
Bentlif 12

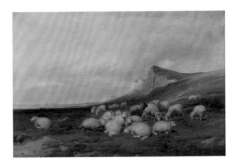

Cooper, Thomas Sidney 1803–1902
Sheep on the Kentish Coast, 1865 1865
oil on canvas 65 × 100
Bentlif 11

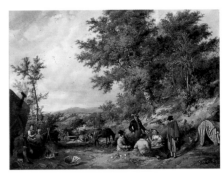

Cooper, Thomas Sidney 1803–1902
Country Lane with Gypsies
oil on canvas 65 × 85
PCF_KT_MM_23_030

Cooper, Thomas Sidney 1803–1902
Sheep Stampeding in a Storm 1890
oil on canvas 120 × 240
PCF_KT_MM_31_020

Cooper, William Sidney 1854–1927
Whitchurch Hill, Oxfordshire 1884
oil on canvas 41 × 76
Bentlif 13

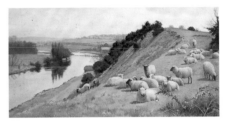

Cooper, William Sidney 1854–1927
A Riverside Pasture with Sheep
oil on canvas 40 × 75
Bentlif 15

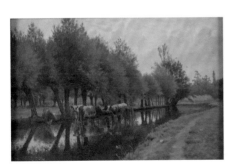

Cooper, William Sidney 1854–1927
In the Shade
oil on canvas 30 × 45
Bentlif 16

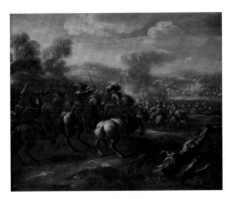

Courtois, Jacques (style of) 1621–1676
Battle Piece
oil on canvas 60 × 74
Bentlif 45.1897.57

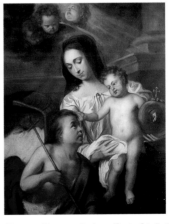

Crayer, Gaspar de (attributed to) 1584–1669
The Virgin and Child with St John
oil on canvas 144 × 134
00.1873.74

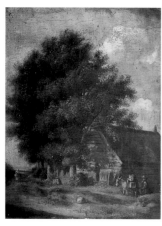

Crome
Group of Trees and Old Buildings with Donkey
oil on canvas 53 × 41
PCF_KT_MM_11_015

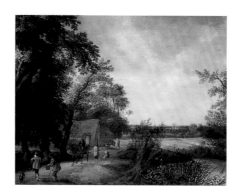

Croos, Jan Jacobsz. van der
1654/1655–c.1716
Landscape with Peasants on a Road
oil on panel 49 × 63
00.40

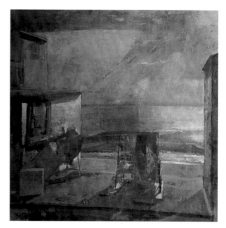

Cuming, Frederick b.1930
Hythe Beach (with Winding Gear)
oil on board 60 × 60
PCF_KT_MM_14_028

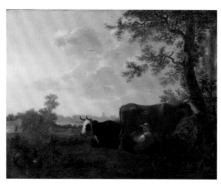

Cuyp, Aelbert (imitator of) 1620–1691
Milking Time
oil on canvas 80 × 104
Bentlif 64.1897.112

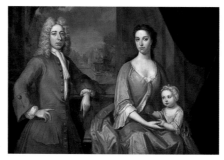

Dahl, Michael I (attributed to)
1656/1659–1743
*Mawdisty Best, Wife Elizabeth and Daughter
Dorothy*
oil on canvas 117 × 180
65.1955

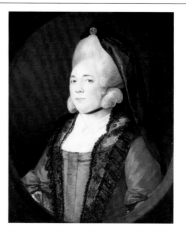

Dance-Holland, Nathaniel (attributed to)
1735–1811
*Mrs Burbridge of Staverton Hall,
Northamptonshire*
oil on canvas 80 × 65
BAL_MAI 46479 🐝

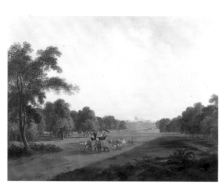

Daniell, Thomas 1749–1840 or **Daniell,
William** 1769–1837
Allington Hunting Party in India
oil on canvas 91 × 120
36.188 🐝

Day, Jane active 1894–1897
*Boy in the Costume of the Ancient Bluecoat
School, Maidstone*
oil on canvas 85 × 70
30.1894

Day, Jane active 1894–1897
*Portrait of a Girl in the Costume of Dr
Woodward's School, Maidstone*
oil on canvas 85 × 70
31.1894 🐝

Day, Jane active 1894–1897
Head and Shoulders of a Girl Wearing the
Bonnet as Worn by Girls of Dr Woodward's
School, Maidstone
oil on canvas 33 × 23
32.1894

Day, Jane active 1894–1897
Reverend Henry Collis MA c.1896
oil on canvas 89 × 74
48.1973

Day, Jane active 1894–1897
The Late Samuel Bentlif JP
oil on canvas 118 × 95
Bentlif 19

Day, Jane
William Laurence JP (1822–1899) 1898
oil on canvas 90 × 70
PCF_KT_MM_16_035

Day, Herbert J. 1864–1915
View Near Buttermere, Cumberland
oil on canvas 45 × 60
23.1923

Dickinson, Lowes Cato 1819–1908
Edmund Law Lushington, 1876 1876
oil on canvas 108 × 85
72.1977

Dobson, William Charles Thomas
1817–1898
Julius Lucius Brenchely Esq. 17 Oct. 1876 1876
oil on canvas 132 × 100
95.1876

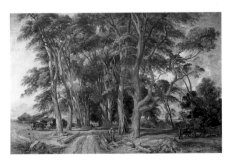

Dodd, Charles Tattershall I 1815–1878
Avenue of Fir Trees at Shoesmith's Farm,
Wadhurst
oil on canvas 67 × 100
9.1944

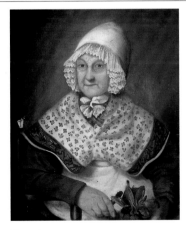

Doord
Mrs Shaw
oil on canvas 74 × 65
PCF_KT_MM_35_017

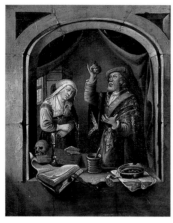

Dou, Gerrit (imitator of) 1613–1675
The Apothecary's Shop
oil on canvas 25 × 21
9.1961.116

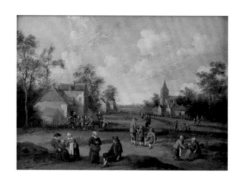

Droochsloot, Joost Cronelisz. 1586–1666
Village Scene c.1660
oil on panel 35 × 50
Bentlif 20.1897.44

Drummond
The Wife and Child of Drummond
oil on canvas 61 × 50
PCF_KT_MM_06_003

Drummond, Julian d.1892
Mrs Dowson c.1865
oil on canvas 203 × 120
PCF_KT_MM_05_028

Drummond, Samuel 1765–1844
*John Blake (1770–1810) Mayor of Maidstone,
1799*
oil on canvas 58 × 47
PCF_KT_MM_2/02_012

Drummond, Samuel 1765–1844
A Boat at Sea (The Rescue)
oil on canvas 113 × 117
PCF_KT_MM_06_014

Drummond, Samuel 1765–1844
Ben Johnson, (1574–1637)
oil on panel 75 × 63
PCF_KT_MM_07_003

Drummond, Samuel 1765–1844
*Rev. James Reeve, Vicar of All Saints,
Maidstone, (1800–1842)*
oil on canvas 55 × 45
PCF_KT_MM_20_032

Drummond, Samuel 1765–1844
John Brenchley of Kingsley House, Maidstone
oil on canvas 78 × 65
PCF_KT_MM_34_024

Ducq, Johan le (style of) 1629–1676/1677
Spanish Merchant Saluting a Lady
oil on canvas 86 × 130
00.1873.119

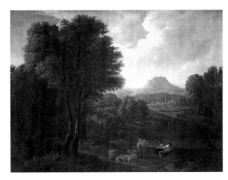

Dughet, Gaspard (style of) 1615–1675
Classical Landscape
oil on canvas 44 × 58
00.1873.16

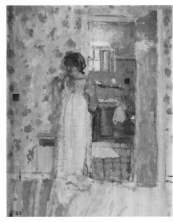

Dunstan, Bernard b.1920
Auberge belles choses, St Cirq-Lapopie 1985
oil on board 31 × 26
Bentlif 234

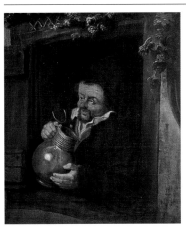

Dutch School 17th C
Peasant with a Jar
oil on canvas 32 × 28
00.1873.49

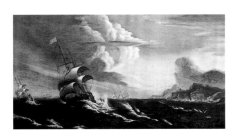

Dutch School 17th C
Storm at Sea
oil on canvas 33 × 60
00.1873.120

Etty, William 1787–1849
Male Nude
oil on paper 52 × 39
B75/53

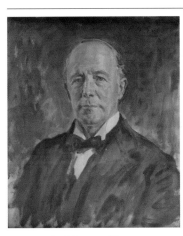

Eves, Reginald Grenville 1876–1941
Lord Runciman
oil on canvas 59 × 49
Bentlif 213

Finn, F. L.
J. H. Allchin, Curator of Maidstone Museum,
(1902–1923)
oil on canvas 54 × 44
5.1934

Foord, Charles
Mrs Swain's House, Union Street, Maidstone
oil on canvas 53 × 33
PCF_KT_MM_07_016

Fosse, Charles de la 1636–1716
Jacques Rousseau
oil on canvas 61 × 53
PCF_KT_MM_22_006

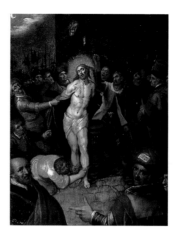

Francken, Frans II (attributed to)
1581–1642
The Mocking of Christ
oil on panel 35 × 28
00.1865.82

Gegan, J. J.
Maidstone from the College Hop Garden 1860
oil on canvas 115 × 190
PCF_KT_MM_02_022

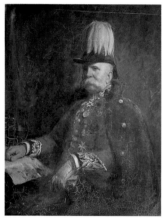

Glazebrook, Hugh de Twenebrokes
1870–1935
Sir John Farley
oil on canvas 115 × 90
3.1940

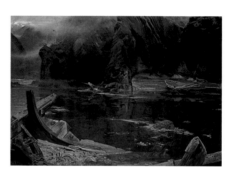

Goodwin, Albert 1845–1932
Sinbad Entering the Cavern 1879
oil on canvas 100 × 150
109.1879.A

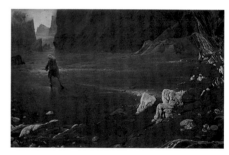

Goodwin, Albert 1845–1932
Sinbad in the Valley of Diamonds 1878
oil on canvas 92 × 138
109.1879.B

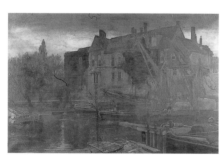

Goodwin, Albert 1845–1932
The Archbishop's Palace, Maidstone
oil on canvas 89 × 135
54.1953

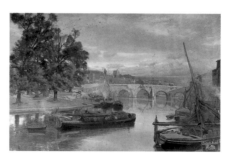

Goodwin, Albert 1845–1932
The Old Bridge at Maidstone Looking North
1878 89 × 140
Bentlif 21.54.1953

Goodwin, Albert 1845–1932
St Michael's Mount, Cornwall
oil on board 47 × 57
44.1957

Goodwin, Albert 1845–1932
The Burning Ghats
oil on panel 24 × 33
9.1962.48

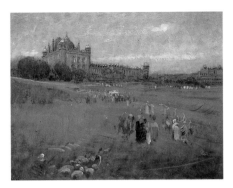

Goodwin, Albert 1845–1932
Agra 1906
oil, pen & ink on canvas 30 × 39
9.1962.49

Goodwin, Albert 1845–1932
Samuel Goodwin, 1868 1868
oil on canvas 54 × 44
9.1962.88

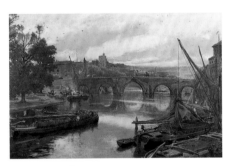

Goodwin, Albert 1845–1932
The Old Bridge at Maidstone Looking South
oil on canvas 97 × 138
BAL_MAI 44987 ✦

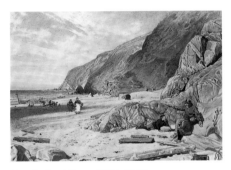

Goodwin, Albert 1845–1932
Lynmouth: The Story of the Shipwreck 1882
oil on canvas 59 × 76
BAL_MAI 46478 ✦

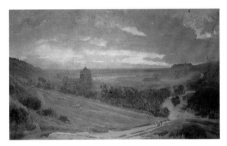

Goodwin, Albert 1845–1932
Hastings: The Old Town 1880
oil on canvas 120 × 200
Bentlif 23

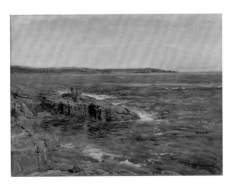

Goodwin, Albert 1845–1932
Blue Water in Mounts Bay, Cornwall 1881
oil on canvas 46 × 61
Bentlif 24

Goodwin, Albert 1845–1932
*View on the Lyn Near Watersmeet, North
Devon* 1881
oil on canvas 42 × 61
Bentlif 25

Goodwin, Albert 1845–1932
The Castle of Enchantments
oil on panel 43 × 60
Bentlif 209

Goodwin, Albert 1845–1932
The Artist's Father, Samuel Goodwin
oil on canvas 55 × 39
Bentlif 210

Goodwin, Albert 1845–1932
Shipwreck
oil on canvas 22 × 31
PCF_KT_MM_03_037

Goodwin, Albert 1845–1932
Allington Castle 1865–1868
oil on canvas 51 × 68
PCF_KT_MM_99_007

Goodwin, Harry 1842–1925
No. 2 Chioggia (Near Venice) 1886
oil on canvas 75 × 121
56.1962

Goodwin, Harry 1842–1925
Archbishop's Palace and All Saints Church, 1885
1885
oil on canvas 22 × 34
Bentlif 27

Goodwin, Harry 1842–1925
The Marketplace, Norwich 1887
oil on canvas 115 × 194
Bentlif 29

Goodwin, Harry 1842–1925
Leaving the Old Home, Norwich 1889
oil on canvas 58 × 94
Bentlif 30

Goodwin, Harry 1842–1925
Venice - Sunset 1888
oil on canvas 17 × 25
Bentlif 31

Goodwin, Harry 1842–1925
Venice - A Rainy Day 1879
oil on canvas 17 × 24
Bentlif 32

Goodwin, Harry 1842–1925
*View on the Thames: Evening, When Swallows
Homeward Fly* 1897
oil on canvas 25 × 50
PCF_KT_MM_03_024

Goodwin Green, Eliza 1851–1932
The Lunar Rainbow, Victoria Falls, Rhodesia
c.1904
oil on canvas 74 × 54
PCF_KT_MM_20_003

Goodwin Green, Eliza 1851–1932
The Main Fall, Victoria Falls, Rhodesia 1904
oil on canvas 71 × 92
PCF_KT_MM_32_034

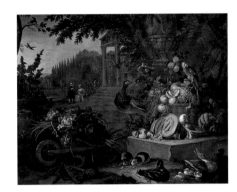

Goyen, Jan van (style of) 1596–1656
Sea Piece: Fishermen
oil on panel 35 × 48
00.1855.28

Grant, Francis 1803–1878
*Alexander Randall, Founder of the Kentish
Bank*
oil on canvas 234 × 146
PCF_KT_MM_29_004

Gryef, Adriaen de 1670–1715
Still Life in Garden
oil on canvas 46 × 57
Bentlif 33.1897.89

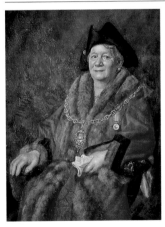

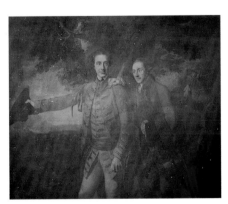

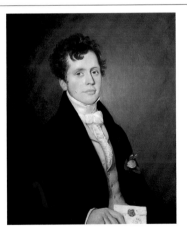

Hailstone, Bernard 1910–1987
*Mrs D. M. Relf (First Lady Mayor of
Maidstone)* 1952/1953
oil on canvas 107 × 89
PCF_KT_MM_2/02_008

Harlow, George Henry 1787–1819
General Ligonier and His Aide-de-Camp
oil on canvas 159 × 188
PCF_KT_MM_29_007

Haslehurst, J. B.
Edward Walker of Canterbury c.1830
oil on canvas 75 × 62
PCF_KT_MM_14_011

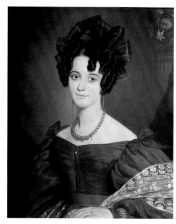

Haslehurst, J. B.
Sarah Walker of Canterbury c.1830
oil on canvas 75 × 62
PCF_KT_MM_14_015

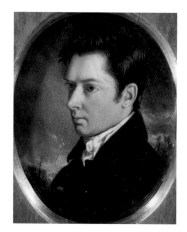

Hazlitt, John 1767–1837
William Hazlitt
oil on canvas 70 × 60
67.1909.24

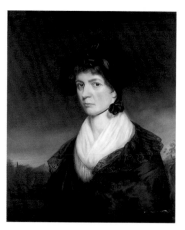

Hazlitt, John 1767–1837
Margaret (Peggy) Hazlitt, Sister of William Hazlitt
oil on canvas 75 × 63
67.1909.27

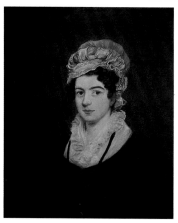

Hazlitt, John 1767–1837
Mary Besley
oil on canvas 73 × 60
64.1954

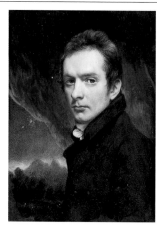

Hazlitt, John 1767–1837
Self Portrait
oil on canvas 65 × 52
BAL_MAI 46489

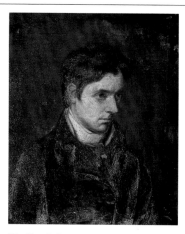

Hazlitt, John 1767–1837
William Hazlitt
oil on canvas 71 × 55
BAL_MAI 46492

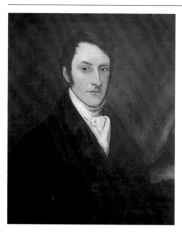

Hazlitt, John (attributed to) 1767–1837
Thomas Besley
oil on canvas 73 × 60
63.1954

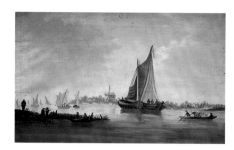

Hazlitt, Margaret 1770–1844
Canal Scene
oil on canvas 40 × 65
67.1909.30

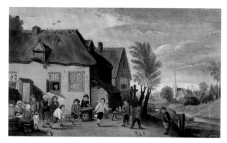

Hazlitt, Margaret 1770–1844
Peasant Scene
oil on canvas 40 × 65
67.1909.31

Facing page: Ward, John Stanton, *The East Kent School* (detail), Canterbury City Council Museums and Galleries (p. 34)

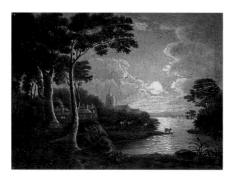

Hazlitt, Margaret 1770–1844
Moonlight Scene
oil on canvas 24 × 30
67.1909.32

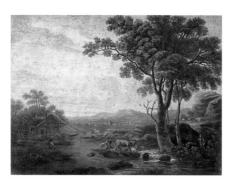

Hazlitt, Margaret 1770–1844
Landscape with Cattle and Stream
oil on canvas 23 × 33
67.1909.33

Hazlitt, Margaret 1770–1844
Cottage in a Wood with Cattle
oil on panel 26 × 30
67.1909.34

Hazlitt, Margaret 1770–1844
Mountain Scene with a Bridge
oil on metal 25 × 30
67.1909.35

Hazlitt, Margaret 1770–1844
Portrait of an Unknown Man
oil on panel 18 × 15
67.1909.35A

Hazlitt, Margaret 1770–1844
Bridge and Waterfall
oil on panel 19 × 15
67.1909.35B

Hazlitt, William 1778–1830
Cardinal Ippolito Medici (copy of Titian)
oil on canvas 145 × 112
07.1909.18

Hazlitt, William 1778–1830
Death of Clorinda (copy of Lodovico Lana)
1802
oil on canvas 106 × 142
67.1909.19

Hazlitt, William 1778–1830
Rev. William Hazlitt c.1802
oil on canvas 75 × 63
67.1909.22

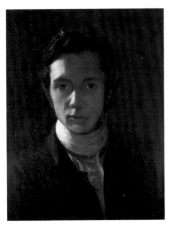

Hazlitt, William 1778–1830
Self Portrait
oil on canvas 70 × 60
BAL_MAI 46509

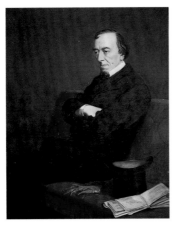

Hodges, Sidney 1829–1900
Benjamin Disraeli MP 1882
oil on canvas 138 × 110
PCF_KT_MM_2/01_016

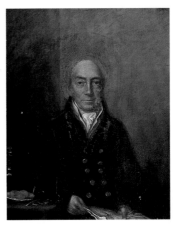

Hopkins, William active 1787–1811
David Hebbes
oil on canvas 29 × 24
PCF_KT_MM_33_004

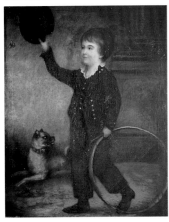

Hopkins, William H. d.1892
Boy with a Hoop and a Dog Chasing a Butterfly
oil on canvas 126 × 100
PCF_KT_MM_22_031

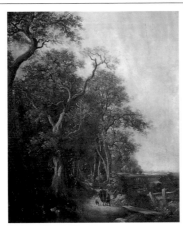

Hopper, M. A. F.
Wood Scene, Man with Boy and Dog
oil on canvas 75 × 61
PCF_KT_MM_08_010

Hoppner, John 1758–1810
The Husband of Mrs Fox
oil on panel 23 × 20
PCF_KT_MM_15_012

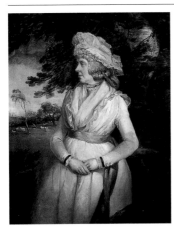

Hoppner, John 1758–1810
Mrs Fox of Maidstone
oil on canvas 96 × 125
PCF_KT_MM_31_010

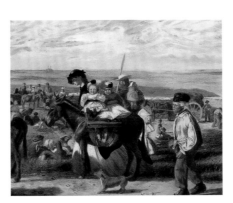

Houghton, Arthur Boyd 1836–1875
At the Seaside: Pegwell Bay, Near Ramsgate, 1862 1862
oil on canvas 50 × 90
Bentlif 241

Howard, Elizabeth
Edward Twopenny of Woodstock, Sittingbourne
oil on canvas 95 × 75
65.1962

Hughes, Arthur 1832–1915
Saying Grace: The Skipper and His Crew 1881
oil on canvas 78 × 93
Bentlif 34 🐝

Hughes, Edward Robert 1851–1914
The Intruder 1872
oil on canvas 75 × 90
Bentlif 219

Hughes-Stanton, Herbert Edwin Pelham
1870–1937
Sheep in a Storm 1894
oil on canvas 36 × 52
85.1959

Hunt, Arthur Ackland active 1865–1902
Job in His Adversity
oil on canvas 101 × 126
27.2.1888

Huysmans, Cornelis 1648–1727
A Woodland Scene with Figures
oil on canvas 63 × 92
00.1873.34

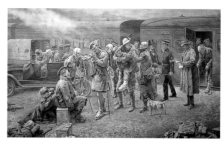

Hyde, Frank 1849–1937
*Arrival of a Convoy of Wounded Soldiers at
Maidstone Station, 1916* 1917
oil on canvas 90 × 145
PCF_KT_MM_17_007

Hyde, Frank 1849–1937
Capri Coastal Scene with Figures
oil on canvas 60 × 49
PCF_KT_MM_20_006

Illingworth, Nancy
The Garden Wall, Old Loose Hill 1992
oil on board 40 × 61
Bentlif 245.1994.1

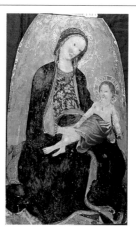

Italian School 14th C
Madonna of Humility
tempera on panel 71 × 43
10.1944.81

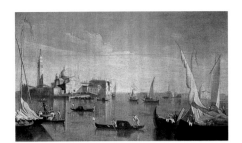

Italian (Venetian) School 18th C
View of San Giorgio Maggiore, Venice
oil on canvas 46 × 77
00.1873.38

Janssens van Ceulen, Cornelis 1593–1661
William Peirs, DD (1579–1670)
oil on canvas 68 × 50
PCF_KT_MM_18_022

Janssens van Ceulen, Cornelis 1593–1661
Sir William Brockman 1642
oil on canvas 76 × 64
PCF_KT_MM_037_023

Jefferys, James 1751–1784
The Scene before Gibraltar
oil on canvas 160 × 245
22.1891

Jefferys, William 1723–1805
Three Fawns
oil on canvas 55 × 65
162.56

Jefferys, William 1723–1805
The Old Market Cross, Maidstone
oil on canvas 30 × 27
PCF_KT_MM_10_024

Jefferys, William 1723–1805
Northwest View of Maidstone
oil on panel 28 × 42
PCF_KT_MM_33_009

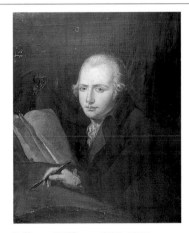

Jefferys, William 1723–1805
James Jefferys at work
oil on canvas 75 × 61
PCF_KT_MM_99_006

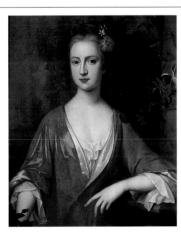

Jervas, Charles (school of) c.1675–1739
Portrait of a Girl with a Flower in Her Hair
oil on canvas 75 × 64
PCF_KT_MM_04_009

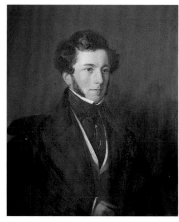

King
James Whatman
oil on canvas 77 × 64
85.1968.A

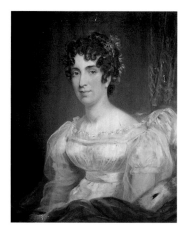

King
Mrs James Whatman
oil on canvas 76 × 65
85.1968.B

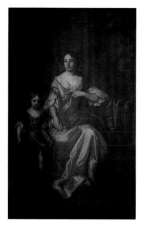

Kneller, Godfrey (after) 1646–1723
Elizabeth, Daughter of Thomas Crispe
oil on canvas 220 × 142
30.1949D

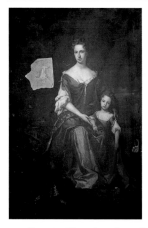

Kneller, Godfrey (attributed to) 1646–1723
Margaretta (Bosville) Marsham
oil on canvas 217 × 143
30.1949C

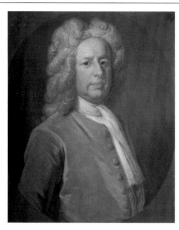

Kneller, Godfrey (school of) 1646–1723
Thomas Best of Chatham
oil on canvas 75 × 63
65.1955.1b

Kruseman, Frederik Marianus 1817–1860
Summer Landscape 1849
oil on panel 19 × 25
Bentlif 35.1897.19

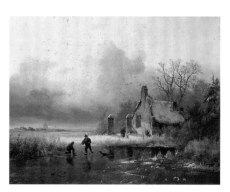

Kruseman, Frederik Marianus 1817–1860
Winter Landscape 1849
oil on panel 19 × 25
Bentlif 36.1897.20

Lambourn, George 1900–1977
Nude Study
oil on canvas 40 × 20
93.1963

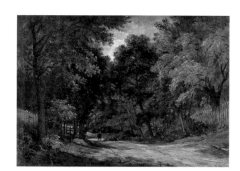

Lee, Frederick Richard 1798–1879
A Lane at Cobham, Kent
oil on canvas 27 × 36
26.21

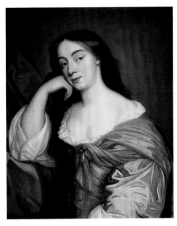

Lely, Peter (after) 1618–1680
Barbara Villiers, Duchess of Cleveland
oil on canvas 72 × 60
PCF_KT_MM_04_026

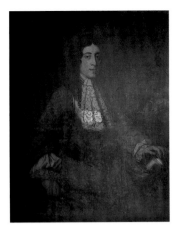

Lely, Peter (after) 1618–1680
James, Duke of Monmouth
oil on canvas 120 × 95
PCF_KT_MM_14_022

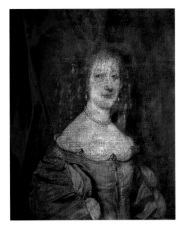

Lely, Peter (after) 1618–1680
Lady Susannah Dormer
oil on canvas 73 × 60
PCF_KT_MM_18_010

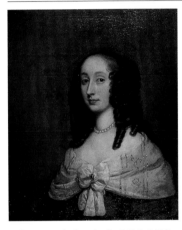

Lely, Peter (school of) 1618–1680
Lady Darrell (Mrs Darell Blount)
oil on canvas 75 × 63
PCF_KT_MM_99_005

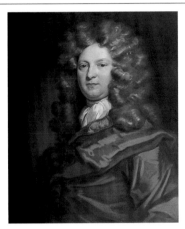

Lely, Peter (style of) 1618–1680
William Wycherley
oil on canvas 75 × 65
PCF_KT_MM_04_003

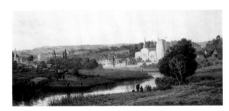

Lewis, John Hardwicke 1840–1927
Maidstone, c.1870 c.1870
oil on canvas 41 × 92
109.1962 🐝

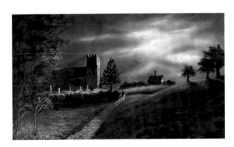

Lines, Vincent Henry 1909–1968
A Kentish Church in Moonlight 1925
oil on canvas 55 × 70
PCF_KT_MM_2/01_005

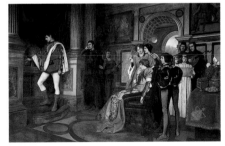

Linton, James Dromgole 1840–1916
The Casket Scene from the Merchant of Venice
oil on canvas 130 × 198
PCF_KT_MM_05_030

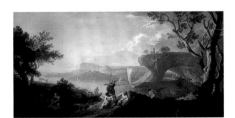

Locatelli, Andrea 1695–1741
Classical Landscape: Coastal Scene with Fishermen
oil on canvas 51 × 102
17.1970.17

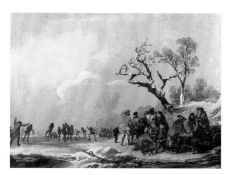

Louterbourg, Phillip James de 1740–1812
Winter Scene with Skating
oil on canvas 90 × 126
Bentlif 37

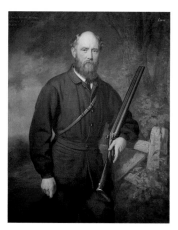

Lucas, John Templeton 1836–1880
Charles Marsham, 4th Earl Romney
oil on canvas 125 × 99
30.1949.A

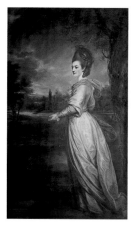

Lucas, John Templeton 1836–1880
Lady Frances Wyndham
oil on canvas 236 × 142
30.1949.B

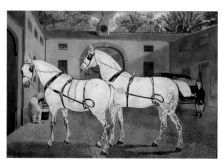

Martin, Sylvester 1856–1906
Two Grey Horses in a Stable Yard
oil on canvas 62 × 90
1994.241

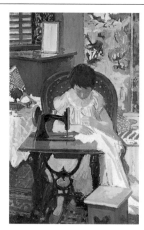

McCall, Charles James 1907–1989
Dressmaking
oil on canvas 75 × 50
65.1958

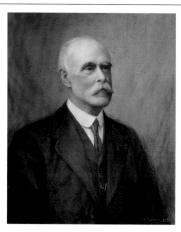

McLernon, Huw (or N. J. W.)
James Mercer Russell
oil on canvas 75 × 63
PCF_KT_MM_24_004

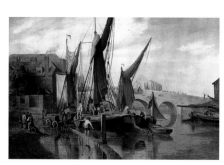

Merritt, Thomas Light d.1870
Maidstone Bridge from the North Side
oil on canvas 85 × 115
PCF_KT_MM_99_011

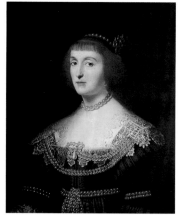

Miereveld, Michiel Jansz van (after)
1567–1641
Elizabeth, Queen of Bohemia
oil on canvas 73 × 61
00.1855.97

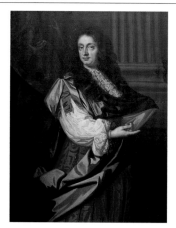

Miereveld, Michiel Jansz van (after)
1567–1641
Maurice, Prince of Orange
oil on panel 66 × 51
00.117

Mignon, Abraham (attributed to)
1640–c.1679
Still Life with Pigeons
oil on canvas 84 × 121
Bentlif 38.1897.94

Molenaer, Klaes d.1676
Winter Scene
oil on panel 59 × 58
Bentlif 39.1897.33 🐝

Molyn, Pieter 1595–1661
Landscape with Travelling Figures
oil on panel 39 × 55
00.1855.31

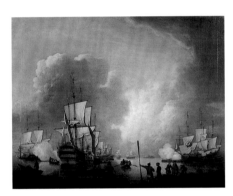

Monamy, Peter 1681–1749
Embarkation of Troops: Ships at Anchor Firing the Evening Salute
oil on canvas 55 × 71
PCF_KT_MM_99_013

Monteitti, J.
Priest and Woman
oil on canvas 75 × 62
PCF_KT_MM_28_028

Mordecai, Joseph 1851–1940
Sir Marcus Samuel, Lord Bearsted
oil on canvas 190 × 110
30.1949E

Morland, George 1763–1804
Pigs at a Trough
oil on panel 20 × 25
BAL_MAI 44980 🐝

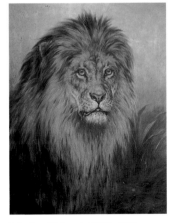

Morley, Robert 1857–1941
Lion's Head
oil on canvas 111 × 86
PCF_KT_MM_03_016

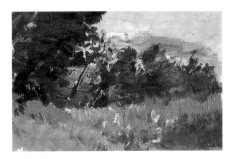

Moynihan, Rodrigo 1910–1990
Landscape 1939
oil on board 15 × 23
PCF_KT_MM_32_019

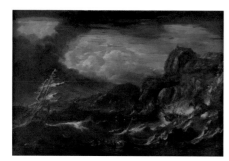

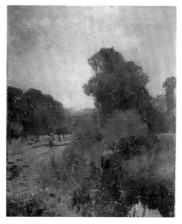

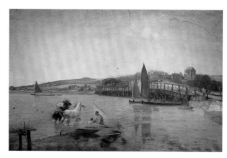

Mulier, Pieter the younger (attributed to)
c.1637–1701
Night Storm at Sea with Dutch Ships Being Wrecked
oil on canvas 97 × 147
Bentlif 00.1897.118

Munnings, Alfred James 1878–1959
The Woodcutters c.1903
oil on board 60 × 50
101.1963

Murray, David 1849–1933
A Summer Day (Shoreham, Sussex)
oil on canvas 120 × 180
PCF_KT_MM_31_025

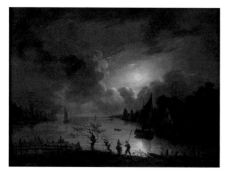

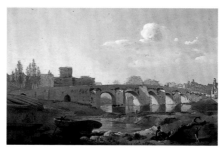

Neer, Aert van der (imitator of) 1603–1677
Moonlit Shore
oil on panel 38 × 55
Bentlif 58.1897.113

Newington Hughes, John
Maidstone Bridge 1851
oil on canvas 48 × 75
PCF_KT_MM_32_014

Nicholls, Bertram 1883–1974
San Giovanni Nepomuceno 1928
oil on canvas 34 × 44
PCF_KT_MM_21_037

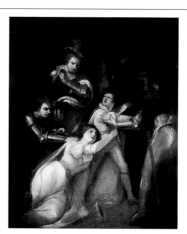

Niemann, Edmund John 1813–1876
The Thames Near Streetley, Berkshire
oil on canvas 40 × 40
PCF_KT_MM_10_007

Niemann, Edmund John 1813–1876
The Thames at Pangbourne, Berkshire
oil on canvas 40 × 40
PCF_KT_MM_10_011

Northcote, James 1746–1831
The Murder of Edward, Prince of Wales, at Tewkesbury
oil on canvas 231 × 195
PCF_KT_MM_31_003

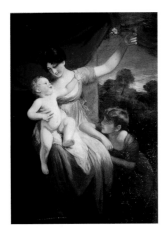

Opie, John 1761–1807
Lady with Two Children and a Parrot
oil on canvas 166 × 118
PCF_KT_MM_04_034

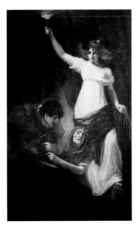

Opie, John 1761–1807
*Gil Blas Taking the Key from Dame Leonarda in
the Cavern of the Banditti*
oil on canvas 205 × 132
PCF_KT_MM_14_009

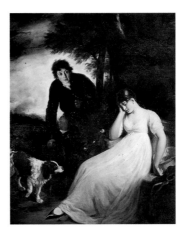

Opie, John 1761–1807
The Surprise
oil on canvas 138 × 110
PCF_KT_MM_31_007

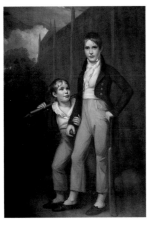

Opie, John (attributed to) 1761–1807
*Mawdisty Best and His Brother outside
Rochester Cathedral* c.1800
oil on canvas 165 × 115
65.1955a

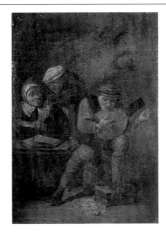

Ostade, Adriaen van (imitator of)
1610–1685
Dutch Peasants
oil on canvas 28 × 21
00.1873.48

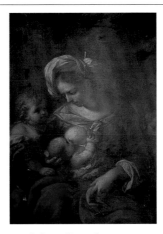

Paccini, Ferdinando
The Virgin Seated Leaning over the Christ Child
c.1847
oil on canvas 116 × 87
00.1873.106

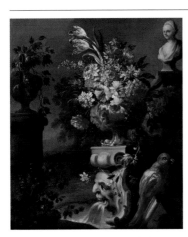

Pace del Campidoglio, Michele
1610–probably 1670
Still Life with Parrot
oil on canvas 77 × 64
Bentlif 42.1897.91

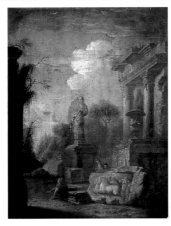

Panini, Giovanni Paolo (after) c.1692–1765
Ruins with a Statue
oil on canvas 63 × 50
00.1855.8

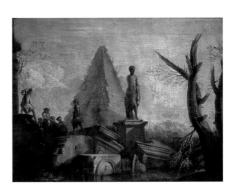

Panini, Giovanni Paolo (after) c.1692–1765
Ruins with the Tomb of Cestius
oil on canvas 49 × 65
00.1863.11

Panini, Giovanni Paolo (after) c.1692–1765
Ruins with a Bust
oil on canvas 49 × 64
00.1873.10

Panini, Giovanni Paolo (style of)
c.1692–1765
Roman Capriccio, Ruins with Colosseum 1734
oil on canvas 97 × 135
00.1873.4 ✸

Panini, Giovanni Paolo (style of)
c.1692–1765
Roman Capriccio 1734
oil on canvas 98 × 135
00.1873.5 ✸

Panini, Giovanni Paolo (style of)
c.1692–1765
Ruins with an Urn and an Arch
oil on canvas 46 × 56
Bentlif 43.1897.7

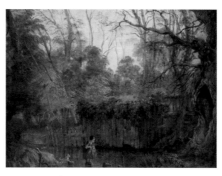

Parrott, William 1813–after 1875
Child Crossing a Brook
oil on canvas 17 × 23
Bentlif 78

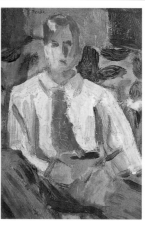

Peake, Mervyn 1911–1968
Portrait of a Young Man
oil on board 22 × 16
36.1968

Plowman, Elisabeth
Maidstone Museum
oil on canvas 70 × 55
4.1963

Poelenburgh, Cornelis van (style of)
1594/1595–1667
Diana and Callista
oil on canvas 35 × 48
00.1855.68

Poelenburgh, Cornelis van (style of)
1594/1595–1667
Mary Magdalene
oil on canvas 31 × 25
74.1865.67

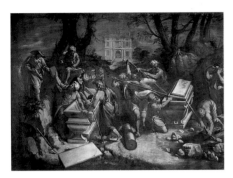

Polidoro da Caravaggio (after)
c.1497–c.1543
The Discovery of the Tomb of Numa Pompilius
oil on canvas 99 × 137
31.1974.103

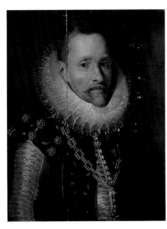

Pourbus, Frans the younger (attributed to)
1569–1622
Albert, Archduke of Austria
oil on panel 66 × 51
00.1883.98

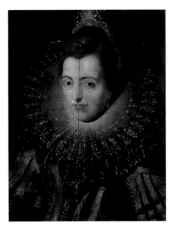

Pourbus, Frans the younger (attributed to)
1569–1622
Isabella Clara Eugenia, Archduchess of Austria
oil on panel 66 × 51
00.1883.99

Pretty, Edward 1792–1865
Thomas Charles of Chillington House, Maidstone
oil on canvas 140 × 112
PCF_KT_MM_25_004

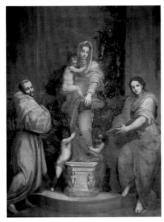

Puccini, Ferdinando
Madonna delle arpe c.1847
oil on canvas 136 × 104
00.1873.104

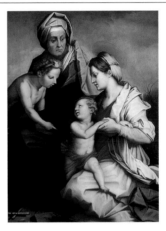

Puccini, Ferdinando
Virgin and Child with Saints John and Elizabeth c.1847
oil on canvas 116 × 87
00.1873.106

Raigersfeld, Baron de
Stables of an Old House at Mote Park, Maidstone
oil on canvas 57 × 62
PCF_KT_MM_03_007

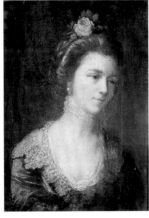

Ramsay, Allan (attributed to) 1713–1784
Maria Gunning
oil on canvas 20 × 15
PCF_KT_MM_04_013

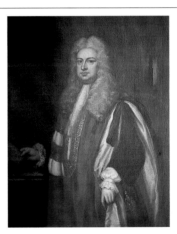

Richardson, Jonathan the elder 1665–1745
Lord Robert Raymond
oil on canvas 125 × 100
13.1939

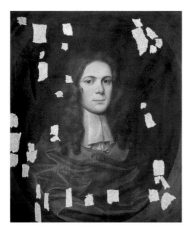

Riley, John 1646–1691
Richard Oxenden
oil on canvas 75 × 65
PCF_KT_MM_35_019

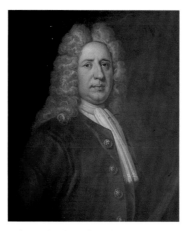

Riley, John (attributed to) 1646–1691
Richard Oxenden
oil on canvas 75 × 63
PCF_KT_MM_04_006

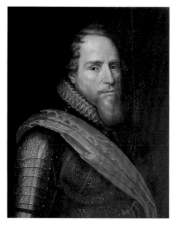

Riley, John (attributed to) 1646–1691
Barnham Family Member of Boughton Place
oil on panel 64 × 51
PCF_KT_MM_25_030

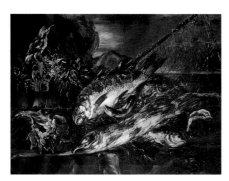

Rosa, Salvator 1615–1673
Study of Fish
oil on canvas 70 × 93
00.1865.96

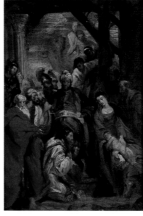

Rubens, Peter Paul (after) 1577–1640
Adoration of the Magi
oil on panel 36 × 26
10.1944.115

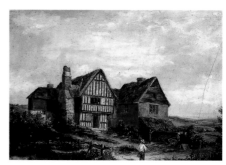

Ruck, F. W. active 19th C
Old Manor House, West Farleigh
oil on canvas 24 × 34
PCF_KT_MM_17_004

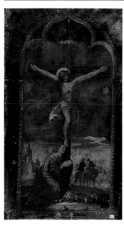

Sadeler, Egidius II (after) 1570–1629
Mary Magdalene at the Feet of Christ on the Cross
oil on canvas 60 × 28
PCF_KT_MM_17_034

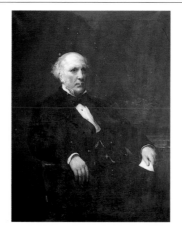

Sant, James 1820–1916
John Monckton, Town Clerk of this Borough (1838–1875)
oil on canvas 120 × 100
PCF_KT_MM_31_031

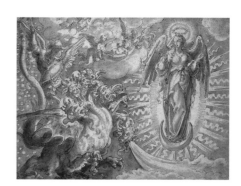

Scaramuccia, Giovanni Antonio 1580–1633
Madonna and Child and Saints
oil on canvas & paper 32 × 46
00.1865.83

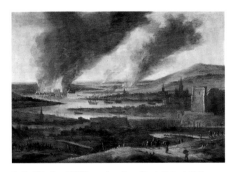

Schellinks, Willem (style of) 1627–1678
The Dutch in the Medway
oil on panel 23 × 33
00.21 ✹

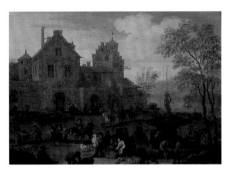

Schoevaerdts, Mathys active 1682–1694
Market Scene by a Fountain
oil on panel 29 × 41
00.1873.41

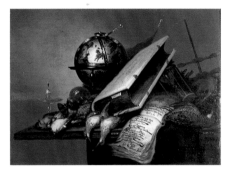

Schotanus, Petrus active c.1663–1687
Vanitas: Still Life with a Globe
oil on panel 60 × 83
Bentlif 46.1897.92

Scott
Bridge with Buildings
oil on canvas 52 × 77
PCF_KT_MM_02_003

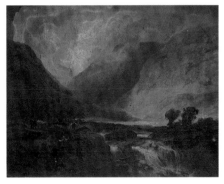

Shalders, George c.1826–1873
Near Connemara, Ireland
oil on canvas 39 × 50
29.52

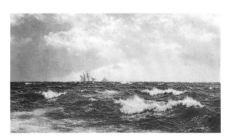

Shaw, W. J.
Shipping in Mid-Channel
oil on canvas 69 × 125
Bentlif 47 ✹

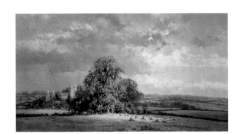

Shepherd, David b.1941
A Kent Landscape 1993
oil on canvas 51 × 91
Bentlif 247.1994.2

Shipley, William 1714–1803
Boy Blowing on a Firebrand (after Godfried Schalcken)
oil on canvas 75 × 62
00.1855.114

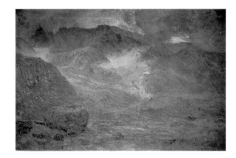

Shrubsole, W. G. 1855–1889
The Heart of the Hills
oil on canvas 90 × 135
PCF_KT_MM_25_014

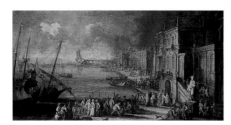

Simonini, Francesco (attributed to)
1686–c.1755
Port Scene
oil on canvas 52 × 101
17.1970.61

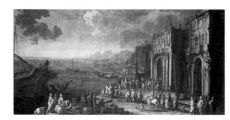

Simonini, Francesco (attributed to)
1686–c.1755
Port Scene
oil on canvas 52 × 101
17.1970.62

Smith, G.
Landscape and River with Figures
oil on canvas 60 × 79
Bentlif 49

Smith, George (after)
Hop Picking
oil on canvas 44 × 59
BAL_MAI 46485

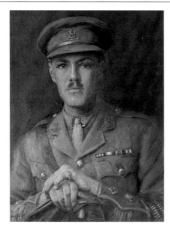

Smith, Hely Augustus Morton 1862–1941
Lieutenant Colonel Dawson
oil on canvas 60 × 48
MNERM 1989.992

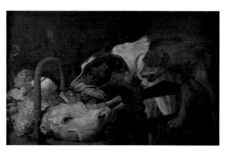

Snyders, Frans 1579–1657
Dogs Stealing Food from a Basket
oil on canvas 67 × 107
Bentlif 51.1897.93

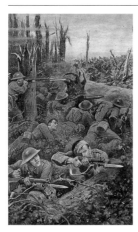

Stanley
Trones Wood
oil on canvas 39 × 25
MNERM 1998.1366

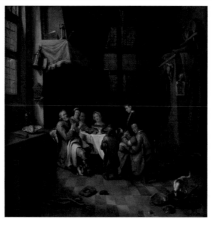

Steen, Jan (imitator of) 1626–1679
Peasants at a Table Saying Grace
oil on canvas 80 × 80
Bentlif 67.1897.52

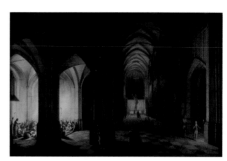

Steenwijck, Hendrick van the elder
c.1550–1603 & **Steenwijck, Hendrick van the
younger** c.1580–1649
Interior of a Cathedral (...) 1591–1624
oil on panel 63 × 92
Bentlif 52.1897.88

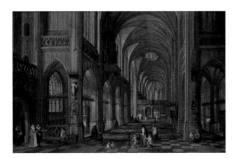

Steenwijck, Hendrick van the younger
c.1580–1649 & **Brueghel, Jan the elder**
1568–1625
Interior of a Gothic Church
oil on panel 48 × 71
Bentlif 41.1897.87

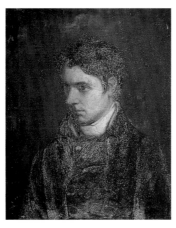

Stewart, James
William Hazlitt (after William Hazlitt)
oil on canvas 65 × 55
67.1909

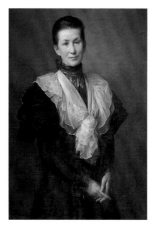

Stoppoloni, Augusto 1855–1910
Miss F. J. Dolby 1896
oil on canvas 101 × 70
PCF_KT_MM_31_013

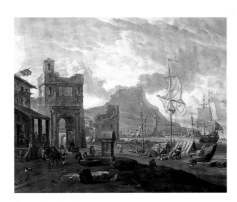

Storck, Abraham 1644–1708
Port Scene with an Arch
oil on panel 51 × 61
Bentlif 53.1897.12

Strange, Albert 1855–1917
View of Great Buckland
oil on canvas 50 × 69
PCF_KT_MM_2/01_009

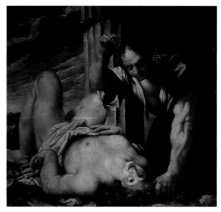

Strozzi, Bernardo (attributed to) 1581–1644
*Two Figures against a Pillar: One Reclining
Nude (The Triumph of Nature over Mankind)*
oil on canvas 120 × 129
00.1855.75

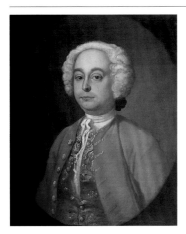

Stuart, Gilbert (attributed to) 1755–1828
Thomas Best of Boxley
oil on canvas 73 × 62
87.1955

Sullivan, J. Owen
Colonel Maunsell
oil on canvas 50 × 40
MNERM 1966.768

Sullivan, J. Owen
Ensign Stainforth
oil on canvas 91 × 70
MNERM 2000.1427

Tennant, John F. 1796–1872
Landscape with Men Salmon Fishing 1844
oil on canvas 54 × 90
Bentlif 56

Tilborgh, Gillis van c.1635–c.1678
A Musical Party
oil on canvas 97 × 79
Bentlif 57.1897.53 🐝

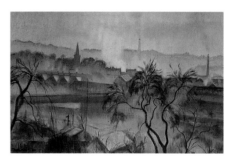

Townsend, William 1909–1973
Early Morning at Tovil, Kent, 1940 1940
oil on canvas 51 × 76
PCF_KT_MM_10_018

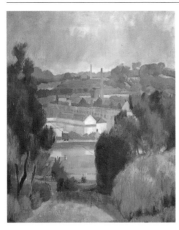

Townsend, William 1909–1973
View across the River to Tovil, Maidstone 1939
oil on canvas 61 × 51
PCF_KT_MM_13_024

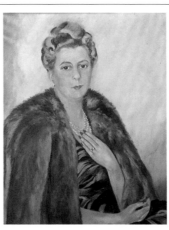

Tyrwhitt-Drake, **Garrard** 1881–1964
Lady Edna Tyrwhitt-Drake
oil on canvas 139 × 91
PCF_KT_MM_2/01_035

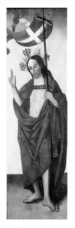

unknown artist
Christ with the Banner of the Resurrection
c.1500
oil on panel 162 × 58
PCF_KT_MM_31_001

unknown artist 16th C
Portrait of a Bearded Man
oil on panel 47 × 36
00.1873.102

unknown artist 16th C
Pietà: Christ with St Peter
oil on panel 23 × 18
00.1875.64

unknown artist 16th C
Adoration of the Magi
oil on canvas 101 × 126
Bentlif 71.1897.71

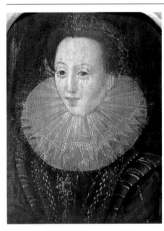

unknown artist 16th C
St Catherine of Siena and a Bishop Saint
oil on canvas 62 × 94
5.1946.73

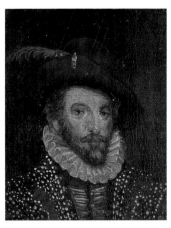

unknown artist 16th C
Portrait of a Man c.1570
oil on panel 10 × 8
PCF_KT_MM_33_032

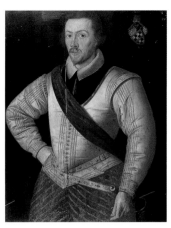

unknown artist 16th C
Sir Conyers Clifford, Governor of Connemara
oil on canvas 89 × 72
PCF_KT_MM_99_008

unknown artist 16th C?
Mary, Queen of Scots
oil on panel 28 × 21
PCF_KT_MM_15_019

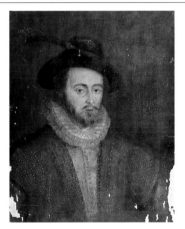

unknown artist 16th or 17th C
Portrait of a Tudor Gentleman
oil on panel 27 × 22
PCF_KT_MM_15_015

unknown artist 17th C
Landscape with Figures
oil on canvas 56 × 79
00.1855.32

unknown artist 17th C
Rustic Sports
oil on canvas 14 × 32
00.1855.42

unknown artist 17th C
Rustic Sports
oil on canvas 14 × 31
00.1855.43

unknown artist 17th C
Peasant Sitting to Tend an Injured Hand
oil on panel 11 × 8
00.1855.47

unknown artist 17th C
Camp Scene
oil on canvas 57 × 84
00.1855.56

unknown artist 17th C
St Thomas
oil on panel 70 × 57
00.1855.69

unknown artist 17th C
The Martyrdom of St Sebastian
oil on panel 41 × 33
00.1855.70

unknown artist 17th C
Joseph and Potiphar's Wife
oil on canvas 90 × 108
00.1855.72

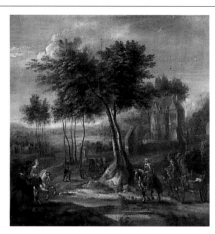

unknown artist 17th C
Landscape with Riders
oil on canvas 35 × 36
00.1873.27

unknown artist 17th C
Arabs Playing Bowls
oil on canvas 39 × 102
00.1873.58

unknown artist 17th C
Arabs Playing Bowls
oil on canvas 38 × 107
00.1873.59

unknown artist 17th C
The Marriage Feast at Cana
oil on canvas 42 × 115
00.1873.77

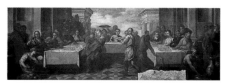

unknown artist 17th C
Feast in the House of Simon the Pharisee
oil on canvas 41 × 115
00.1873.78

Facing page: Goodwin, Albert, *Reculver, Kent* (detail), Canterbury City Council Museums and Galleries (p. 4)

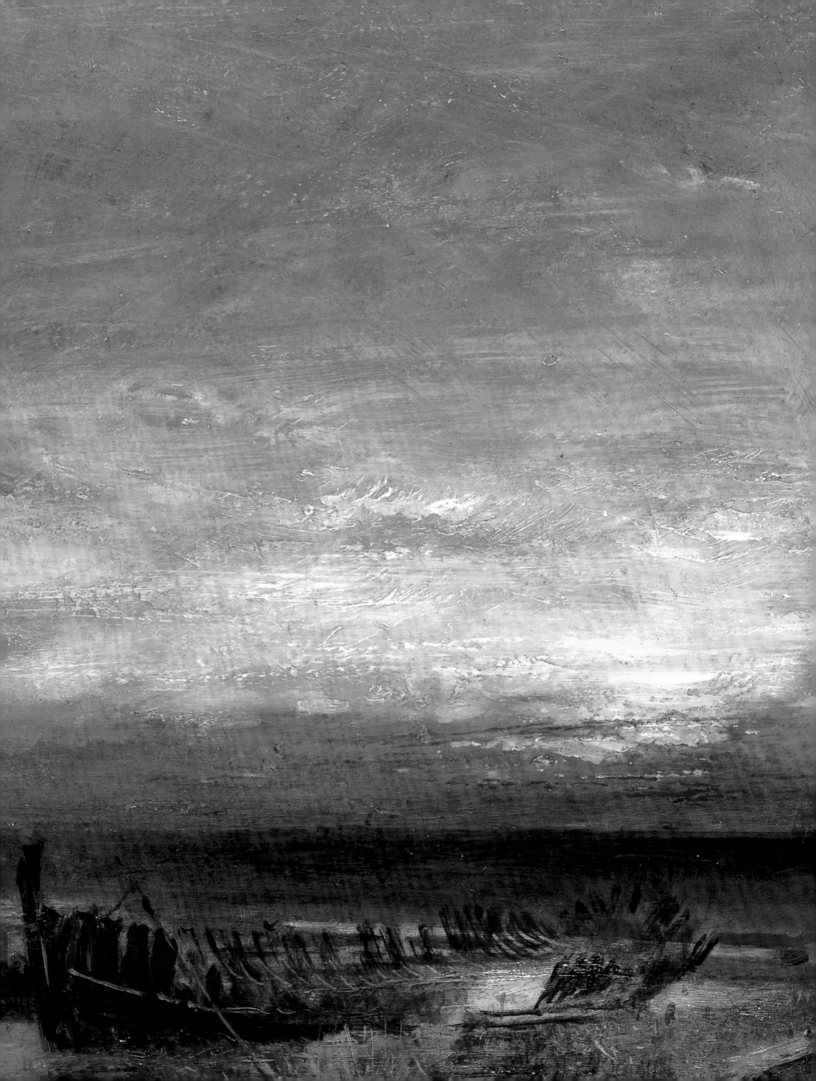

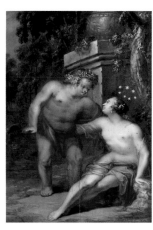

unknown artist 17th C
Bacchus and Ariadne
oil on canvas 42 × 32
00.1873.84

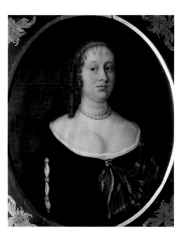

unknown artist 17th C
Catherine Walker, Mother of Catherine Yardley
oil on canvas 70 × 50
26.1880.A

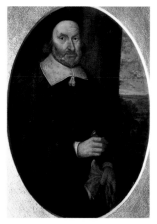

unknown artist 17th C
John Hasted, Son of Rev. John Hasted
oil on canvas 70 × 50
26.1880.B

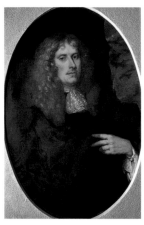

unknown artist 17th C
Moses Hasted of Canterbury and London
oil on canvas 68 × 55
26.1880.C

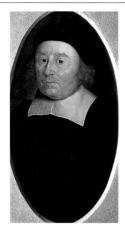

unknown artist 17th C
Rev. John Hasted
oil on canvas 75 × 60
26.1880.D

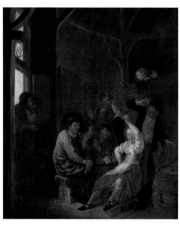

unknown artist 17th C
Peasants Carousing
oil on panel 55 × 45
Bentlif 66.1897.51

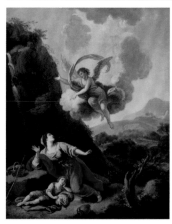

unknown artist 17th C
The Angel Appears to Hagar
oil on canvas 69 × 56
Bentlif 73.1897.76

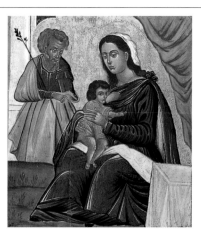

unknown artist 17th C
Madonna and Child with St Joseph
oil on panel 36 × 32
10.1944.A

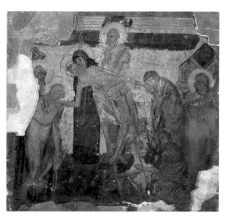

unknown artist 17th C
The Deposition: The Descent from the Cross
oil on panel 18 × 17
10.1944.B

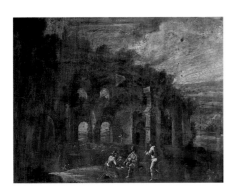

unknown artist 17th C
Card Players in front of a Ruin
oil on copper 29 × 40
00.9

unknown artist 17th C
Peasants Making Music
oil on canvas 35 × 30
00.50

unknown artist 17th C
Umbram Fugat Veritas
oil on canvas 132 × 200
00.122

unknown artist 17th C
Portrait of a Young Woman, c.1630
oil on canvas 96 × 78
BAL_MAI 46501

unknown artist 17th C
Edwin, Son of Sir Francis Wiat
oil on canvas 124 × 102
PCF_KT_MM_02_031

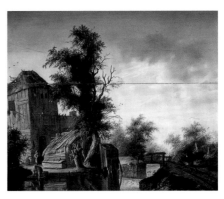

unknown artist 17th C
Robert Abbot, Bishop of Salisbury
oil on canvas 86 × 66
PCF_KT_MM_04_019

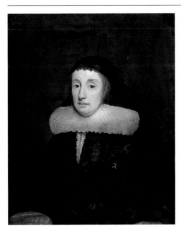

unknown artist 17th C
Elizabeth, Darling Wife of Jonas Bargrave
oil on canvas 76 × 63
PCF_KT_MM_06_033

unknown artist 17th C
Portrait of a Woman, Early 17th Century
oil on copper 25 × 18
PCF_KT_MM_09_008

unknown artist 17th C
Man Building with Wooden Bridge
oil on canvas 45 × 53
PCF_KT_MM_16_026

unknown artist 17th C
Four Putti Lamenting the Crucifixion
oil on canvas 36 × 86
PCF_KT_MM_19_025

unknown artist 17th C
Stuart Child
oil on canvas 127 × 101
PCF_KT_MM_21_007

unknown artist 17th C
James, Duke of Monmouth
oil on canvas 126 × 101
PCF_KT_MM_24_009

unknown artist 17th C
Dr Duthy (or Dethick) of Derby, Aged 67
oil on panel 75 × 65
PCF_KT_MM_25_018

unknown artist 17th C
Sir John Marsham of Whorns Place, Cuxton
oil on panel 75 × 62
PCF_KT_MM_25_022

unknown artist 17th C
Interior of the Hall of an English Mansion
oil on canvas 60 × 83
PCF_KT_MM_33_010

unknown artist 17th C
King Charles I
oil on copper 14 × 12
PCF_KT_MM_33_028

unknown artist 17th C
Rev. John Cross, Vicar of West Malling
oil on canvas 77 × 64
PCF_KT_MM_35_012

unknown artist 18th C
Village Festival
oil on canvas 48 × 57
00.1865.45

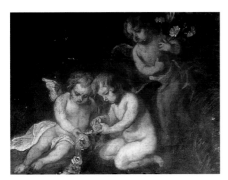

unknown artist 18th C
Cherubs Making Garlands
oil on canvas 27 × 33
00.1873.55

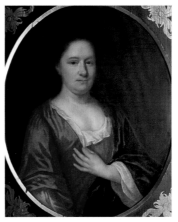

unknown artist 18th C
Catherine Yardley, Wife of Joseph (John?)
Hasted
oil on canvas 70 × 50
26.1880.0.A

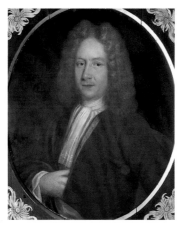

unknown artist 18th C
Joseph Hasted (1660–1732) Son of Moses
Hasted
oil on canvas 70 × 50
26.1880.0.B

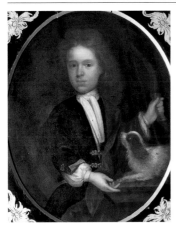

unknown artist 18th C
Edward Hasted (1702–1740)
oil on canvas 70 × 50
26.1880.0.C

unknown artist 18th C
Mary Dorman, Sister of Anna Hasted
oil on canvas 77 × 63
26.1880.6

unknown artist 18th C
Anna Dorman, Wife of Edward Hasted
oil on canvas 29 × 24
26.1880.8

unknown artist 18th C
Madonna and Child with Infant St John
oil on panel 19 × 15
10.1944.125

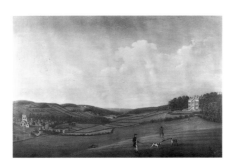

unknown artist 18th C
Mansion on a Hill Overlooking a Village
oil on canvas 48 × 65
BAL_MAI 46481 🐝

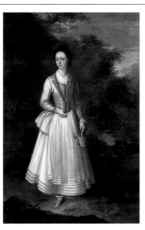

unknown artist 18th C
Lady in Riding Habit
oil on canvas 72 × 51
BAL_MAI 46484 🐝

unknown artist 18th C
Allegorical Landscape
oil on canvas 74 × 93
PCF_KT_MM_01_018

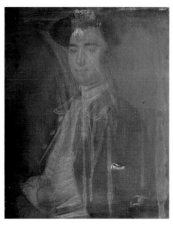

unknown artist 18th C
Portrait of a Man with a Hat
oil on canvas 75 × 62
PCF_KT_MM_03_009

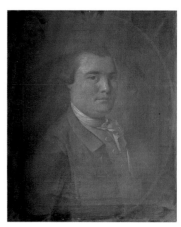

unknown artist 18th C
Portrait of a Corpulent Man
oil on canvas 76 × 64
PCF_KT_MM_03_012

unknown artist 18th C
Portrait of a Man
oil on canvas 76 × 64
PCF_KT_MM_03_026

unknown artist 18th C
Portrait of a Man
oil on canvas 76 × 64
PCF_KT_MM_03_031

unknown artist 18th C
Captain Robert Farmer
oil on canvas 64 × 51
PCF_KT_MM_04_016

unknown artist 18th C
Portrait of a Man with a White Stock
oil on canvas 62 × 62
PCF_KT_MM_08_007

unknown artist 18th C
Judith and Holofernes
oil on panel 16 × 14
PCF_KT_MM_09_010

unknown artist 18th C
Classical Scene, Male and Female Figures with Putti
oil on panel 38 × 32
PCF_KT_MM_09_014

unknown artist 18th C
Hawk Carrier
oil on panel 35 × 29
PCF_KT_MM_09_021

unknown artist 18th C
Landscape
oil on canvas 23 × 34
PCF_KT_MM_10_001

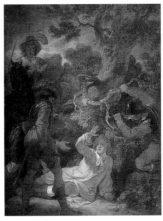

unknown artist 18th C
Figures in a Wood
oil on canvas 43 × 34
PCF_KT_MM_10_004

unknown artist 18th C
Portrait of a Woman, Late 18th Century
oil on canvas 55 × 45
PCF_KT_MM_11_010

unknown artist 18th C
Two Figures on Horseback
oil on canvas 87 × 112
PCF_KT_MM_13_029

unknown artist 18th C
Perseus and Andromeda
oil on zinc 8 × 24
PCF_KT_MM_15_002

unknown artist 18th C
Landscape - Shepherd, Cows and Sheep
oil on panel 28 × 37
PCF_KT_MM_15_028

unknown artist 18th C
Cherubs (after Joos van Cleve)
oil on panel 30 × 45
PCF_KT_MM_17_028

unknown artist 18th C
Landscape River and Figures
oil on canvas 79 × 118
PCF_KT_MM_18_004

unknown artist 18th C
Inn with Gentleman
oil on canvas 64 × 73
PCF_KT_MM_18_019

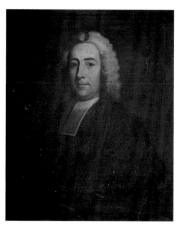

unknown artist 18th C
Rev. Gilbert Innes
oil on canvas 75 × 63
PCF_KT_MM_18_028

unknown artist 18th C
Elizabeth, Wife of Gilbert Innes
oil on canvas 79 × 66
PCF_KT_MM_18_034

unknown artist 18th C
Landscape with Three Figures
oil on canvas 30 × 45
PCF_KT_MM_21_013

unknown artist 18th C
James Best of Boxley, Aged 62
oil on canvas 75 × 62
PCF_KT_MM_22_036

unknown artist 18th C
Oriental Harbour Scene
oil on canvas 44 × 77
PCF_KT_MM_27_027

unknown artist 18th C
Landscape with Chinese Hunting Party
oil on canvas 55 × 73
PCF_KT_MM_28_035

unknown artist 18th C
Portrait of a Man
oil on canvas 33 × 27
PCF_KT_MM_30_010

unknown artist 18th or 19th C
Christ Appearing to Two Disciples
oil on canvas 34 × 68
PCF_KT_MM_23_032

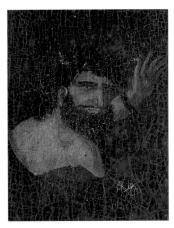

unknown artist
Portrait of a Bearded Man Waving (Despair)
1814
oil on panel 14 × 11
PCF_KT_MM_33_025

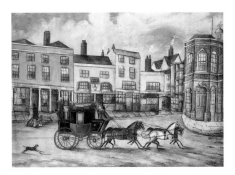

unknown artist
The London to Maidstone Stagecoach Passing the Swan Inn c.1840
oil on canvas 37 × 51
BAL_MAI 45003 🐝

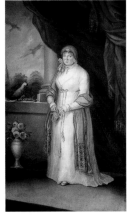

unknown artist
Anna Spong, Wife of Captain Charles Mansfield
c.1866
oil on canvas 220 × 136
3.1955.A

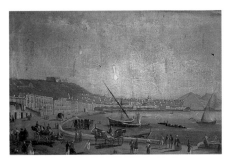

unknown artist 19th C
Bay of Naples
oil on canvas 27 × 40
00.1873.35

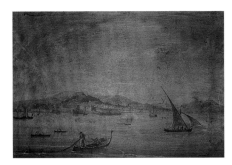

unknown artist 19th C
Bay of Naples
oil on canvas 27 × 40
00.1873.36

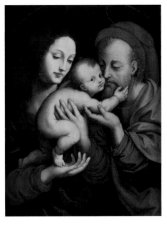

unknown artist 19th C
The Holy Family
oil on canvas 74 × 57
Bentlif 69.1897.107

unknown artist 19th C
Richard Sergeant
oil on canvas 81 × 69
47.1953

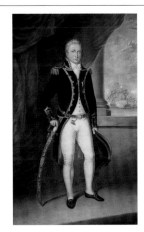

unknown artist 19th C
Captain Charles John Moore Mansfield
oil on canvas 220 × 136
3.1955.B

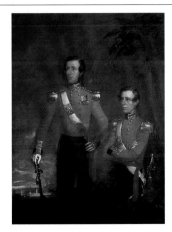

unknown artist 19th C
Robert and William Bellers
oil on canvas 110 × 84
MNERM 2002.1458

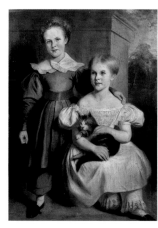

unknown artist 19th C
Two Children and a Cat
oil on canvas 120 × 90
PCF_KT_MCC_09_001

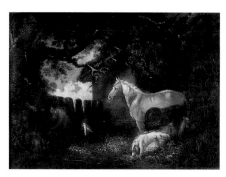

unknown artist 19th C
The Stable Yard
oil on canvas 20 × 25
PCF_KT_MM_01_008

unknown artist 19th C
Seascape
oil on canvas 15 × 20
PCF_KT_MM_01_033

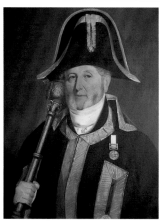

unknown artist 19th C
The War Medal: Sergeant-at-Mace Robert Griffin
oil on canvas 107 × 89
PCF_KT_MM_2/02_005

unknown artist 19th C
Portrait of a Woman
oil on canvas 74 × 61
PCF_KT_MM_06_012

unknown artist 19th C
Robert Tassell JP
oil on canvas 125 × 99
PCF_KT_MM_07_021

unknown artist 19th C
Portrait of a Woman
oil on canvas 72 × 56
PCF_KT_MM_08_001

unknown artist 19th C
Portrait of a Man
oil on canvas 77 × 63
PCF_KT_MM_08_017

unknown artist 19th C
Thomas Day, Mayor of Maidstone
oil on canvas 77 × 64
PCF_KT_MM_08_022

unknown artist 19th C
Landscape with Shepherd, Sheep and Cows
oil on panel 25 × 36
PCF_KT_MM_09_017

unknown artist 19th C
Ducks
oil on panel 22 × 30
PCF_KT_MM_09_029

unknown artist 19th C
Landscape with Sheep and Ferns
oil on panel 20 × 30
PCF_KT_MM_09_034

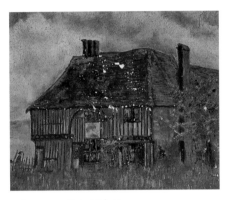

unknown artist 19th C
Luddesdowne
oil on canvas 23 × 28
PCF_KT_MM_10_026

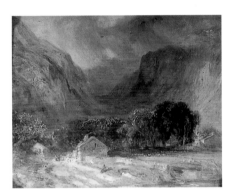

unknown artist 19th C
Cottage in the Mountains
oil on canvas 12 × 16
PCF_KT_MM_10_034

unknown artist 19th C
Portrait of a Man Wearing Black-rimmed Spectacles
oil on canvas 61 × 50
PCF_KT_MM_11_006

unknown artist 19th C
Boy in a Ruff Holding a Red Book
oil on canvas 24 × 20
PCF_KT_MM_11_023

unknown artist 19th C
Woman with a Milk Churn
oil on canvas 126 × 96
PCF_KT_MM_11_032

unknown artist 19th C
George Burr, Town Clerk, (1785–1817)
oil on canvas 75 × 62
PCF_KT_MM_13_007

unknown artist 19th C
Portrait of a Renaissance Man (after Hans Memling)
oil on panel 43 × 31
PCF_KT_MM_17_014

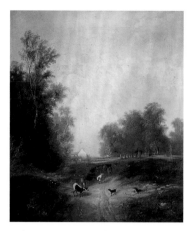

unknown artist 19th C
Landscape
oil on canvas 81 × 66
PCF_KT_MM_18_015

unknown artist 19th C
Tudor Cleric Holding a Ring
oil on canvas 85 × 97
PCF_KT_MM_21_003

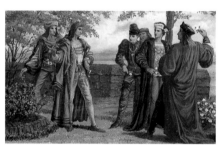

unknown artist 19th C
The Red and the White Rose
oil on canvas 15 × 26
PCF_KT_MM_21_033

unknown artist 19th C
Man on an Ancient Stone
oil on canvas 19 × 29
PCF_KT_MM_24_007

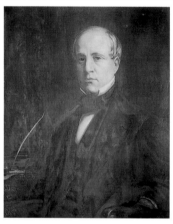

unknown artist 19th C
Thomas Edmett Junior
oil on canvas 75 × 62
PCF_KT_MM_28_032

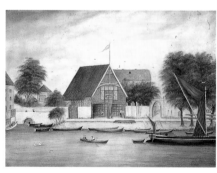

unknown artist 19th C
Hulton-Brown, Boatbuilders
oil on canvas 63 × 84
PCF_KT_MM_29_029

unknown artist 19th C
View of Maidstone
oil on canvas 69 × 100
PCF_KT_MM_29_033

unknown artist 19th C
Portrait of a Woman
oil on canvas 43 × 31
PCF_KT_MM_30_013

unknown artist 19th C
Portrait of a Woman
oil on canvas 43 × 35
PCF_KT_MM_30_016

unknown artist 19th C
Peasant Girl Holding an Orange
oil on canvas 61 × 30
PCF_KT_MM_30_033

unknown artist 19th C
Captain Thomas Best
oil on canvas 122 × 91
PCF_KT_MM_32_029

unknown artist 19th C
Wat Tyler
oil on panel 10 × 8
PCF_KT_MM_33_022

unknown artist 19th C
Alexander Randall
oil on canvas 88 × 78
PCF_KT_MM_34_034

unknown artist 19th C
Thomas Edmett Senior
oil on canvas 80 × 67
PCF_KT_MM_35_009

unknown artist 20th C
Duchess of Kent
oil on canvas 60 × 48
MNERM 1998.1373

unknown artist
Head of Christ (After the Edessa Portrait)
oil on copper 40 × 30
00.1855.111

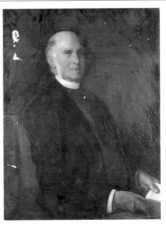

unknown artist
Portrait of an Unknown Clergyman
oil on canvas 90 × 71
MM1889

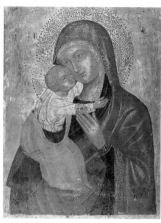

unknown artist
Madonna and Child
oil on panel 29 × 22
10.1944.A

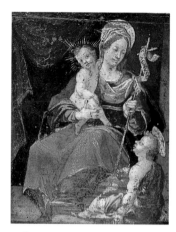

unknown artist
Madonna and Child
oil on panel 19 × 15
10.1944.B

unknown artist
Landscape with an Old Cottage
oil on canvas 54 × 64
Bentlif 75

unknown artist
*Landscape with Ruined Building and Shipping
in the Distance*
oil on canvas 38 × 49
Bentlif 76

unknown artist
Peaches and Grapes
oil on canvas 37 × 45
Bentlif 79

unknown artist
Man Carrying Scythe
oil on panel 27 × 18
PCF_KT_MM_09_031

unknown artist
Mill without Sails
oil on panel 24 × 19
PCF_KT_MM_09_037

unknown artist
Italian View
oil on canvas 38 × 59
PCF_KT_MM_16_029

unknown artist
Mounted Turbaned Warriors (St George?)
oil on canvas 43 × 56
PCF_KT_MM_22_009

unknown artist
Kneeling Knight and Priest
oil on canvas 33 × 24
PCF_KT_MM_22_015

unknown artist
Kneeling Knight and Priest
oil on canvas 34 × 23
PCF_KT_MM_22_018

unknown artist
Christ on the Cross
oil on canvas 21 × 17
PCF_KT_MM_22_022

unknown artist
Group of Fruit
oil on canvas 29 × 42
PCF_KT_MM_23_012

unknown artist
Cottage in a Landscape
oil on canvas 17 × 25
PCF_KT_MM_23_020

unknown artist
Castle Interior with Kneeling Knight
oil on canvas 43 × 35
PCF_KT_MM_27_009

unknown artist
Three Figures (One in Red Cloak)
oil on panel 11 × 12
PCF_KT_MM_27_025

unknown artist
Still Life, Lobster, Fish and Fowl
oil on canvas 99 × 81
PCF_KT_MM_28_007

unknown artist
Portrait of a Man, c.1850
oil on canvas 95 × 76
PCF_KT_MM_28_013

unknown artist
Midshipman 1810
oil on canvas 37 × 30
PCF_KT_MM_30_036

Velde, Willem van de the elder (imitator of)
1611–1693
Shipping: a Kaag and Warship at Anchor
oil & pen on canvas & panel 16 × 25
00.1855.26

Vernet, Claude-Joseph (style of) 1714–1789
Sea Port with Shipping
oil on canvas 84 × 108
68.1897.39

Verwee, Louis Pierre 1807–1877
Shepherd with Animals
oil on canvas 50 × 63
17.1970.30

Vignon, Claude (attributed to) 1593–1670
Solomon and Sheba
oil on canvas 140 × 257
00.1855.124

Vollerdt, Johann Christian 1708–1769
Landscape with a Mill 1765
oil on panel 25 × 31
17.1970.24

Vos, Maarten de (after) 1532–1603
Christ Appears to the Three Marys
oil on canvas 120 × 92
65.1897.85

W. G. C.
Maidstone Bridge 1840
oil on canvas 88 × 112
PCF_KT_MM_2/01_025

W. S. C. 19th C
View on the Medway
oil on canvas 140 × 189
PCF_KT_MM_2/01_012

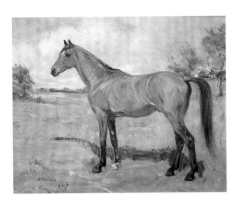

Wales, M.
A Bay Horse
oil on canvas 55 × 67
PCF_KT_MM_06_029

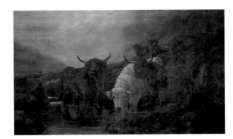

Walls, William 1860–1942
Lance Monckton, Town Clerk, (1905–1930)
oil on canvas 148 × 109
PCF_KT_MM_2/01_028

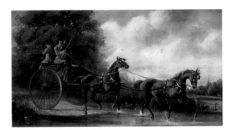

Watson, Robert active 1899–1920
Highland Cattle
oil on canvas 75 × 125
PCF_KT_MM_13_010

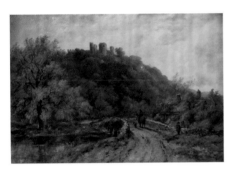

Watts, Frederick W. 1800–1862
Wooded Landscape with Ruins of a Castle
oil on canvas 49 × 71
Bentlif 61

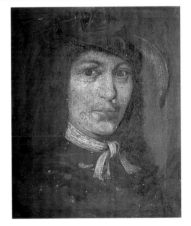

Watts, Isaac
Alexander the Great
oil on canvas 82 × 40
PCF_KT_MM_08_035

Wheeler, T. active 1815–1845
Tandem Dog Cart Crossing a Ford
oil on canvas 22 × 40
PCF_KT_MM_10_021

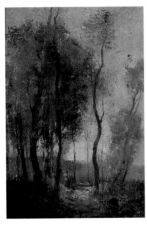

Whitcombe, John active from 1916
Woodland Scene
oil on canvas 35 × 25
79.1963

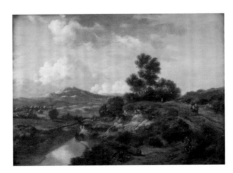

Wijnants, Jan c.1635–1684
Landscape with River and Bridge
oil on panel 29 × 42
Bentlif 62.1897.25

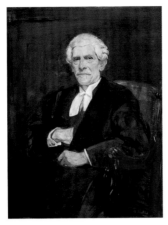

Williamson, William Henry 1820–1883
Seascape
oil on canvas 20 × 40
6.1932

Williamson, William Henry 1820–1883
Seascape, 1863 1863
oil on canvas 24 × 40
PCF_KT_MM_15_035

Wilson, Richard 1713/1714–1782
Landscape
oil on canvas 83 × 103
PCF_KT_MM_01_016

Wood, G. J. d.1838
Scene at Riverhead, Kent
oil on canvas 60 × 45
13.1936

Wright, James
James Best of Boxley, Aged 77, 1826 1826
oil on canvas 74 × 61
65.1955

Zais, Guiseppe (attributed to) 1709–1781
Landscape with Fishermen
oil on canvas 100 × 145
17.1970.18

Zinkeisen, Anna Katrina 1901–1976
Baby's Head
oil on panel 40 × 28
PCF_KT_MM_30_028

Zuccarelli, Franco 1702–1788
Macbeth Meeting the Witches
oil on canvas 50 × 74
PCF_KT_MM_22_003

Zuccarelli, Franco (school of) 1702–1788
Rest on the Flight into Egypt
oil on panel 25 × 39
PCF_KT_MM_09_004

Museum of Kent Life

The Museum of Kent Life is an independent open-air museum in the heart of the Garden of England. The collections reflect life in Kent from the mid-19th century to the mid-20th century and cover both agricultural and social history.

The three paintings show a range of artistic style. There is a naïve depiction of a Kentish village green by W. Poole; a charming scene of work horses at a feeding trough by Sir Garrard Tyrwhitt-Drake, the Museum's benefactor; and finally a lively group of hop-pickers from the 1940s, captured on canvas by Cecilia Carpmael, a well-known exhibitor at the Royal Academy in London.

Although small in number, the paintings add a dimension to the interpretation of the past and capture the essence of a certain warmth and pride associated with Kentish traditions.

Sam Cutter, Curator

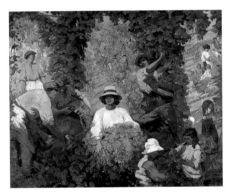

Carpmael, Cecilia
Hop-picking 1941
oil on canvas 245.1 × 294.6
MNERM-2004.1 (P)

Poole, W.
Village Green
oil on board 29 × 36
KENRL: 6453

Tyrwhitt-Drake, Garrard 1881–1964
Working Horses and Pony Eating at Manger,
Goat Sitting in Foreground
oil on canvas 36 × 45
KENRL: 6557

Margate Library

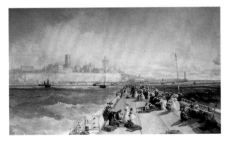

Webb, James c.1825–1895
Margate 1869
oil on canvas

Margate Old Town Local History Museum

I start with an unashamed apology for the less than complete information that the museum was able to offer to the Public Catalogue Foundation. The reasons lie in the chequered history of the collection and governance of Margate Museum, which I will briefly set out here.

The collection has its origins in the Rowe Bequest. In 1926, Arthur Walton Rowe, a noted antiquary, archaeologist and historian, made a gift to the then Borough of Margate of his substantial collection of objects and illustrations connected with the history of Margate and the surrounding area. In 1929 the corporation added to this gift by purchasing the Parker Collection. These formed the basis of the local collection which was housed in Margate Public Library and comprised almost 14,000 items, of which 288 were original watercolour and oil paintings, pen, pencil and crayon drawings. The works in oil were mainly topographical – landscapes and seascapes of Margate – but included portraits; an area which has expanded over the intervening years.

The collection, like many of its contemporaries, was seen as an offshoot of the library, and although a Friends of Margate Museum association was proposed in the 1930s, little curation of the collections was carried out. World War II caused the collection to be stored and dispersed for safety – some items into private homes – and it is not surprising that it was in a diminished and confused state at the end of the war.

The 1950s saw a new lease of life for the library and its dedicated museum wing in the former cottage hospital, with an outstation in the newly restored Tudor House. This relatively stable state of affairs lasted until the 1970s, when local government reorganisation moved the library to county council control and the collection was split between that authority and the newly formed Thanet District Council. There is no doubt that further shrinkage of the collection took place during this interregnum.

Thanet District Council re-opened Margate Museum in its current location in 1987, together with the Tudor House. Again, the collection was shared between the sites, and cataloguing – although meticulous – concentrated on the demands of an inventory rather than the interests of the curator or researcher. The Tudor House operation was short-lived, and before long the museum itself was threatened with closure. The collection was further split by the loan of objects with a perceived high commercial value to other institutions, the intention being to ensure their short-term safe-keeping. This evacuation included many of the better works in oil, and few of these are included in this listing. In 1994, the East Kent Maritime Trust was invited by the district council to assume responsibility for the governance of the museum – but with a relatively low level of support and resources. That situation is still current.

As a result of the change, far more of the collection is displayed, and access has been improved. However, the basic work of researching quite fundamental information is far from complete. This collaboration with the Public Catalogue Foundation has encouraged some of that work to go ahead but has reminded us of the huge amount still to do.

This collection has significant local importance and deserves a higher level of conservation and curation. We hope that inclusion in this catalogue will help to raise its profile and assist us in securing its future.

Michael Cates, former Director

Facing page: Dahl, Michael I (attributed to), *Mawdisty Best, Wife Elizabeth and Daughter Dorothy* (detail), Maidstone Museum and Bentlif Art Gallery (p. 132)

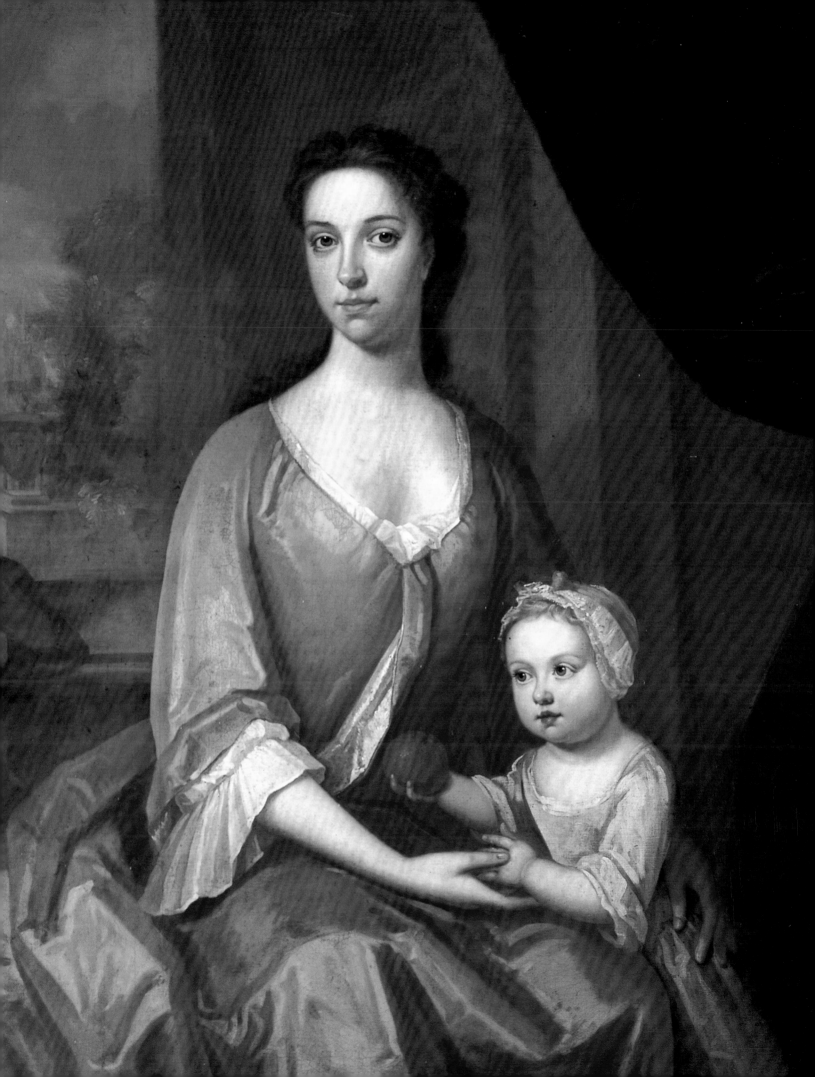

Alexander, Christopher (attributed to)
1926–1982
Harry Annish c.1974
oil on board 74.9 × 60.5
0164

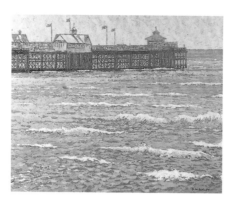

Burley, David
Margate Pier c.1950
oil on board 55.9 × 66.0
3907

Burley, David
Seascape from Margate Pier c.1950
oil on board 55.9 × 66.0
3908

Clint, Alfred 1807–1883
Margate from Westbrook c.1850
oil on canvas 85.9 × 113.0
1109

E. I.
Shipping in Margate Harbour with Droit House and Stone Pier c.1830 21.6 × 28.7
1392

Goddard, V.
Northdown Park
oil on board 44.5 × 58.4
0265

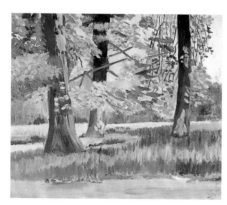

Goddard, V.
Northdown Park
oil on board 44.5 × 58.4
0266

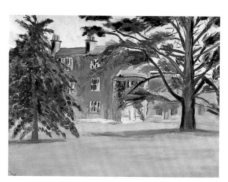

Goddard, V.
Northdown House and Park, Margate
oil on board 43.9 × 57.9
0267

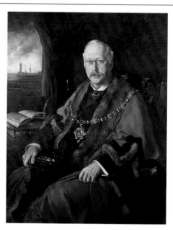

Hawkins, G. M.
William Booth Reeve, Mayor of Margate 1910
oil on canvas 172.7 × 132.1
1260

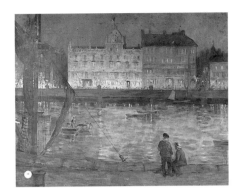

Hawkins, G. M.
Margate Harbour 1830–1890?
oil on canvas 61.0 × 71.1
1602

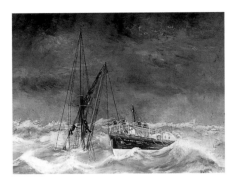

Hopper, W. G.
RNLI Rescue of 'Vera' 1952
oil on board 66.0 × 86.4
1333

Hopper, W. G.
Newgate Gap: Coast Guards Looking for Smugglers c.1820
oil on board 57.9 × 64.8
1441

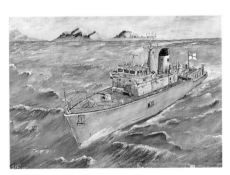

Jackson, Bob
'HMS Margate', an RNA M30 Ship 1990
oil on board 25.4 × 35.6
3241

Jackson, J.
Daniel Jarvis
oil on wood 69.9 × 52.1
1370

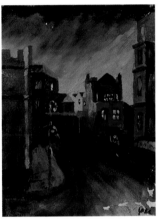

Judd (attributed to) 20th C
Margate Street Scene
oil on canvas 45.7 × 35.6
3704

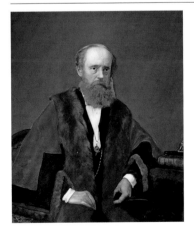

N. K.
Mayor of Margate, Alderman Edward Rapson 1866–1887
oil on board 71.1 × 62.2
1184

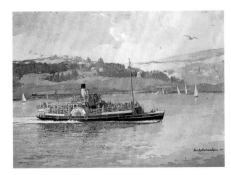

Orchardson, Ian
PS 'Kingswear Castle' 1981
oil on hardboard 91.4 × 119.4
3909

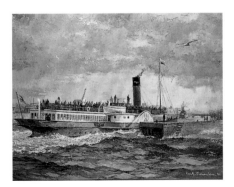

Orchardson, Ian
PS 'Nephine' 1982
oil on hardboard 91.4 × 119.4
3910

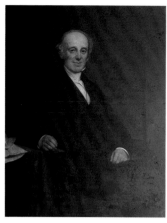

Phillips, Thomas 1770–1845
Francis Cobb 1790
oil on canvas 165.1 × 114.3
1175

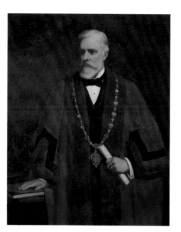

Ruith, Horace van active 1874–1919
Mayor William Leach Lewis 1888–1906
oil on canvas 147.3 × 119.4
1261

Sherrin, Daniel 1869–1940
Hodges Flagstaff, Palm Bay c.1920
oil on canvas 40.6 × 61.0
1335

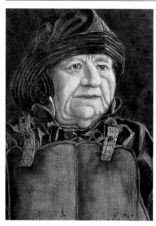

Smith, Frank Sidney b.1928
Albert John Emptage 1987
oil on canvas 38.1 × 22.9
0903

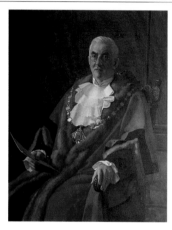

Souter, John Balloch 1890–1972
F. J. Cornford 1946
oil on canvas 165.1 × 121.9
1151

Souter, John Balloch 1890–1972
Edward Sidney Linnington JP, Mayor of Ramsgate, (1935–1936) 1949
oil on canvas 165.1 × 127.0
1189

unknown artist
British Warships off Reculver c.1800
oil on canvas 55.9 × 135.9
1368

unknown artist
Droit House with Bathing Machines c.1800
oil on canvas 21.6 × 28.7
1389

unknown artist
Francis Cobb? c.1800
oil on canvas 111.8 × 86.4
3486

unknown artist
Francis Cobb? c.1800
oil on canvas 113.0 × 87.6
3487

unknown artist
Margate Harbour with Ships c.1830
oil on canvas 21.6 × 28.7
1390

unknown artist
Fort Hill, No Man's Land, Mrs Booth's House
c.1830
oil on canvas 21.6 × 28.7
1391

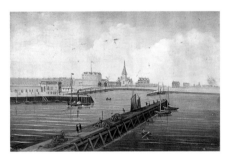

unknown artist
Yarmouth Harbour c.1830
oil on wood 26.2 × 38.9
1661

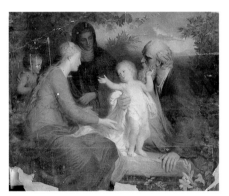

unknown artist
Religious Theme c.1850
oil on card 55.9 × 64.8
1610

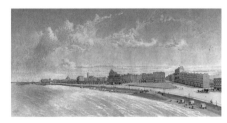

unknown artist
Marine Terrace, Margate c.1860–1880
oil on board 86.4 × 162.6
1259

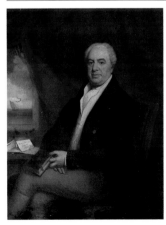

unknown artist
Francis Cobb 1880
oil on canvas 165.1 × 121.9
1169

unknown artist
Assembly Rooms Fire, Margate, Friday October 27, 1882 1882
oil on canvas 55.9 × 99.1
1436

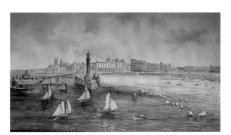

unknown artist
Margate Main Sands and Harbour from the Sea
c.1890
oil on canvas 66.0 × 99.1
0270

unknown artist
Edward Wooton 1895
oil on canvas 165.1 × 121.9
1128

unknown artist
Newgate Gap, Margate c.1910
oil on glass 19.1 × 27.9
2050

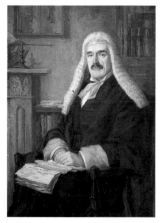

unknown artist
Sir Herbert Stuart Sankey 1913
oil on canvas 72.4 × 58.4
1182

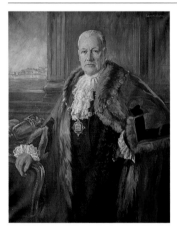

unknown artist
F. L. Pettman 1935
oil on canvas 165.1 × 134.6
1241

unknown artist
Margate Twinning 1980–1982
oil on canvas 62.2 × 74.9
1438

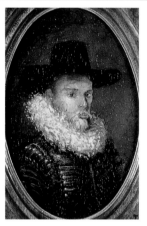

unknown artist
Tudor Male
oil on board 26.7 × 19.1
0275

unknown artist
Tudor Female
oil on board 26.7 × 19.1
0276

unknown artist
Thomas Dalby Reeve, Mayor of Margate,
(1873–1875)
oil on canvas 143.8 × 116.8
1258

unknown artist
Marine Terrace, Margate, the Kent Hotel,
Ladies on Bicycles
oil on cardboard 21.6 × 30.5
1600

unknown artist
Draper's Mill, Margate
oil on wood 17.8 × 43.2
1782

unknown artist
Alderman Hughes
oil on canvas 127.0 × 101.6
3485

unknown artist
Old Town Hall, Margate
oil on canvas 45.7 × 35.6
3703

The Guildhall, Queenborough

Gascoyne, George 1862–1933
Alderman Alfred Whittaker Howe JP, CC 1897
oil on canvas 213.3 × 182.9
A1

Hucker, A.
Josiah Hall Esq. JP, Mayor of Queenborough
1881
oil on canvas 226.0 × 175.3
A2

Shrubsole, F.
J. Breeze Esq., Mayor of Queenborough c.1840
oil on canvas 121.9 × 91.4
A4

unknown artist
G. Iles Esq., Mayor of Queenborough c.1700
oil on canvas 147.0 × 121.9
A5

unknown artist
Thomas Young Greet, Mayor of Queenborough
c.1818
oil on canvas 261.6 × 170.0
A3

Ramsgate
Maritime Museum

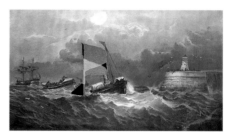

Acock, A. P.
Sir Ernest Shackleton's Ship, 'Quest', in Ramsgate Harbour 1921
oil on board 25.5 × 20.0
KENMT:472

Broome, William (attributed to) 1838–1892
Tug 'Vulcan' Towing Stricken Vessel into Ramsgate with Lifeboat
oil on canvas 61 × 107
KENMT:1396

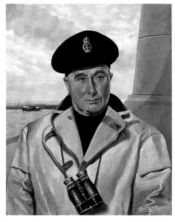

Gore, David
Douglas Kirkaldie c.1950
oil on canvas 76.0 × 63.5
KENMT:551

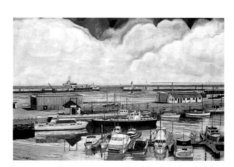

Gould, Brian S.
Ramsgate Harbour Entrance and Crosswall 1975
oil on board 136 × 193
KENMT:473

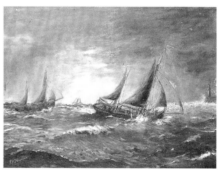

Hawkins, F. W. late 19th C
Seascape: Fishing Smacks off a Harbour
oil on canvas 47 × 61
E.0425/ID.1437 (P)

Hopper, William G.
Helicopter Rescue from South Goodwin Lightship 1950s
oil on board 25.5 × 30.0
KENMT:910

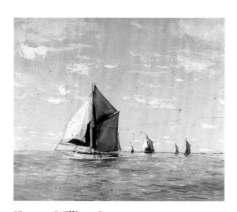

Hopper, William G.
Everard's 'Sara' Leading in the Thames Barge Race 1950s
oil on board 22 × 28
KENMT:1107

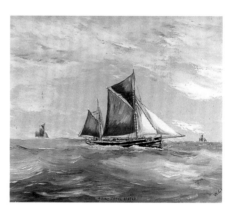

Hopper, William G.
A Fine Trawl Breeze 1950s
oil on board 22 × 28
KENMT:1108

Lightoller, Mavis
*Motor Yacht 'Sundowner' in WWII Admirality
Livery and Flying the White Ensign*
oil on board 12.5 × 17.5
KENMT:1355

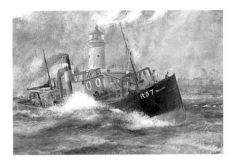

Millett, K. G.
*Steam Trawler 'Treasure R37' at Ramsgate
Harbour Entrance*
oil on tea tray 35 × 50
KENMT:1114

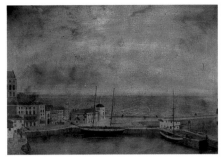

unknown artist early 19th C
View of Ramsgate Harbour
oil on wooden panel 33 × 47
E.0425/ID.1354 (P)

unknown artist early 20th C
*Painting of Sunk Lightship from Starboard
Quarter*
oil on wooden panel 13.5
KENMT:324.1

unknown artist early 20th C
*Painting of Sunk Lightship from Abeam, in
Wooden 'Lifebelt' Surround*
oil on wooden panel 13.5
KENMT:324.2

Ramsgate Museum

*Sadly, Ramsgate Library, Museum and Art Gallery was almost completely
destroyed by fire on 13 August 2004. Any enquiries relating to either the surviving
paintings, or those which did not survive, should be addressed to Kent County
Council Arts and Museums, Springfield, Maidstone ME14 2LH.*

Ramsgate Museum was opened in 1912. It is located in the Ramsgate Public
Library building, which was built in 1904 and was partly funded by the
Carnegie Foundation. A Neo-Georgian, Adams-style building, designed by A.
D. Ashhead, the building was bombed during World War II, resulting in the loss
of the original artefacts. After the war, the collections were reassembled. It was
at this time that the museum began its collection of fine art.

The museum's main collections document the social history of the town,
reflecting its development from early fishing village to popular 19th century
resort and, more recently, 20th century port. The fine art collection generally

has the same aims, and adds a useful dimension to the museum's cultural range.

The Ramsgate Museum fine art collection contains more than 400 works, in various media. Watercolours are the largest group but there are also engravings, drawings, photographs and oil paintings. There are some 55 oil paintings in the collection, dating from the late 18th century to the most recent acquisition, which was executed in 1986. The paintings are mainly of local topographical and biographical interest. There are several portraits, among them one of Sir Moses Montefiore, the renowned 19th century campaigner for Jewish emancipation, and one of 'Lord' George Sanger, the famous circus owner and entrepreneur. Portraits of less well-known residents of the town typically include local churchmen and civic dignitaries, reflecting the fashion of the day. The maritime character of Ramsgate is abundantly represented in a number of seascapes and views of the harbour. In addition, there are several studies of local sailing craft, such as the trawler *Gull* and several of the town's lifeboats. Particularly useful historically are several paintings which record sites and buildings that have been changed or demolished. In the latter category we have Montefiore House.

Apart from local themes, the collection contains a few paintings which reflect the emergence of new schools of art, in particular during the Victorian era. Several, including *Stranger in the Woods* by Dorothy Mostyn, were influenced by the Pre-Raphaelite school; others, such as *Arab Scene* by an unknown artist, and *Acropolis at Sunrise* by Herbert Edwin Pelham Hughes-Stanton, are traditional in style and illustrate the voracious Victorian appetite for travel and culture.

The artists represented in the collection are mainly local painters, such as E. G. Moody and Kennett Beacham Martin, who were little known outside Kent. The work of these painters ranged from local subjects to thematic studies. However, a small number of the paintings are by well-known artists, in particular Charles Spencelayh and Sidney Paget, who were known for their portraiture. The collection also contains examples of works by maritime artists such as S. Broome, who travelled around the British Isles, painting the coastal districts. Their work was often reproduced in books of engravings, popular with the Victorian tourists – a practice common among many artists of the day, including J. M. W. Turner.

Most of the paintings in the Fine Art Collection were gifted to the people of Ramsgate during the post-war years; since then Ramsgate Museum has acted as custodian. Among the donors was Dame Janet Stancomb-Wills, a member of an eminent local family, who served Ramsgate as a councillor for many years. She was also a great benefactor of the town; among her many bequests were a number of oil paintings in the collection, including a portrait of the great lady herself.

Beth Thomson, Team Librarian, Reference Information and Local Studies

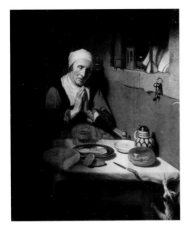

Asschen, B.
Grace before Meat 1906
oil on canvas 132 × 110
R209

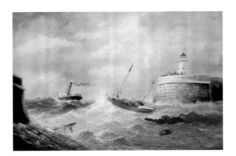

Broome, S.
Lifeboat Leaving Harbour 1891
oil on canvas 50 × 74
R312

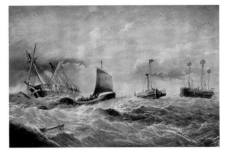

Broome, S.
Lifeboat at the Goodwins 1891
oil on canvas 49 × 74
R313

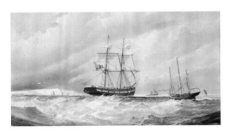

Broome, S.
Seascape 1880
oil on canvas 43.1 × 78.8
R378

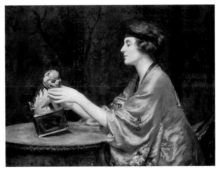

Collings, Albert Henry 1858–1947
Kimono and Kylin 1917
oil on canvas 85 × 115
R208

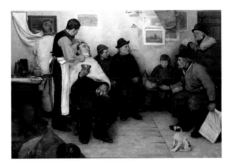

Craft, Percy Robert 1856–1934
Barber's Shop c.1900
oil on canvas 111 × 162
R200

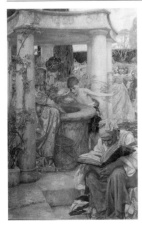

Dixon, Arthur A. active 1892–c.1927
Well 1913
oil on canvas 122 × 80
R214

Grace, Frances Lily active 1876–1909
Still Life 1877
oil on canvas 41 × 51
R226

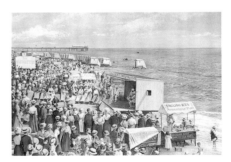

Hollings, A. B.
Ramsgate Sands 1956
oil on canvas 52 × 77
R314

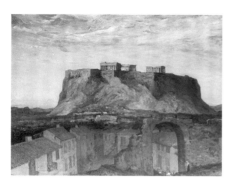

Hughes-Stanton, Herbert Edwin Pelham
1870–1937
Acropolis at Sunrise c.1910
oil on canvas 88 × 115
R204

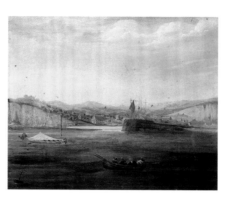

Martin, Kennett Beacham 1788–1859
View from the Sea 1821
oil on canvas 49 × 60
R306

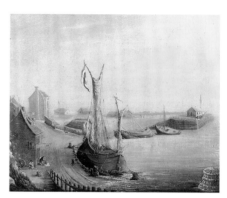

Martin, Kennett Beacham 1788–1859
Ramsgate Harbour 1821
oil on canvas 49 × 59
R307

Martin, Kennett Beacham 1788–1859
Ramsgate Harbour 1821
oil on canvas 49 × 100
R308

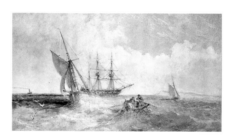

Meadows, James Edwin active 1853–1875
Off Folkestone
oil on canvas 60 × 105
R206

Moody, E. G.
Sandwich Grammar School 1889
oil on wood 12.0 × 19.5
R225

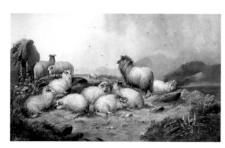

Morris, A.
Sheep 1986
oil on canvas 75 × 126
R218

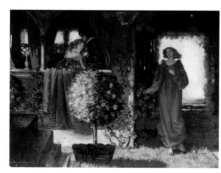

Mostyn, Dorothy
Stranger in the Woods c.1910
oil on canvas 49 × 67
R205

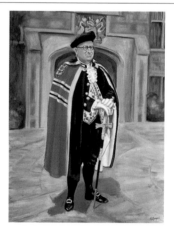

Moyes, E.
E. G. Butcher, Baron of Cinque Ports
oil on canvas 102 × 76
R483

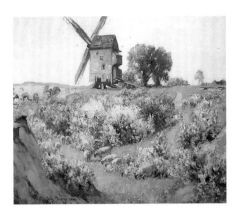

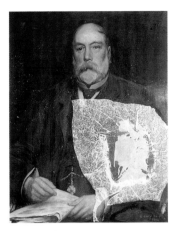

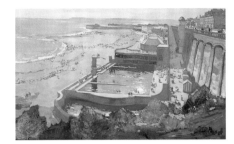

Murray, David 1849–1933
Water Meadows of Hampshire 1916
oil on canvas 52.0 × 59.5
R217

Paget, Sidney 1861–1908
Sir William Henry Wills 1901
oil on canvas 90 × 70
R216

Richmond, Leonard active 1912–1940
Ramsgate Swimming Pool 1920–1930
oil on canvas 74.5 × 105.0
R293

Salles, Jules 1814–1900
Woman in 18th Century Dress 1870–1900
oil on canvas 103 × 80
R221

Shepherd, Alfred
Ramsgate Library
oil on canvas 86 × 42
R488 (P)

Spencelayh, Charles 1865–1958
'Lord' George Sanger 1908
oil on canvas 150.0 × 98.5
R300

Stokes, Adrian Scott 1854–1935
Sunset c.1910
oil on canvas 69 × 84
R228

Tanner, Alice
'Lion Gate' at Hampton Court c.1910
oil on canvas 74 × 62
R219

unknown artist 18th C
Rev. George Townsend Snr
oil on canvas 75.0 × 62.5
R302

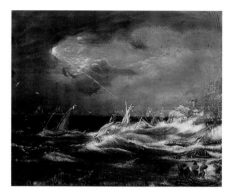

unknown artist
Storm at Ramsgate 1821
oil on canvas 49 × 60
R310

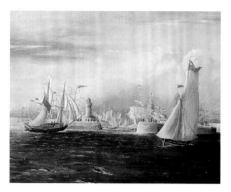

unknown artist
Shipping at Ramsgate 1821
oil on canvas 48 × 60
R311

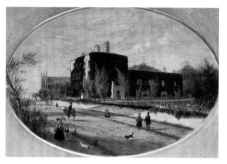

unknown artist
Ramsgate Street c.1850
oil on canvas 32.5 × 48.0
R322

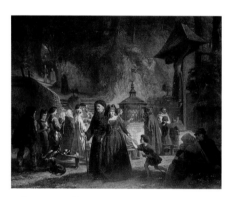

unknown artist
Scene with Shrine 1852
oil on canvas 79 × 100
R213

unknown artist
Cloister or Church Interior 1850–1900
oil on canvas 90 × 70
R215

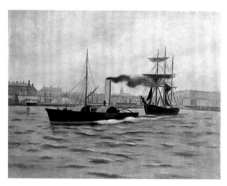

unknown artist
Paddle Steamer 1850–1900
oil on canvas 62 × 77
R222

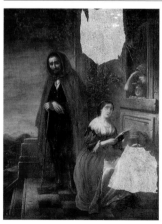

unknown artist
Monk and Woman c.1850–1900
oil on canvas 123 × 95
R210

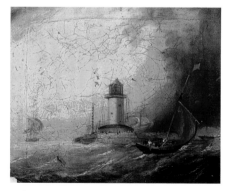

unknown artist
Ramsgate Lighthouse 1885
oil on canvas 24.0 × 29.5
R295

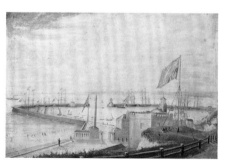

unknown artist 19th C
Ramsgate Harbour
oil on canvas 75 × 105
R290

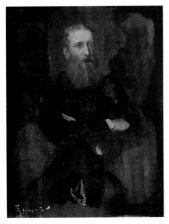

unknown artist
Colonel King Harman c.1900
oil on canvas 116 × 91
R211

unknown artist
James Webster c.1900
oil on wood 140 × 108
R202

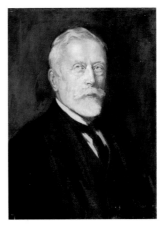

unknown artist
Thomas Whitehead c.1900
oil on canvas 140 × 110
R203

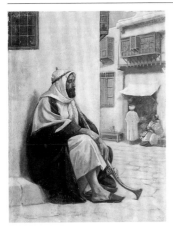

unknown artist
Arab Scene c.1900
oil on canvas 45 × 35
R227

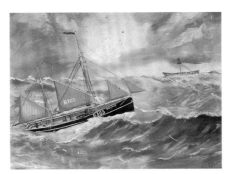

unknown artist
Trawler 'Gull' 1902
oil on wood 44.5 × 60.5
R294

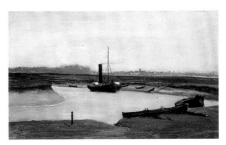

unknown artist
Port of Richborough 1918
oil on wood 12.0 × 19.5
R224

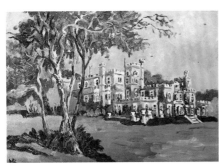

unknown artist
Montefiore House 1950–1980
oil on canvas 36 × 51
R419

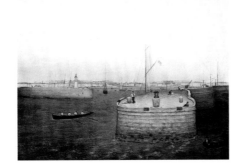

unknown artist
Ramsgate Harbour
oil on canvas 97 × 123
R207

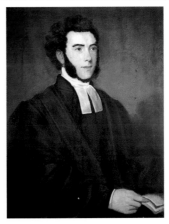

unknown artist
Rev. Henry Joseph Bevis
oil on canvas 90 × 70
R298

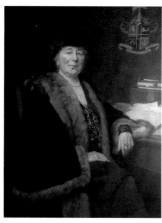

unknown artist
Dame Janet Stancomb-Wills
oil on canvas 124 × 97
R299

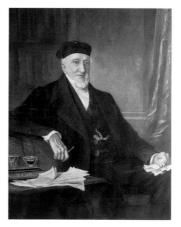

unknown artist
Sir Moses Montefiore
oil on canvas 125 × 100
R301

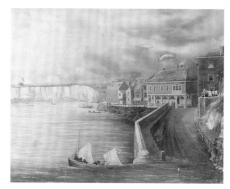

unknown artist
Ramsgate Harbour
oil on canvas 49 × 60
R309

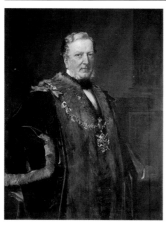

unknown artist
John Kennett Esq.
oil on canvas 115 × 90
R317

unknown artist
Mr Speechley (Church Clerk)
oil on canvas 73.0 × 62.5
R318

unknown artist
Sandwich Bay
oil on canvas 59 × 90
R320

unknown artist
no information available

Fairway Library, Rochester

This painting, finished in 2000, depicts a fox held in a woman's arms. It is rich in symbolism: the moon embodies the power of nature and its strong connection with the female, while the wild predator represented by the urban fox symbolises city dwellers' tenuous connection with wildlife. A poet and painter based in Chatham, Lewis was one of the six original Medway Poets, a group of writers, visual artists and musicians which formed around poetry readings organised at a Maidstone pub, and is now an active member of the Stuckists art group. This group was established in 1999 to promote the cause of painting as the most viable art form to address contemporary issues.

Judy Frayne, Senior Library Assistant

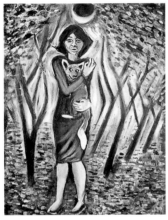

Lewis, Bill b.1953
The Moon, the Woman and the Fox 2000
acrylic on canvas 45.7 × 30.5
PCF_KT_FLR_01_006

Guildhall Museum, Rochester

The Guildhall Museum holds a collection of some hundred oil paintings. Since it opened in 1897, the museum has collected artwork to add to the diverse and colourful collections originating from local collectors. However, it was not until the 1970s that two major themes in the collection emerged.

The Guildhall Portraits

When the Museum was moved from Eastgate House to its current location in the 17th century Guildhall building, the curator became responsible for a whole new collection of portraits. These were 12 life-size portraits with an association of nearly three centuries with the Guildhall Main Chamber. These are of the members of parliament for Rochester, mostly from the early 18th century. These men were often absentee members and spent most of their time as serving admirals who commanded fleets fighting the French, the Dutch and pirates in the Mediterranean. These magnificent pictures were painted by some of the principal portrait artists of the day, including Godfrey Kneller and

Daniel de Konink. Charles Dickens is known to have been familiar with the portraits in the Guildhall, as he incorporates them into a scene from *Great Expectations*. Pip is taken to the Town Hall to be bound over as an apprentice. He notices 'some black shining portraits on the wall, which my unartistic eye regarded as a composition of hardbake and sticking-plaster'. Fortunately, careful cleaning and conservation of these items has transformed them from their blackened state to reveal the majestic appearance they have today.

The Paintings of Charles Spencelayh (1865-1958)

Born in Rochester, his father a friend of Dickens, this local man has rarely been acknowledged for his unique talent. Obsessed with portraying ordinary people, often the elderly in cluttered domestic settings, Spencelayh demonstrated wry humour and a discriminating eye for social observation, all underpinned by his extraordinary painting skill. Spencelayh was indifferent to changing whims and fashions, continuing to paint and draw in his own distinctive style throughout his long life.

The Guildhall Museum holds over 20 oil paintings by this artist, together with drawings, engravings and preliminary sketches. The collection attempts to provide a biographical story and focuses on the artist's self-portraits, portraits of his son and both wives, and pictures that incorporate other personal touches such as family pets and visual references to the Medway area that this artist was so familiar with. The collection also includes several examples of his well-known works, showing his interest in the eccentric and whimsical portrayal of elderly character studies. The museum purchased some items at auction during the 1980s, and further pictures were purchased from and generously donated by descendants of the artist.

Stephen Nye, Assistant Curator

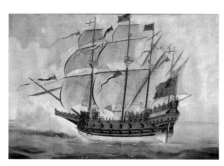

Allen, Thomas (attributed to) d.1772
The 'Great Harry' Warship c.1767–1772
oil on canvas 65 × 90
A2957

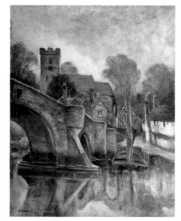

Bassett, Grace 20th C
Aylesford Bridge and Church
oil on canvas 43.3 × 35.3
A2662

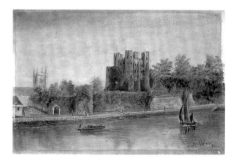

Bell, Henry
Rochester Castle and Esplanade 1884
oil on canvas 20.5 × 30.5
A2668

Cooper, Thomas Sidney 1803–1902
In the Meadows c.1850
oil on canvas 45 × 75
A2650

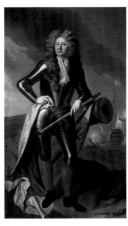

Dahl, Michael I 1656 or 1659–1743
Sir Cloudesley Shovell, MP
oil on canvas 228 × 143
A2601

E. J. B.
View of Strood from Ladbury's Quay, Rochester
1844
oil on canvas 55 × 89
A2631

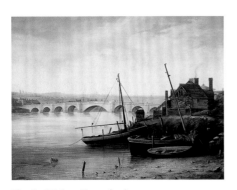

Finch, W. (attributed to)
View of Frindsbury from Ladbury's Quay
mid-19th C
oil on canvas 46.0 × 61.5
A2678

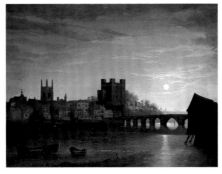

Finch, W. (attributed to)
Rochester Bridge by Moonlight mid-19th C
oil on canvas 46.0 × 60.5
A2679

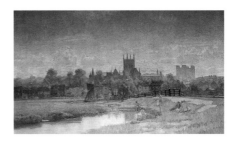

Fox, Ernest R. active 1886–1919
*Old Rochester before the Building of the
Railway* c.1893
oil on canvas 100.7 × 152.4
A2640

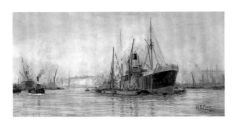

Freer, H. Branston active 1870–1902
River View of the Medway c.1902
oil on canvas 59.2 × 119.5
A2642

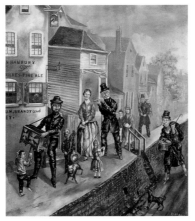

Glibber, N. T.
Scene at the White Swan, Chatham
mid-19th C
oil on canvas 86.5 × 78.0
A2660

Hayman, H. W.
*Rochester Castle from the West End of Baker's
Walk* 1890
oil on canvas 30 × 24
A2649

Hayter, George 1792–1871
Lieutenant Waghorne RN 1844
oil on canvas 75 × 62
A2629

Hopper, Henry
Rochester Castle in Winter late 19th C
oil on metal 25.1
A237

Hopper, Henry
Rochester Castle in Winter with Robin
late 19th C
oil on metal 29.8
A238

Hopper, Henry
View of Rochester Castle from Epaul Lane
late 19th C
oil on canvas 24.5 × 34.5
A2646

Hopper, Henry
Rochester Castle from Strood Esplanade
c.1880s
oil on canvas 24.5 × 34.5
A2647

Hopper, Henry
Prior's Gate, Rochester late 19th/early 20th C
oil on canvas 34.5 × 44.5
A2685

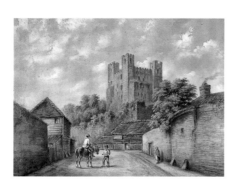

Hopper, Henry
Rochester Castle and the King's Head Stables
late 19th/early 20th C
oil on canvas 54.5 × 72.0
A2694

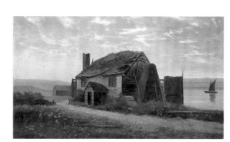

Hopper, Henry (attributed to)
Ladbury's Cottage, Rochester late 19th C?
oil on artboard 24.0 × 57.2
A2638

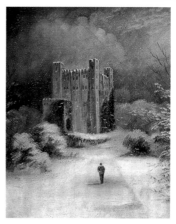

Hopper, Henry (attributed to)
Rochester Castle under Snow late 19th C?
oil on artboard 29 × 24
A2639

Facing page: Peake, Mervyn, *Portrait of a Young Man* (detail), Maidstone Museum & Bentlif Art Gallery (see p. 152)

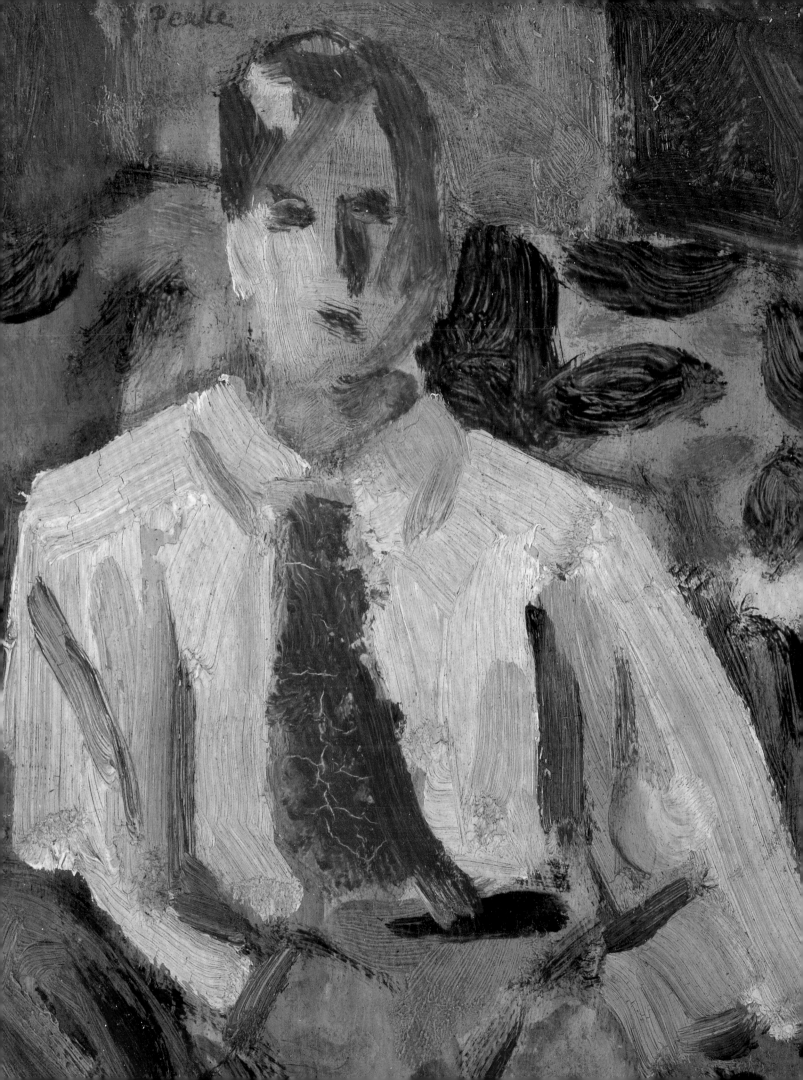

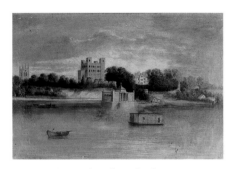

Hopper, Henry (attributed to)
View of Rochester Castle and River Medway
19th C
oil on canvas 50 × 75
A2687

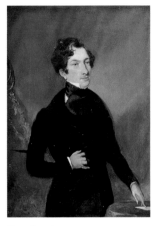

Huntley, W.
John Dickens (Father of Charles Dickens)
c.1820
oil on canvas 35.5 × 25.5
A2670

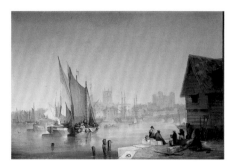

Knell, William Adolphus 1805–1875
Rochester, a Misty Morning c.1840s
oil on canvas 75.7 × 90.9
A2641

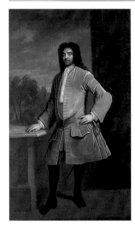

Kneller, Godfrey 1646–1723
Sir Joseph Williamson, MP
oil on canvas 250 × 152
A2591

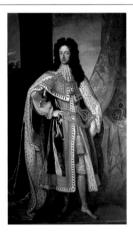

Kneller, Godfrey (attributed to) 1646–1723
King William III
oil on canvas 243 × 144
A2594

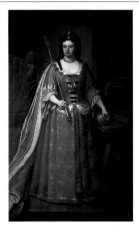

Kneller, Godfrey (attributed to) 1646–1723
Queen Anne
oil on canvas 243.0 × 145.5
A2595

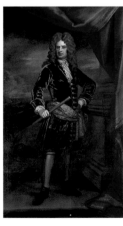

Kneller, Godfrey (attributed to) 1646–1723
Sir Stafford Fairbourne, MP
oil on canvas 242.4 × 150.3
A2597

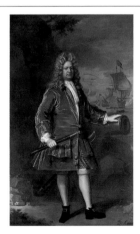

Konink, Daniel de 1668–after 1720
Sir John Leake, MP
oil on canvas 223 × 148
A2593

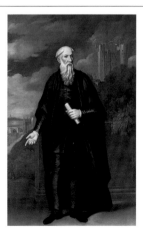

Konink, Daniel de 1668–after 1720
Richard Watts, MP
oil on canvas 243 × 150
A2596

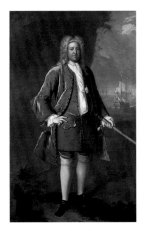

Konink, Daniel de (attributed to) 1668–after 1720
Sir Thomas Colby, Bt, MP
oil on canvas 243.0 × 148.4
A2598

Lacy, Charles John de c.1860–1936
Stormy Sea Scene with Sailing Ships
oil on canvas 60 × 89
A2657

Lint, Hendrik Frans van 1684–1763
Classical Italian Landscape mid-18th C
oil on canvas 103.0 × 165.5
A2692

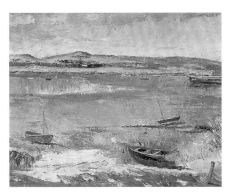

Lott, Eva C. 20th C
Dell Quay
oil on canvas 34.0 × 44.5
A2689

Peachey, Alfred
Old Luton 1904
oil on canvas 59 × 79
A2667

Peachey, E. H.
Dull Prospect Near Gillingham Park 1960
oil on canvas 59.0 × 49.5
A2661

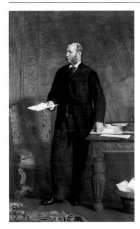

Pearce, Stephen 1819–1904
Philip Wykeham Martin, MP 1880
oil on canvas 226 × 148
A2600

Perugini, Kate 1838–1929
Mary Angela Dickens (Daughter of Charles Dickens) 1882
oil on canvas 23 × 15
A2671

Perugini, Kate 1838–1929
Dorothy De Michele 1892
oil on canvas 73.5 × 44.0
A2682

Phillips, J. E.
Roebuck Inn, St Margaret's Street, Rochester
1876
oil on wood 83.5 × 125.5
A2696

Phillips, Richard 1681–1741
Sir Thomas Palmer, Bt, MP 1722
oil on canvas 223 × 150
A2592

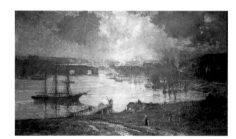

Priestman, Bertram 1868–1951
Sunset and Smoke over Rochester 1912
oil on canvas 114 × 180
A2632

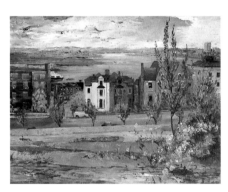

Shortland, Dorothy b.1908
View of the Medway from the New Road
oil on canvas 85.4 × 137.5
A2690

Smetham, H. M.
Eastgate House Entrance Hall late 19th C?
oil on canvas 49.5 × 75.0
A2666

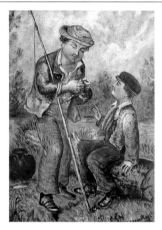

Spencelayh, Charles 1865–1958
Boys Fishing 1873
oil on canvas 12 × 8
A2605

Spencelayh, Charles 1865–1958
Boy's Head 1880s
oil on canvas 40.0 × 30.3
A2606

Spencelayh, Charles 1865–1958
If They Were Real
oil on canvas 42 × 26
A2607

Spencelayh, Charles 1865–1958
Polly Not Forgotten
oil on canvas 20 × 16
A2609

Spencelayh, Charles 1865–1958
My Pet 1890
oil on canvas 31.8 × 24.2
A2610

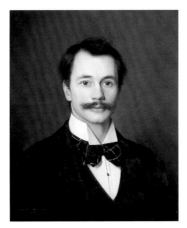

Spencelayh, Charles 1865–1958
Charles Spencelayh at the Age of 33 1898
oil on canvas 61.0 × 50.8
A2612

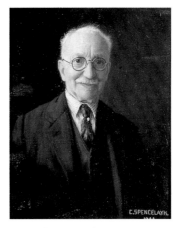

Spencelayh, Charles 1865–1958
Charles Spencelayh at the Age of 79 1944
oil on canvas 29.2 × 24.4
A2613

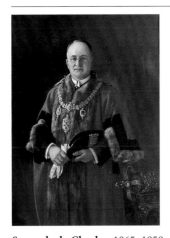

Spencelayh, Charles 1865–1958
Alderman Price (Mayor of Rochester in 1921, 1922 & 1923) 1922
oil on canvas 64.5 × 49.0
A2615

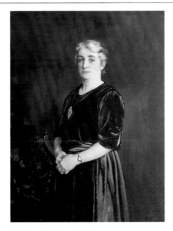

Spencelayh, Charles 1865–1958
Mrs Price, Wife of Alderman Price (Mayor of Rochester in 1921, 1922 & 1923) 1922
oil on canvas 64.5 × 49.5
A2616

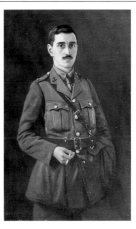

Spencelayh, Charles 1865–1958
Vernon Spencelayh (Artist's Son) 1917
oil on canvas 44.5 × 29.3
A2617

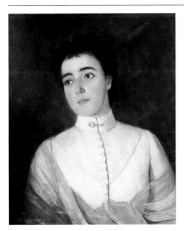

Spencelayh, Charles 1865–1958
The first Mrs Spencelayh (Elizabeth Hodson Stowe) 1889
oil on canvas 61.0 × 50.8
A2618

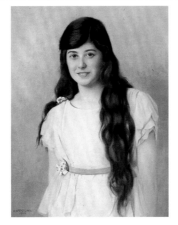

Spencelayh, Charles 1865–1958
A Dark Beauty 1922
oil on canvas 64.7 × 49.4
A2643

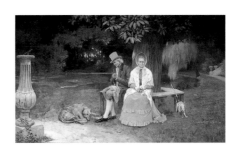

Spencelayh, Charles 1865–1958
Sunset c. 1890s
oil on canvas 59.5 × 100.0
A2644

Spencelayh, Charles 1865–1958
Frindsbury Steam Brewery c.1890s
oil on canvas 29.5 × 34.7
A2645

Spencelayh, Charles 1865–1958
Panoramic View of Luton, Chatham 1905
oil on photographic paper 28.1 × 111.5
A2673

Spencelayh, Charles 1865–1958
The Twilight of Life
oil on canvas 51 × 38
A2681

Spencelayh, Charles 1865–1958
Dutch Snow Scene 1882
oil on canvas 17.8 × 46.0
A2683

Spencelayh, Charles 1865–1958
The Second Mrs Spencelayh 1947
oil on canvas 40.0 × 29.5
A2684

Spencelayh, Charles 1865–1958
Dog's Head 1897
oil on canvas 8.0 × 6.4
A2686

Spencelayh, Charles (attributed to)
1865–1958
Henry Spencelayh c.1875
oil on canvas 39.5 × 34
A2652

Spencelayh, Charles (attributed to)
1865–1958
Mrs Spencelayh c.1875
oil on canvas 39 × 34
A2653

Stedman 19th C
Naïve Painting of Delce Farm
oil on artboard 20.3 × 25.3
A2633

Stedman 19th C
Naïve Painting of Delce Farm
oil on artboard 20.3 × 25.3
A2634

Stedman 19th C
Naïve Painting of Delce Farm, Showing Haymaking
oil on artboard 45.5 × 62.0
A2635

Stephen, Daniel
The Medway Bridge M2 1963
oil on canvas 85.4 × 137.5
A2691

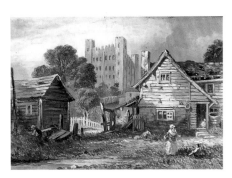

S. N.
Ladbury's Cottage, Rochester 1812
oil on canvas 21.5 × 31.5
A2648

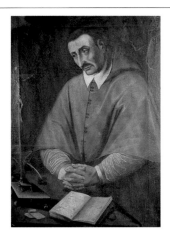

unknown artist 17th C?
Unknown Cardinal
oil on canvas 96 × 69
A2688

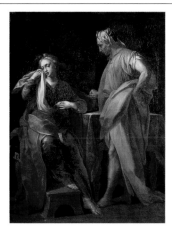

unknown artist late 17th C?
Scene with Two Classical Figures
oil on canvas 101 × 78
A2659

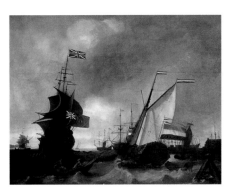

unknown artist late 17th C?
Dutch Raid on the River Medway in 1667
oil on canvas 81.0 × 103.5
A2663

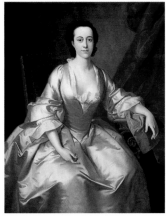

unknown artist
Lady Carberry c.1720
oil on canvas 124.5 × 99.0
A2664

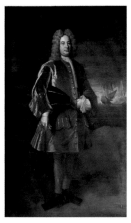

unknown artist
Sir John Jennings, MP 1721
oil on canvas 227.2 × 136.3
A2599

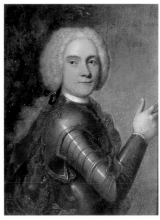

unknown artist early 18th C?
Sir Cloudesley Shovell, MP
oil on copper 21 × 16
A2604

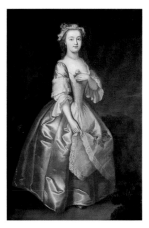

unknown artist early 18th C?
*Portrait of Unknown Lady with Roses in Early
18th C Pink Dress*
oil on canvas 147.5 × 100.0
A2674

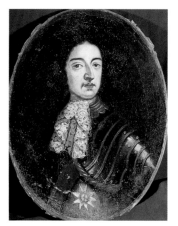

unknown artist 18th C?
King James II
oil on canvas 41.5 × 32.9
A2665

unknown artist late 18th/early 19th C
Classical Italian Landscape
oil on canvas 103 × 151
A2693

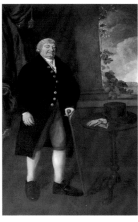

unknown artist late 18th/early 19th C?
Alderman Thomas Stevens, Mayor of Rochester
oil on canvas 250 × 170
A2627

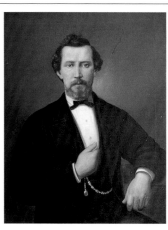

unknown artist
John Foord c.1850
oil on canvas 90 × 77
A2655

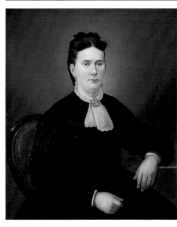

unknown artist
Rebekah Foord c.1850
oil on canvas 92 × 77
A2656

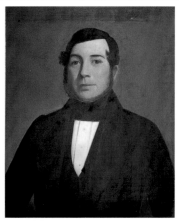

unknown artist
Thomas Hill 1857
oil on canvas 66.5 × 55.0
A2637 (P)

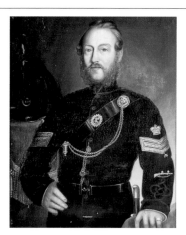

unknown artist
*Sergeant Cuthbertson of the 19th City of
Rochester Volunteer Rifles* c.1860
oil on canvas 57.0 × 46.5
A2630

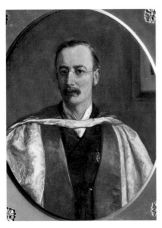

unknown artist
Frank Bridge CVO, MusD 1887
oil on canvas 70 × 60
A2654

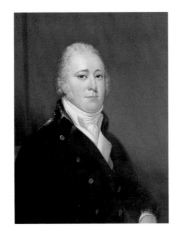

unknown artist early 19th C
William Peter King, Mayor of Rochester in 1815
oil on canvas 75.0 × 61.5
A2602

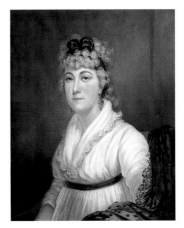

unknown artist early 19th C
Mrs P. King, Wife of William Peter King, Mayor of Rochester in 1815
oil on canvas 75.0 × 61.5
A2603

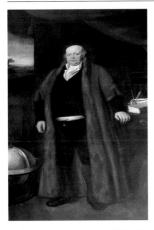

unknown artist early 19th C?
Alderman Richard Thompson, MD, Mayor of Rochester
oil on canvas 250 × 180 (E)
A2626

unknown artist 19th C
The Maidstone, Rochester and Chatham Post Coach
oil on wood 42.0 × 57.5
A2669

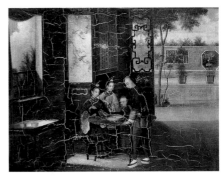

unknown artist 19th C?
Chinese Painting of Ladies Watching a Contest between Two Crickets
oil on canvas 46 × 60
A2677

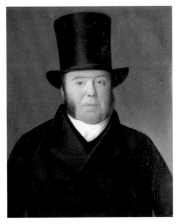

unknown artist mid-19th C
James Pye (Local Farmer)
oil on canvas 67 × 55
A2636

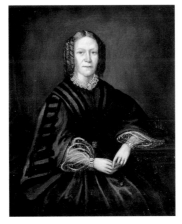

unknown artist mid-19th C
Portrait of a Victorian Lady
oil on canvas 59.5 × 49.5
A2680

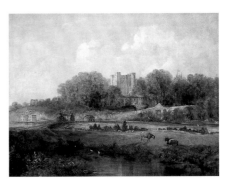

unknown artist mid-19th C
Rochester Castle from the River Medway
oil on canvas 57.0 × 74.5
A2695

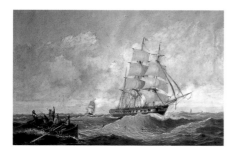

unknown artist mid-late 19th C
Stormy Sea Scene with Sailing Ships
oil on canvas 62.5 × 74.5
A2651

Valentini, Valentino b.1858
Portrait of a Male Classical Figure, possibly Cupid 1877
oil on canvas 52 × 42
A2675

Wollaston, John active 1736–1775
Alderman David Wharam (Mayor in 1744) 1740
oil on canvas 75 × 61
A2628

Wright, T. T. active 1820–1826
J. Best 1826
oil on canvas 73.5 × 61.5
A2658

Sandwich Guildhall Museum

The Sandwich Guildhall collection of oil paintings, although not large, contains examples from three centuries of the history of the town. Unfortunately, the majority have little provenance history and the artists are largely unknown.

The Council Chamber has two sets of paintings, each on four panels, showing the Battle of Sole Bay of 1672 against the Dutch, and the visit of Catherine of Braganza, passing through Sandwich with the Lord Warden of the Cinque Ports (then Duke of York, later James II) on her way to Dover to meet the King. Both sets of paintings are remarkable for the detail shown – from the rigging of the ships depicted in the Battle of Sole Bay to the dress, accoutrements and personal appearance of the main characters in the visit of Catherine of Braganza. The town councillors are shown greeting the coaches holding the royal party, whilst children scramble for pennies thrown to them from the coaches.

In addition, there are numerous portraits of past mayors and persons with

historical connections to Sandwich, including the First Earl of Sandwich, who was killed at the Battle of Sole Bay.

The ancient courtroom has paintings of Charles II, Catherine of Braganza and James II, (when he was Duke of York and Lord Warden of the Cinque Ports), as well as a picture by Henry Weigall, a Royal Academician, showing the Quarter Sessions in progress, with the full detail of contemporary dress and the panoply of the administration of justice at the turn of the 19th century.

The Grand Jury Room has some very old paintings showing the (now demolished) Sandown Gate, with some mischievous child trying to hit a donkey with a stick whilst a well-appointed coach passes through the gate. In addition to some large local scenes painted in the late 19th century, there is also a lovely domestic scene by the Royal Academician Herbert Finn, of a sailor chatting with a local girl at one of the town's pumps.

Charles Wanostrocht, former Curator

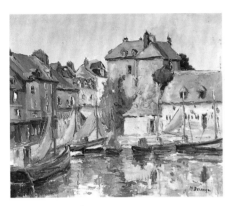

Delange, Maurice
La Lieutenance, Honfleur c.1970
oil on board 38.1 × 45.7
PIC-181

Finn, Herbert b.1860
Sailor and Girl in Delf Street c.1880
oil on canvas 101.6 × 86.3
PIC-126 (P)

Gabrielli, W. 1920–2001
Mayor William R. Rose, (1930–1931) c.1932
oil on canvas 91.4 × 76.1
PIC-039

Harle, Dennis F. 1920–2001
Flemish Gabled Cottages in Cattle Market
c.1970
oil on board 45.7 × 66.0
PIC-168

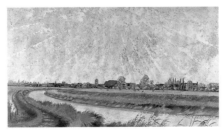

Harle, Dennis F. 1920–2001
Panoramic View of Sandwich c.1980
oil on board 101.6 × 182.9
PIC-177

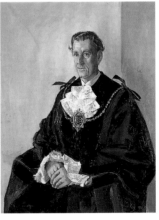

Kay, Pamela b.1939
Mayor Robert Raymond Chesterfield,
(1972–1973 & 1983–1984) 1973
oil on canvas 106.6 × 81.2
PIC-121

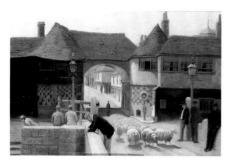

Maxton, H.
Barbican and Tollbridge c.1930
oil on canvas 53.3 × 68.6
PIC-117

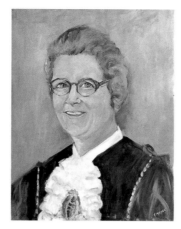

Moyes, E.
Mayor Mrs Jean C. Maughan, (1970–1971)
c.1970
oil on canvas 76.1 × 61.0
PIC-035

Moyes, E.
Queen Elizabeth II c.1955
oil on canvas 76.1 × 61.0
PIC-038

Moyes, E.
Queen Elizabeth, the Queen Mother c.1955
oil on board 76.1 × 61.0
PIC-040

Oving, William
Mayor Henry Burch, Cinque Ports Baron,
(1945–1946) c.1954
oil on canvas 91.4 × 76.1
PIC-120

Page, **Henry Maurice** 1845–1908
Market Day in Sandwich 1906
oil on canvas 101.6 × 177.8
PIC-128

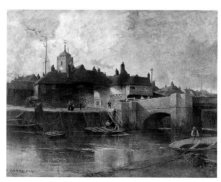

Page, **Henry Maurice** 1845–1908
Barbican and River Stour c.1900
oil on canvas 91.4 × 121.9
PIC-129

R. M. P.
St Peter's Church, with Laburnum Tree c.1970
oil on board 38.1 × 50.8
PIC-186

Swanton, Ann
View of the Butts c.1985
oil on board 50.8 × 40.6
PIC-187

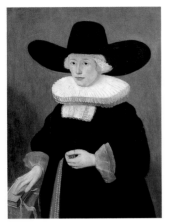

unknown artist
Puritan Lady c.1650
oil on canvas 96.5 × 71.1
PIC-125 (P)

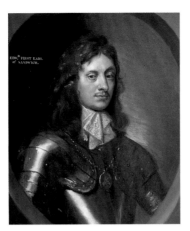

unknown artist
1st Earl of Sandwich c.1670
oil on canvas 76.1 × 63.5
PIC-167

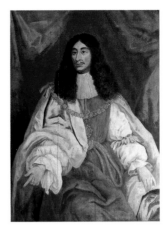

unknown artist
Charles II c.1670
oil on wood 129.5 × 96.5
PIC-171

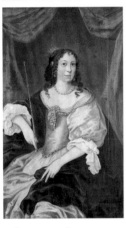

unknown artist
Catherine of Braganza c.1670
oil on wood 127.0 × 76.1
PIC-173

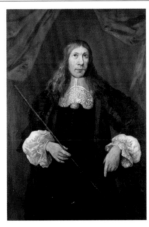

unknown artist
Mayor Bartholomew Coombes, (1671–1672)
c.1672
oil on canvas 137.2 × 96.5
PIC-119

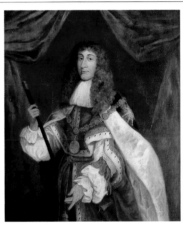

unknown artist
Duke of York - Later James II c.1672
oil on wood 124.5 × 109.2
PIC-172

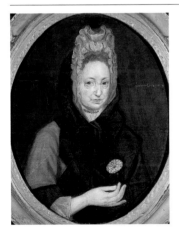

unknown artist
Lady with Carnation c.1680
oil on canvas 76.1 × 61.0
PIC-132

unknown artist
Sandown Gate c.1700
oil on canvas 81.2 × 127.0
PIC-127

unknown artist
Cinque Ports Fleet in Pegwell Bay c.1700
oil on wood 45.7 × 152.4
PIC-154

unknown artist
Fleet with Neptune in Centre Cartouche c.1700
oil on wood 25.4 × 193.1
PIC-192

unknown artist
View of Sandwich from the South with Post Mills and Newgate c.1720
oil on canvas 27.9 × 40.6
PIC-193

unknown artist
Mayor Richard Solly, (1718, 1728, 1736 & 1749) c.1750
oil on canvas 101.6 × 78.7
PIC-118

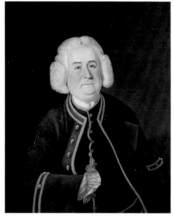

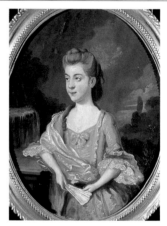

unknown artist
Mayor John Matson, (1777–1778) c.1777
oil on canvas 73.6 × 61.0
PIC-170

unknown artist
Captain William Boys c.1790
oil on canvas 73.6 × 61.0
PIC-164

unknown artist
Elizabeth Boys c.1790
oil on canvas 43.1 × 33.0
PIC-180

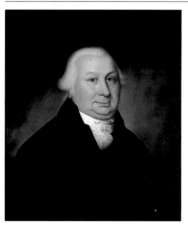

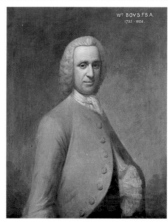

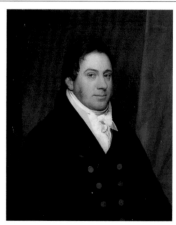

unknown artist
Mayor Richard Emmerson, (1793–1794, 1801, 1812, 1830 & 1845) c.1793
oil on canvas 76.1 × 63.5
PIC-169

unknown artist
William Boys FSA, (1735–1808) c.1795
oil on canvas 78.7 × 63.5
PIC-185

unknown artist
Mayor William Wyborn Bradly, (1785–1786) c.1800
oil on canvas 76.1 × 61.0
PIC-165

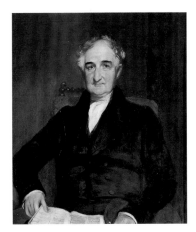

unknown artist
Rev. Henry Pemble c.1820
oil on canvas 61.0 × 38.1
PIC-037

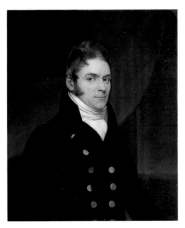

unknown artist
Mayor William Rolfe, (1827–1828, 1839, 1841 & 1843) c.1830
oil on canvas 76.1 × 63.5
PIC-166

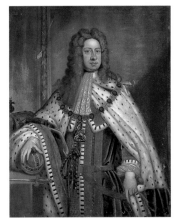

unknown artist
George II?
oil on canvas 177.8 × 121.9
PIC-034

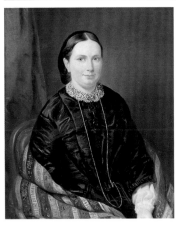

unknown artist
Mayoress Harriett Marsh, Wife of Richard Marsh c.1860
oil on canvas 91.4 × 76.1
PIC-123

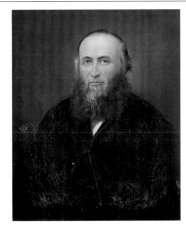

unknown artist
Mayor Richard Marsh, (1856 & 1862) c.1860
oil on canvas 91.4 × 76.1
PIC-124

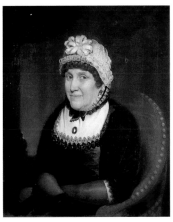

unknown artist
Mayoress Bradly, Wife of Stephen, (1817–1818) c.1881
oil on canvas 91.4 × 91.4
PIC-031

unknown artist
Toll Bridge, with Barge c.1900
oil on wood 81.2 × 162.5
PIC-130

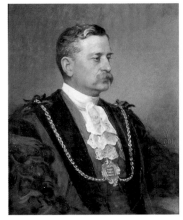

unknown artist
Mayor William J. Hughes, (1882–1883, 1888–1890, 1896–1899 & 1912–1918) c.1900
oil on canvas 76.1 × 63.5
PIC-176

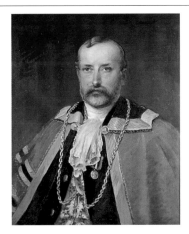

unknown artist
Mayor Henry S. Watts, Cinque Ports Baron, (1884–1886, 1891, 1901 & 1907–1908) c.1903
oil on canvas 76.1 × 63.5
PIC-175

unknown artist
The Courtroom c.1920
oil on canvas 121.9 × 91.4
PIC-036

unknown artist
Map with Cinque Port Towns Marked c.1930
oil on board 73.6 × 119.4
PIC-182

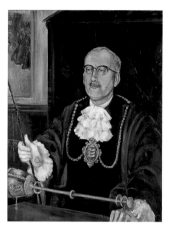

unknown artist
Mayor James J. Thomas, (1950–1951 & 1954–1959) c.1955
oil on canvas 152.4 × 121.9
PIC-033

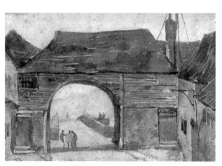

unknown artist
Barbican (after 18th C engraving) c.1970
oil on board 17.9 × 25.4
PIC-191

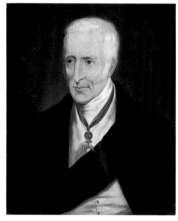

unknown artist
Duke of Wellington
oil on canvas 66.0 × 55.8
PIC-122

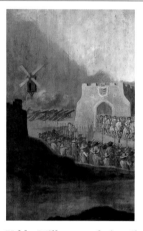

Velde, Willem van de (attributed to)
1633–1707
Catherine of Braganza's Visit (first part of quadruptych) c.1670
oil on wood 127.0 × 81.2
PIC-163.1

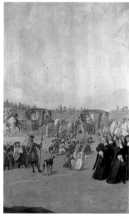

Velde, Willem van de (attributed to)
1633–1707
Catherine of Braganza's Visit (second part of quadruptych) c.1670
oil on wood 127.0 × 81.2
PIC-163.2

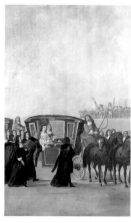

Velde, Willem van de (attributed to)
1633–1707
Catherine of Braganza's Visit (third part of quadruptych) c.1670
oil on wood 127.0 × 81.2
PIC-163.3

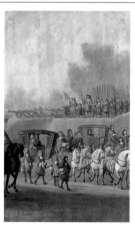

Velde, Willem van de (attributed to)
1633–1707
Catherine of Braganza's Visit (fourth part of quadruptych) c.1670
oil on wood 127.0 × 81.2
PIC-163.4

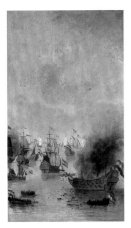

Velde, Willem van de (attributed to)
1633–1707
Battle of Sole Bay (first part of quadruptych)
c.1672
oil on wood 125.5 × 75.0
PIC-164.1

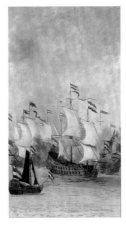

Velde, Willem van de (attributed to)
1633–1707
Battle of Sole Bay (second part of quadruptych)
c.1672
oil on wood 125 × 70
PIC-164.2

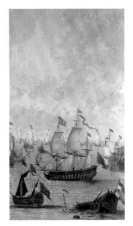

Velde, Willem van de (attributed to)
1633–1707
Battle of Sole Bay (third part of quadruptych)
c.1672
oil on wood 125 × 75
PIC-164.3

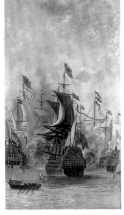

Velde, Willem van de (attributed to)
1633–1707
Battle of Sole Bay (fourth part of quadruptych)
c.1672
oil on wood 125 × 75
PIC-164.4

Weigall, Henry 1829–1925
Sandwich Quarter Sessions, 1898 1899
oil on canvas 116.8 × 170.2
PIC-174

Court Hall Museum

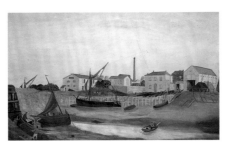

Poniter
Crown Quay 1866
oil on canvas 54.5 × 89.0
PCF_KT_CHM_01_032 (P)

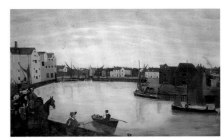

Poniter
Head of Miton Creek 1866
oil on canvas 54.5 × 89.0
PCF_KT_CHM_01_037 (P)

unknown artist early 19th C
Stephen Hills, (1778–1848)
oil on canvas 118 × 98
PCF_KT_CHM_2/01_004

unknown artist mid-19th C
William Hills
oil on canvas 100 × 88
PCF_KT_CHM_01_018

unknown artist
John Hills snr c.1860
oil on wood & plaster 118 × 98
PCF_KT_CHM_01_022

unknown artist
Elizabeth Phillis Hills (née Webb) c.1860
oil on wood & plaster 118 × 98
PCF_KT_CHM_2/01_034

Swale Borough Council

Boxall, William 1800–1879
Rev. John Poore DD, JP 1859
oil on canvas 128.3 × 102.9
PCF_KT_SWB_01_010

Eddis, Eden Upton 1812–1901
George Smeed 1878
oil on canvas 128.3 × 102.9
PCF_KT_SWB_01_002

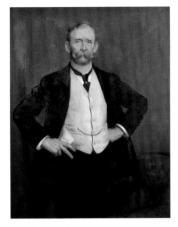

Hacker, Arthur 1858–1919
Henry Payne JP, CC 1908
oil on canvas 128.3 × 102.9
PCF_KT_SWB_01_013

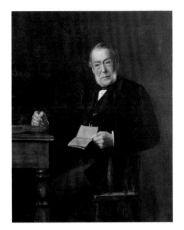

Rook, Barnard 1857–1889
George Payne 1889
oil on canvas 128.3 × 102.9
PCF_KT_SWB_01_005.

Tenterden Museum Collection

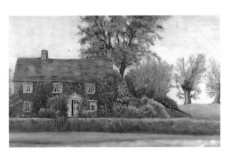

Love, W.
Ismonger Farm House 1911
oil on board 45.7 × 66.0
PCF_KT_TTM_001_020

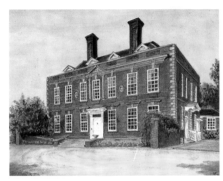

Peskett, John
Westwell House
oil on board 45.8 × 55.9
PCF_KT_TTM_001_017

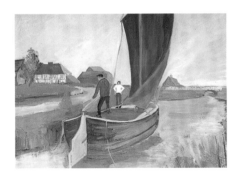

Sykes, C. Hildegarde
Barge at Small Hythe
oil on canvas 38.1 × 48.3
PCF_KT_TTM_001_000

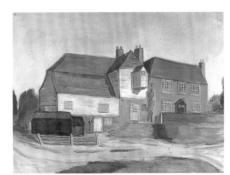

Sykes, C. Hildegarde
Ashbourne Mill
oil on board 38.1 × 49.5
PCF_KT_TTM_001_003

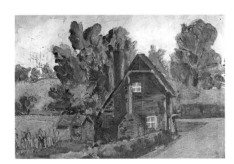

Sykes, C. Hildegarde
Castweazle Toll House
oil on canvas
PCF_KT_TTM_001_013

unknown artist
Old Man with Beard
oil on canvas 50.8 × 41.9
PCF_KT_TTM_001_004

unknown artist
18th Century Man with Lazy Eye - Mr Curteis
oil on wood 20.3 × 15.3
PCF_KT_TTM_001_010

Willcocks, John 1898–1991
Reaben Collison 1972
oil on board 67.3 × 54.6
PCF_KT_TTM_001_023

Wills, J. H.
Edward Langley Fisher 1851
oil on canvas 92.7 × 73.6
PCF_KT_TTM_001_026

Tenterden Town Council

Adams, Bernard d.1965
Vivian Dampier-Palmer, High Sherriff of Kent 1921 1921
oil on canvas 74.9 × 61.6
PCF_KT_TTH_01_022

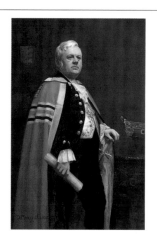

Beresford, Daisy Radcliffe d.1939
Joseph Robert Diggle 1903
oil on canvas 152.4 × 97.8
PCF_PCF_KT_TTH_01_006

Facing page: Middleton, James Godsell, *Sir Henry Oxenden, b.1756* (detail), Canterbury City Council Museums and Galleries (p. 19)

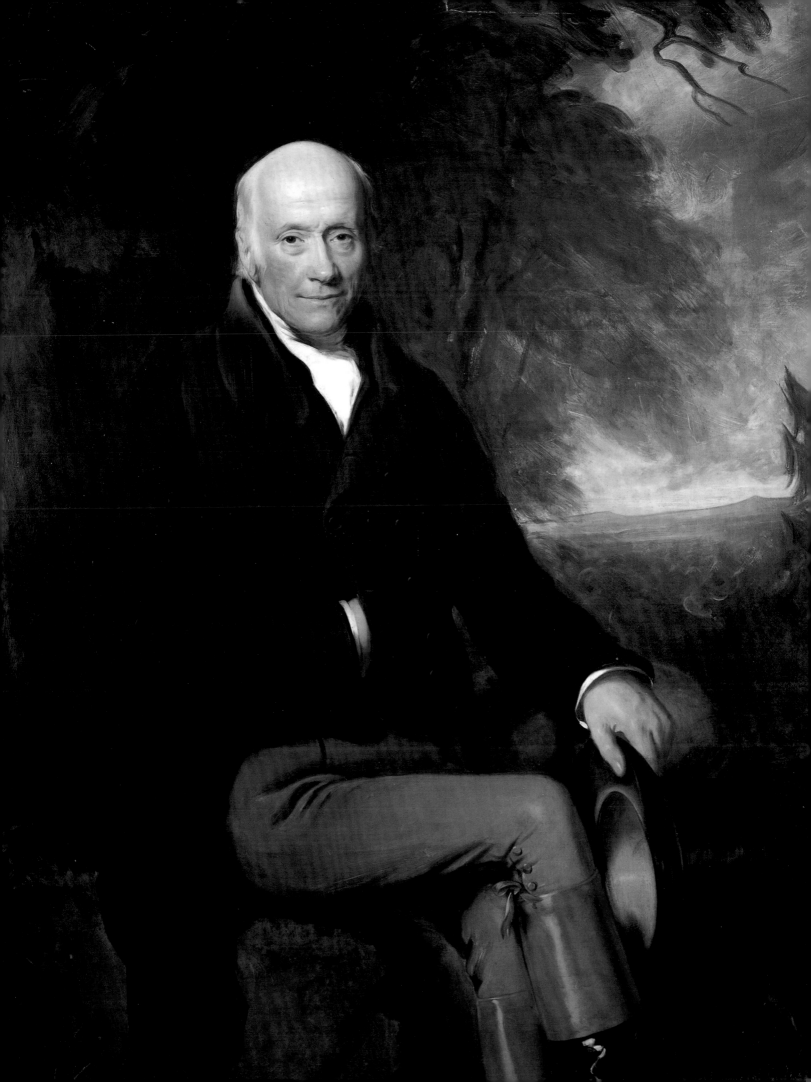

British (English) School
Elizabeth Curteis 1632
oil on panel 108.6 × 83.8
PCF_KT_TTH_01_030

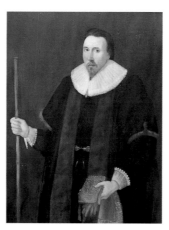

British (English) School
Robert Curteis, Aged 45, Baillie Mayor,
(1627–1632) 1632
oil on panel 107.9 × 83.8
PCF_KT_TTH_01_033

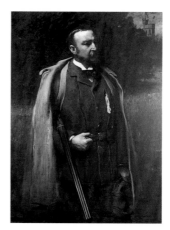

British (English) School early 20th C
Colonel James Dampier-Palmer
oil on canvas 147.3 × 91.5
PCF_KT_TTH_02_036

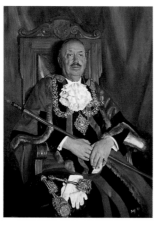

British (English) School
Alderman Leslie Chalk 1961
oil on canvas 120.7 × 91.5
PCF_KT_TTH_01_013

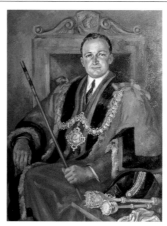

Colles, Dorothy b.1917
Stanley Day 1950
oil on canvas 94.0 × 72.4
PCF_KT_TTH_01_015

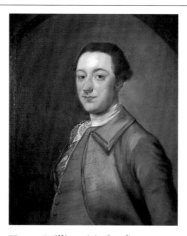

Hoare, William (circle of) c.1707–1792
Samuel Curteis
oil on canvas 74.9 × 62.2
PCF_KT_TTH_01_026

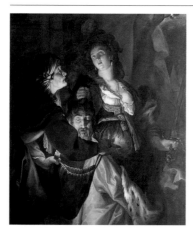

Seghers, Gerard 1591–1651
Judith with the Head of Holofernes 1645
oil on canvas 137.2 × 137.2
PCF_KT_TTH_02_033

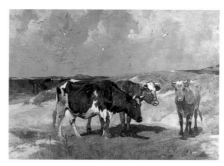

Van Damme-Sylva, Willem Bataille Emile
Cows Grazing in Summer Pasture 1891
oil on canvas 108.6 × 153.7
PCF_KT_TTH_01_018

Tunbridge Wells Museum and Art Gallery

Although Tunbridge Wells Museum and Art Gallery as an institution dates back to 1885, its collection of oil paintings was acquired mainly after 1952. That was the year in which the Ashton Bequest of Victorian oil paintings was received. At that time the current museum and library building was still being fitted out, and the arrival of the Ashton Bequest provided the impetus for adding an art gallery to that new development. The 31 paintings originally belonged to Alfred Ashton, a keen collector of contemporary art who lived in Camden Park, Tunbridge Wells. They were purchased between 1852 and 1863, either from the artists' studios or when the artists exhibited their latest work at the Royal Academy or the British Institution. Alfred's son, Ernest Russell Ashton, was a distinguished art photographer who travelled the world in search of subjects. He inherited the paintings in 1910 and decided to leave them in his will for the enjoyment of the people of his home town.

Most of the other oil paintings in the museum form part of a wider collection of local topographical views in various media. The most significant of the older works of this nature are paintings by local artist Charles Tattershall Dodd I (1815–1878). His numerous works, which include watercolour and pencil drawings as well as oils, provide a unique picture of the growing town of Tunbridge Wells and its environs. Dodd was born at Tonbridge in January 1815, the son of a local miller, and served for forty years as the drawing master at Tonbridge School, a post which he took up in 1837. Dodd was exhibiting his work in public as early as 1832, and from 1847 to 1859 he exhibited frequently at the Royal Academy.

Since the 1960s, the museum has acquired a number of works by contemporary artists who have depicted the town's changing scenery and architecture. These continue for later generations the historical record provided by Victorian artists such as Charles Tattershall Dodd I. The museum collection also includes a number of portraits of noteworthy local residents and famous visitors to the town. Hung in the adjacent town hall are several portraits of early mayors of Tunbridge Wells and other civic dignitaries, and two Italian views by a Victorian mayor.

Ian Beavis, Museum Technical Officer

Aldridge, J. E.
Interior of Great Bounds, Southborough 1959
oil on canvas 50.6 × 40.5
1984.130

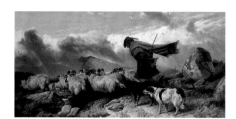

Ansdell, Richard 1815–1885
Crossing the Moor 1863
oil on canvas 65.0 × 128.5
1952.86.17

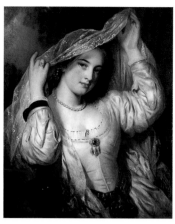

Baxter, Charles 1809–1878
Olivia 1862
oil on canvas 76 × 63
1952.86.11

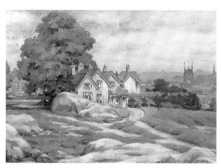

Betteridge, Harold 1892–1972
The Common
oil on board 23.5 × 33.5
1973.35

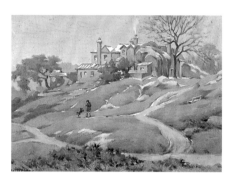

Betteridge, Harold 1892–1972
February Morning
oil on board 23.5 × 33.5
1973.36

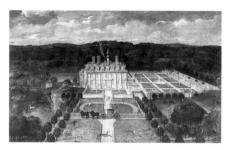

British (English) School
Bayhall, Pembury c.1740
oil on canvas 123 × 200
1984.667

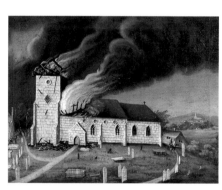

British (English Naïve) School
Speldhurst Church Struck by Lightning 1791?
oil on canvas 44 × 58
1984.668

British (English) School
Rev. Thomas Edwards
oil on canvas 75 × 62
PCF_KT_TW_03_034

Bronckhorst, Arnold (after) c.1566–1586
A Young Nobleman (James I?) with a Falcon
18th C
oil on board 18.5 × 14.5
1933.36

Brooks, Thomas 1818–c.1891
The Valentine 1863
oil on canvas 51.5 × 41.0
1952.86.24

Burgess, John Bagnold 1830–1897
Spanish Girl c.1860
oil on canvas 39.0 × 26.5
1952.86.2

Burgess, John Bagnold 1830–1897
Portrait of a Girl c.1860
oil on canvas 39 × 29
1952.86.4

Carr Cox
Alderman J. R. Gower
oil on canvas 117 × 83
PCF_KT_TW_05_026

Clover, Joseph (attributed to) 1779–1853
Richard Cumberland
oil on canvas 74 × 61
1976.12

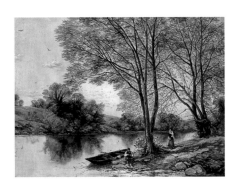

Creswick, Thomas 1811–1869
Autumn Leaves c.1860
oil on canvas 51.5 × 69.5
1952.86.6

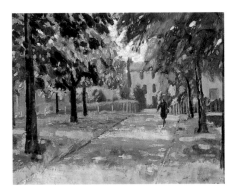

Curtler, F. M.
In the Grove c.1950
oil on canvas 34 × 43
1985.97

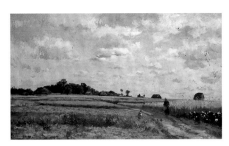

Damoye, Pierre Emmanuel 1847–1916
Rural Landscape with Figures in the Foreground
1879
oil on panel 43.0 × 72.5
1950.24

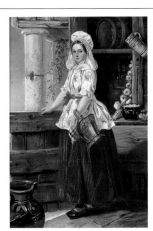

Davies, Charlotte active c.1860
Normandy Girl 1862
oil on canvas 33 × 23
1952.86.31

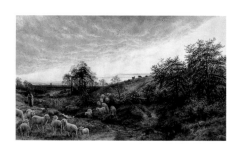

Davis, Henry William Banks 1833–1914
Twilight, Vallée de la Cluse, Near Boulogne
1863
oil on board 25 × 43
1952.86.30

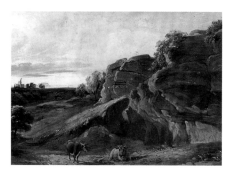

Dodd, Charles Tattershall I 1815–1878
Rocks with Cattle Grazing c.1870
oil on board 24 × 34
1970.24

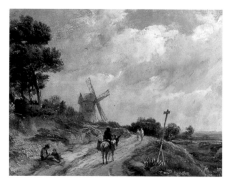

Dodd, Charles Tattershall I 1815–1878
Culverden Common, Tunbridge Wells 1870
oil on board 14.0 × 18.5
1972.82

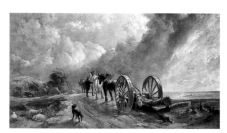

Dodd, Charles Tattershall I 1815–1878
The Timber Wagon c.1872
oil on canvas 59.5 × 108.0
1979.21

Dodd, Charles Tattershall I 1815–1878
Standings Mill c.1850
oil on canvas 52.5 × 60.5
1980.63

Dodd, Charles Tattershall I 1815–1878
Rusthall Common c.1850
oil on canvas 47.0 × 72.5
1984.703

Dodd, Charles Tattershall I 1815–1878
St Helena Cottage, Tunbridge Wells Common
oil on canvas 31 × 41
1988.174

Dodd, Charles Tattershall I 1815–1878
*Isabelle Rebecca Dodd Feeding a Ewe, Ducks
and Chickens at Groombridge* c.1872
oil on board 44.5 × 34.0
1991.06

Dodd, Charles Tattershall I 1815–1878
Culverden Down, Tunbridge Wells 1835
oil on board 25.5 × 38.0
1991.446

Dodd, Charles Tattershall I 1815–1878
Castle Road, the Common, Tunbridge Wells
1855
oil on board 25 × 35
1991.447

Dodd, Charles Tattershall I 1815–1878
Reynold's Farm, Reynold's Lane, Tunbridge Wells c.1860
oil on board 23.0 × 33.5
1991.448

Dodd, Charles Tattershall I 1815–1878
View over Eridge c.1850
oil on canvas 86 × 101
1999.85

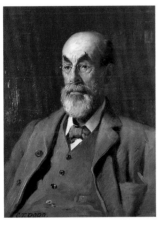

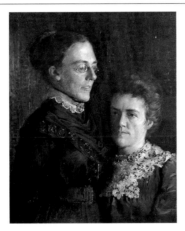

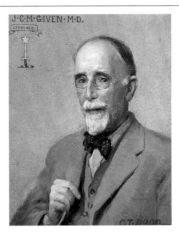

Dodd, Charles Tattershall II 1861–1951
Dr George Abbott
oil on canvas 67.5 × 51.0
1970.44

Dodd, Charles Tattershall II 1861–1951
Isabelle Rebecca Dodd and Henrietta Jane Sadd
1902
oil on canvas 74.5 × 62.0
1973.77

Dodd, Charles Tattershall II 1861–1951
J. C. M. Given
oil on canvas 56.6 × 47.0
1984.666

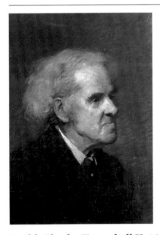

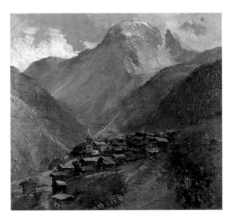

Dodd, Charles Tattershall II 1861–1951
Thomas Sims c.1900
oil on canvas 55 × 41
1984.701

Dodd, Charles Tattershall II 1861–1951
The Sasseneire and Val de Moiry, Grimentz
oil on canvas 39 × 44
1990.01

Dodd, Charles Tattershall II 1861–1951
St Michel, Quimperlé
oil on canvas 69 × 42
1999.88

Duffield, William 1816–1863
Still Life with Dead Game 1863
oil on canvas 41.5 × 62.5
1952.86.10

Edwards, Thomas
*The Bowling Green, St John's Recreation
Ground* 1909
oil on canvas 61.0 × 91.5
1983.413

Enhuber, Karl von 1811–1867
The Piping Bullfinch 1843
oil on canvas 39 × 31
1952.86.20

Enhuber, Karl von 1811–1867
The Dead Bullfinch 1844
oil on canvas 42.0 × 33.5
1952.86.21

Flemish School 17th C
Unknown Woman
oil on panel 61.0 × 47.5
1984.695

Goodall, Frederick 1822–1904
A Letter from Papa 1855
oil on canvas 35 × 29
1952.86.22

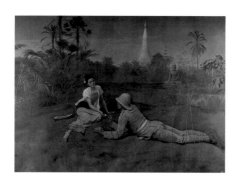

Goodall, Frederick 1822–1904
On the Road to Mandalay 1899
oil on canvas 142 × 195
1969.133

Grant, Nina
Rev. James Mountain
photograph overpainted with oils 48 × 39
PCF_KT_TW_03_025

Grant, F.
The Picture House at Poundsbridge 1906
oil on canvas 19.5 × 24.7
1955.53

Hailstone
George Sturgeon 1975
oil on canvas 125 × 100
PCF_KT_TW_12_001

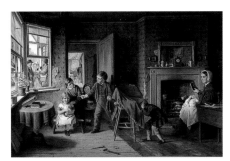

Hardy, Frederick Daniel 1826–1911
Young Photographers 1862
oil on canvas 29.0 × 44.5
1952.86.23

Hedgecock, Derek
The Opera House, Tunbridge Wells 1980
oil on board 88.5 × 62.5
1985.15

Helm, Patricia
Closed Shop (Camden Road) 1982
oil on canvas 49 × 59
1984.212

Helm, Patricia
Mount Ephraim Road 1985
oil on board 59.0 × 49.5
1986.67

Herbert, Margaret
Commuters c.1969
oil on board 35 × 135 (E)
1989.289

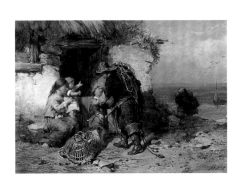

Hill, James John 1811–1882
The Fisherman's Return c.1860
oil on canvas 23.5 × 34.0
1952.86.15

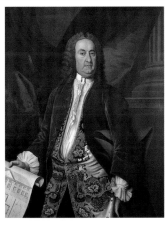

Hoare, William c.1707–1792
Richard Beau Nash c.1745
oil on canvas 124 × 99
1991.213

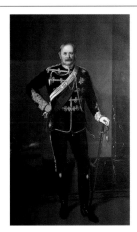

Hodges, Sidney 1829–1900
William, Marquess of Abergavenny 1887
oil on canvas 238 × 145
1984.693 (P)

Hoogsteyns, Jan b.1935
Still Life c.1979
oil on board 30 × 40
1990.276

Hughes, William 1842–1901
Still Life with Bird's Nest and Fruit 1863
oil on canvas 32 × 40
1952.86.7

Huysman, Jacob c.1633–1696
Charles II
oil on canvas 125.0 × 98.5
PCF_KT_TW_01_032 (P)

Ivimey, John
The Toad Rock, Rusthall Common 1983
oil on canvas 31.5 × 43.0
1984.103

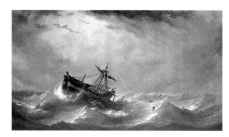

Knell, William Adolphus 1805–1875
The Shipwreck 1856
oil on canvas 10.5 × 59.5
1952.86.3

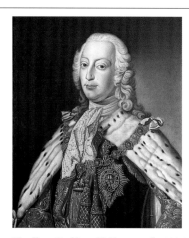

Kneller, Godfrey (follower of) 1646–1723
Frederick, Prince of Wales
oil on canvas 72.5 × 62.0
1986.241

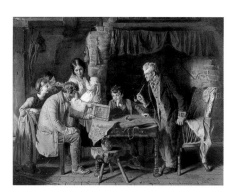

Knight, William Henry 1823–1863
Grandfather's Portrait 1860
oil on panel 40 × 50
1952.86.29

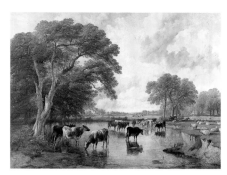

Lee, Frederick Richard 1798–1879 & **Cooper,
Thomas Sidney** 1803–1902
Cattle on the Banks of a River 1855
oil on canvas 106.0 × 146.5
1952.86.18

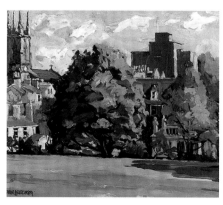

Leech, John
Trinity, Autumn 1984
oil on canvas 39 × 47
1985.11

Leech, John
London Road and Mount Ephraim Junction
1988
oil on canvas 76.0 × 90.5
1990.102

Leech, John
The Building of Victoria Place 1990
oil on canvas 37 × 76
1993.18

Leech, John
Victoria Place - Stairway 1996
oil on canvas 90.5 × 70.5
1999.97

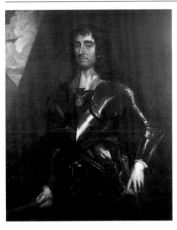

Lely, Peter (studio of) 1618–1680
General Monk
oil on canvas 124 × 100
PCF_KT_TW_01_035 (P)

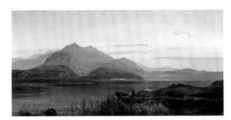

Leslie, Charles active 1835–1863
Evening in the Highlands
oil on canvas 29.5 × 60.0
1952.86.1

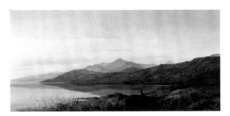

Leslie, Charles active 1835–1863
Morning - Ullswater c.1860
oil on canvas 29.0 × 59.5
1952.86.5

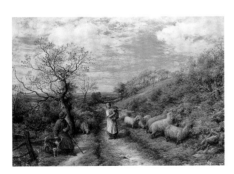

Linnell, John 1792–1882
A Surrey Lane 1863
oil on board 68 × 96
1952.86.26

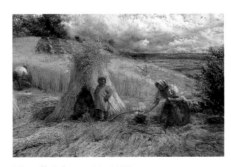

Linnell, John 1792–1882
The Cornfield Shelter 1862
oil on canvas 50 × 75
1952.86.27

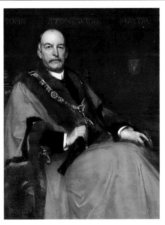

Llewellyn, William Samuel Henry
1854–1941
John Stone-Wigg c.1890
oil on canvas 125 × 100
PCF_KT_TW_13_001

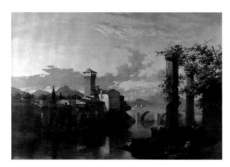

Lutwidge, Charles Fletcher 1836–1907
Ponte del mare, Pisa
oil on canvas 125 × 185
PCF_KT_TW_09_001

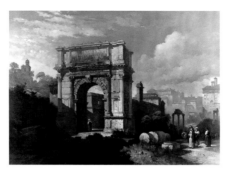

Lutwidge, Charles Fletcher 1836–1907
L'Arco di Tito, Roma
oil on canvas 125 × 185
PCF_KT_TW_14_001

McCulloch, M.
Hop-pickers c.1969
oil on canvas 50.5 × 60.5
1989.287

Meacham, C. S. early 20th C
Bottom of London Road, Tunbridge Wells (Old Forge)
oil on board 22.0 × 34.5
1955.10.1

Mutrie, Annie Feray 1826–1893
Still Life with Fruit and Flowers
oil on canvas 73.0 × 57.5
1952.86.25

Octavius Wright, Charles
Beau Nash at the Gaming Table 1953
oil on canvas 57.5 × 75.5
1961.67

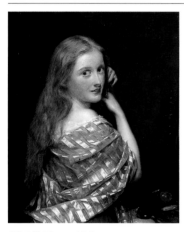

O'Neil, Henry Nelson 1817–1880
The Toilette 1863
oil on canvas 35 × 30
1952.86.8

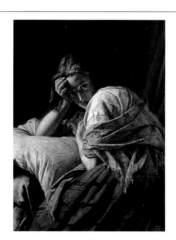

O'Neil, Henry Nelson 1817–1880
The Lazy Girl 1861
oil on panel 45 × 35
1952.86.9

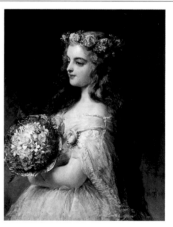

Philip, John 1817–1867
The Bridesmaid 1860
oil on board 50 × 40
1952.86.28

Seymour, William
Symphony in Red and Blue c.1980
oil on canvas 41 × 51
1984.254

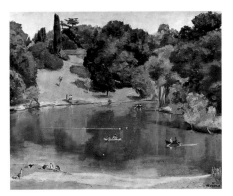

Seymour, William
The Lake in Dunorlan Park c.1986
oil on board 40.0 × 50.5
1986.229

Seymour, William
On the Rocks (Wellington Rocks, Tunbridge Wells Common) c.1987
oil on canvas 40.0 × 50.5
1987.208

Solomon, Abraham 1824–1862
Brighton Front c.1860
oil on panel 42.0 × 95.5
1952.86.12

Solomon, Abraham 1824–1862
Waiting for the Verdict 1857
oil on board 31.0 × 38.5
1952.86.13

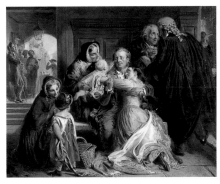

Solomon, Abraham 1824–1862
The Acquittal 1859
oil on panel 31.0 × 38.5
1952.86.14

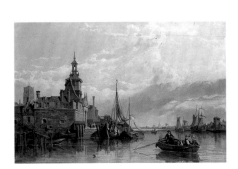

Stanfield, George Clarkson 1828–1878
Rotterdam c.1860
oil on canvas 49.5 × 75.0
1952.86.16

Tuke, Henry Scott (circle of) 1858–1929
Boy in a Punt
oil on canvas 10 × 9
1984.702

unknown artist
Light Infantry Officer 1877
oil on canvas 44.5 × 29.5
1984.696

unknown artist
Lower Green, Rusthall c.1900
oil on board 29 × 48
1971.14

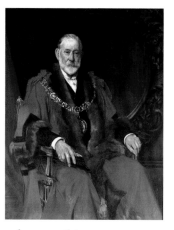

unknown artist
Charles Fletcher Lutwidge c.1903
oil on canvas 125 × 100
PCF_KT_TW_15_001

unknown artist
A Cob Mute Swan
oil on panel 33 × 45
1961.17

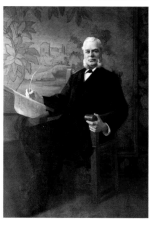

unknown artist
Thomas Fox Simpson
oil on canvas 150 × 125
PCF_KT_TW_11_001

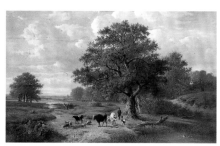

Verboeckhoven, Eugène 1799–1881 &
Verveer, Salomon Leonardus 1813–1876
Landscape c.1860
oil on canvas 80 × 128
1952.86.19

Wheatley, John 1892–1955
Hall's Bookshop, Chapel Place
oil on canvas 49.5 × 62.0
1969.47

Wheeler, Cecil
The Pantiles 1960s
oil on canvas 112 × 135
1969.70

Wilkinson, Jean
Upper Grosvenor Road 1991
oil on board 45 × 60
1992.119

Wilkinson, Jean
Calverley Gardens 1990
oil on board 50 × 40
1992.120

English Heritage, Walmer Castle

Walmer Castle was built in 1539 as one of a chain of coastal artillery forts constructed by Henry VIII against the threat of invasion by Spain. From 1708 it became the official residence of the Lords Warden of the Cinque Ports, an historic title dating from the 13th century. The castle's martial appearance has been much modified by the alterations of successive Lords Warden, transforming the imposing fortress into a comfortable residence. The office of Lord Warden was originally created to regulate the powerful confederation of the five ports of Hastings, Romney, Hythe, Dover and Sandwich, whose citizens gained royal privileges in return for defending the ports, but in recent years the title has been conferred primarily as a distinguished honour.

The collections consist mainly of 18th and 19th century furniture, works of art and engravings. Most of the collection is associated with past Lords Warden such as William Pitt the Younger (Lord Warden 1792–1806) and the Duke of Wellington (Lord Warden 1829–1852), who died at Walmer in 1852. The Duke of Wellington's Room is arranged as he knew it, with his original campaign bed and the chair in which he died. There are over 200 political cartoons associated with the Duke, as well as personal memorabilia, including a pair of his celebrated Wellington boots. After the death of W. H. Smith (Lord Warden 1891), a trust was set up according to his wishes to designate items of historical interest which could not be removed from the castle. Various gifts and bequests have also been made, such as those from Lady Reading, wife of the Lord Warden in 1936, and from Wing Commander Lucas's collection of Wellington memorabilia in 1966.

Lisa Shakespeare, Assistant to Chief Curator

Alford, John b.1890
Winter Landscape 1955
oil on canvas 50 × 60
88056003

Campbell, Reginald
Australian Landscape 1959
oil on canvas 71 × 80
88056001

Cook, Allon
The Sunburnt Hills of the North 1963
oil on canvas 70 × 87
88056004

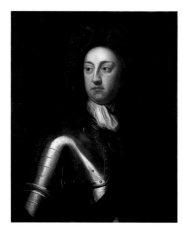

Dahl, Michael I 1656/1659–1743
Prince George of Denmark 1705
oil on canvas 95.0 × 62.5
88215507

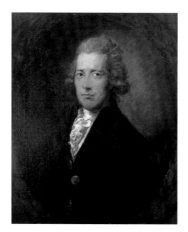

Dupont, Gainsborough 1754–1797
William Pitt the Younger
oil on canvas 76.0 × 63.5

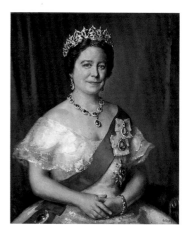

Gilroy, John M. 1898–1985
HM Queen Mother c.1950s
oil on canvas 99 × 77
78600839

Langker, Erik 1898–1982
Australian Landscape 1965
oil on canvas 80 × 94
88056000

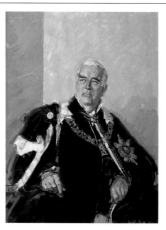

Poole, David b.1931
Sir Robert Menzies 1971
oil on wood 148 × 118
78600899

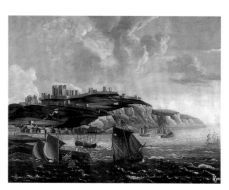

unknown artist 18th C
Dover Castle and Town
oil on canvas 97 × 131
78600860

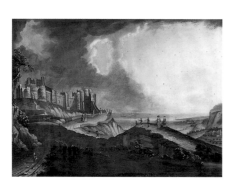

unknown artist 18th C
Dover Castle
oil on canvas 97 × 131
78600865

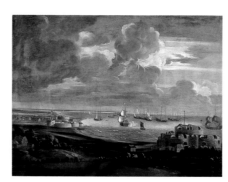

unknown artist 18th C
Cinque Ports Castles of Deal, Walmer and Sandown
oil on canvas 95 × 125
78600866

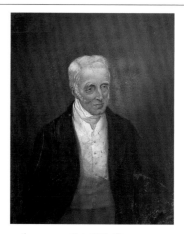

unknown artist 19th C
The Duke of Wellington
oil on canvas 52.5 × 47.5
78600095

unknown artist
Church Interior 1914–1918
oil on canvas 31.0 × 25.5
81000096

unknown artist
Remembrance 1914–1918
oil on canvas 75 × 61
88054944

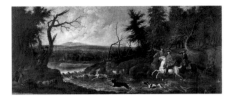

Wootton, John c.1682–1765
Stag Hunt
oil on canvas 61 × 155
78600883

Paintings Without Reproductions

This section lists all the paintings that have not been included in the main pages of the catalogue. They were excluded from the main pages because it was not possible to photograph them for this project. Additional information relating to acquisition credit lines or loan details is also included. For this reason the information below is not repeated in the Further Information section.

Canterbury City Council Museums and Galleries: Herne Bay Museum and Gallery

unknown artist, *House and Conservatory, Herne Bay*, oil on canvas, 27 x 32, H1660, not available at the time of the project

Canterbury City Council Museums and Galleries: Royal Museum and Art Gallery and other Canterbury collections

Palmer, Alfred 1877–1951, *Alderman Henry Hart JP, Mayor of Canterbury*, 1914, oil on canvas, 81.5 x 65.5, CANCM:10772, not available at the time of the project

unknown artist, *Henry Wace, Dean of Canterbury*, c.1890–1900, oil on canvas, 102.0 x 81.5, CANCM:2003.381, not available at the time of the project

Canterbury City Council Museums and Galleries: Whitstable Museum and Gallery

Brown, Alexander Kellock 1849–1922, *Evening in the Gareloch*, 1874, oil on canvas, 19 x 33, CANWH:2003.51, not available at the time of the project

Burney, Henry B., *Still Life*, oil on canvas, 123 x 143, CANWH:2003.54, in conservation

Cole, George 1810–1883, *Cattle by*

River, oil on canvas, 91 x 152, CANWH:2003.55, gift, in conservation

Neubert, Ludwig 1846–1892, *The Marshes*, oil on canvas, 100 x 161, CANWH:2003.56, in conservation

Paine, R. 19th C, *Shrimpers*, oil on canvas, 24.5 x 43.2, CANCM:11357, painting missing

Historic Dockyard, Chatham

Weaver, C. L., '*HMS Gannet*', 1982, oil on canvas, 49 x 39, 1993.0005.32 GAN 32, loan from Mercury Old Boys Association, not available at the time of the project

Dartford Library

Youens, Clement T. 1852–1919, *The Glen, Dartford Heath*, oil, 88.9 x 68.5, 191, painting missing

Youens, Ernest Christopher, 1856–1933, *The Windmill, The Brent*, oil, 88.9 x 73.6, 221, donated by Mr S. K. Keyes, painting missing

Maidstone County Hall

Buckner, Richard active 1820–1877, *Beatrice Knatchbull (d.1932)*, oil on canvas, 62 x 50, loan from Lord Brabourne, not available at the time of the project

Copley, John Singleton 1738–1815, *The Rt Hon. Sir Edward Knatchbull, Later 9th Bt, (1781–1849) with His*

Brother Norton Joseph Knatchbull (d.1801), 233 x 145, oil on canvas, loan from Lord Brabourne, not available at the time of the project

Partridge, John 1790–1872, *Eleanor Knatchbull (d.1883)*, oil on canvas, 62 x 50, loan from Lord Brabourne, not available at the time of the project

Seemann, Enoch the younger (circle of) 1694–1744, *Rev. Wadham Knatchbull (1707–1760)*, oil on canvas, 75 x 63, loan from Lord Brabourne, not available at the time of the project

Maidstone Museum & Bentlif Art Gallery

Goodwin, Albert 1845–1932, *View of a River and Cows Near Arundel, West Sussex*, oil on canvas, 50 x 90, Bentlif 26, not available at the time of the project

Storck, Abraham 1644–1708, *Sea Port with Small Ships*, oil on canvas, 77 x 109, Bentlif 54.1897.13, donation, www.bridgeman.co.uk,not available at the time of the project

Margate Old Town Local History Museum

Chambers, George 1803–1840, '*Off Margate*', c.1830, oil on canvas, 182.9 x 121.9, 1846, Margate Museum T. D. C., not available at the time of the project

Fairbrass, Irene, *George Knott*, oil on canvas, 48.3 x 38.1, 4648, not available at the time of the project

Sherrin, Daniel 1868–1940, *Newgate Gap, Flag and Battery*, c.1892, oil on canvas, 61.0 x 40.6, 1325, Margate Museum, not available at the time of the project

unknown artist, *Margate Harbour*, c.1820, oil on wood, 55.9 x 39.4, 1364, Margate Museum, not available at the time of the project

unknown artist, *Margate Pier and Jetty*, c.1860–1880, oil on canvas, 58.4 x 37.6, 1336, Margate Museum, not available at the time of the project

unknown artist, *Kingsgate Castle*, 1890, oil on canvas, 52.1 x 37.8, 1324, Margate Museum, not available at the time of the project

unknown artist, Ramsgate Harbour from West Cliff, 55.9 x 43.2, 1354, Margate Museum, not available at the time of the project

unknown artist, *Fishing in a Rough Sea, Making for Margate Harbour*, oil on canvas , 61.7 x 48.3, 1437, Margate Museum T. D. C., not available at the time of the project

unknown artist, *Pier at Margate*, 1428, Margate Museum, not available at the time of the project

unknown artist, *Foreness Point*,

Margate, oil on canvas, 4430, Margate Museum, painting missing

Ramsgate Museum

Clarke, T. E., *High Street St Lawrence*, oil on card, 41 x 26, R032, gift of Dame Janet Harcourt-Wills, not available at the time of the project

Cook, Ebenezer Wake, 1843–1926, *Ramsgate Harbour, before 1900*, oil on canvas, 62 x 75, R036, gift of Dame Janet Harcourt-Wills, not available at the time of the project

Cranbrook, W., *Ramsgate from the Pier*, oil on board, 41.5 x 29.5, oil on board, R012, bequest Mr Blandford, not available at the time of the project

Hayman, H. W., *Sandwich Road with Sportsman*, 1888, oil on canvas, 18.0 x 25.5, R425, gift of Ramsgate Library, not available at the time of the project

Petrie, Graham, 1859–1940, *Lake View*, c.1910, oil on paper, 51 x 61, R220, gift, not available at the time of the project

unknown artist, *Horse*, 1850–1900, oil on canvas, 37 x 53, R223, gift, not available at the time of the project

Facing page: Dunstan, Bernard, *Auberge belles choses, St Cirq-Lapopie* (detail), 1985, Maidstone Museum & Bentlif Art Gallery (p. 135)

Further Information

This section lists all the paintings that are featured on the illustrated pages of the catalogue, under the same headings and in the same order as on those pages. Where there is any additional information relating to one or more of the five categories outlined below, this information is also included.

I The full name of the artist if this was too long to display in the illustrated pages of the catalogue. Such cases are marked in the catalogue with a (…).

II The full title of the painting if this was too long to display in the illustrated pages of the catalogue. Such cases are marked in the catalogue with a (…).

III Acquisition information or acquisition credit lines as well as information about loans, copied from the records of the owner collection.

IV Artist copyright credit lines where the copyright owner has been traced. Exhaustive efforts have been made to locate the copyright owners of all the images included within this catalogue and to meet their requirements. Any omissions or mistakes brought to our attention will be duly attended to and corrected in future publications.

V The credit line of the lender of the transparency if the transparency has been borrowed. Bridgeman images are available subject to any relevant copyright approvals from the Bridgeman Art Library at www.bridgeman.co.uk

Dickens House Museum

unknown artist, *Charles Dickens (Aged Late 40s, Early 50s)*, unknown, photo credit: David Ault

Canterbury City Council Museums and Galleries: Herne Bay Museum and Gallery

Cook, Janet, *Fossil Fishes*, purchase
Cooper, William Sidney 1854–1927, *Herne Mill, Kent*, gift
Cooper, William Sidney 1854–1927, *Cattle on a Bridge, Kent*, purchase
Cooper, William Sidney 1854–1927, *Herne Bay, Kent*, purchase
Cooper, William Sidney 1854–1927, *Evening at Sturry, Kent*, transfer
Cooper, William Sidney 1854–1927, *Cattle Watering on the River Stour*, transfer
Cox, D. C., *Eddington Post Office and Forge, Herne Bay as in 1887*
Cox, D. C., *Toll Gate, Canterbury Road, Herne Bay as in 1860*, gift
Cox, D. C., *School Lane, Herne Bay*, gift
Cox, D. C., *School Lane, Herne as in 1862*
Goodwin, Albert 1845–1932, *Reculver, Kent*, purchase
Grey-Jones, Michael b.1950, *Cows in a Farm Barn Near Herne Bay*, purchase
T. E. 19th C, *Boats and Barges, Reculver in Distance*
Thoresby, Valerie, *Towards Reculver*, purchase

unknown artist, *John Banks, First Postmaster of Herne Bay*
unknown artist 19th C, *Moonlight Scene off Reculver as in 1779*, bequest
Westmacott, Stewart b.c.1824, *View of Reculver*, purchase

Canterbury City Council Museums and Galleries: Royal Museum and Art Gallery and other Canterbury collections

Atkinson, John Gunson active 1849–1885, *Moel Siabod from the Llugwy, North Wales with Welsh Cattle*, bequest from Dr James George Beaney, 1891
Atkinson, John Gunson active 1849–1885, *Old Moel Siabod from Near Dolwyddelan, North Wales*, bequest from Dr James George Beaney, 1891
Atkinson, John Gunson active 1849–1885, *Skiddaw, Derwentwater*
Bates, David active 1868–1893, *A Bean Field at Pickersleigh, Near Malvern*
Beale, Mary 1633–1699, *Sir Basil Dixwell*, purchased with grant-aid from the V&A/MLA Purchase Grant Fund, the NACF and Friends of the Canterbury Museums
Beavis, Richard 1824–1896, *In the Shade of the Beeches, Buckhurst Park*, bequest from Fred Goldfinch, 1956
Beechey, William (studio of) 1793–1839, *Mrs Crole*
Bionda, P., *Dr J. G. Beaney*, bequest from Dr J. G. Beaney

Bloemen, Jan Frans van 1662–1749, *A Classical Landscape with Figures*, gift from G. F. de Zoete, 1905
Bratby, John 1928–1992, *The Artist's Ten-Year-Old Son*, purchase, © collection/©copyright courtesy of the artist's estate/www.bridgeman.co.uk
British (English) School, *William Hutchinson of Canterbury on 'Staring Tom' riding from Canterbury to London Bridge in 2 hours 25 minutes and 51 seconds on Thursday 6th May 1819*, gift from Mr G. H. Clarke, 1945
British (English) School, *West Gate from St Dunstan's, Canterbury*
Brown, Alfred J., *Downland Pasture*, bequest from Fred Goldfinch, 1956
Bruton, W., *River Scene with Bridge*, bequest from Dr James George Beaney, 1891
Burrell, James active 1859–1876, *Fishing Boats on a Choppy Sea*, bequest from Dr James George Beaney, 1891
Clarke, S., *Canterbury Cathedral from the Stour Meadows*, bequest 1974
Cleeve, E., *An Officer in Tropical Uniform*
Collins, William 1788–1847, *The Snyders Family (after Anthony van Dyck)*, gift from G. F. de Zoete, 1905
Constable, John (style of) 1776–1837, *Watermill at Flatford*, bequest from G. F. de Zoete, 1933
Constable, John (style of) 1776–1837, *Landscape with Man Fishing*, G. F. de Zoete
Cooper, Thomas George

1836–1901, *Canterbury Meadows*, bequest from Dr James George Beaney, 1891
Cooper, Thomas Sidney 1803–1902, *A Border Collie*, purchase with V&A grant
Cooper, Thomas Sidney 1803–1902, *Through the Glen in a Mist*, purchase 1995 with V&A grant
Cooper, Thomas Sidney 1803–1902, *The Stolen Horse*, purchase 1996 with V&A grant
Cooper, Thomas Sidney 1803–1902, *A Young Bull*, purchase 1996
Cooper, Thomas Sidney 1803–1902, *A Study of Cattle and Sheep on a Cliff Top*, purchase 1999
Cooper, Thomas Sidney 1803–1902, *A Peasant Boy with a Cow and a Dog*, purchase
Cooper, Thomas Sidney 1803–1902, *View of Canterbury from Tonford, with Cattle*, gift from Thomas Sidney Cooper, 1836
Cooper, Thomas Sidney 1803–1902, *Catching Wild Goats on Moel Siabod, North Wales*, gift 1896
Cooper, Thomas Sidney 1803–1902, *Donkey, Goat and Kid*, bequest from E. E. Cook, 1955 through NACF
Cooper, Thomas Sidney 1803–1902, *The Home Farm*, gift from Mrs T. G. Cannon, 1946
Cooper, Thomas Sidney 1803–1902, *On the Thames, Pushing off for Tilbury Fort*, gift from Mrs T. G. Cannon, 1946
Cooper, Thomas Sidney 1803–1902, *Separated, but not Divorced (The Bull)*, purchase 1936

Cooper, Thomas Sidney 1803–1902, *Spring: in the Springtime of the Year*, gift from Whitstable Trustees (Goldfinch Collection), 1985
Cooper, Thomas Sidney 1803–1902, *Winter: through the Fells, Cumberland; the Drove in a Snowdrift*, gift from Whitstable Trustees (Goldfinch Collection), 1985
Cooper, Thomas Sidney 1803–1902, *Sheep in the Snow*, gift from Canterbury College of Art
Cooper, Thomas Sidney 1803–1902, *Self Portrait*, gift
Cooper, William Sidney 1854–1927, *Canterbury Cathedral from the Stour Meadows*, purchase 1978
Corbould, Aster Richard Chilton 1811–1882, *Highland Cattle on the Hills*, bequest from Fred Goldfinch, 1956
Cotman, John Sell 1782–1842, *Woodland Scene with Stream, Man and Dog*, bequest from G. F. de Zoete, 1932
Cox, E. Albert 1876–1955, *Ancient and Modern*, gift from E. A. Cox, 1946
Cox, E. Albert 1876–1955, *Venice*, gift from E. A. Cox, 1946
Creswick, Thomas (attributed to) 1811–1869, *Hayfield*, bequest from G. F. de Zoete
Crome, John 1768–1821, *Woodland with River and Barges with Sails*, bequest from G. F. de Zoete, 1933
Cuming, Frederick b.1930, *Rye Harbour*, purchase
Cuming, Frederick b.1930, *Verandah Evening*, gift Trustees of

Chantrey Bequest, Royal Academy of Arts London

Curtois, Mary Henrietta Dering 1854–1929, *Figure in a Street*

Davies, Gordon b.1926, *Rebuilding and Repairs in St George's, Canterbury, including the construction of the David Greig shop*, purchase

Dawson, Alfred active 1860–1894, *Canterbury from Kingsmead*, purchase 1980 with V&A grant

de Grey, Roger 1918–1995, *Orchard*, purchase from Phillips, London, 1996

Desanges, Louis William 1822–c.1887, *Thomas Gilbert Peckham, Deputy Lieutenant, JP*

Desanges, Louis William 1822–c.1887, *Virginia Peckham*

Dinsdale, T. early 19th C, *William Baldock of Petham, Near Canterbury*

Dodd, Charles Tattershall I (attributed to) 1815–1878, *Deane, Near Canterbury (after L. L. Razé)*, purchase 1985 with V&A grant

Dodd, Charles Tattershall I (attributed to) 1815–1878, *Broome Park, Canterbury (after L. L. Razé)*, purchase 1985 with V&A grant

Dou, Gerrit (after) 1613–1675, *The Viola Player*, bequest from G. F. de Zoete, 1932

Doxford, James 1899–1978, *Self Portrait*, purchase 1996

Dubbels, Hendrik Jacobsz. (attributed to) 1620/1621–1676, *Seascape*, gift from G. F. de Zoete, 1905

Dudley, Colin b.1923, *Freedom Ceremony at Canterbury Guildhall for the Prince of Wales*, commissioned by the Council

Dusart, Cornelis 1660–1704, *The Hurdy-gurdy Player*, gift from G. F. de Zoete, 1905

Dusart, Cornelis 1660–1704, *The Pedlar*, bequest from G. F. de Zoete, 1933

Dyck, Anthony van 1599–1641, *Sir Basil Dixwell*, purchased with grant-aid from National Heritage Memorial Fund, the NACF and Friends of the Canterbury Museums

Fletcher, E., *Seascape with Fishing Boats*, © DACS 2004

Foreman, Margaret b.1951, *Canon Ingram Hill MA, DD, FSA*, purchase from Margaret Foreman, 1984 through V&A Purchase Grant Fund

Foster, Walter H. active 1861–1888, *The Lledr Valley from Near the Conway Falls*, bequest from Dr James George Beaney, 1891

Foster, Walter H. active 1861–1888, *At Beddgelert, North Wales*, bequest from Dr James George Beaney, 1891

Fox, Ernest R. active 1886–1919, *Dr Henry Wace, Dean of Canterbury, (1903–1924)*, gift

Gainsborough, Thomas 1727–1788, *Portrait of a Gentleman*, gift from G. F. de Zoete

Gerrard, Kaff 1894–1970, *Still Life*

Gerrard, Kaff 1894–1970, *Still Life with Pumpkin and Green Jug*, gift from Professor A. H. Gerrard, 1991

Gerrard, Kaff 1894–1970, *Poppy in a Glass Jar*, gift from Professor A. H. Gerrard, 1991

Gerrard, Kaff 1894–1970, *In the Twilight, in the Evening*, gift from Professor A. H. Gerrard, 1991

Gerrard, Kaff 1894–1970, *Still Life with Fruit and Mushrooms*, gift from Professor A. H. Gerrard, 1991

Gibbs, Henry 1630/1631–1713, *The Judgement of Solomon (after Peter Paul Rubens)*, from Canterbury Corporation

Goodwin, Albert 1845–1932, *Bosham, Sussex*, gift 1928

Goodwin, Albert 1845–1932, *Nightfall*, bequest from Fred Goldfinch, 1956

Goodwin, Albert 1845–1932, *The Shrimper*, bequest from Fred Goldfinch, 1956

Gregory, Edward John 1850–1909, *The Awakening*, bequest from Fred Goldfinch, 1956

Halhed, Harriet 1850–1933, *The Little Girl at the Door*, gift from 16 of the artist's former pupils

Hallady, A. E., *Canterbury Blitz 1st June 1942*

Hardy, Paul active 1890–1903, *The Canterbury Pilgrims*, purchase from Sotheby's, London, 1989

Harrison, *Unknown Mayor of Canterbury*

Hawksley, Arthur 1842–1915, *The Old Gangway, Broadstairs*, gift from Mrs Hawksley, 1925

Hayman, H. W., *Old Ridingate, Canterbury as in 1770*, gift

Herrick, William Salter active 1852–1888, *Annie Clara Dudley*, transfer

Hewson, Stephen 1775–1807, *William Goulden (1749–1816), holding a Leyden jar with a friction machine for generating electricity in the background. Goulden was a founder of the Canterbury Philosophical and Literary Institution*, gift from Canterbury Philosophical & Literary Society

Hewson, Stephen 1775–1807, *Thomas Ridout (1761–1843), Land Surveyor and a Founder of the Canterbury Philosophical and Literary Institution*, from Canterbury Philosphical & Literary Institution

Hewson, Stephen 1775–1807, *Alderman James Simmons, (1741–1807)*, from Canterbury Corporation

Hewson, Stephen 1775–1807, *John Calloway, Silk Weaver and a Founder of the Canterbury Philosophical and Literary Institution*, from Canterbury Philosphical & Literary Institution

Hewson, Stephen 1775–1807, *Mr Cooper Holding an Architectural Plan, Member of the Canterbury Philosophical and Literary Institution*, from Canterbury Philosphical & Literary Institution

Hewson, Stephen 1775–1807,

Charles Robinson (1732–1807), MP for Canterbury

Hodges, Sidney 1829–1900, *Henry Cooper, Mayor of Canterbury*

Holl, Frank 1845–1888, *William Oxenden Hammond*, purchase 1985

Hollins, John 1798–1855, *Charles Abbott, Lord Chief Justice 1st Baron Tenterden*, presented by John Plummer in 1851

Hone, Nathaniel I 1718–1784, *Kitty Fisher*, gift from G. F. de Zoete, 1905

Honthorst, Gerrit van (after) 1590–1656, *Cavalier Carousing*, loan

Howard, Bill, *Tudor Tea Rooms, High Street, Canterbury*, gift

Hudson, Thomas 1701–1779, *Margaret, Wife of Sir Henry Oxenden*, purchase with grant-aid from V&A/MGC, NACF and Friends of Canterbury Museums

Hunter, Ian b.1939, *Gutter Apples*, purchase from the artist

Isabey, Eugène (attributed to) 1803–1886, *Fishing Boats in Rough Weather off St Michael's Mount*, bequest from Dr James George Beaney, 1891

Jackson, John 1778–1831, *Portrait of a Lady*, gift from G. F. de Zoete, 1905

James, Walter John 1869–1932, *The Big Cloud - Near Canterbury*

Janssens van Ceulen, Cornelis 1593–1661, *Colonel Robert Hammond*, purchase with grant-aid from V&A/MGC, NACF and Friends of Canterbury Museums

Janssens van Ceulen, Cornelis 1593–1661, *Two Children with a Dog*, acceptance in lieu from Council for Museums, Archives and Libraries

Janssens van Ceulen, Cornelis (after) 1593–1661, *Dudley Digges*, purchase 1985 with grant-aid from V&A

Jenkins, George Henry 1843–1914, *Mountain Landscape with Stream and Highland Cattle*, gift 1935

Jenkins, George Henry 1843–1914, *Seascape with Fisherman and Rocky Shore*, gift 1935

Jobert, Paul 1863–after 1924, *Tug Towing a Three-Master*, bequest: Fred Goldfinch 1956

Jordaens, Jacob (after) 1593–1678, *A Musical Party*, bequest from E. B. Goulden, 1931

Judkin, Reverend Thomas James 1788–1871, *Windmill on St Martin's Hill, Canterbury*, gift 1916

Knight, John Prescott 1803–1881, *Thomas Sidney Cooper, RA*, bequest from Nevill Louis Cooper, 1936

Knight, Laura 1877–1970, *Hop-picking Granny Knowles - an Old Hand*, purchase from V&A/MGC and NACF grants

Knight, Laura 1877–1970, *Hop-picking No.1*, purchase V&A, NACF grants

Kooyhaylen or Koningshusen, J.,

Portrait of a Gentleman, bequest from Fred Goldfinch, 1956

L. A. R 19th C, *Burgate, Canterbury*, gift

L. A. R. 19th C, *Northgate, Canterbury*, gift

La Thangue, Henry Herbert 1859–1929, *Farm Near Horsey, Norfolk*, gift

Lee, P., *On the Moira Station, Australia*, bequest from Dr James George Beaney, 1891

Loo, Jean-Baptiste van 1684–1745, *Sir Thomas Hales, MP, (1694–1762)*, purchase 1987 with V&A grant

MacTavish, Euphemia L. C., *'Nothing to do with me'*, purchase from Euphemia MacTavish, 1995

Manson, James Bolivar 1879–1945, *Summer Fields, Rye*, gift from Mrs Elizabeth Deighton

Maratti, Carlo (style of) 1625–1713, *St Cecilia (from Canterbury Catch Club)*, gift from Canterbury Catch Club

Marshall, Benjamin 1767–1835, *Thomas Hilton and His Hound 'Glory'*, purchase with V&A, NACF and Friends of Canterbury Museums grants

McLachlan, Thomas Hope 1845–1897, *Shepherd Girl with Sheep in Moonlight*

Meadows, (Canon), *Norman Stairs, Canterbury*, gift

Metsu, Gabriel (after) 1629–1667, *Woman Peeling Apples*, gift G. F. de Zoete

Middleton, James Godsell active 1826–1872, *Sir Henry Oxenden, (b.1756)*, purchase with V&A grant

Miles, Arthur active 1851–1885, *A Posthumous Portrait of John Brent, Canterbury Antiquarian*, purchase

Mitchell 19th C, *River Scene*, bequest from Dr James George Beaney, 1891

Money-Coutts, Godfrey Burdett 1905–1979, *Teasels*, gift

Monnington, Walter Thomas 1902–1976, *The Artist's Home at Groombridge Looking at Kaff Gerrard's Garden*, purchase with V&A grant

Morland, George 1763–1804, *Outside the Alehouse Door*, bequest from G. F. de Zoete, 1932

Morland, George 1763–1804, *A Road through a Woodland (A Man on a White Horse Giving Alms to a Child)*, gift 1961

Müller, William James 1812–1845, *Woodland Scene*, gift from G. F. de Zoete, 1905

Müller, William James (attributed to) 1812–1845, *On the River Avon*, bequest from Fred Goldfinch, 1956

Murray, David 1849–1933, *'It Was the Time of Roses'*, gift from Executors of Sir David Murray, 1939

Nasmyth, Patrick (after) 1787–1831, *Landscape with Labourer and Dog*, bequest from G. F. de Zoete, 1932

Neame, Austin 1789–1862, *A Bay Hunter in a Landscape*, purchase

1996

Neer, Aert van der 1603–1677, *A River Moonlit Scene with Cattle*, gift from G. F. de Zoete, 1905

Ogden, Joseph, *Still Life with Tankard and Bananas*, bequest from Mrs J. Ogden, 1943

Opie, John 1761–1807, *Murder of Thomas Becket in Canterbury Cathedral*, purchase from Colnaghi with V&A and NACF grants

Orley, Bernaert van c.1492–1541, *The Virgin and Child Resting in an Imaginary Landscape*, gift from G. F. de Zoete, 1905

Ouless, Walter William 1848–1933, *Thomas Sidney Cooper, RA*, bequest from Nevill Louis Cooper, 1936

Palmer, Alfred 1877–1951, *Boy in the Orchard*, purchase from the artist's family 1977

Palmer, James, *Daisy Law of Canterbury (1895–1984)*, purchase from James Palmer, 1993

Pardon, James c.1794–1862, *Canterbury from St Stephen's*, purchase from Sotheby's, London, 1987 with V&A grant

Parris, Edmund Thomas 1793–1873, *The Canterbury Pilgrims*, bequest 1990

Pemell, James active 1836–1856, *Stephen Rumbold Lushington (1776–1868), MP for Canterbury, (1812–1830 & 1835–1837)*, gift from Canterbury Corporation

Perugino (after) c.1450–1523, *The Baptism of Christ*, gift from G. F. de Zoete, 1905

Pirri, Antonio active 1509–1520, *The Madonna and Child Enthroned with St Peter and a Carthusian Prior, and St Catherine of Siena*, gift from G. F. de Zoete, 1905

Pissarro, Lucien 1863–1944, *Rye from Cadborough Hill - Grey Afternoon*, purchase with V&A and NACF grants, © the artist's estate

Pyne, James Baker (attributed to) 1800–1870, *A River Landscape with Figure and a Bridge*, from G. F. de Zoete

Raphael (after) 1483–1520, *Portrait of a Young Man (copy of a self portrait believed to be by Raphael)*, gift from G. F. de Zoete, 1905

Read, Catherine (attributed to) 1723–1778, *Little Girl with a Bonnet*, bequest from Mr F. M. Furley, 1969

Richards, F., *A Pair of Roach*, bequest 1963

Richards, F., *A Roach*, bequest 1963

Richards, F., *A Catch with Ruffe, Gudgeon and Dace*, bequest 1963

Richards, F., *A Catch of Perch and Bream*, bequest 1963

Richards, F., *A Catch of Perch*, bequest 1963

Richmond, George 1809–1896, *The Murder of Becket*, purchase from Sotheby's, London, 1994

Rosenburg, Gertrude Mary, *Fishing Smacks off the Cornish Coast*, gift from Percy Godfrey, 1929

Schaefer, Henry Thomas active 1873–1915, *Cricket Match at Heathfield Park, Sussex*, bequest from G. F. de Zoete, 1933

Scott, Walter 1771–1832, *Thomas Sidney Cooper*, bequest, 1982

Seemann, Enoch the younger 1694–1744, *Sir George Oxenden, 5th Baronet*, purchase Christie's 1988 with V&A and NACF grants

Sevier, Joseph b.1961, *Town, Gown, Mitre and Drum - Marking the Millennium*, commissioned and presented by Cllr Miss Samper, Lord Mayor in 2000

Sickert, Walter Richard 1860–1942, *Romeo and Juliet Near Reculver, Kent*, purchase with V&A and NACF grants, © Estate of Walter R. Sickert 2004. All rights Reserved DACS

Snell, James Herbert 1861–1935, *Marshy Landscape with Trees*

Snell, James Herbert 1861–1935, *Figure on a Bridge, with River and Buildings*

Soldi, Andrea (attributed to) c.1703–1771, *Lady Oxenden, Daughter of Edmund Dunch Esq. Married to Sir George Oxenden, 5th Bt*, purchase from Christie's, London, 1988 with V&A and NACF grants

Stannard, Alfred 1806–1889, *Canterbury from the Stour Meadows*, purchase 1981 with V&A grant

Stark, James 1794–1859, *Eel Traps*, gift from G. F. de Zoete, 1905

Stark, James 1794–1859, *Landscape with a Church*, gift from G. F. de Zoete

Stark, James 1794–1859, *View of Uxbridge*, bequest from G. F. de Zoete, 1932

Stokes, Adrian Scott 1854–1935, *By the Walls of the Hougue, France*

Stothard, Thomas 1755–1834, *The Canterbury Pilgrims*, purchase 1975 with V&A and NACF grants

Stothard, Thomas 1755–1834, *The Pardoner's Tale*, purchase 1982

Stothard, Thomas 1755–1834, *Martyrdom of St Thomas Becket*, purchase from Phillips, London, 1988

Swain, Ned, *Fordwich Bridge from the River*, purchase 1987 with V&A grant

Swiney, Captain Stephen, *The Vale of Rest - At Eventime There Shall Be Light (copy of John Everett Millais)*, gift from Captain Stephen Swiney, 1900

Syer, John 1815–1885, *A Rocky River Landscape*

Tayler, Albert Chevallier 1862–1925, *John Howard Esq. JP, DL of Sibton and Chartham, MP for Northeast Kent, (1902–1908)*, gift

Temple, Robert Scott active 1874–1905, *Lingering Summer: Ightham Woods, Kent*, gift from Mrs F. Kidd, 1934

Titian (after) c.1488–1576, *Lady in White Satin Holding a Rose*, gift from G. F. de Zoete 1905

Towne, Charles 1763–1840, *Cattle on a River Bank*, gift from G. F. de Zoete

Townsend, William 1909–1973, *Self Portrait*, purchase from the artist's family, 1979

unknown artist, *Colonel Francis Hammond*, purchase with V&A grant-aid

unknown artist, *Sir Thomas White, Benefactor (d.1566)*, from the Old Guildhall

unknown artist, *Mrs Elizabeth Lovejoy (1627–1694)*

unknown artist, *Interior of Canterbury Cathedral - The Quire*, purchase with V&A/MGC, Beecroft Bequest and Friends of the Canterbury Museums grants

unknown artist, *The Fordwich Trout*, gift from George Lee Warner, 1948

unknown artist 17th C, *Interior of Canterbury Cathedral*, purchase 1991 with V&A, NACF and Friends of the Canterbury Museums grants

unknown artist 17th C, *John Watson, Mayor (d.1633) Aged 75*

unknown artist 17th C, *Joseph Colfe, Mayor (d.1620)*

unknown artist 17th C, *Henry Johnson, Benefactor*

unknown artist 17th C, *John Cogan, Benefactor, (John Cogan established an almshouse in Canterbury by his will in 1657)*

unknown artist late 17th C, *John Whitfield, (1636–1691)*, gift from Canterbury Corporation

unknown artist late 17th C?, *Portrait of a Gentleman*, gift

unknown artist, *John Warly - Surgeon of Canterbury*, gift 1959

unknown artist, *Interior of Canterbury Cathedral*, purchase from Sotheby's, London, 1991

unknown artist, *Portrait of a Man with a White Cravat and Indigo Jacket (Head and Shoulders)*

unknown artist, *Herbert Randolph (d.1752), Recorder of Canterbury, Buried in the Cathedral*, gift c.1934

unknown artist, *Portrait of a Man Holding a Wine Glass*

unknown artist, *Mary, Wife of Surgeon John Warly, and Daughter of Alderman Lee of Canterbury*, gift

unknown artist, *Wooded Landscape and Distant Village*

unknown artist, *Mr Frend of Canterbury*, purchase 1979

unknown artist, *Portrait of a Man with White Cravat and Holding a Box in his Left Hand, Mr William Paine, Canterbury Apothecary*

unknown artist, *Mr Delmar, Member of the Canterbury Catch Club*

unknown artist, *Alderman Cyprian Rondeau Bunce, Archivist and Mayor*, presented by Miss Bunce in 1942

unknown artist, *Richard Harris Barham as a Boy with Dog Lion*, gift from Edward A. Platt, 1937

unknown artist 18th C, *Handel, Holding the Score of the Messiah - from Canterbury Catch Club*

unknown artist 18th C, *Thomas Hanson (1691–1770), Benefactor, (Thomas Hanson - merchant in London & benefactor of Canterbury almshouses)*

unknown artist 18th C?, *Rev. William Gostling, Historian of Canterbury*

unknown artist, *The Cob, Owned by Osborn Snoulten of Canterbury*, bequest

unknown artist, *Mr Goodban of Canterbury Catch Club with Violin and Music*

unknown artist, *Arcangelo Corelli - from Canterbury Catch Club*, Canterbury Catch Club

unknown artist, *Mr Baskerville of Canterbury Catch Club, Holding a Scroll and a Quill Pen in an Ink Stand*

unknown artist, *William Mount JP, DL (1789–1871) of Howfield, Chartham*, gift 1994

unknown artist, *Miss Polly Barham, Daughter of Richard Harris Barham of Canterbury*, gift 1956

unknown artist, *Dame Frances Caroline Bond, Daughter of Richard Harris Barham*

unknown artist, *William Warman (1806–1875), Latin Master at The King's School*, gift

unknown artist, *Rev. Richard Harris Barham (1788–1845) (Author of Ingoldsby Legends)*, gift

unknown artist, *Richard Halford (1754–1823), Alderman and Chamberlain*, from Canterbury Corporation

unknown artist, *Richard Halford Esq. 33 Years Chamberlain to this City Died 26 November 1823 Aged 69*

unknown artist, *Richard Frend, Mayor of Canterbury (1803 & 1833)*, purchase 1979

unknown artist, *Lake Scene with Mountains*, bequest from Dr James George Beaney, 1891

unknown artist, *Landscape with Stream and Groups of Cattle*

unknown artist, *Mr Saffrey with a Viola (Committee Member of the Canterbury Catch Club)*

unknown artist, *Sunset Lake Scene with Mountains and Cows Watering*, bequest from Dr James George Beaney, 1891

unknown artist, *North Lane, Canterbury*, gift

unknown artist, *Alderman W. H. Linom, Mayor of Canterbury, (1871 & 1876)*

unknown artist 19th C, *Dr Chalk*, gift 1994

unknown artist 19th C, *Farmyard with Cattle, Calf and Child*, bequest from Dr James George Beaney, 1891

unknown artist 19th C, *Forest Scene with Figures and Sheep*, bequest from Dr James George Beaney, 1891

unknown artist 19th C, *The Norfolk Broads with Storm Brewing*, gift from G. F. de Zoete

unknown artist 19th C, *King Thibor, His Wife and Attendants in a Palace in Mandalay*, gift

unknown artist 19th C, *Landscape with Tree, House and Figure of a Man*

unknown artist 19th C, *Fishing Boats with a Continental Town to the Right - Labelled Granville*

unknown artist 19th C, *Alderman Collard, Mayor of Canterbury*

unknown artist 19th C, *Mr Burgess (First Violin of Canterbury Catch Club) Holding a Roll of Music*

unknown artist 19th C, *Fisherman with Net on a Boat in a Lake, Trees to the Right*

unknown artist 20th C, *Alderman W. S. Bean, Mayor of Canterbury 1956–1958*

unknown artist, *Geoffrey Chaucer*, purchase with V&A grant

unknown artist, *Landscape with Pool*, gift

unknown artist, *Leonard Cotton, Mayor*

unknown artist, *Sir John Boys, (d. 1612) Aged 77*, gift

unknown artist, *Seascape with Fishing Boats (Y51 on Sail)*

unknown artist, *San Giorgio Maggiore, Venice*, bequest from Dr James George Beaney, 1891

unknown artist, *Dr J. G. Beaney in Military Uniform*, bequest of Dr J. G. Beaney

unknown artist, *St Augustine's Great Gateway, Canterbury*, purchase 1909

unknown artist, *Alderman Barham (1788–1845)*

Vickers, Alfred 1786–1868, *Farmhouse and Figure in a Wooded Landscape*, bequest from Dr James George Beaney, 1891

Ward, James 1769–1859, *Reculver Church, Isle of Thanet*, purchase from Agnew's, London, 1984 with V&A and NACF grants

Ward, John Stanton b.1917, *Self Portrait Seated at an Easel*, purchase from John Ward, © the artist

Ward, John Stanton b.1917, *Geraldine Caufield*, purchase with V&A and SE Arts grants, © the artist

Ward, John Stanton b.1917, *The East Kent School*, purchase from John Ward, 1987 with V&A, NACF and Friends of Canterbury Museums grants, © the artist

Ward, John Stanton b.1917, *Councillor Tom Steele, First Lord Mayor of Canterbury*, presented by the artist, © the artist

Weenix, Jan Baptist (after) 1621–1660/1661, *The Tinker and His Dog*, bequest from G. F. de Zoete, 1932

Weight, Carel Victor Morlais 1908–1997, *Edwin La Dell's Cottage*, purchase from Christie's, London, 1995

Wicks, Sara, *Angel over Canterbury*, purchase

Wilkie, David (after) 1785–1841, *A Study for the Jews Harp*, gift from G. F. de Zoete

Williams, George Augustus 1814–1901, *Wooded Landscape with Figures, Church in the Distance*, gift from Miss Higgs, 1919

Woodward, Thomas (after) 1801–1852, *The Market Pony*, bequest from G. F. de Zoete, 1932

Canterbury City Council Museums and Galleries: Whitstable Museum and Gallery

Archer, C., *The Abbey House and Refectory, Malvern*

Cassell, H., *Tankerton Pier, Whitstable*

Cheadle, David, *Whitstable Harbour*, gift

Davies, Peter b.1970, *Upturned Boat, Whitstable*, gift

De Simone, Alfredo (style of) 1898–1950, *'Sparkling Foam 60232' with Vesuvius*, gift

Dunlop, Ronald Ossory 1894–1973, *Whitstable Beach*, purchase MGC/ V&A GF

Fannen, John active 1887–1901, *'Raymond'*

Fannen, John active 1887–1901, *'Guide'*

Fannen, John active 1887–1901, *'Rapid'*

Fraser, John 1858–1927, *Low Tide, Whitstable Harbour*, purchase with V&A grant

Goodsall, R. H., *Lady with a Lace Collar*

Harold, S. R., *Tankerton Pier, Whitstable*

Koekkoek, Hermanus the younger 1836–1909, *Landing the Catch, Whitstable*, gift

Lacy, Charles John de c.1860–1936, *Shipping in the Pool of London*

Lynn, John active 1826–1838, *Smeaton's Eddystone Lighthouse*, gift

Niemann, Edmund John 1813–1876, *Unloading Barges at the Horse Bridge, Whitstable*, purchase MGC/V&A GF

Roberto, Luigi active 1870–1890, *'Cassandra' 45554 Foul Weather*

Roberto, Luigi (attributed to) active 1870–1890, *'Cassandra' 45554 Fair Weather*, gift

Severn, Arthur 1842–1931, *Sunset*

Sherrin, Daniel 1869–1940, *Sailing Boat*

Sherrin, Daniel 1869–1940, *Sailing Boats*, gift

Sherrin, Daniel 1869–1940, *Sailing Boat*

Sherrin, Daniel 1869–1940, *Woodland*

Sherrin, Daniel 1869–1940, *Cliff and Birds*, gift

Sherrin, Daniel 1869–1940, *The Wreck at Sunset, Seasalter*, purchase

unknown artist 19th C, *Dutch Canal Scene*

unknown artist 19th C, *Paddle Steamer in a Storm*

unknown artist 19th C, *Man with High Collar and Cravat*

unknown artist 19th C, *Ships off a Coast*, purchase

unknown artist 19th C, *Landscape with Cottage at Forest Edge*
unknown artist, *Two Brewers Inn*
unknown artist, *Sunset with Boats at Horsebridge, Whitstable*
W. H. G., *Fred Goldfinch, Museum Founder*
Walker, G. H., *'Resolute'*
Walker, G. H., *'Duluth'*

Corridor Arts, Marlowe Theatre

Hill, Austin b.1933, *The Old Marlowe Theatre*

Historic Dockyard, Chatham

Beadle, James Prinsep 1863–1947, *Admiral Sir Edward Eden Bradford*, donation from Miss Katherine Bradford
British (English) School 19th C, *Sloop/Frigate Moored off Anchor Wharf*, purchase from Christie's Amsterdam
Dawson, Montague J. c.1894–1973, *The Convoy Got Through*, loan from Furness, Withy & Co. Ltd
Hyde, Frank 1849–1937, *Bugler Timmins R. M. - The Boy Hero*, loan from Napier Road School
Jarvis, P. V. active 1930–1935, *Alfie Merryweather*, donation
Joyce, Arthur 1923–1997, *'HMS Lynx' at Dover, 26 September 1973*, loan from Mrs Marjorie Joyce, © the artist's estate
Joyce, Arthur 1923–1997, *'HMS Endurance' Returning to Chatham Dockyard, 20 August 1982*, loan from Mrs Marjorie Joyce, © the artist's estate
Joyce, Arthur 1923–1997, *'HMS Prince of Wales' Going through the Convoy*, loan from Mrs Marjorie Joyce, © the artist's estate
Joyce, Arthur 1923–1997, *'HMS Avenger'*, loan from Mrs Marjorie Joyce, © the artist's estate
Joyce, Arthur 1923–1997, *Fleet Tenders at Work in the River Medway*, loan from Mrs Marjorie Joyce, © the artist's estate
Joyce, Arthur 1923–1997, *'HMS Cuxton' 1977*, loan from Mrs Marjorie Joyce, © the artist's estate
Joyce, Arthur 1923–1997, *'HMS Belfast'*, loan from Mrs Marjorie Joyce, © the artist's estate
Joyce, Arthur 1923–1997, *Tall Ships Race, River Medway, 24 July 1985*, loan from Mrs Marjorie Joyce, © the artist's estate
Joyce, Arthur 1923–1997, *'HMS Ark Royal'*, loan from Mrs Marjorie Joyce, © the artist's estate
Joyce, Arthur 1923–1997, *'HMS Illustrious'*, loan from Mrs Marjorie Joyce, © the artist's estate
Joyce, Arthur 1923–1997, *'HMS Kent'*, loan from Mrs Marjorie Joyce, © the artist's estate
Joyce, Arthur 1923–1997, *'HMS Brighton'*, loan from Mrs Marjorie Joyce, © the artist's estate
Martin, Elias 1739–1818, *A View of Chatham Dockyard*, purchase from Carlton Hobbs
Maxwell, Donald 1877–1936, *A Giant Refreshed*, donation from Vice-Admiral Sir John and Lady Webster
Maxwell, Donald 1877–1936, *The Recall - Zeebrugge, April 23 1918*, donation
Nickalls, Beatrix, *On Guard at the Nore*, purchase from Christie's Maritime Sale 1988
Tonkin, Paul b.1951, *'HMS Cleopatra' at the Battle of Sirte, 23 March 1942*, donation from HMS Cleopatra Association
Turner, *Chatham Reach*, bequest from Captain R. L. Jermain RN
unknown artist, *William Drake, Foreman, Chatham Dockyard*, bequest from Miss D. W. Southcombe

Kent Police Museum

Fowler, Norman 1903–2001, *Kent '9 Pints of the Law'*, donation

Cranbrook Museum

Burrell, Joseph Francis b.1770, *Rev. W. Huntington*, loan
Chapman (jnr), W. J. b.1808, *Old Buck Wraight (Aged 90)*
Chapman (jnr), W. J. b.1808, *Mrs Farmer (Dame Schoolmistress)*, loan
unknown artist, *Rev. W. Huntington*, loan
unknown artist, *Rev. I. Beeman*, from the Beeman family?

Cranbrook Parish Council

Johnson, G., *Mrs Mary Buss - Professional Fortune Teller*

Dartford Borough Council Civic Centre

Lee, May Bridges active c.1905–1967, *Everard Hesketh*, donation
Lee, May Bridges active c.1905–1967, *Alderman Alfred J. Penney*, donation

Dartford Borough Museum

Pearce, Sylvia, *Nos 13 & 15 Miskin Road, Dartford*, donation, © the artist
Pearce, Sylvia, *Nos 17 & 19 Miskin Road, Dartford*, donation, © the artist
Pearce, Sylvia, *Athol Lodge and Alpine Lodge, Dartford*, donation, © the artist
Pearce, Sylvia, *No. 25 Miskin Road, Dartford*, donation, © the artist
Pearce, Sylvia, *The Prince of Orange, 19 Heath Lane, Dartford*, donation, © the artist

Dartford Library

Bugg, E. J., *Overy Street, Dartford*, purchased from the artist, © the artist
Coker, Olive, *River Darent, Horton Kirby*, purchased from Dartford Art Group 1972, © the artist
Cork, M. E., *Colyer's Mill*, purchased from Dartford Art Group 1958
Howells, Gerald S., *Dartford Parish Church*, purchased from Mr G. S. Howells, Dartford in 1958
Howells, Gerald S., *Dartford Parish Church*, purchased from Mr G. S. Howells, Dartford in 1958
Jowett, F., *Eynsford*, purchased from the artist
Lee, May Bridges active c.1905–1967, *Everard Hesketh*, donation to Borough Council by J. & E. Hall in 1966
Passingham, E. S., *Horton Kirby*, purchased from the Dartford Art Group 1955
Pearce, Sylvia, *Horton Kirby*, purchased from Dartford Art Group 1957
Pearce, Sylvia, *Lowfield Street, Dartford*, purchased from Mrs S. Pearce 1970
Pearce, Sylvia, *Overy Street, Dartford*, purchased from the artist, 1969
Pearce, Sylvia, *Dover-London Coach c.1860*, purchased from Dartford Art Group 1970
Pearce, Sylvia, *Dartford Market*, purchased from Mrs S. Pearce, Dartford 1971
Rousham, Edwin, *Dartford Creek*, purchased from the artist, 1950
Rousham, Edwin, *Darenth Mill*, purchased from Dartford Art Group, 1951
unknown artist 19th C, *Dartford Heath*
unknown artist 19th C, *Richard Trevithick*
unknown artist, *Thomas Batt, the Beadle*, donated by Mrs Cracroft Fooks in 1908
unknown artist, *High Street, Dartford*, purchased from Mrs F. Wilkins, Herne Bay
unknown artist, *The Windmill, the Brent*, donated by Mrs F. M. Perkins in 1957
unknown artist, *The Priory, Dartford*
unknown artist, *High Street, Dartford*, donated by Mr W. J. Pither in 1958
unknown artist, *Long Reach Tavern, Dartford Marshes*, purchased from Mr W. Salmon
unknown artist, *Cornfield, Cotton Lane Farm, Stone*
unknown artist, *Cornfield and Farmhouse, Cotton Lane, Stone*
Warcup, Samuel, *Overy Liberty, Dartford*, donated by Mr F. Pelton
Youens, Clement T. 1852–1919, *Gravel Path, Dartford Heath*
Youens, Clement T. 1852–1919, *Dartford Heath*
Youens, Clement T. 1852–1919, *Central Park, Dartford*, donated by Miss W. B. Dunn, Dartford in 1959
Youens, Clement T. 1852–1919, *Lowfield Street, Dartford*, donated by Mr E. C. Youens
Youens, Clement T. 1852–1919, *High Street, Dartford*, donated by the artist
Youens, Clement T. 1852–1919, *Stanham Farm, Dartford*
Youens, Clement T. 1852–1919, *Chancespring Wood, Dartford Heath*
Youens, Clement T. 1852–1919, *John Treadwell 'Old Nattie'*
Youens, Clement T. 1852–1919, *Stoneham Farm, Dartford*, donated by Miss O. B. Youens in 1969
Youens, Clement T. 1852–1919, *Priory Building*, donated by Miss O. B. Youens, Dartford in 1969
Youens, Clement T. 1852–1919, *Priory, Infirmary Building*, donated by Miss O. B. Youens, Dartford in 1969
Youens, Clement T. 1852–1919, *The Windmill, the Brent*, donated by Mrs A. Gillham 1993
Youens, Clement T. 1852–1919, *Dartford Heath*, donated by Mrs A. Gillham 1993
Youens, Ernest Christopher 1856–1933, *The Windmill, the Brent*, purchased from Mrs H. Hayes

Deal Town Council

Appleton, Thomas Gooch 1854–1924, *Alderman J. R. Lush*
Appleton, Thomas Gooch 1854–1924, *Alderman A. F. Bird, Mayor*
Appleton, Thomas Gooch 1854–1924, *Alderman W. H. Hayward, Mayor*
Brooks, F. G., *J. F. Torr, Recorder*
Grant, Francis 1803–1878, *William IV*
Henson, S. active late 18th C, *Chas Robinson*
Highmore, Joseph 1692–1780, *Elizabeth Carter*, gift of Rev. Pennington
Hudson, Thomas 1701–1779, *Lord Chief Justice Ward, Mayor*
Ramsey, Dennis, *Winston Churchill, Lord Warden of the Cinque Ports*, donated to the people of Deal
Wissing, Willem c.1656–1687, *William III*, presented by Mr Iggulden

Dover Collections

Alma-Tadema, Laura Theresa Epps 1852–1909, *Measuring Heights*, bequest Williamson
Amos, George Thomas 1827–1914, *Sheep in a Stable*
Amos, George Thomas 1827–1914, *Sheep and Horses in a Wind*
Anderson, William I 1757–1837, *London Bridge and St Paul's by Moonlight*, bequest Williamson

Anglo-Chinese School, *Foreign Legations in Peking*, bequest of Lady Cory
Arison, Mark, *Mont St Michel*, bequest Williamson
Bailey, Colin C., *Buckland Paper Mill, Dover, in the 1600s*
Baldry, George W., *Soldier in Dress Uniform*
Baldry, George W., *Soldier in Mess Uniform*
Baldry, George W., *Dr E. F. Astley MD, Mayor of Dover*
Baldry, George W., *H. P. Mackenzie, Dover Builder*
Barker, Thomas 1769–1847, *View of Venice*, bequest Williamson
Birley, Oswald Hornby Joseph 1880–1952, *Sir William Crundall*, © the artist's estate
Birley, Oswald Hornby Joseph 1880–1952, *Alfred Charles Leney JP*, © the artist's estate
Blackman, John, *The River Stour at Sandwich*
Blommaert, G., *Temple Ewell Mill*, donated by the artist
Booth, Raymond C. b.1929, *Jay in a Winter Woodland*, bequest Williamson, © the artist's estate
British (English) School, *Excise Cutter off Dover*
British (English) School, *Maison Dieu, Dover*
British (English) School, *George Stringer of Archers Court*
British (English) School, *Charles Lamb, Mayor 1853*
British (English) School 19th C, *Mrs Williamson's Great Grandmother*, bequest Williamson
British (English) School 19th C, *Fishing Boat by Moonlight*, bequest Williamson
British (English) School 19th C, *George and Dragon Inn, Temple Ewell*
British (English) School 19th C, *Study of a Horse's Head*
British (English) School 19th C, *Lieutenant Sclater*, gift of Mrs D. B. Allen
British (English) School 19th C, *Dock Hand Mummery*, gift of Miss English
British (English) School late 19th C?, *Fishing Vessels off the Coast*, gift from Mrs M.Prescott
British (English) School 20th C, *Wintry Street Scene*
British (English) School, *John Lewis Minet*, gift Susan Minet
British (English) School, *Fishing Boats and Man of War*, bequest Williamson
Broad, William Henry (attributed to) 1853–1939, *Mayor George Raggett*
Brooks, Henry Jamyn 1865–1925, *Earl Granville, Lord Warden of the Cinque Ports*
Brouwer, Adriaen 1605/1606–1638, *The Topers (Boors Smoking in an Interior)*, bequest Williamson
Burgess, William 1805–1861, *Buckland Bridge 1839*, purchase John Skelton
Burgess, William 1805–1861, *The*

243

Old Market House

Burgess, William 1805–1861, *Army Wagoners beneath Dover Castle*

Burgess, William 1805–1861, *Toll Gate, Crabble Hill*

Burgess, William 1805–1861, *Christchurch from the Folkestone Road*, gift Susan Minet

Burgess, William (attributed to) 1805–1861, *Dover from the Western Heights*, gift Susan Minet

Carmichael, James Wilson 1800–1868, *Off Dover*, presented by H. B. Poland

Carr, Leslie active 20th C, *The Royal Yacht*

Castan, Pierre Jean Edmond 1817–after 1865, *Coming out of Church*

Castle, G., *Charlton Church*, gift of Mrs Bettridge

Castle, G., *Charlton Church*, gift from Mr S. King

Chalon, Henry Bernard 1770–1849, *Two Chestnut Horses with Eager Spaniel*, bequest Williamson

Clint, Alfred 1807–1883, *Landing at East Cliff, Dover*

Cockerham, Charles active c.1900–1935, *'HMS Daffodil' after Zeebrugge*

Coffyn, A., *Ruines, la Panne*

Cole, Ethel b.1892, *Pastoral Landscape, Stream with Bridge*, bequest Williamson

Cole, Ethel b.1892, *Pastoral Landscape, Stream with Town in Distance*, bequest Williamson

Cooke, Edward William 1811–1880, *Dutch Saw Mill and Shipping on the Zuyder Zee*, bequest Williamson

Cooper, Thomas Sidney (after) 1803–1902, *Milking Time*, gift from M. Payn

Copri, Adrienne, *The Visit to Grandmamma*, bequest Williamson

Coward, Noël 1899–1973, *White Cliffs*, © WHITE CLIFFS © NC Aventales AG

Cox, David the elder 1783–1859, *Bettys-y-Coed*, bequest Williamson

Curtis, C. E., *Crabble Mill 1812*, gift from Mr C. E. Curtis

Dahl, Michael I 1656/1659–1743, *George I*, gift of Alexander Wellard

Davey, Doreen b.1968, *Dover*

de Garay, Talla, *The Charade*, bequest Williamson

Dommard, E. M., *The Shepherd*, bequest Williamson

Dubreuil, C., *Allied Fleet before Cherbourg*, gift of Mr R. W. Philpott

Dutch School 19th C, *Peasants (Pipes)*, bequest Williamson

Dutch School 19th C, *Peasants*, bequest Williamson

Dyck, Anthony van (after) 1599–1641, *The Earl of Strafford in Armour*, bequest Williamson

Eddy, W., *Queen Victoria Reviewing the Fleet*, gift of Mr Newman

Eversen, Johannes Hendrik 1906–1995, *Still Life of Tankard*

and Oysters, bequest Williamson

Failing, R., *The Young Barber*, bequest Williamson

Fallshaw, Daniel 1878–1971, *Kearsney Abbey Gardens*, purchased at auction

Fantin-Latour, Henri 1836–1904, *White Azaleas*, bequest Williamson

Fantin-Latour, Henri 1836–1904, *Camelias*, bequest from W. E. Williamson

Ferg, Franz de Paula 1689–1740, *Peasants Brawling in a Village Street*, bequest Williamson

Gainsborough, Thomas (after) 1727–1788, *Wooded Landscape*, bequest Williamson

Gerard, Theodore 1829–1895, *Interior with Serving Maid and Young Man*, bequest Williamson

Glazebrook, Hugh de Twenebrokes 1870–1935, *Sir Harry Bodkin Poland*

Goodwin, H. C., *White Cliffs*

Greiffenhagen, Maurice 1862–1931, *Sir A. H. Bodkin, Recorder*

Grossmann, Alexander J. 1833–1928, *John Coram*

H. F. H., *The Beach at Dover*

Hailstone, Bernard 1910–1987, *HM Queen Elizabeth the Queen Mother, Lord Warden of the Cinque Ports*

Hailstone, Bernard 1910–1987, *Sir Winston Churchill, Lord Warden of the Cinque Ports*

Hals, Dirck 1591–1656, *An Elegant Company*, bequest Williamson

Harle, Dennis F. 1920–2001, *Young Magpie*

Harp, C. S., *The Waterworks High Reservoir*

Harrod, J., *'The Cause is Altered Inn', Dover*

Haydon, Benjamin Robert 1786–1846, *Bartholomew Fair*, bequest Williamson

Henzell, Isaac 1815–1876, *Country Maid Driving Calf and Ducks*, bequest Williamson

Herring, John Frederick I 1795–1865, *Runaway Chestnut Horse with Beagles*, bequest from W. E. Williamson

Hewson, S., *Dr Charles Robinson, Recorder*

Highmore, Joseph 1692–1780, *The Children of Hughes Minet*, gift Susan Minet

Hosking, H. L., *Russell Gardens, Kearsney*, purchase Mrs Lewis

Hunt, Edgar 1876–1953, *Dicing with Death*, bequest Williamson

Hunt, Edgar 1876–1953, *Meeting the Opposition*, bequest Williamson

Hunt, Edgar 1876–1953, *Cockerel and Three Hens*, bequest Williamson

Innis, D. active 20th C, *Three Pot Plants*, bequest Williamson

Italian School, *View of Old Naples*, bequest from Lady Cory

Italian School, *Icon: Madonna and Child*, bequest Williamson

Italian (Venetian) School 19th C, *Trading on the Canal at Rialto Bridge*, bequest Williamson

Kennedy, Cecil 1905–1997, *Still Life of Basket of Flowers*, bequest Williamson

Kennedy, Philomena 1932–1999, *From Chiesi, Tuscany 1966*, © 2004. All rights reserved, DACS

Kennedy, Philomena 1932–1999, *Kent Landscape 1965*, © 2004. All rights reserved, DACS

Kennedy, Philomena 1932–1999, *Near Meifod*, © 2004. All rights reserved, DACS

Kennedy, Philomena 1932–1999, *Kent Landscape*, © 2004. All rights reserved, DACS

Kennedy, Philomena 1932–1999, *Near Sierra 1970*, © 2004. All rights reserved, DACS

Kent, M. A., *Dover College*

Kneller, Godfrey 1646–1723, *Queen Anne*, gift of Capt. John Ball

Knight, Laura 1877–1970, *The Coil of Hair*, bequest Williamson

Krieghoff, Cornelius 1815–1872, *Mountainous Lake Scene*, bequest Williamson

Lawrence, Thomas (attributed to) 1769–1830, *George IV*

Lely, Peter (attributed to) 1618–1680, *John, Duke of Lauderdale*

Lilley, John active 1832–1853, *Duke of Wellington, Lord Warden of the Cinque Ports*, commissioned

Luny, Thomas 1759–1837, *Ischia, Bay of Naples*, bequest Williamson

Maclise, Daniel 1806–1870, *Nicolo Paganini*, bequest from Lady Cory

Martin, *St Martin Dividing His Cloak (after Anthony van Dyck)*, gift of Mr & Mrs Bell

Mignard, Pierre I (school of) 1612–1695, *Isaac Minet*

Millais, John Everett 1829–1896, *Marquess of Salisbury, Lord Warden of the Cinque Ports*

Mor, Antonis b.1512–1516–d.c.1576, *William Brook, Lord Cobham, Lord Warden of the Cinque Ports*, purchase

Morland, George 1763–1804, *Shepherd in a Snowy Landscape*, bequest Williamson

Morris, Ebenezer Butler active 1833–1863, *Lord Palmerston, Lord Warden of the Cinque Ports*

Morris, Ebenezer Butler active 1833–1863, *Sir John Rae Reed, MP*

Nash, John Northcote 1893–1977, *Bore Hill Gower*, bequest Williamson, © artist's estate of John Nash

Nelson, Arthur active 1766–1790, *A View of the Town and Castle of Dover*, NHMF and NACF

Nicholls, Charles Wynne 1831–1903, *Envious Glances*, bequest from Lady Cory

Ogilvie, Frank Stanley b.c.1856, *Sir E. Wollaston Knocker*, gift from corporation members

Olsson, Albert Julius 1864–1942, *A Port Scene with Shipping*

Ostade, Adriaen van 1610–1685, *Peasants Dancing in a Barn*, bequest Williamson

P. N., *HMS Mail Steam Packet 'Vivid'*

P. N., *'HMS Arethusa'*

Page, Patricia, *Kentish Landscape*

Parish, James Harnett b.1832, *Peace (after Edwin Henry Landseer)*, presented to Town of Dover

Parish, James Harnett b.1832, *The Scanty Meal (after John Frederick Herring I)*

Parish, James Harnett b.1832, *Old Dover about 1840*, gift of J. H. Parish

Parish, James Harnett b.1832, *'A Distinguished Member of the Humane Society'*

Parker, Mordaunt M., *Palace Gate and Castle Keep*, gift from M. M. Parker

Parker, Mordaunt M., *Peverells Tower*, gift from M. M. Parker

Parker, Mordaunt M., *Constable's Gate, Dover Castle*, gift from M. M. Parker

Parker, Mordaunt M., *Inner Curtain Wall, Dover Castle*, gift from M. M. Parker

Parker, Mordaunt M., *Castle Keep and Averanches Tower*, gift from M. M. Parker

Parris, Edmund Thomas 1793–1873, *Queen Victoria*

Peellaser, J., *Middle East White Slave Trade*, bequest W. G. Lewis

Piper, J. E., *Montmatre*

Proctor, E., *Highstead Farm, Leeds*, gift from Rev. M. Gillett

Ramsay, Allan 1713–1784, *Lord Chancellor Hardwicke*

Reynolds, Joshua 1723–1792, *Portrait of an Old Gent*

Richardson, William (attributed to), *Lionel Sackville, Duke of Dorset, Lord Warden of the Cinque Ports*, gift of Sackville

Robins, Thomas Sewell 1814–1880, *Fishng Craft in a Choppy Sea*, bequest Williamson

Romney, George 1734–1802, *Michael Russell, Agent Victualler of Dover*, gift from Mr C. Russell

Russell, John, *Charles I*, bequest Williamson

Russell, John, *Queen Henrietta Maria*, bequest Williamson

Russian School 19th C, *Icon: Life of Christ*, bequest Williamson

Schendel, Petrus van 1806–1870, *The Lantern*, bequest Williamson

Scott, S., *Dover Castle from the Heights*

Scott, S., *Dover Castle from the Pier*

Sears, E. H., *Rescuing HMAT 'Blackburn Rovers'*

Smart, *Woolcomber Street about 1850*, gift of Mrs Lester

Snagg, J., *Dover Castle and the Rice Mansion*

Snagg, J., *Dover from the Castle Jetty*

Snagg, J., *Dover Castle and the Rice Mansion*, gift of Miss M. Prescott

Speed, Harold 1872–1957, *Earl Brassey, Lord Warden of the Cinque Ports*

Speed, Harold 1872–1957, *The Rt Hon. George Wyndham, MP*

Stanfield, Clarkson 1793–1867, *Fishing Barges off the South Foreland*, bequest Williamson

Stannard, Joseph 1797–1830,

Fishing Boats in a Rough Sea, bequest Williamson

Stone, D. W., *A Winter Scene*, bequest Williamson

Tapley, M. E., *Pilots Transferring to Pilot Cutter*, gift from Cinque Ports Pilots

Teniers, Abraham (style of) 1629–1670, *Landscape with Cottages*, bequest Williamson

Terry, W. J., *St Martin Dividing His Cloak*

Terry, W. J., *Cinque Ports Ship at Sea*

Troubetzkoy, Paolo Prince 1866–1938, *Marquis of Dufferin and Ava, Lord Warden of the Cinque Ports*

unknown artist, *Queen Elizabeth I and the Cardinal and Theological Virtues*, bought by corporation

unknown artist 18th C, *The Lower Road*, bequest Williamson

unknown artist, *View of Dover from the Guston Road*, presented to Mayor Barnes

unknown artist, *Miss Martha Winthrop, Principal Founder*

unknown artist, *Dover Cutter off Shakespeare Cliff*

unknown artist, *HMS Steam Packet 'Vivid'*, purchase

unknown artist, *Clergyman*, Royal Victoria Hospital

unknown artist, *St Mary's Church, Dover*, donated by Mrs F. Ellis

unknown artist 19th C, *Madonna della sedia (copy of Raphael)*, bequest Williamson

unknown artist, *Mayor of Dover Receiving Royalty*

unknown artist, *Proposed Dover-St Margaret's Road*, gift from artist

unknown artist, *Sergeant-Major Quinlan, Royal Marines Light Infantry*, donated by Norman Clark

unknown artist, *Dover Harbour 1897*

unknown artist, *Sailing Boats off Dover*

unknown artist, *Maison Dieu, Dover and Tram*, gift from Mrs Castle

unknown artist, *View of Old Naples*

unknown artist, *Dover Castle from the Pier Heads*

unknown artist, *Windmill in Cornfield*

unknown artist, *Living Room Scene*

unknown artist, *Sailing Boat off Dover*

unknown artist, *Old Dover about 1830*

unknown artist, *Castle from Alkham Valley (?)*

unknown artist, *Dover from the Deal Road*

Veale, S. I., *Phyllis Williamson*, bequest Williamson

Veroucke, P. 1528–1588, *The Marriage at Cana (after Paolo Veronese)*, bequest Williamson

Victoryns, Anthoni, *The Foot Doctor*, bequest Williamson

Warren, K., *Deal Seafront*, bequest Williamson

Warren, K., *Kingsdown, Kent*, bequest Williamson

Waters, William Richard 1813–1880, *William Marsh, Cinque Ports Pilot*, purchase

Waters, William Richard 1813–1880, *Richard Arnold, Cinque Ports Pilot*, bequest De Wolff

Waters, William Richard 1813–1880, *Elizabeth Arnold, Wife of Richard Arnold*, bequest of Mrs A. M. De Wolff

Waters, William Richard 1813–1880, *James Sandford, Cinque Ports Pilot*, gift from Cinque Ports Pilots

Waters, William Richard 1813–1880, *Mary, Wife of James Sandford*, gift from Cinque Ports Pilots

Waters, William Richard 1813–1880, *Sir W. H. Bodkin*

Waters, William Richard 1813–1880, *James Poulter, Mayor*

Waters, William Richard 1813–1880, *Rev. J. Maule, Vicar of St Mary's*

Waters, William Richard 1813–1880, *John Birmingham, Mayor of Dover*

Waters, William Richard 1813–1880, *Edward Royd Rice MP*

Waters, William Richard 1813–1880, *Country Road, Dover*

Waters, William Richard 1813–1880, *Country Lane Near Dover*

Waters, William Richard 1813–1880, *Red Cow Inn at Night*

Waters, William Richard 1813–1880, *William Waters, Cinque Ports Pilot*

Whitcombe, George E., *Best of British 1974*

Whiting, Alf 1905–1972, *S. Goodwin Lightship (WAT)*

Whiting, Alf 1905–1972, *150th Anniversary of the Lifeboat*

Wilkinson, Norman 1878–1971, *The Ostend Boat Leaving Dover*, purchased at auction

Willis, Henry Brittan 1810–1884, *A Sunny Lane in Sussex*, bequest Williamson

Wilson, *Shipping off Dover*

Wissing, Willem c.1656–1687, *William of Orange*, gift of John Holingbery

Wootton, Frank 1914–1998, *The Convoy*

Wright, John Michael 1617–1694, *Charles II*, gift of mayor John Hollingbery in 1707

Zoffany, Johann 1733–1810, *Peter Fector, Dover Banker*

Folkestone Charter Trustees

Baldry, George W., *Alderman John Banks*, acquired by public subscription

unknown artist 17th C?, *Christ's Charge to Peter (Feed My Sheep) (after Raphael)*, loan from Folkestone Charter Trustees

unknown artist 17th C?, *Paul & Barnabas at Lystra (Sacrifice at Lystra) (after Raphael)*, loan from

Folkestone Charter Trustees

unknown artist, *Alderman John Sherwood*, acquired by public subscription

unknown artist, *Sir Stephen Penfold*, acquired by public subscription

unknown artist, *Alderman W. Salter*, acquired by public subscription

unknown artist, *Councillor George Peden*, acquired by public subscription

Weston, Lambert, *Councillor Chas Carpenter*, acquired by public subscription

Weston, Lambert, *H. B. Bradley*, acquired by public subscription

Weston, Lambert, *Councillor Daniel Baker*, acquired by public subscription

Folkestone Museum

Akerbladh, Alexander 1886–1958, *Lady Arranging Flowers*, bequest 1964

Argyle, R. V., *Elham*, gift 1973

Beach, Ernest George 1865–c.1934, *At the Foot of the Downs*, gift 1942

Brockman, Cornelia active 19th C, *Old Houses, the Stade*, purchase 1950

Cackett, Leonard 1896–1963, *Morning, Whitby Harbour*, gift by artist 1958

Cox, E. Albert 1877–1955, *Little Thatched Cottage*, gift by artist 1948

Cox, E. Albert 1877–1955, *Doubtful Story*, gift by artist 1948

Cox, E. Albert 1877–1955, *Departure of William*, gift by artist 1948

Ewer, Peggy, *Seafront, Sandgate*, gift by artist 1965

Farrar, C. Brooke, *'Victoria' Leaving Boulogne*, gift 1963

Foley, Victor Sebastian, *Sinking of the 'Bienvenue'*, gift 1963

Franzoni, Fredo, *Landing of the Belgian Refugees*, gift 1916

Goodall, Frederick 1822–1904, *Landscape Near Folkestone*, gift 1938

Grant, Francis 1803–1878, *Lady Mary Watkin*, gift

Grant, Francis 1803–1878, *Sir Edward Watkin*, gift

Harpers, D., *Lower Sandgate Road*, gift by artist 1951

Haughton, Benjamin 1865–1924, *Coombe in the Quantocks*, gift 1937

Henry, James Levin 1855–1929, *Lengthening Shadows*, purchase 1924

Kerr, Richard, *Folkestone c.1790*, gift 1892

Laidman, G., *'Aneroid'*, purchase 1973

Lindon, Francis, *Steps at Stade, Folkestone*, gift by artist 1959

Lindon, Francis, *Oil Forge, Fishing Town*, gift by artist 1959

Lindon, Francis, *Copt Point*, gift by artist 1959

Maitland, Paul Fordyce

1863–1909, *Folkestone Pier, Morning*, gift 1937

Major, John, *Old Folkestone*, gift 1887

Marlow, William 1740–1813, *Old Folkestone*, purchase 1925

Mears, George active 1866–1890, *'Mary Beatrice' Leaving Boulogne*, gift 1962

Mears, George active 1866–1890, *'Mary Beatrice' Leaving Boulogne*, gift 1963

Mears, George active 1866–1890, *'Woodside'*, gift

Mears, George active 1866–1890, *'Albert Victor' Leaving Boulogne*, gift

Mears, George active 1866–1890, *'Louise Dagmar' Leaving Boulogne*, gift 1945

Mitchell 19th C, *Sandgate*, gift 1960

Mornewick I and II, Charles Augustus active 1832–1874, *'Pelter' in the Warren*, purchase 1952

Morris, D., *Folkestone Harbour*, gift

Murray, David 1849–1943, *Golden Autumn - Bettws-y-coed*, purchase 1924

Norman, M., *Warren Inn*, gift

Padday, Charles 1890–1940, *Dogfish Season*, gift 1935

Paton, Waller Hugh 1828–1895, *Cobbles at Sundown, Arrochar*, gift 1947

Pole-Stuart, Reginald, *Beach Below Radnor Cliff*, gift 1974

Pragoe, C. b.1830, *Jenny Pope's Alley*, purchase 1964

Priestman, Bertram 1868–1951, *Folkestone Boat Train*, gift by artist 1945

Ribera, Jusepe de (attributed to) 1591–1652, *St Francis of Assisi*, gift

Roberts, Edna Dorothy 1877–1970, *Landing the Catch*, bequest 1970

Roberts, Edna Dorothy 1877–1970, *Folkestone Fishermen*, bequest 1970

Sampson, John, *'Dignity' and 'Impudence'*, gift

Schulman, David 1881–1966, *Old Farm*, purchase 1925

Stevens, Charles Hastings, *Harbour Steps*, gift 1982

Tayler, Albert Chevallier 1862–1925, *Manor House Hall*, purchase 1924

Taylor, Terri, *'British Lion'*, gift 1999

Taylor, Terri, *The Bayle*, gift 1999

unknown artist, *Sandgate - Looking West*, gift 1964

unknown artist, *Folkestone Viaduct*, gift

unknown artist, *Mr Radford*, gift 1999

unknown artist, *Mrs Radford*, gift 1999

unknown artist, *Alderman Sherwood*, gift 1960

unknown artist, *Sandy Lane, Foord*, gift 1958

unknown artist, *Saltwood Castle*, gift

unknown artist, *William Harvey*,

gift 1930

unknown artist, *Rakemere Pond*, gift 1972

unknown artist, *Rakemere Pond*, gift 1972

unknown artist, *John Clark Jnr*, gift 1957

unknown artist, *Rakemere Pond*, gift 1957

unknown artist, *Cheriton Rectory*, gift 1960

Videan, John Allen 1903–1989, *Beach Street, Folkestone*, gift by artist 1946

Ward, Edwin Arthur 1859–1933, *Sir Alfred Mellor Watkin*, gift 1968

Watton, M. H., *Caesar's Camp*, gift 1974

Watton, M. H., *Sugar Loaf and Dover Hill*, gift 1974

Wightwick, William 1831–1907, *Saltwood Castle*, purchase 1950

Wightwick, William 1831–1907, *Millfield Mill*, gift

Williams, R., *Alkham Valley*, gift 1966

Williamson, James active 1868–1889, *Leas Shelter, Folkestone*, gift 1975

Williamson, James active 1868–1889, *Leas Shelter, Folkestone*, gift 1966

Williamson, James active 1868–1889, *Toll House, Lower Sandgate Road*, gift 1966

Wilson, John H. 1774–1855, *After the Storm*, gift

Wilson, John James II 1818–1875, *Ships Returning to Harbour*, gift 1966

Wilson, John James II 1818–1875, *Pastoral Scene, Redhill*, gift 1966

Wilson, John James II 1818–1875, *View on Coast of Norway*, purchased 1927

Wilson, John Snr, *Old Star Inn, Newington*, gift

Faversham Town Council, Mayor's Parlour and Guildhall

unknown artist, *George Beckett*

unknown artist, *Henry Wreight Esq.*, presented by the mayor (Isaac Fairbrass 1817–1827) and common council of Faversham

unknown artist, *Alderman John Andrew Anderson JP*, presented to the corporation for the council chamber by 151 inhabitants of Faversham and neighbourhood

unknown artist, *Sidney Robert Alexander Mayor, (1910–1919)*

unknown artist, *Florence Emily Graham*

unknown artist, *Lord Harris the 4th of Belmont, Captain of the England Amateur Cricket Team*

Medway NHS Trust

Crosse, Tony b.1944, *Isis and Queen Nefertari*, donated by the painter, © the artist

Crosse, Tony b.1944, *Best of Friends*, donated by the painter, © the artist

Crosse, Tony b.1944, *Moonset*, donated by the painter, © the artist

Crosse, Tony b.1944, *Feeder of the Fish*, donated by the painter, © the artist

Crosse, Tony b.1944, *Space City*, donated by the painter, © the artist

Crosse, Tony b.1944, *Feeder of the Birds*, donated by the painter, © the artist

Crosse, Tony b.1944, *Siesta*, donated by the painter, © the artist

Crosse, Tony b.1944, *Happy Giraffes*, donated by the painter, © the artist

Crosse, Tony b.1944, *Two Colourful Kissing Fish*, donated by the painter, © the artist

Crosse, Tony b.1944, *Love Nests*, donated by the painter, © the artist

Crosse, Tony b.1944, *A House by the Sea*, donated by the painter, © the artist

Foster, Roger b.1936, *Sharp's Green, Low Tide*, commissioned by the Healing Arts Group, © the artist

Foster, Roger b.1936, *Sharp's Green, Estuary View*, commissioned by the Healing Arts Group, © the artist

Foster, Roger b.1936, *Upper Upnor on the River Medway*, commissioned by the Healing Arts Group, © the artist

Fricker, Pat b.1948, *Field of Sunflowers*, commissioned by the Healing Arts Group, © the artist

Fricker, Pat b.1948, *The Pasture*, commissioned by the Healing Arts Group, © the artist

Fricker, Pat b.1948, *The Path*, commissioned by the Healing Arts Group, © the artist

Royal Engineers Museum, Gillingham

Baldry, George W., *Sergeant G. Howkett*, gift

Bennett, H., *Buccaneer REYC*, gift

Davidson, G. H., *'The Royal Engineer' Locomotive*, gift

Desanges, Louis William 1822–c.1887, *Major General Sir H. C. Elphinstone*, loan

Desanges, Louis William 1822–c.1887, *General Sir H. N. D. Prendergast*, loan

Guggisberg, F. G., *Brigadier General Sir F. G. Guggisberg*, gift

Holden, W. F. C., *Ypres Cathedral*, gift

Hutching, R. F., *The Menin Gate*, gift

Leighton, Charles Blair 1823–1855, *General Sir C. W. Pasley*, gift

Tomkys, A., *'Gordon' Locomotive*, gift

Turner, E., *CQMS A. Sergison*, gift

unknown artist, *Gibraltar*, purchase

unknown artist, *Captain J. Fiddes*, purchase

unknown artist, *Unknown R. E. Officer*, purchase

unknown artist, *Painting from*

King of Oudh's Palace, gift
unknown artist, *Painting from King of Oudh's Palace*, gift
unknown artist, *HMS Troopship 'Nevasa'*, bequest
unknown artist, *General Sir W. O. Lennox VC, KCB*, gift
unknown artist, *2nd Corporal James Cray R. S. & M.*, purchase
unknown artist, *Major General P. Barry*, gift
unknown artist, *Lieutenant D. C. Home, VC*, purchase
unknown artist, *Sir H. Elphinstone*, loan
unknown artist, *Sapper Wise*, gift
unknown artist, *Sapper G. W. Whatford*, gift
unknown artist, *Major General C. G. Gordon*, gift
Willass, C., *Major General C. G. Gordon*, loan

Gravesham Borough Council

Barland, Adams active 1843–1916, *Cottage Scene*, donation
Clark active 1899–1930, *Henry Huggins*, donation
Clark active 1899–1930, *John Russell*, donation
Clark active 1899–1930, *Henry E. Davis*, donation
Cook or Cooke, *House on Tubbs Hill, Sevenoaks*, donation
Cowan, Ian, *General Gordon*, donation
Dunnage, W. active 1843–1852, *Topsail Schooner 'Commodore'*, donation
Gilbert, A., *Sevenoaks, Kent*, donation
Haynes-Williams, John 1836–1908, *George M. Arnold*, donation
Holloway, Charles Edward 1838–1897, *The Old Falcon*, donation
Leeder, H., *Chiddingstone*, donation
Leeder, H., *Milton Church (Sittingbourne)*, donation
Leeder, H., *Fort House*, donation
Lowcock, C. J., *Casper Paine*, donation
Mason, Arnold 1885–1963, *Robert Palmer, VC*, donation
Mason, Arnold 1885–1963, *Alderman W. E. Thomas*, donation
Miller, William Ongley b.1883, *Eric Harden, VC*, donation
Petrie, Graham 1859–1940, *Tree in front of Lake*, donation
Snowman, Isaac b.1874, *Unknown Mayor*, donation
Thompson, A. H., *Waterfront Gravesend*, donation
unknown artist 18th C, *Gentleman in High White Collars*, donation
unknown artist, *Thomas Troughton*, donation
unknown artist 19th C, *Huggens*, donation
unknown artist, *James Harmer*, donation
unknown artist, *John Hanks Cooper*, donation

unknown artist, *Henry Hopton Brown*, donation
unknown artist, *John Parkinson*, donation
unknown artist, *Landscape*, donation
unknown artist, *Portrait of a Gentleman*, donation
unknown artist, *T. F. Wood*, donation
Walters, Douglas, *Robert Pocock*, donation, © the artist
Weigall, Henry 1829–1925, *Queen Alexandra*, donation
Williams, Edgar, *George H. Edmunds*, donation
Winter, M., *Thames Barge, Bawley Bay*, donation
Winter, M., *Gravesham, Kent*, donation

Hythe Council Offices, Local History Room and Town Hall

Alvaridale, *Looking across Romney Marshes*
Baker-Clack, Arthur 1877–1955, *Daffodils*, gift
Baker-Clack, Arthur 1877–1955, *Church Hill Steps, Hythe*, gift
Cardew, G. E., *Harry Sharp, Mayor, (1937–1938)*, gift 1967
Hoogsteyns, Jan b.1935, *The Table*, gift 1979, © the artist
Lavery, John 1856–1941, *The Right Hon. Mayor of London Sir Charles Cheers Wakefield*, © the estate of Sir John Lavery by courtesy of Felix Rosenstiel's Widow & Son ltd
Lee, L. M., *Landscape*
Playford, *Hythe High Street*, gift 1975
unknown artist 17th C, *Painting of a Man*
unknown artist 18th C, *Charles James Fox*
unknown artist 18th C, *Bathsheba*
unknown artist 19th C, *Portrait of a Woman*
unknown artist, *Landscape*
unknown artist, *Painting of a Lady*
unknown artist, *The East Kent Indiaman Going into Macao Roads*
unknown artist, *The East Kent Indiaman off Amere Point in the Strait of Sunda*
unknown artist, *Hythe Church from the Green*, purchased 1936
unknown artist, *Hythe Canal*

Kent County Council, Arts and Museums

Alexander, Christopher 1926–1982, *Broadstairs*
Alexander, Jack, *Little Sands, Folkestone Harbour*
Beamand, B., *Canal*
Beamand, B., *The Black Line around England*
Brown, W. T., *County Road Near Ashford*
Bull, W. B., *The High Street, Ashford*
Clegg, Richard b.1966, *King and Queen 1988*
Corke, C., *The Shambles,*

Sevenoaks, 1883
Coulson, J., *Singing while She Falls, 1987*
Farthing, Stephen b.1950, *Ramsgate*
Foster, *Woods Near Sevenoaks*
Hackney, Arthur b.1925, *Winter Scene*
Harris, P. A., *Tonbridge Castle*
Helm, Stewart b.1960, *Trees*
Hosking, John, *Wet Road – Cars*
Hosking, John, *Self Portrait (triptych)*
Hosking, John, *Self Portrait (triptych)*
Hosking, John, *Self Portrait (triptych)*
Illingworth, Nancy, *Changing Weather, Warehorne*
Illingworth, Nancy, *The Weald from Linton*
Knight, J., *St Nicholas Church and Rectory*
Le Claire, M., *The Warren, Folkestone*, © Christopher Le Brun 2004. All rights reserved DACS
Lloyd, Vincent b.1960, *Quarry with Apple*
Lord, Sarah b.1964, *Steps*
Lord, Sarah b.1964, *Golden Sands*
Lord, Sarah b.1964, *Triangle*
Lord, Sarah b.1964, *Fishing Debris*
Mackley, George 1900–1983, title unknown*
Mackley, George 1900–1983, *Kentish Oast*
Norden, Gerald, *Pieces of Music*
Osborne, K., *La voyageuse*
Parsons, Christine, *Elephant Just Walked Through*
Parsons, Christine, *White Cyclamen with Fruit and Bottle*
Peisley, T., *Abstract Woman*
Peisley, T., *Odious Norma*
Robinson, Beverley, *Cottages*
Robinson, Beverley, *Orchard*
Titchell, Tim, *Interior*
Titchell, Tim, *End of the Bed*
unknown artist 20th C, *Still Life*
unknown artist, *Coastal Landscape in Kent*
unknown artist, *Tonbridge Castle*
unknown artist, *The Pantiles, Tunbridge Wells*
Watt, Thomas 1920–1989, *Mario's Blue Boat at Margate*
Weight, Carel Victor Morlais 1908–1997, *Battersea Park Tragedy*, © the artist's estate
Weight, Carel Victor Morlais 1908–1997, *Old Lovers*, © the artist's estate
Weight, Carel Victor Morlais 1908–1997, *Young Lovers*, © the artist's estate

Kent Fire and Rescue Service Museum

unknown artist, *Fireman John Cruttenden of Hastings Fire Brigade (1875–1963)*, donated by Mr Bryan Cruttenden of Hastings

Kent Police

Palmer, Alfred 1877–1951,

Constable R. J. Stone, Canterbury City Police 1911, presented 1965

Maidstone County Hall

Bardwell, Thomas 1704–1767, *Judith Long, Mrs Knatchbull, (d.1772)*, loan from Lord Brabourne
Bassano, Alessandro, *Sir Hugessen Edward Knatchbull, 11th Bt, (1838–1871)*, loan from Lord Brabourne
Birley, Oswald Hornby Joseph 1880–1952, *Norton Knatchbull, 6th Lord Brabourne, (1922–1943)*, loan from Lord Brabourne, © the artist's estate
Birley, Oswald Hornby Joseph 1880–1952, *Sir Edward Hardy*, © the artist's estate
Birley, Oswald Hornby Joseph (and studio) 1880–1952, *Herbert Michael Rudolf Knatchbull, 5th Baron Brabourne, (1895–1939)*, loan from Lord Brabourne, © the artist's estate
Bower, Edward (attributed to), *Dorothy Westrow, Lady Knatchbull*, loan from Lord Brabourne
British (English) School, *Gentleman of the Knatchbull Family*, loan from Lord Brabourne
Buckner, Richard active 1820–1877, *Sir Norton Knatchbull, 10th Bt, (1808–1868)*, loan from Lord Brabourne
Buckner, Richard active 1820–1877, *Sir Wyndham Knatchbull, 12th Bt, (1844–1917)*, loan from Lord Brabourne
Cooper, Thomas Sidney 1803–1902, *Cattle on the Banks of the River Stour*
Cotes, Francis 1726–1770, *Sir Edward Knatchbull, 7th Bt, (1704–1789)*, loan from Lord Brabourne
Critz, John de the elder (circle of) 1551/1552–1642, *Richard Knatchbull, (1554–1590)*, loan from Lord Brabourne
Critz, John de the elder (circle of) 1551/1552–1642, *Sir Norton Knatchbull, (1569–1636)*, loan from Lord Brabourne
Dahl, Michael I 1656/1659–1743, *Alice Wyndham, (1676–1723)*, loan from Lord Brabourne
Dahl, Michael I 1656/1659–1743, *Edward Knatchbull*, loan from Lord Brabourne
Dahl, Michael I 1656/1659–1743, *The Rt Hon. Sir George Rooke, (1650–1709), Vice-Admiral of England*, loan from Lord Brabourne
Dance-Holland, Nathaniel 1735–1811, *Grace Legge, Lady Knatchbull, (d.1788)*, loan from Lord Brabourne
Dance-Holland, Nathaniel 1735–1811, *Sir Edward Knatchbull, 7th Bt, (1704–1789)*, loan from Lord Brabourne
Dicksee, Frank 1853–1928, *Joan Marion Neville* c.1908
Geeraerts, Marcus the younger

(circle of) 1561–1635, *Susan Greene, Mrs Richard Knatchbull*, loan from Lord Brabourne
Graves, Henry Richard (circle of) 1818–1882, *Anna Maria Elizabeth Southwell, Lady Brabourne, (d.1889)*, loan from Lord Brabourne
Herkomer, Hubert von 1849–1914, *Rt Hon. Edward Hugessen-Knatchbull, 1st Baron Brabourne, (1829–1893)*, loan from Lord Brabourne
Hoogstraten, Samuel van 1627–1678, *Sir Norton Knatchbull, 1st Bt, (1601–1684)*, loan from Lord Brabourne
Hoogstraten, Samuel van 1627–1678, *Thomas Knatchbull*, loan from Lord Brabourne
Janssens van Ceulen, Cornelis 1593–1661, *Mary Aldersey, Lady Knatchbull, (d.1674)*, loan from Lord Brabourne
Janssens van Ceulen, Cornelis 1593–1661, *Sir Norton Knatchbull, 1st Bt, (1601–1684)*, loan from Lord Brabourne
Kauffmann, Angelica 1741–1807, *Sarah Sophia Banks (1744–1818)*, loan from Lord Brabourne
Kennedy, Charles Napier 1852–1898, *Ivo Francis Walter*
Kneller, Godfrey 1646–1723, *Catherine Harris, Lady Knatchbull Wyndham, (d.1741)*, loan from Lord Brabourne
Kneller, Godfrey 1646–1723, *Catherine Knatchbull, Lady Rooke*, loan from Lord Brabourne
Kneller, Godfrey 1646–1723, *Edward Dering, 2nd Bt, (1625–1685)*, loan from Lord Brabourne
Noakes, Michael b.1933, *Mrs Patricia Nesham*
Partridge, John 1790–1872, *Mary Watts Russell, Lady Knatchbull*, loan from Lord Brabourne
Partridge, John (attributed to) 1790–1872, *Fanny Cathering Knight, Lady Knatchbull, (b.1793)*, loan from Lord Brabourne
Peake, Robert I (circle of) c.1551–1619, *Eleanor Astley (1575–1638)*, loan from Lord Brabourne
Peake, Robert I (circle of) c.1551–1619, *Thomas Knatchbull*, loan from Lord Brabourne
Phillips, Thomas 1770–1845, *Sir Edward Knatchbull, 9th Bt, (1781–1849)*, loan from Lord Brabourne
Riley, John (attributed to) 1646–1691, *Dorothea Honywood, Lady Knatchbull, (d.1694)*, loan from Lord Brabourne
Romney, George 1734–1802, *Mary Hugessen, Lady Knatchbull, (d.1784)*, loan from Lord Brabourne
Somer, Paulus van I 1576–1621, *Sir Norton Knatchbull (1569–1636)*, loan from Lord Brabourne
Somer, Paulus van I (circle of) 1576–1621, *Susan Knatchbull, (b.1579)*, loan from Lord

Brabourne

unknown artist 19th C, *Unknown Lady*

unknown artist, *Alderman E. W. Hussey c.1923*

unknown artist, *Bridgit Astley (1570–1625)*, loan from Lord Brabourne

unknown artist, *Charles, 3rd Earl of Romney 1870*

unknown artist, *Frederick Walter Payne c.1935*

unknown artist, *George, 4th Baron Harris 1889–1890*

unknown artist, *George Marsham 1911*

unknown artist, *John Charles Pratt 1916*

unknown artist, *Kings Ferry Bridge c.1960*

unknown artist, *Lionel Edward, 3rd Baron Sackville 1930*

unknown artist, *Lord Cornwallis (1864–1935)*

unknown artist, *Rt Hon. J. G. Talbot 1910*

unknown artist, *Sarah Isles and Her Eighth Son 1626*

unknown artist, *Sir John Farnaby Lennard 1889–1890*

Wissing, Willem c.1656–1687, *Mary Dering, Lady Knatchbull, (d.1724)*, loan from Lord Brabourne

Wissing, Willem c.1656–1687, *Thomas Knatchbull, (d.1702)*, loan from Lord Brabourne

Wissing, Willem c.1656–1687, *Sir Thomas Knatchbull, 3rd Bt, (d.1711)*, loan from Lord Brabourne

Wright, John Michael 1617–1694, *Mary Knatchbull, (1610–1696)*, loan from Lord Brabourne

Wright, John Michael 1617–1694, *Sir John Knatchbull, 2nd Bt, (1637–1698)*, loan from Lord Brabourne

Maidstone Museum & Bentlif Art Gallery

A. B. C. 17th C, *Winter Scene with an Arch*, donation, photo credit: www.bridgeman.co.uk

A. B. C. 17th C, *Summer Townscape with a Fountain*, donation, photo credit: www.bridgeman.co.uk

Anderson, William 1757–1837, *Seascape with Shipping*

Anderson, William 1757–1837, *Seascape with Shipping*

André, James Paul the younger active 1823–1859, *View of Maidstone from Bearsted Ferry, 1829*, presented by NACF

Anguissola, Sofonisba c.1532–1625, *The Granddaughter of the Duke and Duchess of Parma*

Anthony, Henry Mark 1817–1886, *A Funeral Procession Near Lake Killarney*

Anthony, Henry Mark 1817–1886, *A Mill on the Hague*, photo credit: www.bridgeman.co.uk

Arellano, Juan de (attributed to) 1614–1676, *Carnations, Roses and Other Flowers in a Thin-stemmed Vase*, donation

Banner, Delmar Harmond 1896–1983, *Scafell from Hardiknott Fell*, donation

Barker, Thomas Jones 1815–1882, *Riderless War Horses After the Battle of Sedan*

Barrett, George (attributed to) 1728–1784, *River Scene with Buildings and Bridge*, donation

Beadle, James Prinsep 1863–1947, *The Battle of Neuve Chapelle, 1915*

Beale, Mary 1633–1699, *Two Figures - Vertumnus and Pomona*

Bellingham-Smith, Elinor 1906–1988, *Burning Stubble*, © the artist's estate

Bensted, Joseph, *Fowling in the Marshes*

Berry, John, *Arthur H. Clark, Mayor of Maidstone*

Birch, Samuel John Lamorna 1869–1955, *The Stream in My Garden*, purchased

Blinks, Thomas 1860–1912, *Startled*, bequest, photo credit: www.bridgeman.co.uk

Bloemen, Jan Frans van (attributed to) 1662–1749, *Landscape with a Fountain*, donation

Bloemen, Jan Frans van (attributed to) 1662–1749, *Classical Landscape with Figures*, donation, photo credit: www.bridgeman.co.uk

Boddington, Henry John 1811–1865, *Lake Scene with Men Fishing*

Bogdany, Jakob c.1660–1724, *Still Life (Flowers and Fruit)*, donation

Bolitho, A., *Stretcher Bearers, Passchendaele, 1917*, donation

Bolitho, A., *Lone Casualty, Polygon Wood*, donation

Bolitho, A., *Ration Party, Gommecourt*, donation

Bouvier, Augustus Jules c.1825–1881, *Italian Gossip at a Fountain*, bequest

Breydel, Karel 1678–1733, *Battle Scene: Cavalry Skirmish*, donation

Breydel, Karel 1678–1733, *Battle Scene: Cavalry Skirmish*, donation

Breydel, Karel 1678–1733, *Battle Scene: Cavalry Skirmish*, donation

Breydel, Karel 1678–1733, *Battle Scene: Cavalry Skirmish Aftermath*, donation

Bright, Henry 1814–1873, *Tintern Abbey*

British (Norwich) School, *Landscape with Cottage and Figures*

British (Norwich) School, *Landscape with Church*

Brooking, Charles 1723–1759, *Sea Fight*

Brothers, Alfred active 1882–1893, *View of Maidstone from the South*, donation

Broun, Phillip, *Beauvais Cathedral*, donation

Brueghel, Jan the elder 1568–1625, *Rest on the Flight into Egypt*, donation, photo credit: www.bridgeman.co.uk

Brueghel, Jan the elder 1568–1625 & Rottenhamer, Hans I 1564–1625, *Rest on the Flight into Egypt*, donation

Bryan, Edward 1804–1860, *Mrs William Hazlitt, née Catherine Reynell*

Bryan, Edward 1804–1860, *Catherine Reynell*

Burgess, C. W. B. (attributed to), *Mountain Scene*

Burton, Frederic William 1816–1900, *River Scene at Maidstone*, donation

Canaletto (style of) 1697–1768, *View of the Piazzetta, Venice*, donation

Carpmael, Cecilia, *Sir Garrard Tyrwhitt-Drake, Mayor of Maidstone*

Chalon, Alfred Edward 1780–1860, *Woman Holding a Pendant*

Charlton, John 1849–1917, *The Challenge*

Chatelain active 18th C, *The Virgin and Infant Saviour (after Bartolomé Esteban Murillo)*

Chatelain, Antoine (attributed to) 1794–1859, *Portrait of a Young Woman Holding a Rose (Titian's Daughter?)*, donation

Chatelain, Antoine (attributed to) 1794–1859, *Portrait of a Woman (after Titian)*

Chinnery, George (after) 1748–1847, *Hunting Piece: Horsemen Attended by Four Hounds*

Chitty, Cyril, *Benjamin Harrison*, purchased

Clark, Joseph 1834–1926, *Home from the War, 1901*, photo credit: www.bridgeman.co.uk

Clarke, J. H., *Stephen Monckton (1824–1885)*, donation

Cobbett, Edward John 1815–1899, *A Woodland Scene with a Wagon Drawn by Two Horses*, donation

Codazzi, Viviano (style of) c.1604–1670, *Classical Ruins with Peasants and Cattle*, donation

Codazzi, Viviano (style of) c.1604–1670, *Roman Capriccio*, donation

Codazzi, Viviano (style of) c.1604–1670, *The Pantheon, Rome*, donation

Collier, John (attributed to) 1850–1934, *The Connoisseur, Reginald Barrett, RWS*

Collin, Charles, *View in the Farnese Palace Gardens*

Collins, James Edgell 1820–after 1875, *Charles Ellis, 1865*

Collinson, Robert 1832–after 1890, *Young Girl with a Basket of Flowers*, donation

Colonia, Adam (attributed to) 1634–1685, *The Annunciation to the Shepherds*, donation photo credit: www.bridgeman.co.uk

Cooper, Thomas George 1836–1901, *Cows and Sheep on a Mountain Pasture*, photo credit: www.bridgeman.co.uk

Cooper, Thomas Sidney 1803–1902, *Sheep on the Kentish Coast, 1865*

Cooper, Thomas Sidney 1803–1902, *Country Lane with Gypsies*, Brenchley Collection

Cooper, Thomas Sidney 1803–1902, *Sheep Stampeding in a Storm*, donation

Cooper, William Sidney 1854–1927, *Whitchurch Hill, Oxfordshire*

Cooper, William Sidney 1854–1927, *A Riverside Pasture with Sheep*, photo credit: www.bridgeman.co.uk

Cooper, William Sidney 1854–1927, *In the Shade*

Courtois, Jacques (style of) 1621–1676, *Battle Piece*, donation

Crayer, Gaspar de (attributed to) 1584–1669, *The Virgin and Child with St John*, donation

Crome, *Group of Trees and Old Buildings with Donkey*, donation

Croos, Jan Jacobsz. van der 1654/1655–c.1716, *Landscape with Peasants on a Road*

Cuming, Frederick b.1930, *Hythe Beach (with Winding Gear)*, purchased

Cuyp, Aelbert (imitator of) 1620–1691, *Milking Time*, donation

Dahl, Michael I (attributed to) 1656/1659–1743, *Mawdisty Best, Wife Elizabeth and Daughter Dorothy*, donation

Dance-Holland, Nathaniel (attributed to) 1735–1811, *Mrs Burbridge of Staverton Hall, Northamptonshire*, photo credit: www.bridgeman.co.uk

Daniell, Thomas 1749–1840 or Daniell, William 1769–1837, *Allington Hunting Party in India*, photo credit: www.bridgeman.co.uk

Day, Herbert J. 1864–1915, *View Near Buttermere, Cumberland*, presented by Mrs H. J. Day

Day, Jane active 1894–1897, *Boy in the Costume of the Ancient Bluecoat School, Maidstone*, donation

Day, Jane active 1894–1897, *Portrait of a Girl in the Costume of Dr Woodward's School, Maidstone*, donation, photo credit: www.bridgeman.co.uk

Day, Jane active 1894–1897, *Head and Shoulders of a Girl Wearing the Bonnet as Worn by Girls of Dr Woodward's School, Maidstone*

Day, Jane active 1894–1897, *Reverend Henry Collis MA*, bequest

Day, Jane active 1894–1897, *The Late Samuel Bentlif JP*

Day, Jane, *William Laurence JP (1822–1899)*

Dickinson, Lowes Cato 1819–1908, *Edmund Law Lushington, 1876*, donation

Dobson, William Charles Thomas 1817–1898, *Julius Lucius Brenchley Esq. 17 Oct. 1876*, donation

Dodd, Charles Tattershall I 1815–1878, *Avenue of Fir Trees at Shoesmith's Farm, Wadhurst*, donation

Doord, *Mrs Shaw*

Dou, Gerrit (imitator of) 1613–1675, *The Apothecary's Shop*, donation

Droochsloot, Joost Cronelisz. 1586–1666, *Village Scene*, donation

Cooper, Thomas Sidney 1803–1902, *Sheep Stampeding in a Storm*, donation

Drummond, *The Wife and Child of Drummond*, bequest

Drummond, Julian, *Mrs Dowson*

Drummond, Samuel 1765–1844, *John Blake (1770–1810) Mayor of Maidstone, 1799*, donation

Drummond, Samuel 1765–1844, *A Boat at Sea (The Rescue)*, bequest

Drummond, Samuel 1765–1844, *Ben Johnson, (1574–1637)*, bequest

Drummond, Samuel 1765–1844, *Rev. James Reeve, Vicar of All Saints, Maidstone, (1800–1842)*

Drummond, Samuel 1765–1844, *John Brenchley of Kingsley House, Maidstone*

Ducq, Johan le (style of) 1629–1676/1677, *Spanish Merchant Saluting a Lady*, donation

Dughet, Gaspard (style of) 1615–1675, *Classical Landscape*, donation

Dunstan, Bernard b.1920, *Auberge belles choses, St Cirq-Lapopie*, © the artist

Dutch School 17th C, *Peasant with a Jar*, donation

Dutch School 17th C, *Storm at Sea*, donation

Etty, William 1787–1849, *Male Nude*

Eves, Reginald Grenville 1876–1941, *Lord Runciman*

Finn, F. L., *J. H. Allchin, Curator of Maidstone Museum, (1902–1923)*, donation

Foord, Charles, *Mrs Swain's House, Union Street, Maidstone*, donation

Fosse, Charles de la 1636–1716, *Jacques Rousseau*, Pretty Collection

Francken, Frans II (attributed to) 1581–1642, *The Mocking of Christ*, donation

Gegan, J. J., *Maidstone from the College Hop Garden*, donation

Glazebrook, Hugh de Twenebrokes 1870–1935, *Sir John Farley*, donation

Goodwin, Albert 1845–1932, *Sinbad Entering the Cavern*, donation

Goodwin, Albert 1845–1932, *Sinbad in the Valley of Diamonds*, donation

Goodwin, Albert 1845–1932, *The Archbishop's Palace, Maidstone*, donation

Goodwin, Albert 1845–1932, *The Old Bridge at Maidstone Looking North*, purchased

Goodwin, Albert 1845–1932, *St Michael's Mount, Cornwall*, gift of the Museum Auxiliary Fund

Goodwin, Albert 1845–1932, *The Burning Ghats*, bequest

Goodwin, Albert 1845–1932, *Agra*, donation

Goodwin, Albert 1845–1932, *Samuel Goodwin, 1868*

Goodwin, Albert 1845–1932, *The Old Bridge at Maidstone Looking South*, photo credit: www.bridgeman.co.uk

Goodwin, Albert 1845–1932, *Lynmouth: The Story of the Shipwreck*, photo credit:

www.bridgeman.co.uk

Goodwin, Albert 1845–1932, *Hastings: The Old Town*

Goodwin, Albert 1845–1932, *Blue Water in Mounts Bay, Cornwall*

Goodwin, Albert 1845–1932, *View on the Lyn Near Watersmeet, North Devon*

Goodwin, Albert 1845–1932, *The Castle of Enchantments*

Goodwin, Albert 1845–1932, *The Artist's Father, Samuel Goodwin*

Goodwin, Albert 1845–1932, *Shipwreck*

Goodwin, Albert 1845–1932, *Allington Castle 1865–1868*

Goodwin, Harry 1842–1925, *No. 2 Chioggia (Near Venice)*, donation

Goodwin, Harry 1842–1925, *Archbishop's Palace and All Saints Church, 1885*

Goodwin, Harry 1842–1925, *The Marketplace, Norwich*

Goodwin, Harry 1842–1925, *Leaving the Old Home, Norwich*

Goodwin, Harry 1842–1925, *Venice - Sunset*

Goodwin, Harry 1842–1925, *Venice - A Rainy Day*

Goodwin, Harry 1842–1925, *View on the Thames: Evening, When Swallows Homeward Fly*, gift

Goodwin Green, Eliza 1851–1932, *The Lunar Rainbow, Victoria Falls, Rhodesia*, donation

Goodwin Green, Eliza 1851–1932, *The Main Fall, Victoria Falls, Rhodesia*, donation

Goyen, Jan van (style of) 1596–1656, *Sea Piece: Fishermen*, donation

Grant, Francis 1803–1878, *Alexander Randall, Founder of the Kentish Bank*

Gryef, Adriaen de 1670–1715, *Still Life in Garden*, donation

Hailstone, Bernard 1910–1987, *Mrs D. M. Relf (First Lady Mayor of Maidstone)*, presented by public subscription

Harlow, George Henry 1787–1819, *General Ligonier and His Aide-de-Camp*, donation

Haslehurst, J. B., *Edward Walker of Canterbury*, donation

Haslehurst, J. B., *Sarah Walker of Canterbury*, donation

Hazlitt, John 1767–1837, *William Hazlitt*, photo credit: www.bridgeman.co.uk

Hazlitt, John 1767–1837, *Margaret (Peggy) Hazlitt, Sister of William Hazlitt*

Hazlitt, John 1767–1837, *Mary Besley*

Hazlitt, John 1767–1837, *Self Portrait*, photo credit: www.bridgeman.co.uk

Hazlitt, John 1767–1837, *William Hazlitt*, donation, photo credit: www.bridgeman.co.uk

Hazlitt, John (attributed to) 1767–1837, *Thomas Besley*, donation

Hazlitt, Margaret 1770–1844, *Canal Scene*

Hazlitt, Margaret 1770–1844, *Peasant Scene*

Hazlitt, Margaret 1770–1844,

Moonlight Scene

Hazlitt, Margaret 1770–1844, *Landscape with Cattle and Stream*

Hazlitt, Margaret 1770–1844, *Cottage in a Wood with Cattle*

Hazlitt, Margaret 1770–1844, *Mountain Scene with a Bridge*

Hazlitt, Margaret 1770–1844, *Portrait of an Unknown Man*

Hazlitt, Margaret 1770–1844, *Bridge and Waterfall*

Hazlitt, William 1778–1830, *Cardinal Ippolito Medici (copy of Titian)*

Hazlitt, William 1778–1830, *Death of Clorinda (copy of Lodovico Lana)*

Hazlitt, William 1778–1830, *Rev. William Hazlitt*

Hazlitt, William 1778–1830, *Self Portrait*, photo credit: www.bridgeman.co.uk

Hodges, Sidney 1829–1900, *Benjamin Disraeli MP*

Hopkins, William active 1787–1811, *David Hebbes*

Hopkins, William H. d.1892, *Boy with a Hoop and a Dog Chasing a Butterfly*, Gray Bequest

Hopper, M. A. F., *Wood Scene, Man with Boy and Dog*

Hoppner, John 1758–1810, *The Husband of Mrs Fox*

Hoppner, John 1758–1810, *Mrs Fox of Maidstone*, donation

Houghton, Arthur Boyd 1836–1875, *At the Seaside: Pegwell Bay, Near Ramsgate, 1862*, photo credit: www.bridgeman.co.uk

Howard, Elizabeth, *Edward Twopenny of Woodstock, Sittingbourne*, donation

Hughes, Arthur 1832–1915, *Saying Grace: The Skipper and His Crew*, photo credit: www.bridgeman.co.uk

Hughes, Edward Robert 1851–1914, *The Intruder*

Hughes-Stanton, Herbert Edwin Pelham 1870–1937, *Sheep in a Storm*

Hunt, Arthur Ackland active 1865–1902, *Job in His Adversity*, donation

Huysmans, Cornelis 1648–1727, *A Woodland Scene with Figures*

Hyde, Frank 1849–1937, *Arrival of a Convoy of Wounded Soldiers at Maidstone Station, 1916*

Hyde, Frank 1849–1937, *Capri Coastal Scene with Figures*

Illingworth, Nancy, *The Garden Wall, Old Loose Hill*

Italian School 14th C, *Madonna of Humility*, donation

Italian (Venetian) School 18th C, *View of San Giorgio Maggiore, Venice*, donation

Janssens van Ceulen, Cornelis 1593–1661, *William Peirs, DD (1579–1670)*

Janssens van Ceulen, Cornelis 1593–1661, *Sir William Brockman*

Jefferys, James 1751–1784, *The Scene before Gibraltar*

Jefferys, William 1723–1805, *Three Fawns*

Jefferys, William 1723–1805, *The Old Market Cross, Maidstone*,

donation

Jefferys, William 1723–1805, *Northwest View of Maidstone*

Jefferys, William 1723–1805, *James Jefferys at work*

Jervas, Charles (school of) c.1675–1739, *Portrait of a Girl with a Flower in Her Hair*

King, *James Whatman*

King, *Mrs James Whatman*

Kneller, Godfrey (after) 1646–1723, *Elizabeth, Daughter of Thomas Crispe*, donation

Kneller, Godfrey (attributed to) 1646–1723, *Margaretta (Bosville) Marsham*, donation

Kneller, Godfrey (school of) 1646–1723, *Thomas Best of Chatham*, donation

Kruseman, Frederik Marianus 1817–1860, *Summer Landscape*, donation

Kruseman, Frederik Marianus 1817–1860, *Winter Landscape*, donation, photo credit: www.bridgeman.co.uk

Lambourn, George 1900–1977, *Nude Study*

Lee, Frederick Richard 1798–1879, *A Lane at Cobham, Kent*

Lely, Peter (after) 1618–1680, *Barbara Villiers, Duchess of Cleveland*

Lely, Peter (after) 1618–1680, *James, Duke of Monmouth*, donation

Lely, Peter (after) 1618–1680, *Lady Susannah Dormer*

Lely, Peter (school of) 1618–1680, *Lady Darrell (Mrs Darell Blount)*

Lely, Peter (style of) 1618–1680, *William Wycherley*

Lewis, John Hardwicke 1840–1927, *Maidstone, c.1870*, photo credit: www.bridgeman.co.uk

Lines, Vincent Henry 1909–1968, *A Kentish Church in Moonlight*

Linton, James Dromgole 1840–1916, *The Casket Scene from the Merchant of Venice*

Locatelli, Andrea 1695–1741, *Classical Landscape: Coastal Scene with Fishermen*

Loutherbourg, Phillip James de 1740–1812, *Winter Scene with Skating*, photo credit: www.bridgeman.co.uk

Lucas, John Templeton 1836–1880, *Charles Marsham, 4th Earl Romney*

Lucas, John Templeton 1836–1880, *Lady Frances Wyndham*

Martin, Sylvester 1856–1906, *Two Grey Horses in a Stable Yard*

McCall, Charles James 1907–1989, *Dressmaking*, © collection/©copyright courtesy of the artist's estate/www.bridgeman.co.uk, photo credit: www.bridgeman.co.uk

McLernon, Huw (or N. J. W.), *James Mercer Russell*

Merritt, Thomas Light, *Maidstone Bridge from the North Side*

Miereveld, Michiel Jansz van (after) 1567–1641, *Elizabeth,*

Queen of Bohemia, donation

Miereveld, Michiel Jansz van (after) 1567–1641, *Maurice, Prince of Orange*, donation

Mignon, Abraham (attributed to) 1640–c.1679, *Still Life with Pigeons*, donation

Molenaer, Klaes, *Winter Scene*, donation, photo credit: www.bridgeman.co.uk

Molyn, Pieter 1595–1661, *Landscape with Travelling Figures*, donation

Monamy, Peter 1681–1749, *Embarkation of Troops: Ships at Anchor Firing the Evening Salute*

Monteitti, J., *Priest and Woman*

Mordecai, Joseph 1851–1940, *Sir Marcus Samuel, Lord Bearsted*

Morland, George 1763–1804, *Pigs at a Trough*, photo credit: www.bridgeman.co.uk

Morley, Robert 1857–1941, *Lion's Head*

Moynihan, Rodrigo 1910–1990, *Landscape 1939*, © the artist's estate

Mulier, Pieter the younger (attributed to) c.1637–1701, *Night Storm at Sea with Dutch Ships Being Wrecked*, donation

Munnings, Alfred James 1878–1959, *The Woodcutters*

Murray, David 1849–1933, *A Summer Day (Shoreham, Sussex)*

Neer, Aert van der (imitator of) 1603–1677, *Moonlit Shore*

Newington Hughes, John, *Maidstone Bridge*

Nicholls, Bertram 1883–1974, *San Giovanni Nepomuceno*

Niemann, Edmund John 1813–1876, *The Thames Near Streetley, Berkshire*

Niemann, Edmund John 1813–1876, *The Thames at Pangbourne, Berkshire*

Northcote, James 1746–1831, *The Murder of Edward, Prince of Wales, at Tewkesbury*

Opie, John 1761–1807, *Lady with Two Children and a Parrot*

Opie, John 1761–1807, *Gil Blas Taking the Key from Dame Leonarda in the Cavern of the Banditti*

Opie, John 1761–1807, *The Surprise*

Opie, John (attributed to) 1761–1807, *Mawdisty Best and His Brother outside Rochester Cathedral*

Ostade, Adriaen van (imitator of) 1610–1685, *Dutch Peasants*, donation

Paccini, Ferdinando, *The Virgin Seated Leaning over the Christ Child*, donation

Pace del Campidoglio, Michele 1610–probably 1670, *Still Life with Parrot*, donation

Panini, Giovanni Paolo (after) c.1692–1765, *Ruins with a Statue*, donation

Panini, Giovanni Paolo (after) c.1692–1765, *Ruins with the Tomb of Cestius*, donation

Panini, Giovanni Paolo (after) c.1692–1765, *Ruins with a Bust*, donation

Panini, Giovanni Paolo (style of) c.1692–1765, *Roman Capriccio, Ruins with Colosseum*, donation, photo credit: www.bridgeman.co.uk

Panini, Giovanni Paolo (style of) c.1692–1765, *Roman Capriccio*, photo credit: www.bridgeman.co.uk

Panini, Giovanni Paolo (style of) c.1692–1765, *Ruins with an Urn and an Arch*, donation

Parrott, William 1813–after 1875, *Child Crossing a Brook*

Peake, Mervyn 1911–1968, *Portrait of a Young Man*, © the estate of Mervyn Peake

Plowman, Elisabeth, *Maidstone Museum*

Poelenburgh, Cornelis van (style of) 1594/1595–1667, *Diana and Callista*, donation

Poelenburgh, Cornelis van (style of) 1594/1595–1667, *Mary Magdalene*, donation

Polidoro da Caravaggio (after) c.1497–c.1543, *The Discovery of the Tomb of Numa Pompilius*, donation

Pourbus, Frans the younger (attributed to) 1569–1622, *Albert, Archduke of Austria*, donation

Pourbus, Frans the younger (attributed to) 1569–1622, *Isabella Clara Eugenia, Archduchess of Austria*, donation

Pretty, Edward 1792–1865, *Thomas Charles of Chillington House, Maidstone*

Puccini, Ferdinando, *Madonna delle arpe*, donation

Puccini, Ferdinando, *Virgin and Child with Saints John and Elizabeth*, donation

Raigersfeld, Baron de, *Stables of an Old House at Mote Park, Maidstone*

Ramsay, Allan (attributed to) 1713–1784, *Maria Gunning*

Richardson, Jonathan the elder 1665–1745, *Lord Robert Raymond*

Riley, John 1646–1691, *Richard Oxenden*

Riley, John (attributed to) 1646–1691, *Richard Oxenden*

Riley, John (attributed to) 1646–1691, *Barnham Family Member of Boughton Place*

Rosa, Salvator 1615–1673, *Study of Fish*

Rubens, Peter Paul (after) 1577–1640, *Adoration of the Magi*, donation

Ruck, F. W. active 19th C, *Old Manor House, West Farleigh*

Sadeler, Egidius II (after) 1570–1629, *Mary Magdalene at the Feet of Christ on the Cross*

Sant, James 1820–1916, *John Monckton, Town Clerk of this Borough 1838–1875*

Scaramuccia, Giovanni Antonio 1580–1633, *Madonna and Child and Saints*, donation, photo credit: www.bridgeman.co.uk

Schellinks, Willem (style of) 1627–1678, *The Dutch in the Medway*, donation, photo credit: www.bridgeman.co.uk

Schoevaerdts, Mathys active 1682–1694, *Market Scene by a Fountain*, donation

Schotanus, Petrus active c.1663–1687, *Vanitas: Still Life with a Globe*, donation

Scott, *Bridge with Buildings*

Shalders, George c.1826–1873, *Near Connemara, Ireland*

Shaw, W. J., *Shipping in Mid-Channel*, photo credit: www.bridgeman.co.uk

Shepherd, David b.1941, *A Kent Landscape*, © the artist

Shipley, William 1714–1803, *Boy Blowing on a Firebrand (after Godfried Schalcken)*

Shrubsole, W. G. 1855–1889, *The Heart of the Hills*

Simonini, Francesco (attributed to) 1686–c.1755, *Port Scene*, donation

Simonini, Francesco (attributed to) 1686–c.1755, *Port Scene*, donation

Smith, G., *Landscape and River with Figures*

Smith, George (after), *Hop-Picking*, photo credit: www.bridgeman.co.uk

Smith, Hely Augustus Morton 1862–1941, *Lieutenant Colonel Dawson*

Snyders, Frans 1579–1657, *Dogs Stealing Food from a Basket*, donation

Stanley, *Trones Wood*

Steen, Jan (imitator of) 1626–1679, *Peasants at a Table Saying Grace*, donation

Steenwijck, Hendrick van the elder c.1550–1603 & **Steenwijck, Hendrik van the younger** c.1580–1649 , *Interior of a Cathedral Dedicated to a Profane Form of Worship*, donation

Steenwijck, Hendrick van the younger c.1580–1649 & **Brueghel, Jan the elder** 1568–1625, *Interior of a Gothic Church*, donation

Stewart, James, *William Hazlitt (after William Hazlitt)*

Stoppoloni, Augusto 1855–1910, *Miss F. J. Dolby*

Storck, Abraham 1644–1708, *Port Scene with an Arch*, donation

Strange, Albert 1855–1917, *View of Great Buckland*

Strozzi, Bernardo (attributed to) 1581–1644, *Two Figures against a Pillar: One Reclining Nude (The Triumph of Nature over Mankind)*, donation

Stuart, Gilbert (attributed to) 1755–1828, *Thomas Best of Boxley*

Sullivan, J. Owen, *Colonel Maunsell*

Sullivan, J. Owen, *Ensign Stainforth*

Tennant, John F. 1796–1872, *Landscape with Men Salmon Fishing*

Tilborgh, Gillis van c.1635–c.1678, *A Musical Party*, donation, photo credit: www.bridgeman.co.uk

Townsend, William 1909–1973, *Early Morning at Tovil, Kent, 1940*

Townsend, William 1909–1973, *View across the River to Tovil, Maidstone*

Tyrwhitt-Drake, Garrard 1881–1964, *Lady Edna Tyrwhitt-Drake*

unknown artist, *Christ with the Banner of the Resurrection*

unknown artist 16th C, *Portrait of a Bearded Man*, donation

unknown artist 16th C, *Pietà: Christ with St Peter*, donation

unknown artist 16th C, *Adoration of the Magi*, donation

unknown artist 16th C, *St Catherine of Siena and a Bishop Saint*, donation

unknown artist 16th C, *Portrait of a Man c.1570*

unknown artist 16th C, *Sir Conyers Clifford, Governor of Connemara*, donation

unknown artist 16th C?, *Mary, Queen of Scots*

unknown artist 16th or 17th C, *Portrait of a Tudor Gentleman*

unknown artist 17th C, *Landscape with Figures*, Charles Collection

unknown artist 17th C, *Rustic Sports*, donation

unknown artist 17th C, *Rustic Sports*, donation

unknown artist 17th C, *Peasant Sitting to Tend an Injured Hand*, donation

unknown artist 17th C, *Camp Scene*, donation

unknown artist 17th C, *St Thomas*, donation

unknown artist 17th C, *The Martyrdom of St Sebastian*, donation

unknown artist 17th C, *Joseph and Potiphar's Wife*, donation

unknown artist 17th C, *Landscape with Riders*, donation

unknown artist 17th C, *Arabs Playing Bowls*, donation

unknown artist 17th C, *Arabs Playing Bowls*, donation

unknown artist 17th C, *The Marriage Feast at Cana*, donation

unknown artist 17th C, *Feast in the House of Simon the Pharisee*, donation

unknown artist 17th C, *Bacchus and Ariadne*, donation

unknown artist 17th C, *Catherine Walker, Mother of Catherine Yardley*

unknown artist 17th C, *John Hasted, Son of Rev. John Hasted*

unknown artist 17th C, *Moses Hasted of Canterbury and London*

unknown artist 17th C, *Rev. John Hasted*

unknown artist 17th C, *Peasants Carousing*, donation

unknown artist 17th C, *The Angel Appears to Hagar*, donation

unknown artist 17th C, *Madonna and Child with St Joseph*

unknown artist 17th C, *The Deposition: The Descent from the Cross*

unknown artist 17th C, *Card Players in front of a Ruin*

unknown artist 17th C, *Peasants Making Music*, donation

unknown artist 17th C, *Umbram*

unknown artist *Fugat Veritas*, donation

unknown artist 17th C, *Portrait of a Young Woman, c.1630*, donation, photo credit: www.bridgeman.co.uk

unknown artist 17th C, *Edwin, Son of Sir Francis Wiat*

unknown artist 17th C, *Robert Abbot, Bishop of Salisbury*

unknown artist 17th C, *Elizabeth, Darling Wife of Jonas Bargrave*

unknown artist 17th C, *Portrait of a Woman, Early 17th Century*

unknown artist 17th C, *Man Building with Wooden Bridge*

unknown artist 17th C, *Four Putti Lamenting the Crucifixion*

unknown artist 17th C, *Stuart Child*

unknown artist 17th C, *James, Duke of Monmouth*

unknown artist 17th C, *Dr Duthy (or Dethick) of Derby, aged 67*

unknown artist 17th C, *Sir John Marsham of Whorns Place, Cuxton*

unknown artist 17th C, *Interior of the Hall of an English Mansion*

unknown artist 17th C, *King Charles I*, donation

unknown artist 17th C, *Rev. John Cross, Vicar of West Malling*

unknown artist 18th C, *Village Festival*, donation

unknown artist 18th C, *Cherubs Making Garlands*, donation

unknown artist 18th C, *Catherine Yardley, Wife of Joseph (John?) Hasted*

unknown artist 18th C, *Joseph Hasted (1660–1732) son of Moses Hasted*

unknown artist 18th C, *Edward Hasted (1702–1740)*

unknown artist 18th C, *Mary Dorman, Sister of Anna Hasted*

unknown artist 18th C, *Anna Dorman, Wife of Edward Hasted*

unknown artist 18th C, *Madonna and Child with Infant St John*, donation

unknown artist 18th C, *Mansion on a Hill Overlooking a Village*, photo credit: www.bridgeman.co.uk

unknown artist 18th C, *Lady in Riding Habit*, photo credit: www.bridgeman.co.uk

unknown artist 18th C, *Allegorical Landscape*

unknown artist 18th C, *Portrait of a Man with a Hat*

unknown artist 18th C, *Portrait of a Corpulent Man*

unknown artist 18th C, *Portrait of a Man*

unknown artist 18th C, *Portrait of a Man*

unknown artist 18th C, *Captain Robert Farmer*

unknown artist 18th C, *Portrait of a Man with a White Stock*

unknown artist 18th C, *Judith and Holofernes*

unknown artist 18th C, *Classical Scene, Male and Female Figures with Putti*

unknown artist 18th C, *Hawk Carrier*

unknown artist 18th C, *Landscape*

unknown artist 18th C, *Figures in a Wood*

unknown artist 18th C, *Portrait of a Woman, Late 18th Century*

unknown artist 18th C, *Two Figures on Horseback*, donation

unknown artist 18th C, *Perseus and Andromeda*

unknown artist 18th C, *Landscape - Shepherd, Cows and Sheep*

unknown artist 18th C, *Cherubs (after Joos van Cleve)*

unknown artist 18th C, *Landscape River and Figures*

unknown artist 18th C, *Inn with Gentleman*

unknown artist 18th C, *Rev. Gilbert Innes*

unknown artist 18th C, *Elizabeth, Wife of Gilbert Innes*

unknown artist 18th C, *Landscape with Three Figures*

unknown artist 18th C, *James Best of Boxley, Aged 62*

unknown artist 18th C, *Oriental Harbour Scene*

unknown artist 18th C, *Landscape with Chinese Hunting Party*, donation

unknown artist 18th C, *Portrait of a Man*

unknown artist 18th or 19th C, *Christ Appearing to Two Disciples*

unknown artist, *Portrait of a Bearded Man Waving (Despair)*

unknown artist, *The London to Maidstone Stagecoach Passing the Swan Inn*, photo credit: www.bridgeman.co.uk

unknown artist, *Anna Spong, Wife of Captain Charles Mansfield*

unknown artist 19th C, *Bay of Naples*, donation

unknown artist 19th C, *Bay of Naples*, donation

unknown artist 19th C, *The Holy Family*, donation

unknown artist 19th C, *Richard Sergeant*

unknown artist 19th C, *Captain Charles John Moore Mansfield*

unknown artist 19th C, *Robert and William Bellers*

unknown artist 19th C, *Two Children and a Cat*

unknown artist 19th C, *The Stableyard*

unknown artist 19th C, *Seascape*

unknown artist 19th C, *The War Medal: Sergeant-at-Mace Robert Griffin*, donation

unknown artist 19th C, *Portrait of a Woman*

unknown artist 19th C, *Robert Tassell JP*

unknown artist 19th C, *Portrait of a Woman*

unknown artist 19th C, *Portrait of a Man*

unknown artist 19th C, *Thomas Day, Mayor of Maidstone*

unknown artist 19th C, *Landscape with Shepherd, Sheep and Cows*

unknown artist 19th C, *Ducks*

unknown artist 19th C, *Landscape with Sheep and Ferns*

unknown artist 19th C, *Luddesdowne*

unknown artist 19th C, *Cottage in the Mountains*

unknown artist 19th C, *Portrait of a Man Wearing Black-rimmed Spectacles*

unknown artist 19th C, *Boy in a Ruff Holding a Red Book*

unknown artist 19th C, *Woman with a Milk Churn*

unknown artist 19th C, *George Burr, Town Clerk, (1785–1817)*

unknown artist 19th C, *Portrait of a Renaissance Man (after Hans Memling)*

unknown artist 19th C, *Landscape*

unknown artist 19th C, *Tudor Cleric Holding a Ring*

unknown artist 19th C, *The Red and the White Rose*

unknown artist 19th C, *Man on an Ancient Stone*

unknown artist 19th C, *Thomas Edmett Junior*

unknown artist 19th C, *Hulton-Brown, Boatbuilders*

unknown artist 19th C, *View of Maidstone*

unknown artist 19th C, *Portrait of a Woman*

unknown artist 19th C, *Portrait of a Woman*

unknown artist 19th C, *Peasant Girl Holding an Orange*

unknown artist 19th C, *Captain Thomas Best*

unknown artist 19th C, *Wat Tyler*

unknown artist 19th C, *Alexander Randall*

unknown artist 19th C, *Thomas Edmett Senior*

unknown artist 20th C, *Duchess of Kent*

unknown artist, *Head of Christ (After the Edessa Portrait)*, donation

unknown artist, *Portrait of an Unknown Clergyman*

unknown artist, *Madonna and Child*

unknown artist, *Madonna and Child*

unknown artist, *Landscape with an Old Cottage*

unknown artist, *Landscape with Ruined Building and Shipping in the Distance*

unknown artist, *Peaches and Grapes*

unknown artist, *Man Carrying Scythe*

unknown artist, *Mill without Sails*

unknown artist, *Italian View*

unknown artist, *Mounted Turbaned Warriors (St George?)*

unknown artist, *Kneeling Knight and Priest*

unknown artist, *Kneeling Knight and Priest*

unknown artist, *Christ on the Cross*, donation

unknown artist, *Group of Fruit*

unknown artist, *Cottage in a Landscape*

unknown artist, *Castle Interior with Kneeling Knight*

unknown artist, *Three Figures (One in Red Cloak)*

unknown artist, *Still Life, Lobster, Fish and Fowl*

unknown artist, *Portrait of a Man,*

c.1850
unknown artist, *Midshipman 1810*
Velde, Willem van de the elder (imitator of) 1611–1693, *Shipping: a Kaag and Warship at Anchor,* donation
Vernet, Claude-Joseph (style of) 1714–1789, *Sea Port with Shipping,* donation
Verwee, Louis Pierre 1807–1877, *Shepherd with Animals,* donation, photo credit: www.bridgeman.co.uk
Vignon, Claude (attributed to) 1593–1670, *Solomon and Sheba*
Vollerdt, Johann Christian 1708–1769, *Landscape with a Mill,* donation, photo credit: www.bridgeman.co.uk
Vos, Maarten de (after) 1532–1603, *Christ Appears to the Three Marys,* donation
W. G. C., *Maidstone Bridge*
W. S. C. 19th C, *View on the Medway*
Wales, M., *A Bay Horse*
Walls, William 1860–1942, *Lance Monckton, Town Clerk, (1905–1930)*
Watson, Robert active 1899–1920, *Highland Cattle*
Watts, Frederick W. 1800–1862, *Wooded Landscape with Ruins of a Castle*
Watts, Isaac, *Alexander the Great*
Wheeler, T. active 1815–1845, *Tandem Dog Cart Crossing a Ford*
Whitcombe, John active from 1916, *Woodland Scene*
Wijnants, Jan c.1635–1684, *Landscape with River and Bridge,* donation
Williamson, William Henry 1820–1883, *Seascape*
Williamson, William Henry 1820–1883, *Seascape, 1863*
Wilson, Richard 1713/1714–1782, *Landscape*
Wood, G. J., *Scene at Riverhead, Kent*
Wright, James, *James Best of Boxley, Aged 77, 1826,* donation
Zais, Guiseppe (attributed to) 1709–1781, *Landscape with Fishermen,* donation
Zinkeisen, Anna Katrina 1901–1976, *Baby's Head,* purchased
Zuccarelli, Franco 1702–1788, *Macbeth Meeting the Witches*
Zuccarelli, Franco (school of) 1702–1788, *Rest on the Flight into Egypt*

Museum of Kent Life

Carpmael, Cecilia, *Hop-picking,* loan from Maidstone Museum & Bentlif Art Gallery
Poole, W., *Village Green,* gift
Tyrwhitt-Drake, Garrard 1881–1964, *Working Horses and Pony Eating at Manger, Goat Sitting in Foreground,* gift

Margate Library

Webb, James c.1825–1895, *Margate*

Margate Old Town Local History Museum

Alexander, Christopher (attributed to) 1926–1982, *Harry Annish,* Margate Museum T. D. C.
Burley, David, *Margate Pier,* Margate Museum
Burley, David, *Seascape from Margate Pier,* Margate Museum
Clint, Alfred 1807–1883, *Margate from Westbrook,* Margate Museum T. D. C.
E. I., *Shipping in Margate Harbour with Droit House and Stone Pier,* Margate Museum T. D. C.
Goddard, V., *Northdown Park,* Margate Museum T. D. C.
Goddard, V., *Northdown Park,* Margate Museum T. D. C.
Goddard, V., *Northdown House and Park, Margate,* Margate Museum T. D. C.
Hawkins, G. M., *William Booth Reeve, Mayor of Margate 1910,* Margate Museum Civic
Hawkins, G. M., *Margate Harbour,* Margate Museum T. D. C.
Hopper, W. G., *RNLI Rescue of 'Vera',* Margate Museum
Hopper, W. G., *Newgate Gap: Coast Guards Looking for Smugglers,* Margate Museum T. D. C.
Jackson, Bob, *'HMS Margate', an RNA M30 Ship,* Margate Museum
Jackson, J., *Daniel Jarvis,* Margate Museum
Judd (attributed to) 20th C, *Margate Street Scene ,* Margate Museum
N. K., *Mayor of Margate, Alderman Edward Rapson,* Margate Museum Civic
Orchardson, Ian, *P. S. 'Kingswear Castle',* Margate Museum
Orchardson, Ian, *P. S. 'Nephine',* Margate Museum
Phillips, Thomas 1770–1845, *Francis Cobb,* Margate Museum Civic
Ruith, Horace van active 1874–1919, *Mayor William Leach Lewis,* Margate Museum Civic
Sherrin, Daniel 1869–1940, *Hodges Flagstaff, Palm Bay,* Margate Museum
Smith, Frank Sidney b.1928, *Albert John Emptage,* Frank Smith
Souter, John Balloch 1890–1972, *F. J. Cornford,* Margate Museum Civic, © the artist's estate
Souter, John Balloch 1890–1972, *Edward Sidney Linnington JP, Mayor of Ramsgate, (1935–1936),* Margate Museum Civic, © the artist's estate
unknown artist, *British Warships off Reculver,* Margate Museum
unknown artist, *Droit House with Bathing Machines,* Margate Museum T. D. C.
unknown artist, *Francis Cobb?,* Margate Museum
unknown artist, *Francis Cobb?,*

Margate Museum
unknown artist, *Margate Harbour with Ships,* Margate Museum T. D. C.
unknown artist, *Fort Hill, No Man's Land, Mrs Booth's House,* Margate Museum T. D. C.
unknown artist, *Yarmouth Harbour,* Margate Museum T. D. C.
unknown artist, *Religious Theme,* Margate Museum T. D. C.
unknown artist, *Marine Terrace, Margate,* Margate Museum
unknown artist, *Francis Cobb,* Margate Museum Civic
unknown artist, *Assembly Rooms Fire, Margate, Friday October 27, 1882,* presented by Kerbey Cleveland Esq.
unknown artist, *Margate Main Sands and Harbour from the Sea,* Margate Museum
unknown artist, *Edward Wooton,* Margate Museum Civic
unknown artist, *Newgate Gap, Margate,* Margate Museum T. D. C.
unknown artist, *Sir Herbert Stuart Sankey,* Margate Museum
unknown artist, *F. L. Pettman,* Margate Museum Civic
unknown artist, *Margate Twinning,* Margate Museum T. D. C.
unknown artist, *Tudor Male,* Margate Museum T. D. C.
unknown artist, *Tudor Female,* Margate Museum T. D. C.
unknown artist, *Thomas Dalby Reeve, Mayor of Margate, (1873–1875),* Margate Museum Civic
unknown artist, *Marine Terrace, Margate, the Kent Hotel, Ladies on Bicycles,* Margate Museum T. D. C.
unknown artist, *Draper's Mill, Margate,* Margate Museum T. D. C.
unknown artist, *Alderman Hughes,* Margate Museum
unknown artist, *Old Town Hall, Margate,* Margate Museum

The Guildhall, Queenborough

Gascoyne, George 1862–1933, *Alderman Alfred Whittaker Howe JP, CC,* presented by public subscription to the borough
Hucker, A., *Josiah Hall Esq. JP, Mayor of Queenborough,* presented by friends & admirers
Shrubsole, F., *J. Breeze Esq., Mayor of Queenborough*
unknown artist, *G. Iles Esq., Mayor of Queenborough*
unknown artist, *Thomas Young Greet, Mayor of Queenborough,* presented by James Kennedy of Sheerness

Ramsgate Maritime Museum

Acock, A. P., *Sir Ernest Shackleton's Ship, 'Quest', in Ramsgate Harbour,* gift
Broome, William (attributed to) 1838–1892, *Tug 'Vulcan' Towing*

Stricken Vessel into Ramsgate with Lifeboat, gift
Gore, David, *Douglas Kirkaldie,* gift
Gould, Brian S., *Ramsgate Harbour Entrance and Crosswall,* gift, © the artist
Hawkins, F. W. late 19th C, *Seascape: Fishing Smacks off a Harbour,* indefinite loan from Margate Museum
Hopper, William G., *Helicopter Rescue from South Goodwin Lightship,* gift
Hopper, William G., *Everard's 'Sara' Leading in the Thames Barge Race,* gift
Hopper, William G., *A Fine Trawl Breeze,* gift
Lightoller, Mavis, *Motor Yacht 'Sundowner' in WWII Admirality Livery and Flying the White Ensign,* gift
Millett, K. G., *Steam Trawler 'Treasure R37' at Ramsgate Harbour Entrance,* gift
unknown artist early 19th C, *View of Ramsgate Harbour,* indefinite loan from Margate Museum
unknown artist early 20th C, *Painting of Sunk Lightship from Starboard Quarter,* gift
unknown artist early 20th C, *Painting of Sunk Lightship from Abeam, in Wooden 'Lifebelt' Surround,* gift

Ramsgate Museum

Asschen, B., *Grace before Meat,* gift
Broome, S., *Lifeboat Leaving Harbour*
Broome, S., *Lifeboat at the Goodwins*
Broome, S., *Seascape,* purchase
Collings, Albert Henry 1858–1947, *Kimono and Kylin,* gift
Craft, Percy Robert 1856–1934, *Barber's Shop,* gift of Dame Janet Harcourt-Wills
Dixon, Arthur A. active 1892–c.1927, *Well,* gift
Grace, Frances Lily active 1876–1909, *Still Life,* gift
Hollings, A. B., *Ramsgate Sands*
Hughes-Stanton, Herbert Edwin Pelham 1870–1937, *Acropolis at Sunrise,* gift of Dame Janet Harcourt-Wills
Martin, Kennett Beacham 1788–1859, *View from the Sea*
Martin, Kennett Beacham 1788–1859, *Ramsgate Harbour*
Martin, Kennett Beacham 1788–1859, *Ramsgate Harbour*
Meadows, James Edwin active 1853–1875, *Off Folkestone,* gift of Dame Janet Harcourt-Wills
Moody, E. G., *Sandwich Grammar School,* gift
Morris, A., *Sheep,* gift
Mostyn, Dorothy, *Stranger in the Woods,* gift of Dame Janet Harcourt-Wills
Moyes, E., *E. G. Butcher, Baron of Cinque Ports,* gift
Murray, David 1849–1933, *Water Meadows of Hampshire,* gift

Paget, Sidney 1861–1908, *Sir William Henry Wills,* gift
Richmond, Leonard active 1912–1940, *Ramsgate Swimming Pool*
Salles, Jules 1814–1900, *Woman in 18th Century Dress,* gift
Shepherd, Alfred, *Ramsgate Library,* loan
Spencelayh, Charles 1865–1958, *'Lord' George Sanger,* © collection/©copyright courtesy of the artist's estate/www.bridgeman.co.uk
Stokes, Adrian Scott 1854–1935, *Sunset*
Tanner, Alice, *'Lion Gate' at Hampton Court,* gift
unknown artist 18th C, *Rev. George Townsend Snr*
unknown artist, *Storm at Ramsgate*
unknown artist, *Shipping at Ramsgate*
unknown artist, *Ramsgate Street*
unknown artist, *Scene with Shrine,* gift
unknown artist, *Cloister or Church Interior,* gift
unknown artist, *Paddle Steamer,* gift
unknown artist, *Monk and Woman,* gift
unknown artist, *Ramsgate Lighthouse*
unknown artist 19th C, *Ramsgate Harbour*
unknown artist, *Colonel King Harman,* gift
unknown artist, *James Webster,* gift of Dame Janet Harcourt-Wills
unknown artist, *Thomas Whitehead,* gift of Dame Janet Harcourt-Wills
unknown artist, *Arab Scene,* gift
unknown artist, *Trawler 'Gull'*
unknown artist, *Port of Richborough,* gift
unknown artist, *Montefiore House,* gift of Mrs Gibbons
unknown artist, *Ramsgate Harbour,* gift
unknown artist, *Rev. Henry Joseph Bevis*
unknown artist, *Dame Janet Stancomb-Wills*
unknown artist, *Sir Moses Montefiore*
unknown artist, *Ramsgate Harbour*
unknown artist, *John Kennett Esq.*
unknown artist, *Mr Speechley (Church Clerk)*
unknown artist, *Sandwich Bay*

Fairway Library, Rochester

Lewis, Bill b.1953, *The Moon, the Woman and the Fox,* purchased in 2001 by Councillor Marcus Chambers from the Ward Improvement Fund, © the artist

Guildhall Museum, Rochester

Allen, Thomas (attributed to), *The 'Great Harry' Warship,* transfer

Bassett, Grace 20th C, *Aylesford Bridge and Church*, gift

Bell, Henry, *Rochester Castle and Esplanade*, gift

Cooper, Thomas Sidney 1803–1902, *'In the Meadows'*, gift

Dahl, Michael I 1656 or 1659–1743, *Sir Cloudesley Shovell, MP*

E. J. B., *View of Strood from Ladbury's Quay, Rochester*, gift

Finch, W. (attributed to), *View of Frindsbury from Ladbury's Quay*

Finch, W. (attributed to), *Rochester Bridge by Moonlight*

Fox, Ernest R. active 1886–1919, *'Old Rochester before the Building of the Railway'*

Freer, H. Branston active 1870–1902, *River View of the Medway*, gift

Glibber, N. T., *Scene at the White Swan, Chatham*, gift

Hayman, H. W., *Rochester Castle from the West End of Baker's Walk*, purchase

Hayter, George 1792–1871, *Lieutenant Waghorne RN*, gift

Hopper, Henry, *Rochester Castle in Winter*, gift

Hopper, Henry, *Rochester Castle in Winter with Robin*, gift

Hopper, Henry, *View of Rochester Castle from Epaul Lane*, gift

Hopper, Henry, *Rochester Castle from Strood Esplanade*, gift

Hopper, Henry, *Prior's Gate, Rochester*

Hopper, Henry, *Rochester Castle and the King's Head Stables*, bequest

Hopper, Henry (attributed to), *Ladbury's Cottage, Rochester*, gift

Hopper, Henry (attributed to), *Rochester Castle under Snow*

Hopper, Henry (attributed to), *View of Rochester Castle and River Medway*

Huntley, W., *John Dickens (Father of Charles Dickens)*, gift

Knell, William Adolphus 1805–1875, *Rochester, a Misty Morning*

Kneller, Godfrey 1646–1723, *Sir Joseph Williamson, MP*, purchase

Kneller, Godfrey (attributed to) 1646–1723, *King William III*, bequest

Kneller, Godfrey (attributed to) 1646–1723, *Queen Anne*, gift

Kneller, Godfrey (attributed to) 1646–1723, *Sir Stafford Fairbourne, MP*

Konink, Daniel de 1668–after 1720, *Sir John Leake, MP*, gift

Konink, Daniel de 1668–after 1720, *Richard Watts, MP*

Konink, Daniel de (attributed to) 1668–after 1720, *Sir Thomas Colby, Bt, MP*

Lacy, Charles John de c.1860–1936, *Stormy Sea Scene with Sailing Ships*

Lint, Hendrik Frans van 1684–1763, *Classical Italian Landscape*, bequest

Lott, Eva C. 20th C, *Dell Quay*

Peachey, Alfred, *'Old Luton'*

Peachey, E. H., *Dull Prospect Near*

Gillingham Park, transfer

Pearce, Stephen 1819–1904, *Philip Wykeham Martin, MP*, gift

Perugini, Kate 1838–1929, *Mary Angela Dickens (Daughter of Charles Dickens)*

Perugini, Kate 1838–1929, *Dorothy De Michele*, gift

Phillips, J. E., *Roebuck Inn, St Margaret's Street, Rochester*

Phillips, Richard 1681–1741, *Sir Thomas Palmer, Bt, MP*, gift

Priestman, Bertram 1868–1951, *Sunset and Smoke over Rochester*, gift

S. N., *Ladbury's Cottage, Rochester*, gift

Shortland, Dorothy b.1908, *View of the Medway from the New Road*

Smetham, H. M., *Eastgate House Entrance Hall*

Spencelayh, Charles 1865–1958, *Boys Fishing*, © collection/©copyright courtesy of the artist's estate/www.bridgeman.co.uk

Spencelayh, Charles 1865–1958, *Boy's Head*, purchase, © collection/©copyright courtesy of the artist's estate/www.bridgeman.co.uk

Spencelayh, Charles 1865–1958, *If They Were Real*, purchase, © collection/©copyright courtesy of the artist's estate/www.bridgeman.co.uk

Spencelayh, Charles 1865–1958, *Polly Not Forgotten*, purchase, © collection/©copyright courtesy of the artist's estate/www.bridgeman.co.uk

Spencelayh, Charles 1865–1958, *My Pet*, purchase, © collection/©copyright courtesy of the artist's estate/www.bridgeman.co.uk

Spencelayh, Charles 1865–1958, *Charles Spencelayh at the Age of 33*, purchase, © collection/©copyright courtesy of the artist's estate/www.bridgeman.co.uk

Spencelayh, Charles 1865–1958, *Charles Spencelayh at the Age of 79*, gift, © collection/©copyright courtesy of the artist's estate/www.bridgeman.co.uk

Spencelayh, Charles 1865–1958, *Alderman Price (Mayor of Rochester in 1921, 1922 & 1923)*, © collection/©copyright courtesy of the artist's estate/www.bridgeman.co.uk

Spencelayh, Charles 1865–1958, *Mrs Price, Wife of Alderman Price (Mayor of Rochester in 1921, 1922 & 1923)*, © collection/©copyright courtesy of the artist's estate/www.bridgeman.co.uk

Spencelayh, Charles 1865–1958, *Vernon Spencelayh (Artist's Son)*, gift, © collection/©copyright courtesy of the artist's estate/www.bridgeman.co.uk

Spencelayh, Charles 1865–1958, *The first Mrs Spencelayh (Elizabeth Hodson Stowe)*, purchase, © collection/©copyright courtesy of the artist's estate/www.bridgeman.co.uk

Spencelayh, Charles 1865–1958, *A*

Dark Beauty, purchase, © collection/©copyright courtesy of the artist's estate/www.bridgeman.co.uk

Spencelayh, Charles 1865–1958, *Sunset*, purchase, © collection/©copyright courtesy of the artist's estate/www.bridgeman.co.uk

Spencelayh, Charles 1865–1958, *Frindsbury Steam Brewery*, © collection/©copyright courtesy of the artist's estate/www.bridgeman.co.uk

Spencelayh, Charles 1865–1958, *Panoramic View of Luton, Chatham*, gift, © collection/©copyright courtesy of the artist's estate/www.bridgeman.co.uk

Spencelayh, Charles 1865–1958, *The Twilight of Life*, purchase, © collection/©copyright courtesy of the artist's estate/www.bridgeman.co.uk

Spencelayh, Charles 1865–1958, *Dutch Snow Scene*, purchase, © collection/©copyright courtesy of the artist's estate/www.bridgeman.co.uk

Spencelayh, Charles 1865–1958, *The Second Mrs Spencelayh*, © collection/©copyright courtesy of the artist's estate/www.bridgeman.co.uk

Spencelayh, Charles 1865–1958, *Dog's Head*, purchase, © collection/©copyright courtesy of the artist's estate/www.bridgeman.co.uk

Spencelayh, Charles (attributed to) 1865–1958, *Henry Spencelayh*, gift, © collection/©copyright courtesy of the artist's estate/www.bridgeman.co.uk

Spencelayh, Charles (attributed to) 1865–1958, *Mrs Spencelayh*, gift, © collection/©copyright courtesy of the artist's estate/www.bridgeman.co.uk

Stedman 19th C, *Naïve Painting of Delce Farm*, purchase

Stedman 19th C, *Naïve Painting of Delce Farm*, purchase

Stedman 19th C, *Naïve Painting of Delce Farm, Showing Haymaking*, purchase

Stephen, Daniel, *The Medway Bridge M2*, purchase

unknown artist 17th C?, *Unknown Cardinal*

unknown artist late 17th C?, *Scene with Two Classical Figures*

unknown artist late 17th C?, *Dutch Raid on the River Medway in 1667*

unknown artist, *Lady Carberry*, bequest

unknown artist, *Sir John Jennings, MP*

unknown artist early 18th C?, *Sir Cloudesley Shovell, MP*, gift

unknown artist early 18th C?, *Portrait of Unknown Lady with Roses in Early 18th C Pink Dress*

unknown artist 18th C?, *King James II*, gift

unknown artist late 18th/early 19th C, *Classical Italian Landscape*, bequest

unknown artist late 18th/early 19th C?, *Alderman Thomas Stevens, Mayor of Rochester*

unknown artist, *John Foord*, gift

unknown artist, *Rebekah Foord*, gift

unknown artist, *Thomas Hill*, loan

unknown artist, *Sergeant Cuthbertson of the 19th City of Rochester Volunteer Rifles*

unknown artist, *Frank Bridge CVO Mus D*, gift

unknown artist early 19th C, *William Peter King, Mayor of Rochester in 1815*, bequest

unknown artist early 19th C, *Mrs P. King, Wife of William Peter King, Mayor of Rochester in 1815*, bequest

unknown artist early 19th C?, *Alderman Richard Thompson, MD, Mayor of Rochester*

unknown artist 19th C, *The Maidstone, Rochester and Chatham Post Coach*, gift

unknown artist 19th C?, *Chinese Painting of Ladies Watching a Contest between Two Crickets*

unknown artist mid-19th C, *James Pye (Local Farmer)*, gift

unknown artist mid-19th C, *Portrait of a Victorian Lady*

unknown artist mid-19th C, *Rochester Castle from the River Medway*

unknown artist mid-late 19th C, *Stormy Sea Scene with Sailing Ships*

Valentini, Valentino b.1858, *Portrait of a Male Classical Figure, possibly Cupid*

Wollaston, John active 1736–1775, *Alderman David Wharam (Mayor in 1744)*, gift

Wright, T. T. active 1820–1826, *J. Best*

Sandwich Guildhall Museum

Delange, Maurice, *La Lieutenance, Honfleur*, gift

Finn, Herbert b.1860, *Sailor and Girl in Delf Street*, permanent loan

Gabrielli, W. 1920–2001, *Mayor William R. Rose, (1930–1931)*, gift

Harle, Dennis F. 1920–2001, *Flemish Gabled Cottages in Cattle Market*, gift by the late Charles F. Burch, © the artist

Harle, Dennis F. 1920–2001, *Panoramic View of Sandwich*, gift, © the artist

Kay, Pamela b.1939, *Mayor Robert Raymond Chesterfield, (1972–1973 & 1983–1984)*, purchased

Maxton, H., *Barbican and Tollbridge*, gift

Moyes, E., *Mayor Mrs Jean C. Maughan, (1970–1971)*, gift

Moyes, E., *Queen Elizabeth II*, gift

Moyes, E., *Queen Elizabeth, the Queen Mother*, gift

Oving, William, *Mayor Henry Burch, Cinque Ports Baron, (1945–1946)*, gift

Page, Henry Maurice 1845–1908, *Market Day in Sandwich*

Page, Henry Maurice 1845–1908, *Barbican and River Stour*

R. M. P., *St Peter's Church, with Laburnum Tree*, gift

Swanton, Ann, *View of the Butts*, gift

unknown artist, *Puritan Lady*, permanent loan

unknown artist, *1st Earl of Sandwich*, gift

unknown artist, *Charles II*, gift

unknown artist, *Catherine of Braganza*, gift

unknown artist, *Mayor Bartholomew Coombes, (1671–1672)*

unknown artist, *Duke of York - Later James II*, gift

unknown artist, *Lady with Carnation*

unknown artist, *Sandown Gate*

unknown artist, *Cinque Ports Fleet in Pegwell Bay*

unknown artist, *Fleet with Neptune in Centre Cartouche*

unknown artist, *View of Sandwich from the South with Post Mills and Newgate*, gift

unknown artist, *Mayor Richard Solly, (1718, 1728, 1736 & 1749)*

unknown artist, *Mayor John Matson, (1777–1778)*

unknown artist, *Captain William Boys*, gift

unknown artist, *Elizabeth Boys*

unknown artist, *Mayor Richard Emmerson, (1793–1794, 1801, 1812, 1830 & 1845)*, gift

unknown artist, *William Boys FSA, (1735–1808)*

unknown artist, *Mayor William Wyborn Bradly, (1785–1786)*, gift

unknown artist, *Rev. Henry Pemble*

unknown artist, *Mayor William Rolfe, (1827–1828, 1839, 1841 & 1843)*, gift

unknown artist, *George II?*

unknown artist, *Mayoress Harriett Marsh, Wife of Richard Marsh*, gift

unknown artist, *Mayor Richard Marsh, (1856 & 1862)*

unknown artist, *Mayoress Bradly, Wife of Stephen, (1817–1818)*

unknown artist, *Tollbridge, with Barge*, gift

unknown artist, *Mayor William J. Hughes, (1882–1883, 1888–1890, 1896–1899 & 1912–1918)*

unknown artist, *Mayor Henry S. Watts, Cinque Ports Baron, (1884–1886, 1891, 1901 & 1907–1908)*

unknown artist, *The Courtroom*

unknown artist, *Map with Cinque Port Towns Marked*, purchased

unknown artist, *Mayor James J. Thomas, (1950–1951 & 1954–1959)*

unknown artist, *Barbican (after 18th C engraving)*, gift

unknown artist, *Duke of Wellington*, gift

Velde, Willem van de (attributed to) 1633–1707, *Catherine of Braganza's Visit (first part of quadruptych)*, gift

Velde, Willem van de (attributed to) 1633–1707, *Catherine of Braganza's Visit (second part of quadruptych)*, gift

Velde, Willem van de (attributed to) 1633–1707, *Catherine of Braganza's Visit (third part of quadruptych)*, gift

Velde, Willem van de (attributed to) 1633–1707, *Catherine of Braganza's Visit (fourth part of quadruptych)*, gift

Velde, Willem van de (attributed to) 1633–1707, *Battle of Sole Bay (first part of quadruptych)*, gift

Velde, Willem van de (attributed to) 1633–1707, *Battle of Sole Bay (second part of quadruptych)*, gift

Velde, Willem van de (attributed to) 1633–1707, *Battle of Sole Bay (third part of quadruptych)*, gift

Velde, Willem van de (attributed to) 1633–1707, *Battle of Sole Bay (fourth part of quadruptych)*, gift

Weigall, Henry 1829–1925, *Sandwich Quarter Sessions, 1898*

Court Hall Museum

Poniter, *Crown Quay*, on loan from G. Jordan

Poniter, *Head of Miton Creek*, on loan from G. Jordan

unknown artist early 19th C, *Stephen Hills, (1778–1848)*

unknown artist mid-19th C, *William Hills*

unknown artist, *John Hills snr*

unknown artist, *Elizabeth Phillis Hills (née Webb)*

Swale Borough Council

Boxall, William 1800–1879, *Rev. John Poore DD, JP*, presented

Eddis, Eden Upton 1812–1901, *George Smeed*, presented

Hacker, Arthur 1858–1919, *Henry Payne JP, CC*, presented

Rook, Barnard 1857–1889, *George Payne*, presented

Tenterden Museum Collection

Love, W., *Ismonger Farm House*, gift

Peskett, John, *Westwell House*, gift

Sykes, C. Hildegarde, *Barge at Small Hythe*, gift

Sykes, C. Hildegarde, *Ashbourne Mill*, gift

Sykes, C. Hildegarde, *Castweazle Toll House*, gift

unknown artist, *Old Man with Beard*, gift

unknown artist, *18th Century Man with Lazy Eye - Mr Curteis*, gift

Willcocks, John 1898–1991, *Reaben Collison*, gift

Wills, J. H., *Edward Langley Fisher*, gift

Tenterden Town council

Adams, Bernard, *Vivian Dampier-Palmer, High Sheriff of Kent 1921*, presented to Tenterden Corporation in 1961 by grand-daughter Mrs Clegg

Beresford, Daisy Radcliffe, *Joseph Robert Diggle*

British (English) School, *Elizabeth Curteis*, presented by Brig. Gen. Drake Brockman 21.9.1938

British (English) School, *Robert Curteis, Aged 45, Baillie Mayor, (1627–1632)*, presented by Brig. Gen. Drake Brockman 21.9.1938

British (English) School early 20th C, *Colonel James Dampier-Palmer*

British (English) School, *Alderman Leslie Chalk*, presented by Mrs Pauline Chalk in July 1995

Colles, Dorothy b.1917, *Stanley Day*, presented by son, Martin Day 7.7.2002

Hoare, William (circle of) c.1707–1792, *Samuel Curteis*

Seghers, Gerard 1591–1651, *Judith with the Head of Holofernes*, presented by Paul Golmick of Mayfield in April 1948

Van Damme-Sylva, Willem Bataille Emile, *Cows Grazing in Summer Pasture*, gift from Mr Ralph Mitchison

Tunbridge Wells Museum and Art Gallery

Aldridge, J. E., *Interior of Great Bounds, Southborough*, gift

Ansdell, Richard 1815–1885, *Crossing the Moor*, bequest from Mr E. R. Ashton

Baxter, Charles 1809–1878, *Olivia*, bequest from Mr E. R. Ashton

Betteridge, Harold 1892–1972, *The Common*, purchase

Betteridge, Harold 1892–1972, *February Morning*, purchase

British (English Naïve) School, *Speldhurst Church Struck by Lightning*, purchase

British (English) School, *Bayhall, Pembury*, untraced find

British (English) School, *Rev. Thomas Edwards*

Bronckhorst, Arnold (after) c.1566–1586, *A Young Nobleman (James I?) with a Falcon*, gift

Brooks, Thomas 1818–c.1891, *The Valentine*, bequest from Mr E. R. Ashton

Burgess, John Bagnold 1830–1897, *Spanish Girl*, bequest from Mr E. R. Ashton

Burgess, John Bagnold 1830–1897, *Portrait of a Girl*, bequest from Mr E. R. Ashton

Carr Cox, *Alderman J. R. Gower*, gift to the borough

Clover, Joseph (attributed to) 1779–1853, *Richard Cumberland*, gift

Creswick, Thomas 1811–1869, *Autumn Leaves*, bequest from Mr E. R. Ashton

Curtler, F. M., *In the Grove*, purchase

Damoye, Pierre Emmanuel 1847–1916, *Rural Landscape with Figures in the Foreground*, gift

Davies, Charlotte active c.1860, *Normandy Girl*, bequest from Mr E. R. Ashton

Davis, Henry William Banks 1833–1914, *Twilight, Vallée de la Cluse, Near Boulogne*, bequest from Mr E. R. Ashton

Dodd, Charles Tattershall I 1815–1878, *Rocks with Cattle Grazing*, purchase

Dodd, Charles Tattershall I 1815–1878, *Culverden Common, Tunbridge Wells*, purchase

Dodd, Charles Tattershall I 1815–1878, *The Timber Wagon*, purchase

Dodd, Charles Tattershall I 1815–1878, *Standings Mill*, purchase

Dodd, Charles Tattershall I 1815–1878, *Rusthall Common*, untraced find

Dodd, Charles Tattershall I 1815–1878, *St Helena Cottage, Tunbridge Wells Common*, purchase

Dodd, Charles Tattershall I 1815–1878, *Isabelle Rebecca Dodd Feeding a Ewe, Ducks and Chickens at Groombridge*, purchase

Dodd, Charles Tattershall I 1815–1878, *Culverden Down, Tunbridge Wells*, transfer

Dodd, Charles Tattershall I 1815–1878, *Castle Road, the Common, Tunbridge Wells*, transfer

Dodd, Charles Tattershall I 1815–1878, *Reynold's Farm, Reynold's Lane, Tunbridge Wells*, transfer

Dodd, Charles Tattershall I 1815–1878, *View over Eridge*, gift

Dodd, Charles Tattershall II 1861–1951, *Dr George Abbott*, gift, © the artist's estate

Dodd, Charles Tattershall II 1861–1951, *Isabelle Rebecca Dodd and Henrietta Jane Sadd*, gift, © the artist's estate

Dodd, Charles Tattershall II 1861–1951, *J. C. M. Given*, untraced find, © the artist's estate

Dodd, Charles Tattershall II 1861–1951, *Thomas Sims*, untraced find, © the artist's estate

Dodd, Charles Tattershall II 1861–1951, *The Sasseneire and Val de Moiry, Grimentz*, purchase, © the artist's estate

Dodd, Charles Tattershall II 1861–1951, *St Michel, Quimperlé*, gift, © the artist's estate

Duffield, William 1816–1863, *Still Life with Dead Game*, bequest from Mr E. R. Ashton

Edwards, Thomas, *The Bowling Green, St John's Recreation Ground*, purchase

Enhuber, Karl von 1811–1867, *The Piping Bullfinch*, bequest from Mr E. R. Ashton

Enhuber, Karl von 1811–1867, *The Dead Bullfinch*, bequest from Mr E. R. Ashton

Flemish School 17th C, *Unknown Woman*, untraced find

Goodall, Frederick 1822–1904, *A Letter from Papa*, bequest from Mr E. R. Ashton

Goodall, Frederick 1822–1904, *On the Road to Mandalay*, gift

Grant, F., *The Picture House at Poundsbridge*, gift

Grant, Nina, *Rev. James Mountain Hailstone, George Sturgeon*, gift to the borough

Hardy, Frederick Daniel 1826–1911, *Young Photographers*, bequest from Mr E. R. Ashton

Hedgecock, Derek, *The Opera House, Tunbridge Wells*, purchase, © Jan Hedgecock

Helm, Patricia, *Closed Shop (Camden Road)*, purchase, © Estate of the late P. A. Helm

Helm, Patricia, *Mount Ephraim Road*, purchase, © Estate of the late P. A. Helm

Herbert, Margaret, *Commuters*, gift

Hill, James John 1811–1882, *The Fisherman's Return*, bequest from Mr E. R. Ashton

Hoare, William c.1707–1792, *Richard Beau Nash*, bequest

Hodges, Sidney 1829–1900, *William, Marquess of Abergavenny*, loan

Hoogsteyns, Jan b.1935, *Still Life*, gift, © the artist

Hughes, William 1842–1901, *Still Life with Bird's Nest and Fruit*, bequest from Mr E. R. Ashton

Huysman, Jacob c.1633–1696, *Charles II*, loan

Ivimey, John, *The Toad Rock, Rusthall Common*, purchase, © the artist

Knell, William Adolphus 1805–1875, *The Shipwreck*, bequest from Mr E. R. Ashton

Kneller, Godfrey (follower of) 1646–1723, *Frederick, Prince of Wales*, gift

Knight, William Henry 1823–1863, *Grandfather's Portrait*, bequest from Mr E. R. Ashton

Lee, Frederick Richard 1798–1879 **& Cooper, Thomas Sidney** 1803–1902, *Cattle on the Banks of a River*, bequest from Mr E. R. Ashton

Leech, John, *Trinity, Autumn*, purchase, © the artist

Leech, John, *London Road and Mount Ephraim Junction*, purchase, © the artist

Leech, John, *The Building of Victoria Place*, purchase, © the artist

Leech, John, *Victoria Place - Stairway*, purchase, © the artist

Lely, Peter (studio of) 1618–1680, *General Monk*, loan

Leslie, Charles active 1835–1863, *Evening in the Highlands*, bequest from Mr E. R. Ashton

Leslie, Charles active 1835–1863, *Morning - Ullswater*, bequest from Mr E. R. Ashton

Linnell, John 1792–1882, *A Surrey Lane*, bequest from Mr E. R. Ashton

Linnell, John 1792–1882, *The Cornfield Shelter*, bequest from Mr E. R. Ashton

Llewellyn, William Samuel Henry 1854–1941, *John Stone-Wigg*, gift to the borough

Lutwidge, Charles Fletcher 1836–1907, *Ponte del mare, Pisa*, gift to the borough

Lutwidge, Charles Fletcher 1836–1907, *L'Arco di Tito, Roma*, gift to the borough

McCulloch, M., *Hop-pickers*, gift, © the artist's estate

Meacham, C. S. early 20th C, *Bottom of London Road, Tunbridge Wells (Old Forge)*, gift

Mutrie, Annie Feray 1826–1893, *Still Life with Fruit and Flowers*, bequest from Mr E. R. Ashton

O'Neil, Henry Nelson 1817–1880, *The Toilette*, bequest from Mr E. R. Ashton

O'Neil, Henry Nelson 1817–1880, *The Lazy Girl*, bequest from Mr E. R. Ashton

Octavius Wright, Charles, *Beau Nash at the Gaming Table*, gift, © the artist's estate

Philip, John 1817–1867, *The Bridesmaid*, bequest from Mr E. R. Ashton

Seymour, William, *Symphony in Red and Blue*, purchase

Seymour, William, *The Lake in Dunorlan Park*, purchase

Seymour, William, *On the Rocks (Wellington Rocks, Tunbridge Wells Common)*, purchase

Solomon, Abraham 1824–1862, *Brighton Front*, bequest from Mr E. R. Ashton

Solomon, Abraham 1824–1862, *Waiting for the Verdict*, bequest from Mr E. R. Ashton

Solomon, Abraham 1824–1862, *The Acquittal*, bequest from Mr E. R. Ashton

Stanfield, George Clarkson 1828–1878, *Rotterdam*, bequest from Mr E. R. Ashton

Tuke, Henry Scott (circle of) 1858–1929, *Boy in a Punt*, untraced find

unknown artist, *Light Infantry Officer*, untraced find

unknown artist, *Lower Green, Rusthall*, gift

unknown artist, *Charles Fletcher Lutwidge*, gift to the borough

unknown artist, *A Cob Mute Swan*, gift

unknown artist, *Thomas Fox Simpson*, gift to the borough

Verboeckhoven, Eugène 1799–1881 **& Verveer, Salomon Leonardus** 1813–1876, *Landscape*, bequest from Mr E. R. Ashton

Wheatley, John 1892–1955, *Hall's Bookshop, Chapel Place*, gift

Wheeler, Cecil, *The Pantiles*, purchase

Wilkinson, Jean, *Upper Grosvenor Road*, purchase

Wilkinson, Jean, *Calverley Gardens*, purchase

English Heritage, Walmer Castle

Alford, John b.1890, *Winter Landscape, Sir Robert Menzies*, photo credit: English Heritage

Campbell, Reginald, *Australian Landscape, Sir Robert Menzies*, photo credit: English Heritage

Collection Addresses

Arts and Museums, Kent County Council
Springfield, Maidstone ME14 2LH
Telephone 01622 696498

Canterbury City Council Museums and Galleries:

Guildhall, Canterbury
(access by special appointment. Correspondence should
be sent to Canterbury Royal Museum)

Lord Mayor's Parlour
Tower House, Canterbury
(access by special appointment. Correspondence should
be sent to Canterbury Royal Museum)

Royal Museum and Art Gallery
18 High Street, Canterbury CT1 2RA
Telephone 01227 452747

Museum of Canterbury
Stour Street, Canterbury CT1 2NR
Telephone 01227 475202

Herne Bay Museum and Gallery
12 William Street, Herne Bay CT6 5EJ
Telephone 01227 367368

Whitstable Museum and Gallery
5 Oxford Street, Whitstable CT5 1DB
Telephone 01227 276998

Corridor Arts, Marlowe Theatre
The Marlowe Theatre, The Friar's, Canterbury
Telephone 01227 786867

Court Hall Museum
High Street, Milton Regis, Sittingbourne (please note that
there is no mail delivery facility or telephone at the
museum)
Telephone 01795 423708 (for enquiries only)

Cranbrook Museum
Carriers Road, Cranbrook TN17 3JX
Telephone 01580 712516

Cranbrook Parish Council
Council Chamber, Vestry Hall, Stone Street, Cranbrook
TN17 3DE
Telephone 01580 713112

Dartford Borough Museum
Market Street, Dartford DA1 1EU
Telephone 01322 224739

Dartford Library
Central Park, Dartford DA1 1EU
Telephone 01322 221133

Deal Town Council
Town Hall, High Street, Deal CT14 6BB
Telephone 01304 361999

Dickens House Museum
2 Victoria Parade, Broadstairs CT10 1QS
Telephone 01843 861232/863453

Dover Collections:

Dover District Council
Council Offices, White Cliffs Business Park, Whitfield,
Dover CT16 3PJ
Telephone 01304 821199

Dover Museum
Market Square, Dover CT14 6PL
Telephone 01304 201066

Dover Town Council
Maison Dieu House, Biggin Street, Dover CT16 1DW
Telephone 01304 242625

Dover Town Hall
Biggin Street, Dover CT16 1DL
Telephone 01304 201200

English Heritage, Walmer Castle
Kingsdown Road, Walmer CT14 7LJ
Telephone 01304 364288

Fairway Library, Rochester
Leake House, The Fairway, Rochester ME1 2LY
Telephone 01634 846813

Faversham Town Council, Mayor's Parlour and Guildhall
The Alexander Centre and the Guildhall, Faversham
(access by special appointment)
Telephone 01795 594442/3

Folkestone Museum
Grace Hill, Folkestone CT20 1HD
Telephone 01303 256710

Folkestone Charter Trustees
The Grand, The Leas, Folkestone CT20 2XL
Telephone 01303 222222

Gravesham Borough Council
Civic Centre, Windmill Street, Gravesend DA12 1AU
Telephone 01474 564422

Guildhall Museum, Rochester
High Street, Rochester ME1 1PY
Telephone 01634 848717

Historic Dockyard, Chatham
Chatham Historic Dockyard Trust,
The Historic Dockyard, Chatham ME4 4TZ
Telephone 01634 823800

Hythe Council Offices, Local History Room and Town Hall
Oaklands, Stade Street, Hythe CT21 6BG
Telephone 01303 266152

Kent Fire and Rescue Service Museum
Tovil, Maidstone ME15 6XB
Telephone 01622 692121 (ask for the museum)

Kent Police
Headquarters, Sutton Road, Maidstone ME15 9BZ
Telephone 01622 652705

Kent Police Museum
The Historic Dockyard, Chatham ME4 4TZ
Telephone 01634 403260

Maidstone County Hall
Sessions House, Maidstone ME14 1XQ
Telephone 01622 694242

Maidstone Museum & Bentlif Art Gallery
St Faith's Street, Maidstone ME14 1LH
Telephone 01622 602838

Margate Library
2 Cecil Square, Margate CT9 1XZ
Telephone 01843 223626

Margate Old Town Local History Museum
Market Place, Margate CT9 1ER
Telephone 01843 231213

Medway NHS Trust
Medway Maritime Hospital, Windmill Road,
Gillingham ME7 5NY
Telephone 01634 830000

Museum of Kent Life
Lock Lane, Sandling, Maidstone ME14 3AU
Telephone 01622 763936

Ramsgate Maritime Museum
Clock House, Pier Yard, Royal Harbour,
Ramsgate CT11 8LS
Telephone 01843 570622

Ramsgate Museum
Guilford Lawn, Ramsgate CT11 9AY
Telephone 01843 593532

Royal Engineers Museum
Prince Arthur Road, Gillingham ME4 4UG
Telephone 01634 822839

Sandwich Guildhall Museum
Guildhall, Cattle Market, Sandwich CT13 9AH
Telephone 01304 617197

Swale Borough Council
Swale House, East Street, Sittingbourne ME10 3HT
Telephone 01795 417394

Tenterden Museum Collection
Tenterden Museum, Station Road, Tenterden TN30 6HN
Telephone 01580 764310

Tenterden Town Council
Town Hall, 24 High Street, Tenterden TN30 6AN
Telephone 01580 762271

The Guildhall, Queenborough
8 North Road, Queenborough ME11 5EZ
Telephone 01795 585609

Tunbridge Wells Museum and Art Gallery
Civic Centre, Mount Pleasant,
Royal Tunbridge Wells TN1 1JN
Telephone 01892 554171

Index of artists

A. B. C. (17th C) 124
Acock, A. P. 188
Adams, Bernard 220
Akerbladh, Alexander (1886–1958) 83
Aldridge, J. E. 224
Alexander, Christopher (1926–1982) 107, 182
Alexander, Jack 107
Alford, John (b.1890) 235
Allen, Thomas 198
Alma-Tadema, Laura Theresa Epps (1852–1909) 54
Alvaridale 104
Amos, George Thomas (1827–1914) 54
Anderson, William (1757–1837) 54, 124
André, James Paul the younger (active 1823–1859) 124
Anglo-Chinese School 54
Anguissola, Sofonisba (c.1532–1625) 124
Ansdell, Richard (1815–1885) 224
Anthony, Henry Mark (1817–1886) 124
Appleton, Thomas Gooch (1854–1924) 52
Archer, C. 35
Arellano, Juan de (1614–1676) 124
Argyle, R. V. 83
Arison, Mark 54
Asschen, B. 191
Atkinson, John Gunson (active 1849–1885) 5
Bailey, Colin C. 55
Baker-Clack, Arthur (1877–1955) 104
Baldry, George W. 55, 80, 95
Banner, Delmar Harmond (1896–1983) 125
Bardwell, Thomas (1704–1767) 114
Barker, Thomas (1769–1847) 55
Barker, Thomas Jones (1815–1882) 125
Barland, Adams (active 1843–1916) 99
Barrett, George (1728–1784) 125
Bassano, Alessandro 114
Bassett, Grace (20th C) 198
Bates, David (active 1868–1893) 5
Baxter, Charles (1809–1878) 224
Beach, Ernest George (1865–c.1934) 83
Beadle, James Prinsep (1863–1947) 42, 125
Beale, Mary (1633–1699) 5, 125
Beamand, B. 107
Beavis, Richard (1824–1896) 6
Beechey, William (1793–1839) 6
Bell, Henry 198
Bellingham-Smith, Elinor (1906–1988) 125
Bennett, H. 95
Bensted, Joseph 125
Beresford, Daisy Radcliffe 220
Berry, John 125
Betteridge, Harold (1892–1972) 224
Bionda, P. 6
Birch, Samuel John Lamorna (1869–1955) 125
Birley, Oswald Hornby Joseph (1880–1952) 55, 114, 115
Blackman, John 55
Blinks, Thomas (1860–1912) 126
Bloemen, Jan Frans van (1662–1749) 6, 126
Blommaert, G. 56

Boddington, Henry John (1811–1865) 126
Bogdany, Jakob (c.1660–1724) 126
Bolitho, A. 126
Booth, Raymond C. (b.1929) 56
Bouvier, Augustus Jules (c.1825–1881) 126
Bower, Edward 115
Boxall, William (1800–1879) 218
Bratby, John (1928–1992) 6
Breydel, Karel (1678–1733) 127
Bright, Henry (1814–1873) 127
British (English Naïve) School 224
British (English) School 6, 42, 56, 57, 115, 222, 224
British (Norwich) School 127
Broad, William Henry (1853–1939) 57
Brockman, Cornelia (active 19th C) 83
Bronckhorst, Arnold (c.1566–1586) 224
Brooking, Charles (1723–1759) 127
Brooks, F. G. 52
Brooks, Henry Jamyn (1865–1925) 57
Brooks, Thomas (1818–c.1891) 225
Broome, S. 191
Broome, William (1838–1892) 188
Brothers, Alfred (active 1882–1893) 127
Broun, Phillip 128
Brouwer, Adriaen (1605/1606–1638) 58
Brown, Alexander Kellock (1849–1922) 238
Brown, Alfred J. 6
Brown, W. T. 107
Brueghel, Jan the elder (1568–1625) 128, 157
Bruton, W. 6
Bryan, Edward (1804–1860) 128
Buckner, Richard (active 1820–1877) 115, 238
Bugg, E. J. 47
Bull, W. B. 107
Burgess, C. W. B. 128
Burgess, John Bagnold (1830–1897) 225
Burgess, William (1805–1861) 58
Burley, David 182
Burney, Henry B. 238
Burrell, James (active 1859–1876) 7
Burrell, Joseph Francis (b.1770) 45
Burton, Frederic William (1816–1900) 128
Cackett, Leonard (1896–1963) 83
Campbell, Reginald 235
Canaletto (1697–1768) 128
Cardew, G. E. 104
Carmichael, James Wilson (1800–1868) 58
Carpmael, Cecilia 128, 179
Carr, Leslie (active 20th C) 58
Carr Cox 225
Cassell, H. 35
Castan, Pierre Jean Edmond (1817–after 1865) 59
Castle, G. 59
Chalon, Alfred Edward (1780–1860) 129
Chalon, Henry Bernard (1770–1849) 59
Chambers, George (1803–1840) 238
Chapman (jnr), W. J. (b.1808) 45
Charlton, John (1849–1917) 129

Chatelain (active 18th C) 129
Chatelain, Antoine (1794–1859) 129
Cheadle, David 36
Chinnery, George (1748–1847) 129
Chitty, Cyril 129
Clark, Joseph (1834–1926) 129
Clark (active 1899–1930) 99
Clarke, J. H. 129
Clarke, S. 7
Clarke, T. E. 238
Cleeve, E. 7
Clegg, Richard (b.1966) 107
Cleve, Joos van 167
Clint, Alfred (1807–1883) 59, 182
Clover, Joseph (1779–1853) 225
Cobbett, Edward John (1815–1899) 130
Cockerham, Charles (active c.1900–1935) 59
Codazzi, Viviano (c.1604–1670) 130
Coffyn, A. 59
Coker, Olive 47
Cole, Ethel (b.1892) 59
Cole, George (1810–1883) 238
Colles, Dorothy (b.1917) 222
Collier, John (1850–1934) 130
Collin, Charles 130
Collings, Albert Henry (1858–1947) 191
Collins, James Edgell (1820–after 1875) 130
Collins, William (1788–1847) 7
Collinson, Robert (1832–after 1890) 130
Colonia, Adam (1634–1685) 130
Constable, John (1776–1837) 7
Cook, Allon 235
Cook, Ebenezer Wake (1843–1926) 238
Cook, Janet 3
Cook or Cooke 99
Cooke, Edward William (1811–1880) 60
Cooper, Thomas George (1836–1901) 7, 131
Cooper, Thomas Sidney (1803–1902) 7, 8, 9, 60, 115, 131, 199, 230
Cooper, William Sidney (1854–1927) 3, 4, 9, 131
Copley, John Singleton (1738–1815) 238
Copri, Adrienne 60
Corbould, Aster Richard Chilton (1811–1882) 9
Cork, M. E. 47
Corke, C. 107
Cotes, Francis (1726–1770) 115
Cotman, John Sell (1782–1842) 9
Coulson, J. 107
Courtois, Jacques (1621–1676) 131
Cowan, Ian 99
Coward, Noël (1899–1973) 60
Cox, D. C. 4
Cox, David the elder (1783–1859) 60
Cox, E. Albert (1877–1955) 9, 10, 83
Craft, Percy Robert (1856–1934) 191
Cranbrook, W. 238
Crayer, Gaspar de (1584–1669) 131
Creswick, Thomas (1811–1869) 10, 225
Critz, John de the elder (1551/1552–1642) 115, 116
Crome 132
Crome, John (1768–1821) 10
Croos, Jan Jacobsz. van der (1654/1655–c.1716) 132
Crosse, Tony (b.1944) 92, 93
Cuming, Frederick (b.1930) 10, 132

Curtis, C. E. 60
Curtler, F. M. 225
Curtois, Mary Henrietta Dering (1854–1929) 10
Cuyp, Aelbert (1620–1691) 132
Dahl, Michael I (1656/1659–1743) 60, 116, 132, 199, 236
Damoye, Pierre Emmanuel (1847–1916) 225
Dance-Holland, Nathaniel (1735–1811) 116, 132
Daniell, Thomas (1749–1840) 132
Daniell, William (1769–1837) 132
Davey, Doreen (b.1968) 60
Davidson, G. H. 95
Davies, Charlotte (active c.1860) 225
Davies, Gordon (b.1926) 10
Davies, Peter (b.1970) 36
Davis, Henry William Banks (1833–1914) 226
Dawson, Alfred (active 1860–1894) 10
Dawson, Montague J. (c.1894–1973) 42
Day, Herbert J. (1864–1915) 133
Day, Jane (active 1894–1897) 132, 133
de Garay, Talla 60
de Grey, Roger (1918–1995) 10
De Simone, Alfredo (1898–1950) 36
Delange, Maurice 211
Desanges, Louis William (1822–c.1887) 11, 95
Dickinson, Lowes Cato (1819–1908) 133
Dicksee, Frank (1853–1928) 116
Dinsdale, T. (early 19th C) 11
Dixon, Arthur A. (active 1892–c.1927) 191
Dobson, William Charles Thomas (1817–1898) 133
Dodd, Charles Tattershall I (1815–1878) 11, 133, 226, 227
Dodd, Charles Tattershall II (1861–1951) 227
Dommard, E. M. 62
Doord 133
Dou, Gerrit (1613–1675) 11, 134
Doxford, James (1899–1978) 11
Droochsloot, Joost Cronelisz. (1586–1666) 134
Drummond 134
Drummond, Julian 134
Drummond, Samuel (1765–1844) 134
Dubbels, Hendrik Jacobsz. (1620/1621–1676) 11
Dubreuil, C. 62
Ducq, Johan le (1629–1676/1677) 135
Dudley, Colin (b.1923) 11
Duffield, William (1816–1863) 228
Dughet, Gaspard (1615–1675) 135
Dunlop, Ronald Ossory (1894–1973) 36
Dunnage, W. (active 1843–1852) 99
Dunstan, Bernard (b.1920) 135
Dupont, Gainsborough (1754–1797) 236
Dusart, Cornelis (1660–1704) 12
Dutch School 62, 135
Dyck, Anthony van (1599–1641) 7, 12, 62, 67
E. I. 182
E. J. B. 199
Eddis, Eden Upton (1812–1901) 218
Eddy, W. 62
Edwards, Thomas 228
Enhuber, Karl von (1811–1867) 228
Etty, William (1787–1849) 135
Eversen, Johannes Hendrik (1906–1995) 62
Eves, Reginald Grenville (1876–1941) 135
Ewer, Peggy 83
Failing, R. 62

Fairbrass, Irene 238
Fallshaw, Daniel (1878–1971) 62
Fannen, John (active 1887–1901) 36
Fantin-Latour, Henri (1836–1904) 63
Farrar, C. Brooke 84
Farthing, Stephen (b.1950) 108
Ferg, Franz de Paula (1689–1740) 63
Finch, W. 199
Finn, F. L. 135
Finn, Herbert (b.1860) 211
Flemish School 228
Fletcher, E. 12
Foley, Victor Sebastian 84
Foord, Charles 135
Foreman, Margaret (b.1951) 12
Fosse, Charles de la (1636–1716) 136
Foster 108
Foster, Roger (b.1936) 94
Foster, Walter H. (active 1861–1888) 12
Fowler, Norman (1903–2001) 44
Fox, Ernest R. (active 1886–1919) 12, 199
Francken, Frans II (1581–1642) 136
Franzoni, Fredo 84
Fraser, John (1858–1927) 36
Freer, H. Branston (active 1870–1902) 199
Fricker, Pat (b.1948) 94
Gabrielli, W. (1920–2001) 211
Gainsborough, Thomas (1727–1788) 12, 63
Gascoyne, George (1862–1933) 187
Geeraerts, Marcus, the younger (1561–1635) 116
Gegan, J. J. 136
Gerard, Theodore (1829–1895) 63
Gerrard, Kaff (1894–1970) 13
Gibbs, Henry (1630/1631–1713) 13
Gilbert, A. 99
Gilroy, John M. (1898–1985) 236
Glazebrook, Hugh de Twenebrokes (1870–1935) 63, 136
Glibber, N. T. 199
Goddard, V. 182
Goodall, Frederick (1822–1904) 84, 228
Goodsall, R. H. 36
Goodwin, Albert (1845–1932) 4, 13, 136, 137, 138, 238
Goodwin, H. C. 63
Goodwin, Harry (1842–1925) 138, 139
Goodwin Green, Eliza (1851–1932) 139
Gore, David 188
Gould, Brian S. 188
Goyen, Jan van (1596–1656) 139
Grace, Frances Lily (active 1876–1909) 191
Grant, F. 228
Grant, Francis (1803–1878) 52, 84, 139
Grant, Nina 228
Graves, Henry Richard (1818–1882) 116
Gregory, Edward John (1850–1909) 13
Greiffenhagen, Maurice (1862–1931) 63
Grey-Jones, Michael (b.1950) 4
Grossmann, Alexander J. (1833–1928) 63
Gryef, Adriaen de (1670–1715) 139
Guggisberg, F. G. 95
H. F. H. 64
Hacker, Arthur (1858–1919) 219
Hackney, Arthur (b.1925) 108
Hailstone 229

Hailstone, Bernard (1910–1987) 64, 139
Halhed, Harriet (1850–1933) 14
Hallady, A. E. 14
Hals, Dirck (1591–1656) 64
Hardy, Frederick Daniel (1826–1911) 229
Hardy, Paul (active 1890–1903) 14
Harle, Dennis F. (1920–2001) 64, 211
Harlow, George Henry (1787–1819) 139
Harold, S. R. 37
Harp, C. S. 64
Harpers, D. 84
Harris, P. A. 108
Harrison 14
Harrod, J. 64
Haslehurst, J. B. 139, 140
Haughton, Benjamin (1865–1924) 84
Hawkins, F. W. (late 19th C) 188
Hawkins, G. M. 182, 183
Hawksley, Arthur (1842–1915) 14
Haydon, Benjamin Robert (1786–1846) 64
Hayman, H. W. 14, 199, 238
Haynes-Williams, John (1836–1908) 99
Hayter, George (1792–1871) 200
Hazlitt, John (1767–1837) 140
Hazlitt, Margaret (1770–1844) 140, 142, 238
Hazlitt, William (1778–1830) 142, 143, 157
Hedgecock, Derek 229
Helm, Patricia 229
Helm, Stewart (b.1960) 108
Henry, James Levin (1855–1929) 84
Henson, S. (active late 18th C) 52
Henzell, Isaac (1815–1876) 64
Herbert, Margaret 229
Herkomer, Hubert von (1849–1914) 117
Herrick, William Salter (active 1852–1888) 14
Herring, John Frederick I (1795–1865) 65, 69
Hewson, S. 65
Hewson, Stephen (1775–1807) 14, 15
Highmore, Joseph (1692–1780) 52, 65
Hill, Austin (b.1933) 39
Hill, James John (1811–1882) 229
Hoare, William (c.1707–1792) 222, 229
Hodges, Sidney (1829–1900) 15, 143, 229
Holden, W. F. C. 96
Holl, Frank (1845–1888) 15
Hollings, A. B. 191
Hollins, John (1798–1855) 15
Holloway, Charles Edward (1838–1897) 100
Hone, Nathaniel I (1718–1784) 15
Honthorst, Gerrit van (1590–1656) 15
Hoogsteyns, Jan (b.1935) 104, 230
Hoogstraten, Samuel van (1627–1678) 117
Hopkins, William (active 1787–1811) 143
Hopkins, William H. (d.1892) 143
Hopper, Henry 200, 202
Hopper, M. A. F. 143
Hopper, W. G. 183
Hopper, William G. 188
Hoppner, John (1758–1810) 143
Hosking, H. L. 65
Hosking, John 108
Houghton, Arthur Boyd (1836–1875) 143
Howard, Bill 16

Howard, Elizabeth 143
Howells, Gerald S. 47
Hucker, A. 187
Hudson, Thomas (1701–1779) 16, 52
Hughes, Arthur (1832–1915) 144
Hughes, Edward Robert (1851–1914) 144
Hughes, William (1842–1901) 230
Hughes-Stanton, Herbert Edwin Pelham (1870–1937) 144, 192
Hunt, Arthur Ackland (active 1865–1902) 144
Hunt, Edgar (1876–1953) 65
Hunter, Ian (b.1939) 16
Huntley, W. 202
Hutching, R. F. 96
Huysman, Jacob (c.1633–1696) 230
Huysmans, Cornelis (1648–1727) 144
Hyde, Frank (1849–1937) 42, 144
Illingworth, Nancy 109, 144
Innis, D. (active 20th C) 65
Isabey, Eugène (1803–1886) 16
Italian School 65, 66, 144
Italian (Venetian) School 66, 145
Ivimey, John 230
Jackson, Bob 183
Jackson, J. 183
Jackson, John (1778–1831) 16
James, Walter John (1869–1932) 16
Janssens van Ceulen, Cornelis (1593–1661) 16, 117, 145
Jarvis, P. V. (active 1930–1935) 42
Jefferys, James (1751–1784) 145
Jefferys, William (1723–1805) 145
Jenkins, George Henry (1843–1914) 17
Jervas, Charles (c.1675–1739) 145
Jobert, Paul (1863–after 1924) 17
Johnson, G. 45
Jordaens, Jacob (1593–1678) 17
Jowett, F. 48
Joyce, Arthur (1923–1997) 42, 43
Judd (20th C) 183
Judkin, Reverend Thomas James (1788–1871) 17
Kauffmann, Angelica (1741–1807) 117
Kay, Pamela (b.1939) 211
Kennedy, Cecil (1905–1997) 66
Kennedy, Charles Napier (1852–1898) 117
Kennedy, Philomena (1932–1999) 66
Kent, M. A. 66
Kerr, Richard 85
King 146
Knell, William Adolphus (1805–1875) 202, 230
Kneller, Godfrey (1646–1723) 67, 117, 118, 146, 202, 230
Knight, J. 109
Knight, John Prescott (1803–1881) 17
Knight, Laura (1877–1970) 17, 67
Knight, William Henry (1823–1863) 230
Koekkoek, Hermanus the younger (1836–1909) 37
Konink, Daniel de (1668–after 1720) 202, 203
Kooyhaylen or Koningshusen, J. 17
Krieghoff, Cornelius (1815–1872) 67
Kruseman, Frederik Marianus (1817–1860) 146
L. A. R (19th C) 18
Lana, Lodovico (1597–1646) 142
Landseer, Edwin Henry (1802–1873) 69
La Thangue, Henry Herbert (1859–1929) 18
Lacy, Charles John de (c.1860–1936) 37, 203

Laidman, G. 85
Lambourn, George (1900–1977) 146
Langker, Erik (1898–1982) 236
Lavery, John (1856–1941) 104
Lawrence, Thomas (1769–1830) 67
Le Claire, M. 109
Lee, Frederick Richard (1798–1879) 146, 230
Lee, L. M. 105
Lee, May Bridges (active c.1905–1967) 46, 48
Lee, P. 18
Leech, John 230, 231
Leeder, H. 100
Leighton, Charles Blair (1823–1855) 96
Lely, Peter (1618–1680) 67, 147, 231
Leslie, Charles (active 1835–1863) 231
Lewis, Bill (b.1953) 197
Lewis, John Hardwicke (1840–1927) 147
Lightoller, Mavis 189
Lilley, John (active 1832–1853) 67
Lindon, Francis 85
Lines, Vincent Henry (1909–1968) 147
Linnell, John (1792–1882) 231
Lint, Hendrik Frans van (1684–1763) 203
Linton, James Dromgole (1840–1916) 147
Llewellyn, William Samuel Henry (1854–1941) 231
Lloyd, Vincent (b.1960) 109
Locatelli, Andrea (1695–1741) 147
Loo, Jean-Baptiste van (1684–1745) 18
Lord, Sarah (b.1964) 109
Lott, Eva C. (20th C) 203
Loutherbourg, Phillip James de (1740–1812) 148
Love, W. 219
Lowcock, C. J. 100
Lucas, John Templeton (1836–1880) 148
Luny, Thomas (1759–1837) 67
Lutwidge, Charles Fletcher (1836–1907) 232
Lynn, John (active 1826–1838) 37
Mackley, George (1900–1983) 110
Maclise, Daniel (1806–1870) 67
MacTavish, Euphemia L. C. 18
Maitland, Paul Fordyce (1863–1909) 85
Major, John 85
Manson, James Bolivar (1879–1945) 18
Maratti, Carlo (1625–1713) 18
Marlow, William (1740–1813) 85
Marshall, Benjamin (1767–1835) 18
Martin 67
Martin, Elias (1739–1818) 43
Martin, Kennett Beacham (1788–1859) 192
Martin, Sylvester (1856–1906) 148
Mason, Arnold (1885–1963) 100
Maxton, H. 212
Maxwell, Donald (1877–1936) 44
McCall, Charles James (1907–1989) 148
McCulloch, M. 232
McLachlan, Thomas Hope (1845–1897) 19
McLernon, Huw (or N. J. W.) 148
Meacham, C. S. (early 20th C) 232
Meadows, (Canon) 19
Meadows, James Edwin (active 1853–1875) 192
Mears, George (active 1866–1890) 85, 86
Memling, Hans (c.1433–1494) 172
Merritt, Thomas Light 148

Metsu, Gabriel (1629–1667) 19
Middleton, James Godsell (active 1826–1872) 19
Miereveld, Michiel Jansz van (1567–1641) 148
Mignard, Pierre I (1612–1695) 68
Mignon, Abraham (1640–c.1679) 149
Miles, Arthur (active 1851–1885) 19
Millais, John Everett (1829–1896) 26, 68
Miller, William Ongley (b.b.1883) 100
Millett, K. G. 189
Mitchell (19th C) 19, 86
Molenaer, Klaes 149
Molyn, Pieter (1595–1661) 149
Monamy, Peter (1681–1749) 149
Money-Coutts, Godfrey Burdett (1905–1979) 19
Monnington, Walter Thomas (1902–1976) 19
Monteitti, J. 149
Moody, E. G. 192
Mor, Antonis (b.1512–1516–d.c.1576) 68
Mordecai, Joseph (1851–1940) 149
Morland, George (1763–1804) 19, 20, 68, 149
Morley, Robert (1857–1941) 149
Mornewick I and II, Charles Augustus (active 1832–1874) 86
Morris, A. 192
Morris, D. 86
Morris, Ebenezer Butler (active 1833–1863) 68
Mostyn, Dorothy 192
Moyes, E. 192, 212
Moynihan, Rodrigo (1910–1990) 149
Mulier, Pieter the younger (c.1637–1701) 150
Müller, William James (1812–1845) 20
Munnings, Alfred James (1878–1959) 150
Murillo, Bartolomé Esteban (1618–1682) 129
Murray, David (1849–1933) 20, 86, 150, 193
Mutrie, Annie Feray (1826–1893) 232
N. K. 183
Nash, John Northcote (1893–1977) 68
Nasmyth, Patrick (1787–1831) 20
Neame, Austin (1789–1862) 20
Neer, Aert van der (1603–1677) 20, 150
Nelson, Arthur (active 1766–1790) 69
Neubert, Ludwig (1846–1892) 238
Newington Hughes, John 150
Nicholls, Bertram (1883–1974) 150
Nicholls, Charles Wynne (1831–1903) 69
Nickalls, Beatrix 44
Niemann, Edmund John (1813–1876) 37, 150
Noakes, Michael (b.1933) 118
Norden, Gerald 110
Norman, M. 86
Northcote, James (1746–1831) 150
Octavius Wright, Charles 232
Ogden, Joseph 20
Ogilvie, Frank Stanley (b.c.1856) 69
Olsson, Albert Julius (1864–1942) 69
O'Neil, Henry Nelson (1817–1880) 232
Opie, John (1761–1807) 20, 151
Orchardson, Ian 183
Orley, Bernaert van (c.1492–1541) 22
Osborne, K. 110
Ostade, Adriaen van (1610–1685) 69, 151
Ouless, Walter William (1848–1933) 22
Oving, William 212
P. N. 68

Paccini, Ferdinando 151
Pace del Campidoglio, Michele (1610–probably 1670) 151
Padday, Charles (1890–1940) 87
Page, Henry Maurice (1845–1908) 212
Page, Patricia 69
Paget, Sidney (1861–1908) 193
Paine, R. 238
Palmer, Alfred (1877–1951) 22, 113, 238
Palmer, James 22
Panini, Giovanni Paolo (c.1692–1765) 151, 152
Pardon, James (c.1794–1862) 22
Parish, James Harnett (b.1832) 69, 70
Parker, Mordaunt M. 70
Parris, Edmund Thomas (1793–1873) 22, 70
Parrott, William (1813–after 1875) 152
Parsons, Christine 110
Partridge, John (1790–1872) 118, 238
Passingham, E. S. 48
Paton, Waller Hugh (1828–1895) 87
Peachey, Alfred 203
Peachey, E. H. 203
Peake, Mervyn (1911–1968) 152
Peake, Robert I (c.1551–1619) 118
Pearce, Stephen (1819–1904) 203
Pearce, Sylvia 46, 47, 48
Peellaser, J. 70
Peisley, T. 110
Pemell, James (active 1836–1856) 22
Perugini, Kate (1838–1929) 203
Perugino (c.1450–1523) 22
Peskett, John 219
Petrie, Graham (1859–1940) 100, 238
Philip, John (1817–1867) 232
Phillips, J. E. 204
Phillips, Richard (1681–1741) 204
Phillips, Thomas (1770–1845) 118, 184
Piper, J. E. 70
Pirri, Antonio (active 1509–1520) 22
Pissarro, Lucien (1863–1944) 23
Playford 105
Plowman, Elisabeth 152
Poelenburgh, Cornelis van (1594/1595–1667) 152
Pole-Stuart, Reginald 87
Polidoro da Caravaggio (c.1497–c.1543) 153
Poniter 217
Poole, David (b.1931) 236
Poole, W. 179
Pourbus, Frans the younger (1569–1622) 153
Pragoe, C. (b.1830) 87
Pretty, Edward (1792–1865) 153
Priestman, Bertram (1868–1951) 87, 204
Proctor, E. 71
Puccini, Ferdinando 153
Pyne, James Baker (1800–1870) 23
R. M. P. 212
Raigersfeld, Baron de 153
Ramsay, Allan (1713–1784) 71, 153
Ramsey, Dennis 53
Raphael (1483–1520) 23, 74, 80
Razé, L. L. 11
Read, Catherine (1723–1778) 23
Reynolds, Joshua (1723–1792) 71
Ribera, Jusepe de (1591–1652) 87

Richards, F. 23
Richardson, Jonathan the elder (1665–1745) 153
Richardson, William 71
Richmond, George (1809–1896) 24
Richmond, Leonard (active 1912–1940) 193
Riley, John (1646–1691) 118, 154
Roberto, Luigi (active 1870–1890) 37
Roberts, Edna Dorothy (1877–1970) 87
Robins, Thomas Sewell (1814–1880) 71
Robinson, Beverley 110, 111
Romney, George (1734–1802) 71, 118
Rook, Barnard (1857–1889) 219
Rosa, Salvator (1615–1673) 154
Rosenburg, Gertrude Mary 24
Rottenhamer, Hans I (1564–1625) 128
Rousham, Edwin 48, 49
Rubens, Peter Paul (1577–1640) 13, 154
Ruck, F. W. (active 19th C) 154
Ruith, Horace van (active 1874–1919) 184
Russell, John 71
Russian School 71
S. N. 207
Sadeler, Egidius II (1570–1629) 154
Salles, Jules (1814–1900) 193
Sampson, John 87
Sant, James (1820–1916) 154
Scaramuccia, Giovanni Antonio (1580–1633) 154
Schaefer, Henry Thomas (active 1873–1915) 24
Schalken, Godfried (1643–1706) 155
Schellinks, Willem (1627–1678) 155
Schendel, Petrus van (1806–1870) 72
Schoevaerdts, Mathys (active 1682–1694) 155
Schotanus, Petrus (active c.1663–1687) 155
Schulman, David (1881–1966) 88
Scott 155
Scott, S. 72
Scott, Walter (1771–1832) 24
Sears, E. H. 72
Seemann, Enoch the younger (1694–1744) 24, 238
Seghers, Gerard (1591–1651) 222
Severn, Arthur (1842–1931) 37
Sevier, Joseph (b.1961) 24
Seymour, William 233
Shalders, George (c.1826–1873) 155
Shaw, W. J. 155
Shepherd, Alfred 193
Shepherd, David (b.1941) 155
Sherrin, Daniel (1869–1940) 37, 38, 184, 238
Shipley, William (1714–1803) 155
Shortland, Dorothy (b.1908) 204
Shrubsole, F. 187
Shrubsole, W. G. (1855–1889) 155
Sickert, Walter Richard (1860–1942) 24
Simonini, Francesco (1686–c.1755) 156
Smart 72
Smetham, H. M. 204
Smith, Frank Sidney (b.1928) 184
Smith, G. 156
Smith, George 156
Smith, Hely Augustus Morton (1862–1941) 156
Snagg, J. 72
Snell, James Herbert (1861–1935) 24
Snowman, Isaac (b.1874) 102

Snyders, Frans (1579–1657) 156
Soldi, Andrea (c.1703–1771) 25
Solomon, Abraham (1824–1862) 233
Somer, Paulus van I (1576–1621) 119
Souter, John Balloch (1890–1972) 184
Speed, Harold (1872–1957) 72, 73
Spencelayh, Charles (1865–1958) 193, 204, 205, 206
Stanfield, Clarkson (1793–1867) 73
Stanfield, George Clarkson (1828–1878) 233
Stanley 156
Stannard, Alfred (1806–1889) 25
Stannard, Joseph (1797–1830) 73
Stark, James (1794–1859) 25
Stedman (19th C) 206, 207
Steen, Jan (1626–1679) 156
Steenwijck, Hendrick van the elder (c.1550–1603) 156
Steenwijck, Hendrick van the younger (c.1580–1649) 156, 157
Stephen, Daniel 207
Stevens, Charles Hastings 88
Stewart, James 157
Stokes, Adrian Scott (1854–1935) 25, 193
Stone, D. W. 73
Stoppoloni, Augusto (1855–1910) 157
Storck, Abraham (1644–1708) 157, 238
Stothard, Thomas (1755–1834) 25
Strange, Albert (1855–1917) 157
Strozzi, Bernardo (1581–1644) 157
Stuart, Gilbert (1755–1828) 157
Sullivan, J. Owen 157
Swain, Ned 26
Swanton, Ann 212
Swiney, Captain Stephen 26
Syer, John (1815–1885) 26
Sykes, C. Hildegarde 219
T. E. (19th C) 4
Tanner, Alice 193
Tapley, M. E. 73
Tayler, Albert Chevallier (1862–1925) 26, 88
Taylor, Terri 88
Temple, Robert Scott (active 1874–1905) 26
Teniers, Abraham (1629–1670) 73
Tennant, John F. (1796–1872) 158
Terry, W. J. 73
Thompson, A. H. 102
Thoresby, Valerie 4
Tilborgh, Gillis van (c.1635–c.1678) 158
Titchell, Tim 111
Titian (c.1488–1576) 26, 129, 142
Tomkys, A. 96
Tonkin, Paul (b.1951) 44
Towne, Charles (1763–1840) 26
Townsend, William (1909–1973) 26, 158
Troubetzkoy, Paolo Prince (1866–1938) 73
Tuke, Henry Scott (1858–1929) 233
Turner 44
Turner, E. 96
Tyrwhitt-Drake, Garrard (1881–1964) 158, 179
Valentini, Valentino (b.1858) 210
Van Damme-Sylva, Willem Bataille Emile 222
Veale, S. I. 76
Velde, Willem van de (1633–1707) 216, 217
Velde, Willem van de the elder (1611–1693) 176
Verboeckhoven, Eugène (1799–1881) 234

Vernet, Claude-Joseph (1714–1789) 176
Veronese, Paolo (1528–1588) 76
Veroucke, P. (1528–1588) 76
Verveer, Salomon Leonardus (1813–1876) 234
Verwee, Louis Pierre (1807–1877) 176
Vickers, Alfred (1786–1868) 34
Victoryns, Anthoni (d. before 1656) 76
Videan, John Allen (1903–1989) 90
Vignon, Claude (1593–1670) 176, 238
Vollerdt, Johann Christian (1708–1769) 176
Vos, Maarten de (1532–1603) 176
W. G. C. 176
W. H. G. 39
W. S. C. (19th C) 176
Wales, M. 177
Walker, G. H. 39
Walls, William (1860–1942) 177
Walters, Douglas 103
Warcup, Samuel 50
Ward, Edwin Arthur (1859–1933) 90
Ward, James (1769–1859) 34
Ward, John Stanton (b.1917) 34
Warren, K. 76
Waters, William Richard (1813–1880) 77, 78
Watson, Robert (active 1899–1920) 177
Watt, Thomas (1920–1989) 111
Watton, M. H. 90
Watts, Frederick W. (1800–1862) 177
Watts, Isaac 177
Weaver, C. L. 238
Webb, James (c.1825–1895) 179
Weenix, Jan Baptist (1621–1660/1661) 34
Weigall, Henry (1829–1925) 103, 217
Weight, Carel Victor Morlais (1908–1997) 34, 111, 112
Westmacott, Stewart (b.c.1824) 5
Weston, Lambert 80, 82
Wheatley, John (1892–1955) 234
Wheeler, Cecil 234
Wheeler, T. (active 1815–1845) 177
Whitcombe, George E. 78
Whitcombe, John (active from 1916) 177
Whiting, Alf (1905–1972) 78
Wicks, Sara 35
Wightwick, William (1831–1907) 90
Wijnants, Jan (c.1635–1684) 177
Wilkie, David (1785–1841) 35
Wilkinson, Jean 234
Wilkinson, Norman (1878–1971) 79
Willass, C. 98
Willcocks, John (1898–1991) 220
Williams, Edgar 103
Williams, George Augustus (1814–1901) 35
Williams, R. 90
Williamson, James (active 1868–1889) 90, 91
Williamson, William Henry (1820–1883) 177, 178
Willis, Henry Brittan (1810–1884) 79
Wills, J. H. 220
Wilson 79
Wilson, John H. (1774–1855) 91
Wilson, John James II (1818–1875) 91
Wilson, John Snr 91
Wilson, Richard (1713/1714–1782) 178
Winter, M. 103

Wissing, Willem (c.1656–1687) 53, 79, 120, 122
Wollaston, John (active 1736–1775) 210
Wood, G. J. 178
Woodward, Thomas (1801–1852) 35
Wootton, Frank (1914–1998) 79
Wootton, John (c.1682–1765) 237
Wright, James 178
Wright, John Michael (1617–1694) 79
Wright, John Michael (1617–1694) 122
Wright, T. T. (active 1820–1826) 210
Youens, Clement T. (1852–1919) 50, 51, 238
Youens, Ernest Christopher (1856–1933) 51, 238
Zais, Guiseppe (1709–1781) 178
Zinkeisen, Anna Katrina (1901–1976) 178
Zoffany, Johann (1733–1810) 79
Zuccarelli, Franco (1702–1788) 178